KU-766-164

TRISTAN MANCO

Raw

+

Material

=

Art

FOUND, SCAVENGED AND UPCYCLED

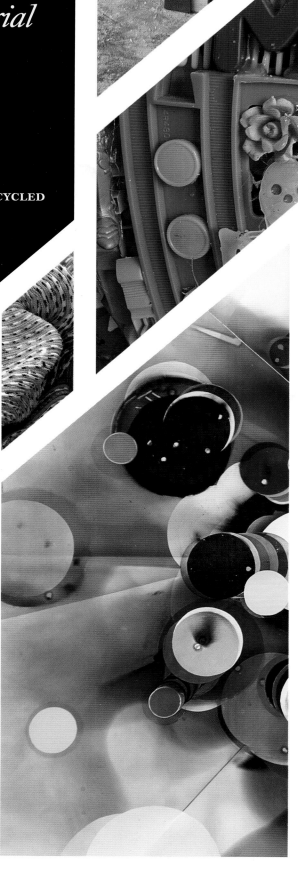

Thames & Hudson

For Louis George Manco

First published in the United Kingdom in 2012 by
Thames & Hudson Ltd, 181A High Holborn, London WC1V 7QX

Raw + Material = Art: Found, Scavenged and Upcycled
Copyright © 2012 Thames & Hudson Ltd, London
Text copyright © 2012 Tristan Manco

All Rights Reserved. No part of this publication may be reproduced or transmitted
in any form or by any means, electronic or mechanical, including photocopy,
recording or any other information storage and retrieval system, without prior
permission in writing from the publisher.

Any copy of this book issued by the publisher as a paperback is sold subject to the
condition that it shall not by way of trade or otherwise be lent, resold, hired out or
otherwise circulated without the publisher's prior consent in any form of binding
or cover other than that in which it is published and without a similar condition
including these words being imposed on a subsequent purchaser.

British Library Cataloguing-in-Publication Data
A catalogue record for this book is available from the British Library

ISBN 978-0-500-28991-4

Printed and bound in China by C & C Offset Printing Co., Ltd

To find out about all our publications, please visit **www.thamesandhudson.com**.
There you can subscribe to our e-newsletter, browse or download our current catalogue,
and buy any titles that are in print.

Contents

Introduction:
The Art of Materials

A new wave of international artists has emerged who use humble or unconventional materials and highly original methods to create work that is tactile, aesthetically arresting and imbued with wit and charm. Many of them repurpose utilitarian or scrap materials, from unglamorous items of domestic waste, found wood and even organic detritus such as skin and nails to recycled toys, books, skateboards, firecrackers and lights. Others show creative approaches to traditional or proven media such as paper, stone, concrete and steel. The beautiful, ingenious and thought-provoking results celebrated in this book range across a broad spectrum, from intimate paper collages to large public sculptures constructed from discarded wood.

While their creations are diverse, the featured artists are typically champions of the handmade, applying established low-tech or craft methods such as collage, assemblage, carving, painting and weaving in exciting new ways. Some of the artists have reinvented traditional techniques, including Dutch sculptor Ron van der Ende who has taken the ancient form of bas-relief and updated it for the 21st century using found wood to almost photorealistic effect. A number of artists have invented completely new methods. American artist Rosemarie Fiore uses lit fireworks to create intensely vibrant and colourful paintings, for example, while Chilean Carlos Zúñiga has developed

a signature approach to his works on paper, striking out names on the pages of local telephone directories to reveal his ghostly portraits and landscapes.

No less innovative are the varied approaches that these artists take in presenting their art. Some of the work has been conventionally exhibited in a formal gallery setting, but more often than not the artists break the rules of the white cube. In some extremes artists have completely altered the structure of the gallery space to provide a highly immersive experience. The labyrinthine installation *Túnel (Tunnel)*, staged by Brazilian artist Henrique Oliveira at the Instituto Itaú Cultural, São Paulo, in 2007, is one of the best examples. Other artists display their work in alternative spaces in the hope of engaging a new audience that might not necessarily choose to visit a gallery. A deserted beach, a mock fruit stall and a field of sunflowers are just some of the settings in which pieces or performances have been created.

From the beautifully intricate cut-paper plumes by American artist Mia Pearlman to Oliveira's flowing organic structures in warped and moulded scrap wood, each body of work reveals the practitioner's transformative touch and relationship with the materials. The artists may be drawn to certain materials for a variety of reasons, be they aesthetic, emotional or intellectual. However, while their goals

01 Michael Johansson, *Self Contained*, containers, caravan, tractor, Volvo, pallets and refrigerators, 2010.

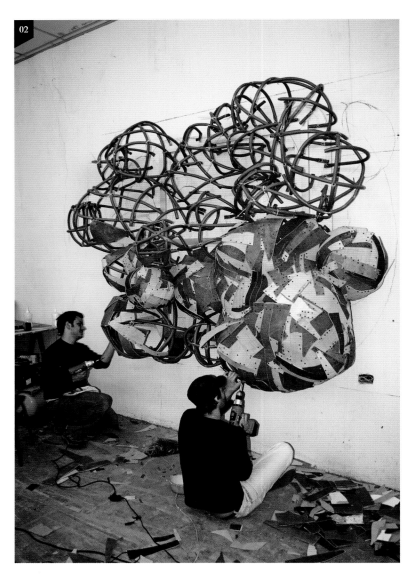

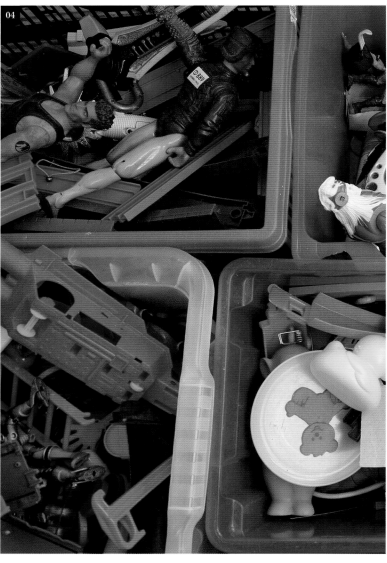

'Objects gain their value through the situations in which they are placed – in other words, what defines the value of an object is not the material it is made from or the function it serves, but its position in a context.'

Michael Johansson

and preoccupations may be poles apart, they share a respect for and a spirit of investigation in their chosen media. Learning from matter and reacting to our material world, they explore both the tactile qualities and the associated meanings of down-to-earth materials to create art that is inventive and often environmentally sensitive.

Waste reinvention

We take it for granted these days that art can be made from any substance or object and can even take a non-material form – a performance, a film projection or a digital work. It is not surprising in itself if an artist presents us with a work made from unusual materials. However, even if we anticipate spectacle, we can still be struck by such a work. Jeff Koons's iconic *Puppy* (1992), a 43-ft (13-m) topiary sculpture now installed outside the Guggenheim Museum in Bilbao, is a prominent example. The artists in this book use unconventional but recognizable materials to shock, amuse or inspire us, and challenge our perception of the world.

Our broad acceptance of alternative materials in art is a relatively recent development, however. We owe it to the rise of modernism and the many avant-garde movements that flourished in the late 19th and early 20th centuries, and those leading exponents who, in reaction to the new

industrial age, began to question the purpose and materialization of art. Marcel Duchamp was particularly influential, questioning the very notion of art and our adoration of it. His idea was to pick an everyday object – a 'readymade', to use his own term – to which he felt indifferent, and present it as art. His most famous piece *Fountain*, created in 1917, was a found urinal that he signed with the pseudonym 'R. Mutt', and at the time it caused a sensation. The philosophy behind *Fountain* continues to inspire generations of artists: to look at the world differently and use objects and materials in a way that questions our understanding of what art can be.

Duchamp's work laid the foundations for conceptual art, and *Fountain* is such an iconic piece that it has become a symbol of contemporary art. French artist Baptiste Debombourg, who often makes use of unusual materials, clearly references *Fountain* in his work *Polybric* (2002), which replicates the form of Duchamp's urinal using hundreds of plastic toy bricks. While Duchamp's intention was to switch the focus of art from craft to intellectual interpretation, Debombourg's urinal, which he installed in a real public toilet for a couple of days, is evidently constructed by hand to colourful effect. Nonetheless, this tongue-in-cheek reinterpretation of the theme is similarly non-conformist in its absurdist rendition of a mundane form.

02 Henrique Oliveira, work in progress, 2008.
03 Gabriel Dawe, *Plexus no. 2 (relics): convergence*, thread from site-specific installation at Conduit Gallery (April–June 2010), Dallas, USA, and plexiglas, 2011.
04 Robert Bradford, materials, 2010. 05 Monica Canilao.

Overleaf 06 Maria Nepomuceno, *Untitled*, sewn ropes, wood, straw and beads, 2008.

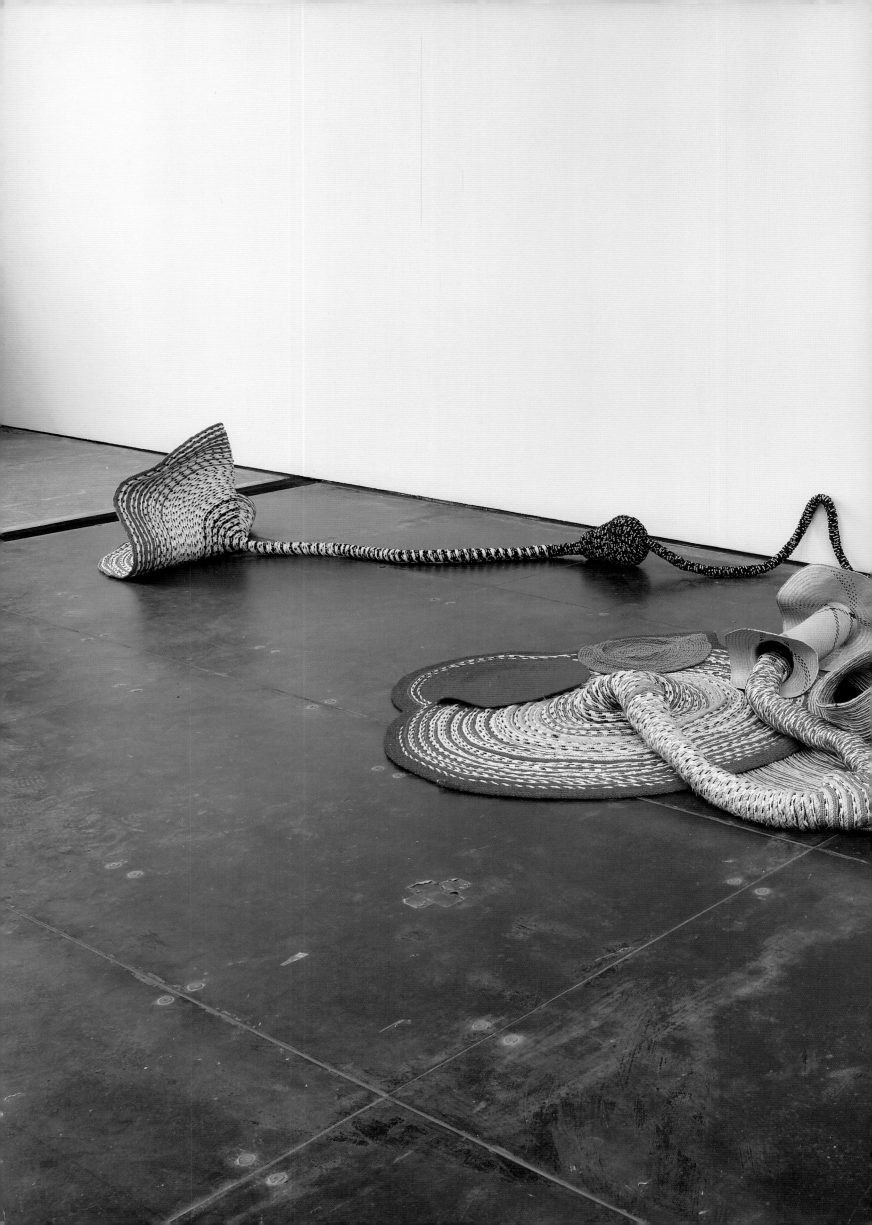

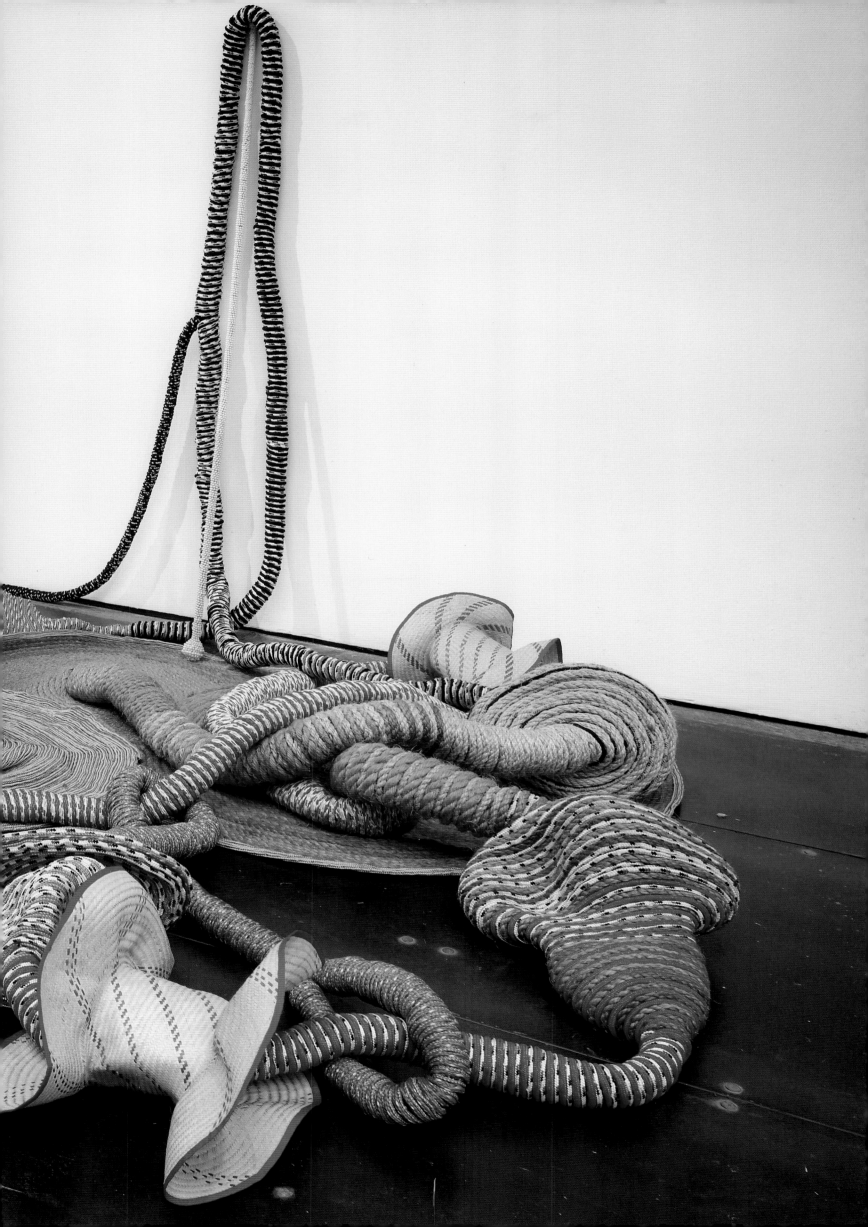

'Many of the materials I pick up serve as tactile memory markers for me… Because the things I use come out of my experiences, I can weld them in a more personal way.'

Monica Canilao

Synthetic Cubism, a decorative abstract movement developed in the 1910s primarily by Pablo Picasso, Georges Braque and Juan Gris, marked another key development in artists' use of materials. Before modernism, artists' materials such as canvas or stone had tended to act as a simple support to a painting or sculpture rather than drawing attention to their own textural properties. The Synthetic Cubists introduced the technique of collage, gluing materials such as paper and fabric to their canvases to create a new textural approach to fine art. By adding newspaper and other items to their paintings, they blurred the line between painting and sculpture while also bridging the gap between real-life objects and art. This notion of promoting a direct correlation between art and life, and consequently the materials of daily life, is finding renewed resonance in the practices of many contemporary artists.

The modernists proposed new forms of art that they felt were more appropriate to the times. The artists in this book continue this idea, responding to global realities in a rapidly changing world with materials and subjects that reflect the present-day. Although unrestrained by a single common agenda, most employ found, scrap or recycled materials. This is partly a reaction to the age we live in, as we become more conscious of the limits of the earth's resources and critical of the throwaway lifestyle. Many of the artists use these materials specifically to draw attention to our wasteful culture, often in ingenious ways. For example, in the *Notice – Forest* series Japanese artist Yuken Teruya created miniature filigree forest dioramas from disposable fast-food bags, which subtly remind the viewer of the natural resources fuelling the consumerist dream. While the artists are not always motivated by strict ecological criteria, there is a shared impulse to make use of resources that would otherwise be wasted. This choice is sometimes driven by economic necessity.

Artists may be inspired to create works from scrap items encountered by chance. In other instances, deliberate scavenging for reusable materials can take them into new environments that spark fresh ideas. US-based Chris Silva, for example, was inspired by the flotsam and jetsam he found washed up on the shore in Puerto Rico, leading him to create a shrine-like work in a secluded spot on the beach. In the spirit of Robinson Crusoe, he had intended this work, made from driftwood and other finds, to remain a secret from the outside world. Fumakaka, a Peruvian artists' collective, sometimes set themselves the goal of creating artworks from everything they find in one particular area – transforming a yard full of trash into a theatrical installation, for example. American Valerie Hegarty does not so much take inspiration from decay and destruction but engineers those

07 Maria Nepomuceno, *Untitled*, sewn ropes and ceramic, 2008. **08** Gabriel Dawe, *Plexus no. 3*, Gütermann thread, wood and nails, GuerillaArts, Dallas, USA, 2010. **09** Luiz Hermano, *Horto*, resin and wire, 2010. **10** Monica Canilao, *Gilded Rook*, 2010.

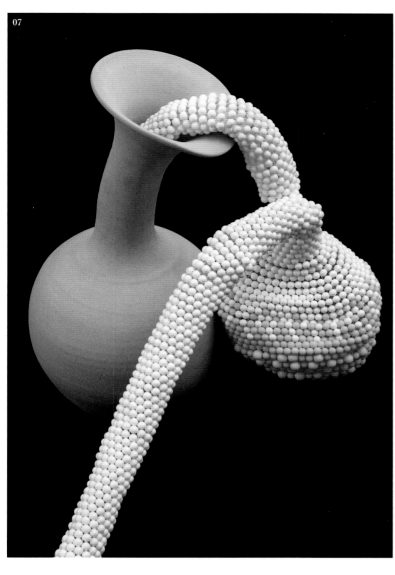

07

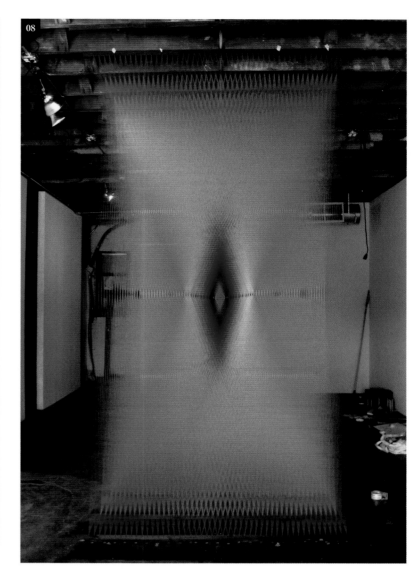

08

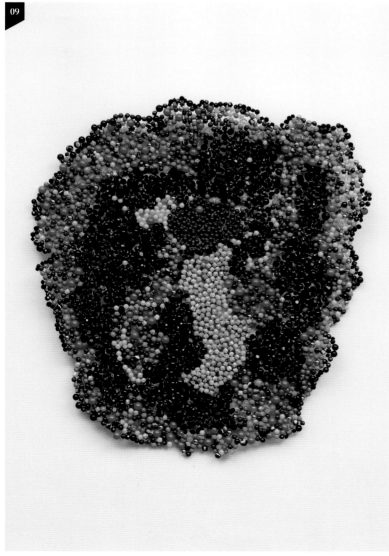

09

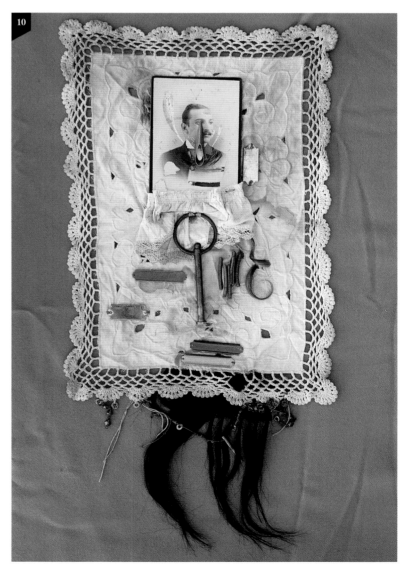

10

11

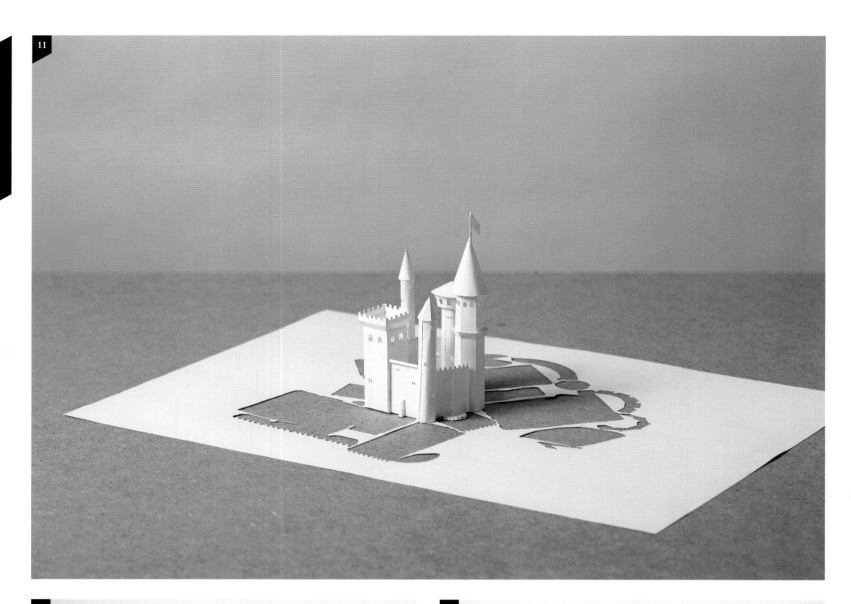

12

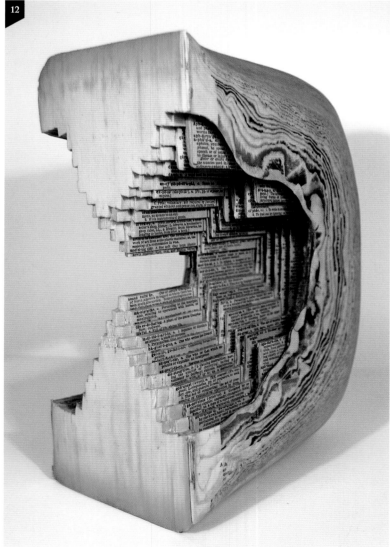

13

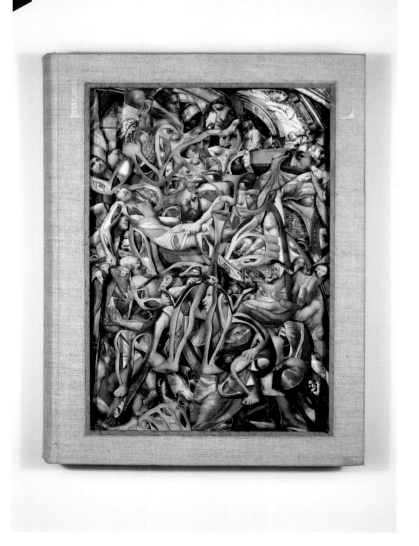

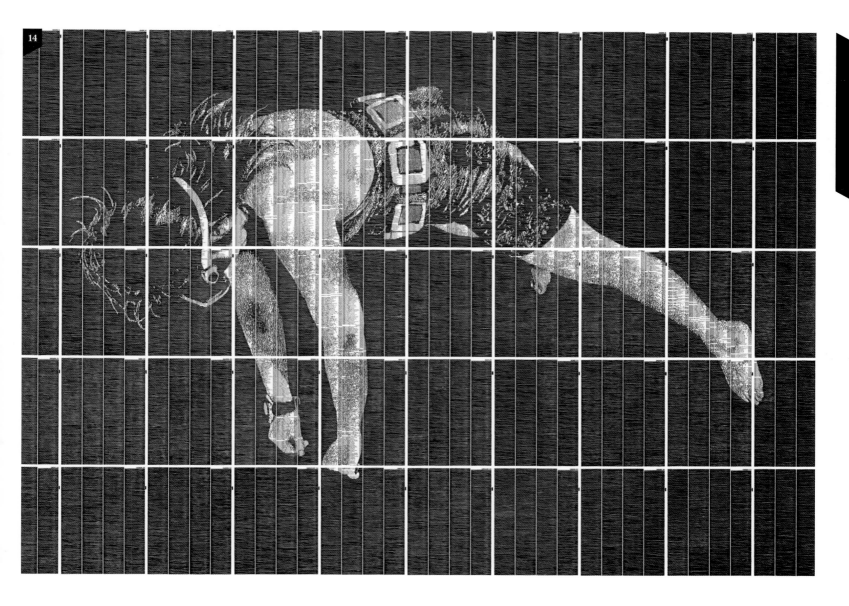

11 Peter Callesen, *Impenetrable Castle II*, A4 80 gsm acid-free paper and glue, 2005. **12** Brian Dettmer, *Mound2*, altered book, 2008. **13** Brian Dettmer, *Raphael*, altered book, 2008. **14** Carlos Zúñiga, *Día 2*, ink on phonebook, *Detained in Apnea* series, 2007.

Overleaf **15** Luzinterruptus, *A Cloud of Bags Visits the Prado*, eighty plastic shopping bags, LEDs and supports, 2009.

processes herself. She employs methods such as burning, striking and deliberate exposure to the elements to transform paintings, furniture and other objects into debris – a process she calls 'reverse archaeology', in which our present represents the past, and the pieces the future.

Unwanted and discarded items are an abundant yet neglected resource. Artists are partly drawn to these objects in order to give them a second life, but they are also attracted to the history that they embody. The American artist Monica Canilao, for instance, weaves and layers vintage fabrics and found photographs into clustered compositions that feel like sensory time capsules – memorials to long-lost relatives. British artist Robert Bradford uses old plastic toys to enrich his sculptures, giving every part of his work a meaning through the previous lives of the materials. Found objects were first created or manufactured, then underwent a process of use, wear and tear, and finally were discarded: they already have a story to tell. By repurposing and re-imagining them, artists can use them to tell new stories.

In using waste materials to fashion new creations, we are often confronted with objects that evoke the past. With a built-in obsolescence in many of the items we consume, even last year's gadgets can sometimes seem nostalgic. Michael Johansson is a Swedish artist who gathers

many of his source materials from second-hand markets, which he then pieces together in Tetris-like compositions. He chooses these items because he is interested in the history they hold. One can see traces from past decades not only in their design, but also in the way they have been used. 'These older items', he explains, 'say a lot about our way of life today. It is much easier to trace a pattern when you are no longer a part of it. Even when I use items from the last decade, it is sometimes still enough to be able to look at them from another point of view.'

When artists re-employ objects that already have a meaning and function in this way, there is often a tension between the original use of the item and the artist's reinterpretation of the material. How much of the original meaning is retained and how much is lost is in the hands of the artist. Brian Dettmer creates works from antique books. As well as being beautiful sculptural objects, his pieces inherently comment on the function of books, the knowledge they contain and their physical properties. He says: 'It's a balance I try to be conscious of, so that I can push and pull the form from its original to a new work. This push and pull works on a material level from book to sculpture, but it also opens questions of authorship and appropriation. At what point does the work become mine? When does the shift take place? I like it to remain a balance and to retain honesty in my work so that

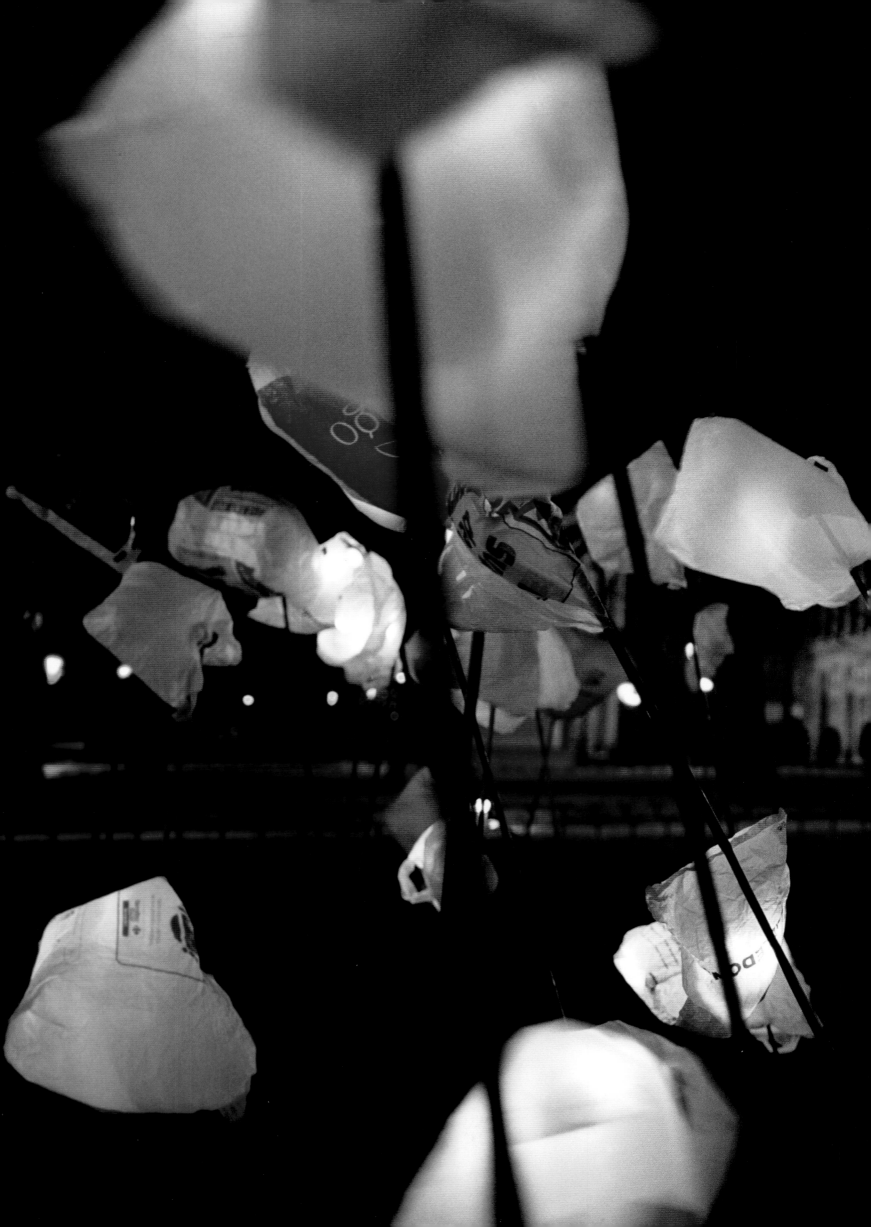

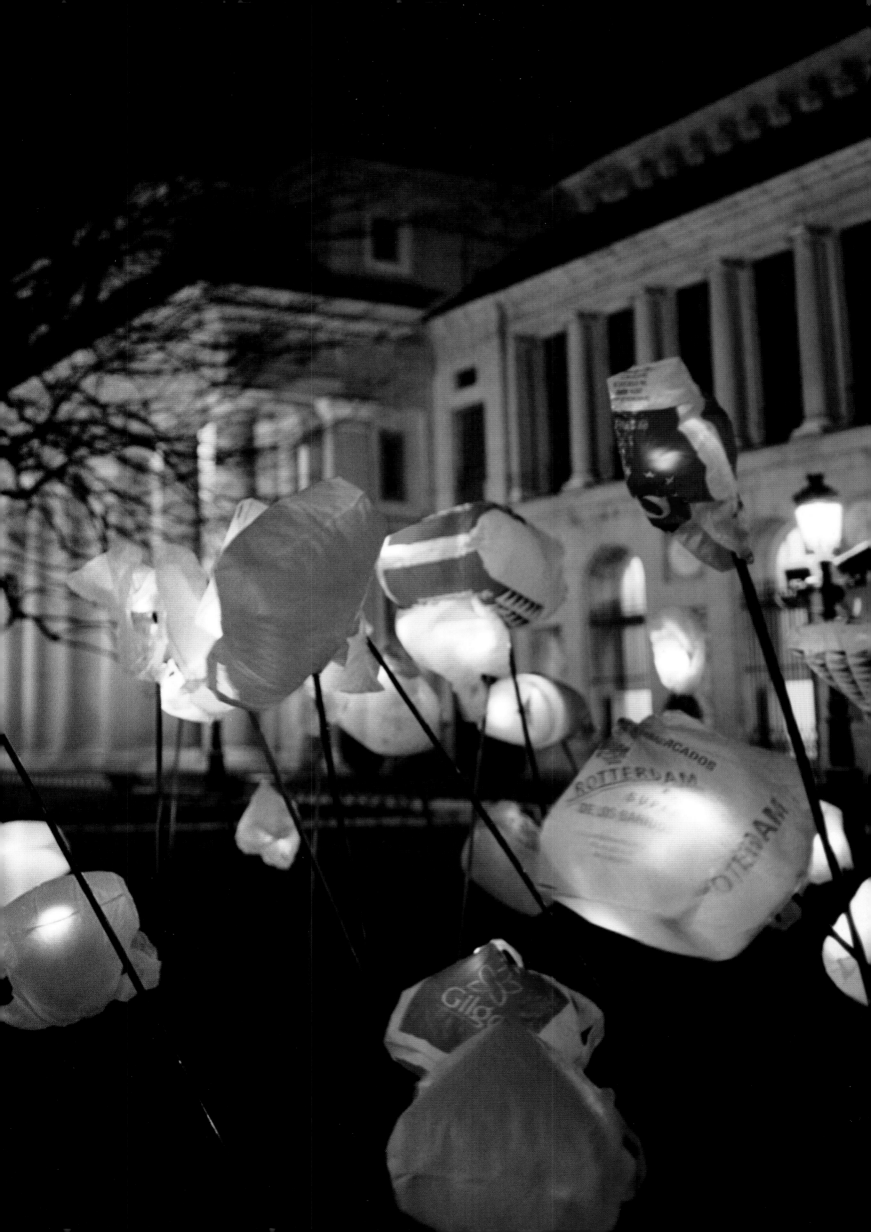

the original author or artist is acknowledged. Keeping the material's identity as a book helps to do this.'

True to nature

Throughout history artists have held an innate respect for the materials they use and have often been entrusted with transforming valuable resources, from precious metals to marble, into works of art. In centuries past, even basic commodities such as canvas, paint and paper were costly items to be eked out, and it was common for artists to paint over old canvases or make use of every scrap of paper. While some artists' materials are now more affordable and plentiful, our present-day concern is where resources come from. Have they been acquired through harmful practices or sustainably sourced? Is it wasteful or legitimate to use vast amounts of natural resources, energy or chemical processes in the name of art? In this age of awareness, there are environmental imperatives as well as economic reasons to be selective about the resources we use to create art.

Of equal interest to artists using natural materials are aesthetic considerations, which often go hand in hand with ethical matters. A widespread concept in modern art and architecture is the belief that art should have a 'truth to materials', meaning that a work of art should be inseparably related to the

material from which it is made rather than having an image forced upon it or being manipulated beyond recognition. This phrase is particularly associated with the British sculptor Henry Moore, who in 1934 wrote: 'Each material has its own individual qualities… Stone, for example, is hard and concentrated and should not be falsified to look like soft flesh… It should keep its hard tense stoniness.' This idea became a key point of debate in the period and continues to have an influence on artistic thinking today.

Whether they choose to stay true to materials or not, contemporary artists consciously exploit the natural properties of their media, be it surface, texture or colour. In this spirit many of the featured artists are being drawn to raw, untreated and sustainable materials to celebrate their ecological importance and aesthetic qualities and bring us more in touch with the natural world. The strategies being used to highlight the virtues of raw and base materials such as wood, metal and stone are diverse. South Korean artist Jae-Hyo Lee, for example, takes a minimalist approach, using simple forms and straightforward processes to emphasize the natural finishes and patterns of different materials. His geometrical and curvilinear sculptures show off the beauty and patina of natural resources such as wood and stone to great effect. The pieces in wood, fashioned in a hyper-modernist style with elegant curves, are particularly evocative, preserving the

16 Elfo, *!!!!!!!!!*, 2010. **17** Elfo, *Clones*, 2010. **18** Florentijn Hofman, *The Giant of Vlaardingen*, salvaged wood, nails and screws, 2002–3. **19** Zadok Ben-David, *Sunny Moon*, Corten steel, 2008. **20** Elfo, *I'm Going to Fuck Vincent*, 2010. **21** Faile, *Prayer Wheel*, acrylic paint on hand-carved merbau wood, mounted on steel base, 2008.

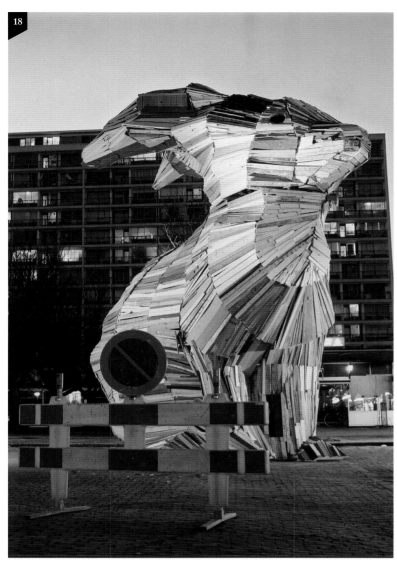

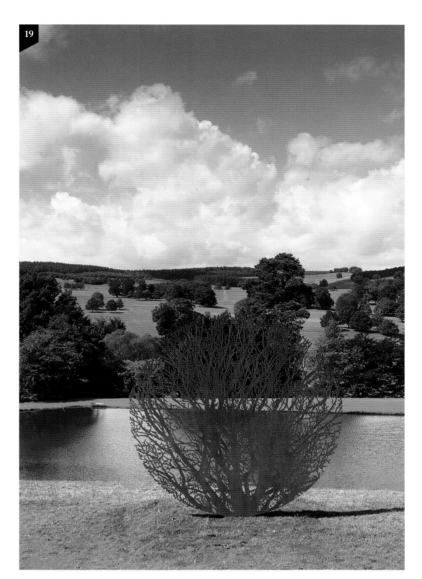

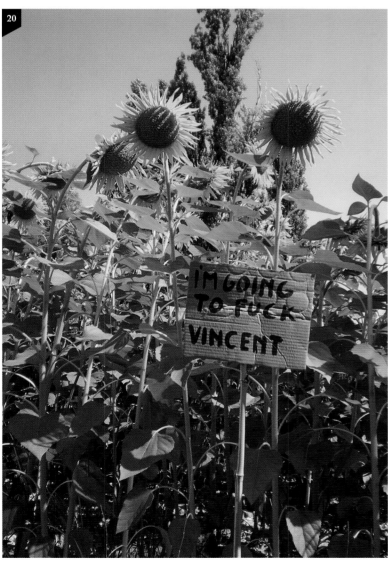

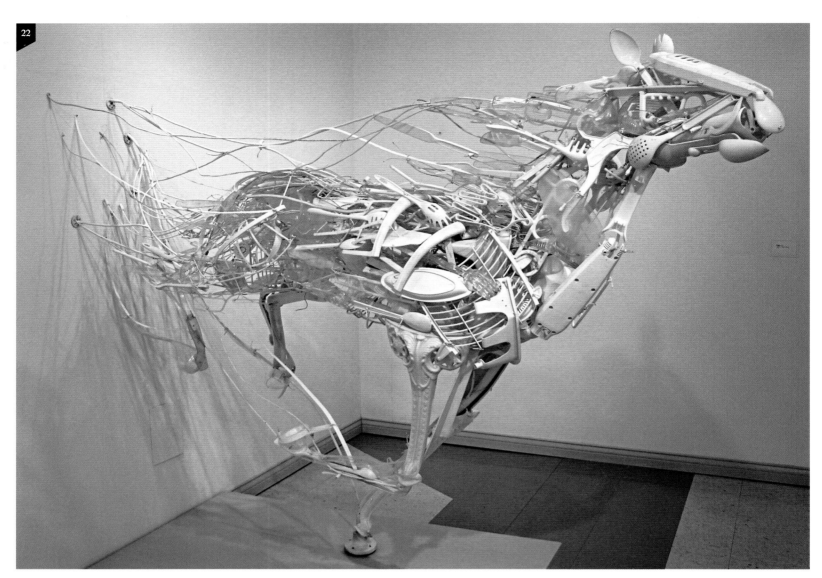

22

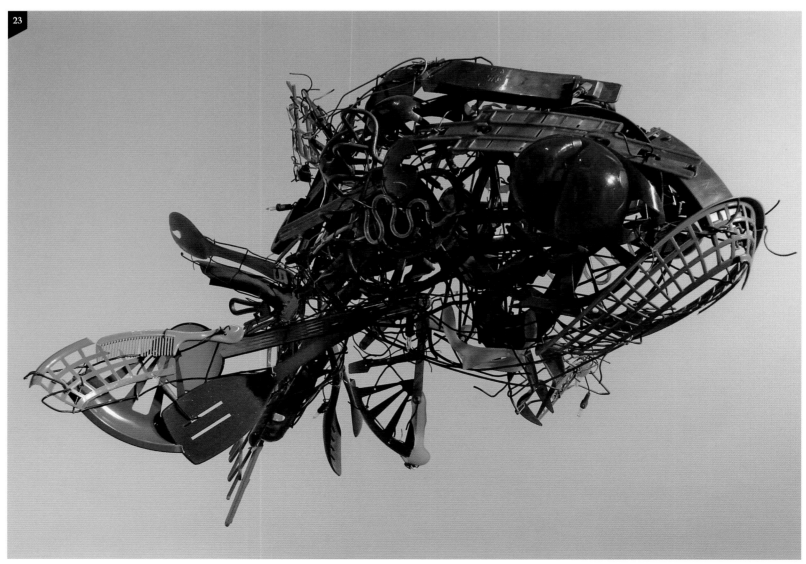

23

'The difference between moulding your own forms and working with pre-existing forms is that in the former the artist is acting, deciding what the materials do, and in the latter the artist is reacting to the objects, the forms they provide, and the physical limitations.'

Sayaka Kajita Ganz

growth rings of the tree and thus reminding viewers of the connection they share with the cycle of life.

Lee's concern with the textural qualities of materials is one that is universally shared among the featured artists but manifests itself in different ways. Whether created naturally, through weathering and other processes, or deliberately engineered, the textural surface of objects can be a powerful element within an artwork, engaging other senses besides sight to evoke sensations, memories and associations. The painstakingly crafted work of Tokyo-based artist Haroshi, who creates multicoloured wooden mosaics from found skateboards, is a particularly rich example. The colours and textures revealed in his work are the product of wear and tear, a tangible record of the intense exertions of the skateboarders, which gives the work an extra dimension. Japanese-born artist Hiroyuki Hamada, based in the USA, works in a completely different way, transforming basic materials such as plaster by sanding, drilling and scoring his constructions into highly textural pieces, to which he then applies resins, wax and pigment to give further depth and earthy hues. The added dimension of textural detail imbues the work with a personality or spirit, bringing the object to life.

A number of the artists work outdoors, creating site-specific art or pieces in the traditions of environmental and street art.

All these artists typically take the location into account when planning and creating the work. Dutch artist Florentijn Hofman shows particular care in his work on site-specific sculptures and temporary interventions. When developing works such as *The Giant of Vlaardingen* (2002–3), an enormous rabbit made from salvaged wood, he takes time to consult with local people and gauge their opinions about art, as well as building up knowledge of the area. In these times of populist politics and social networks, he feels that art should to some extent be interactive and in tune with people's views since it is the public who will ultimately live with and experience the work at a local level.

Working more in the spirit of environmental art, German artist Klaus Dauven uses the landscape as his material. By carefully removing lichen or layers of dirt on walls, he creates images and forms from nature such as flowers, patterns and animals. These works, which utilize naturally found textures, are only ever temporary since the processes of weathering and time eventually return the walls to their natural state. Similarly ephemeral is the field of street art, encompassing a broad spectrum of artistic expressions in the urban landscape. One practitioner who works within the street art genre is the Italian artist Elfo, whose art can be found in rural as well as urban environments. Using minimal, recycled materials, and often juxtaposing the natural

22 Sayaka Kajita Ganz, *Emergence (Wind)*, reclaimed objects (mostly white and clear plastic), 2008. **23** Sayaka Kajita Ganz, *Deep Sea*, reclaimed objects (mostly blue and green plastic), 2007.

Overleaf **24** Faile, *Block Paintings* (detail), paint on wood, 2010.

'I transform the material as little as possible because I don't want to lose the previous meaning. It's not just about changing the function of a thing. It's about enhancing its meaning.'

Felipe Barbosa

with the manmade, his work makes ironic comments about the state of the world through simple interventions. Adept in the art of the sight gag, he makes full use of the opportunities for comedic and thought-provoking contextual works suggested by the landscape – for example, placing a speech bubble sign next to a tree in an idyllic wood with the inscription 'I'm the next Ikea sofa'.

Back to basics

Traditionally artists and artisans, out of necessity, often had to have a wide practical knowledge to produce work in different media or at a different scale. Artists would have needed draughtsmanship and basic skills in carpentry, plaster casting and metalworking, among others. In the 21st century, some practical skills are being bypassed in art education and practice. However, as this book shows, a number of artists are embracing practical skills to produce work of quality that effortlessly stands out from the crowd through accomplished craftsmanship. While some, such as Brazilian artists Maria Nepomuceno and Luiz Hermano, draw on traditional craft techniques including weaving and beading, others have arrived at practical solutions of their own making, such as Ron van der Ende in his creation of bas-relief sculptures from found wood.

The modern revival of traditional craft techniques is interlinked with the renewed appetite for natural materials. Artists are dependent on skills such as carpentry, weaving and sewing in order to shape sustainable wood, straw, natural fibres and other unrefined resources to their will. Nature and craft have a direct relationship, physically and historically, that is being updated to current practice in both art and design. One of the many attractions of the handmade article lies in the unique processes undertaken by the artist to preserve a creative integrity and individuality in the work. Through honest physical labour and distinctive skills, the artist invests consideration, time and effort into a work until it is finally realized, bringing a tactile quality and an emotional value to the piece.

Adopting or adapting handicraft skills in an otherwise increasingly mechanized age is a way of preserving them for the future. For example, the work of Maria Nepomuceno is a hybrid of traditional craft and contemporary art. A fascination with natural materials led her to research and take up indigenous techniques of weaving straw. By working with practitioners of these crafts and presenting the results in her pieces, she generates a fresh appreciation and new applications for these skills, which might otherwise be lost. Similarly, the influential work of Luiz Hermano exhibits traditional craft techniques such as basketry.

25 Baptiste Debombourg, *Triumphal Arch*, cardboard boxes, glue, string and Scotch tape, 2001. 26 Baptiste Debombourg, *Polybric*, FRYD toys (490 pieces), 2002. 27 Felipe Barbosa, *Condominio Volpi*, acrylic paint on wood, Centro Municipal de Arte Hélio Oiticica, Rio de Janeiro, Brazil, 2010. 28 Michael Johansson, *Packa Pappas Kappsäck (Pack Daddy's Suitcases)*, suitcases, 2006.

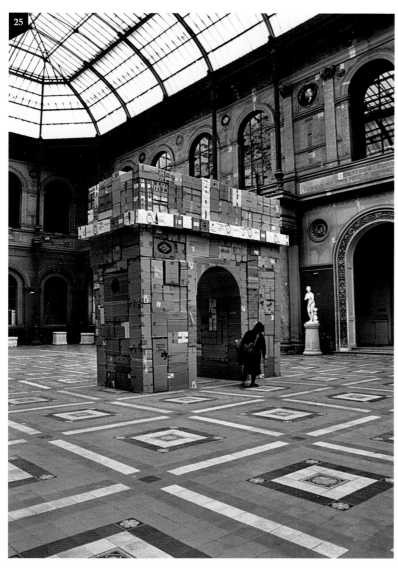

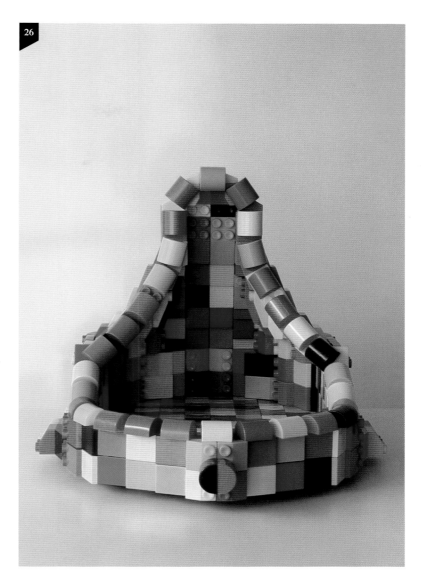

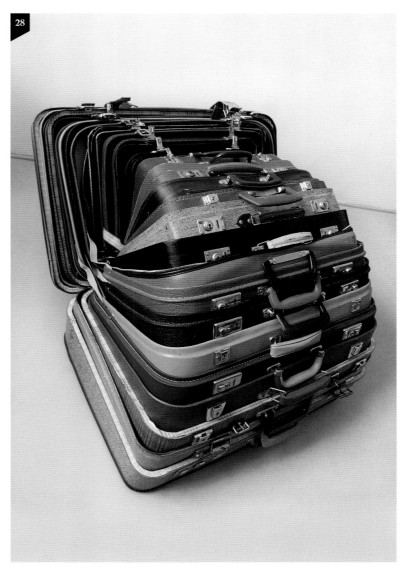

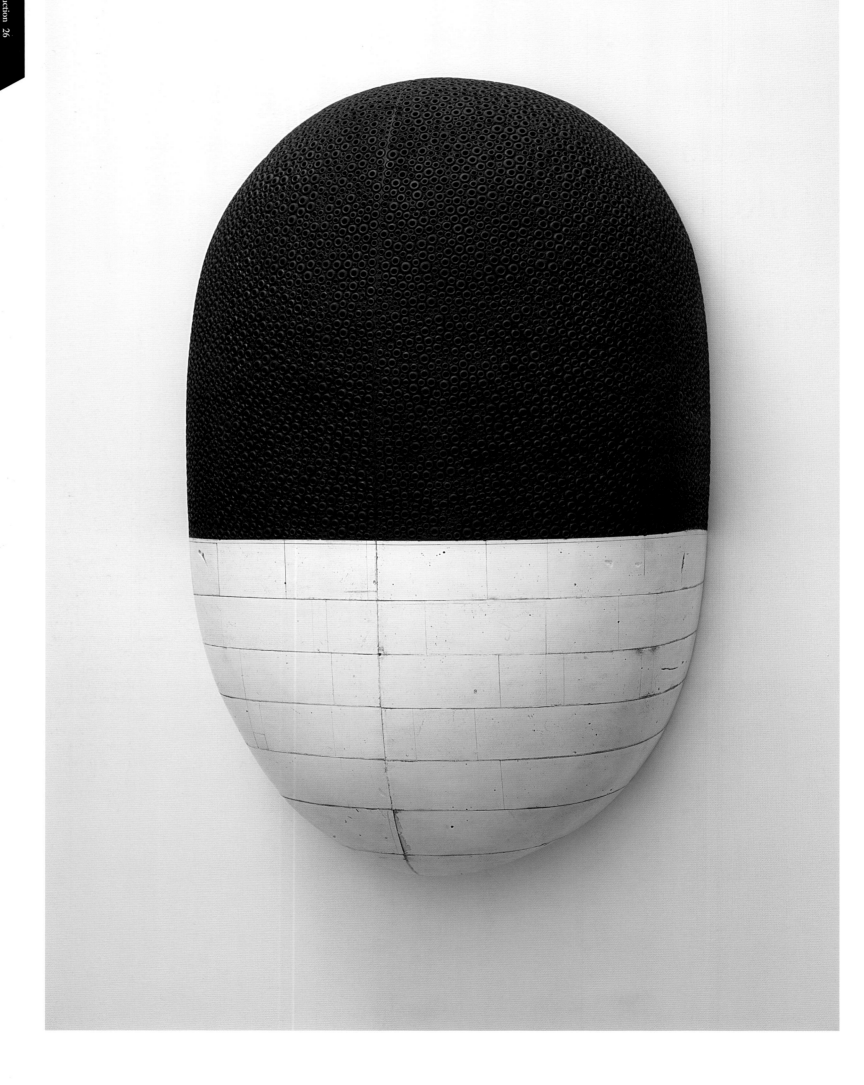

'I try to tell visual stories by putting together various formal elements, sort of like musicians putting together sounds, rhythm, timbre, and so on, to come up with profound experiences.'

Hiroyuki Hamada

However, in contrast, he uses artificial and technological products such as plastic toys and electrical capacitors as his raw materials. By using unconventional materials in a craft context, he explores the potential of handmade techniques in the modern world while reflecting on the wastefulness and our general disconnection from the objects of mass production that surround us.

In the developed and developing world we are increasingly losing touch with the resources and objects – often manufactured elsewhere – that we make use of in our daily lives. High-tech processes have made many crafts and traditional skills almost redundant. At the same time these developments are making low-tech and craft skills all the more attractive to artists who do not want their work to become too processed by digital technology or manufacturing. In reaction to the climate of ubiquitous digital perfection, artists are getting back to basics by reviving skills such as printmaking, carpentry, weaving and sewing. These traditional techniques not only mark a return to the handmade, but also give works an authentic human touch, making them more organic, tactile and natural in their imperfections.

As this book demonstrates, there is a strong trend in contemporary art practice and design for a greater appreciation and usage of natural and recycled materials and for low-cost, low-tech methods of creating art. Aspirations have changed, and we are more critical of our throwaway lifestyles. Function has become more attractive than novelty and frivolity. In the media they choose, artists make a statement about how they value materials for their particular properties, and as a limited natural resource. Although natural forms and materials have always inspired artists, today they have taken on greater resonance. We consume products without having any involvement in their manufacture, and increasingly experience the world through a virtual reality. Art that is tangible, tactile and well crafted celebrates and reconnects us to the physical and natural world. Through their imaginative approaches to medium, method and technique, artists are producing work that is ingenious, inquiring and conscious of its relationship to the natural world, and in the process redefining the materials of art for the 21st century.

29 Hiroyuki Hamada, *#55*, enamel, oil, plaster, tar and wax, 2005–8.

30 AJ Fosik, *As Good as Any God*, wood, paint and nails, 2009. **31** Haroshi, *Apple*, recycled skateboards, 2010. **32** Ron van der Ende, *s.t. (Wood Stack)*, bas-relief in reclaimed timber, 2011.

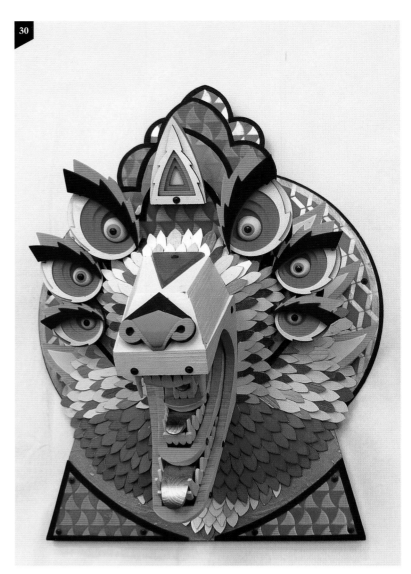

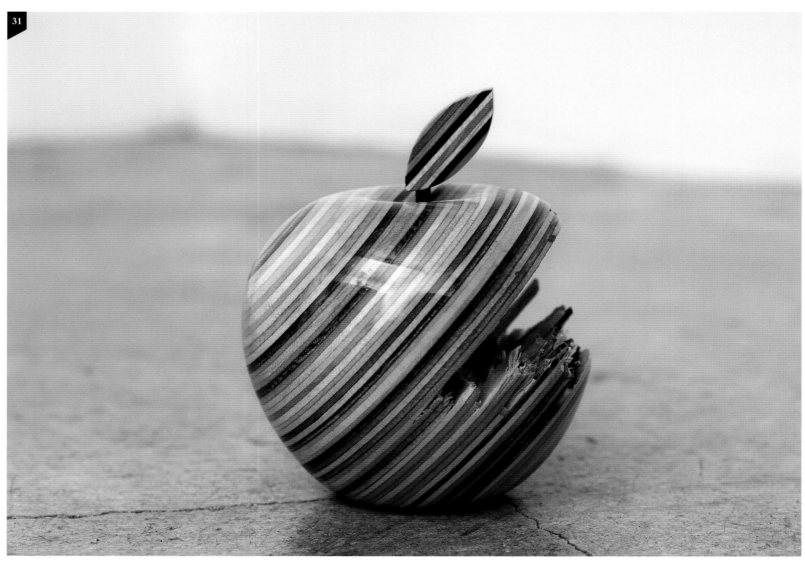

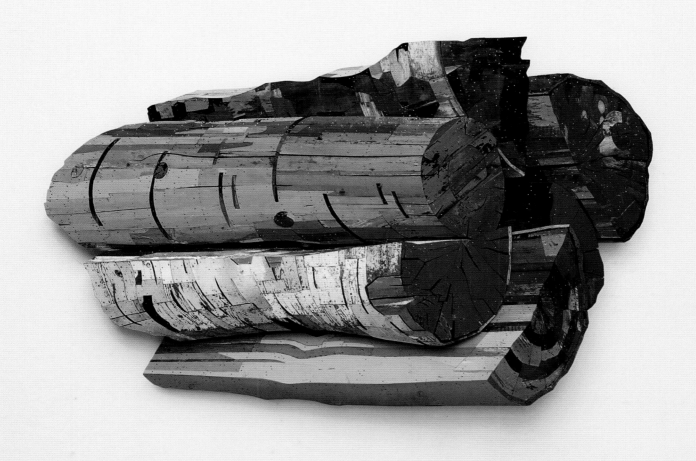

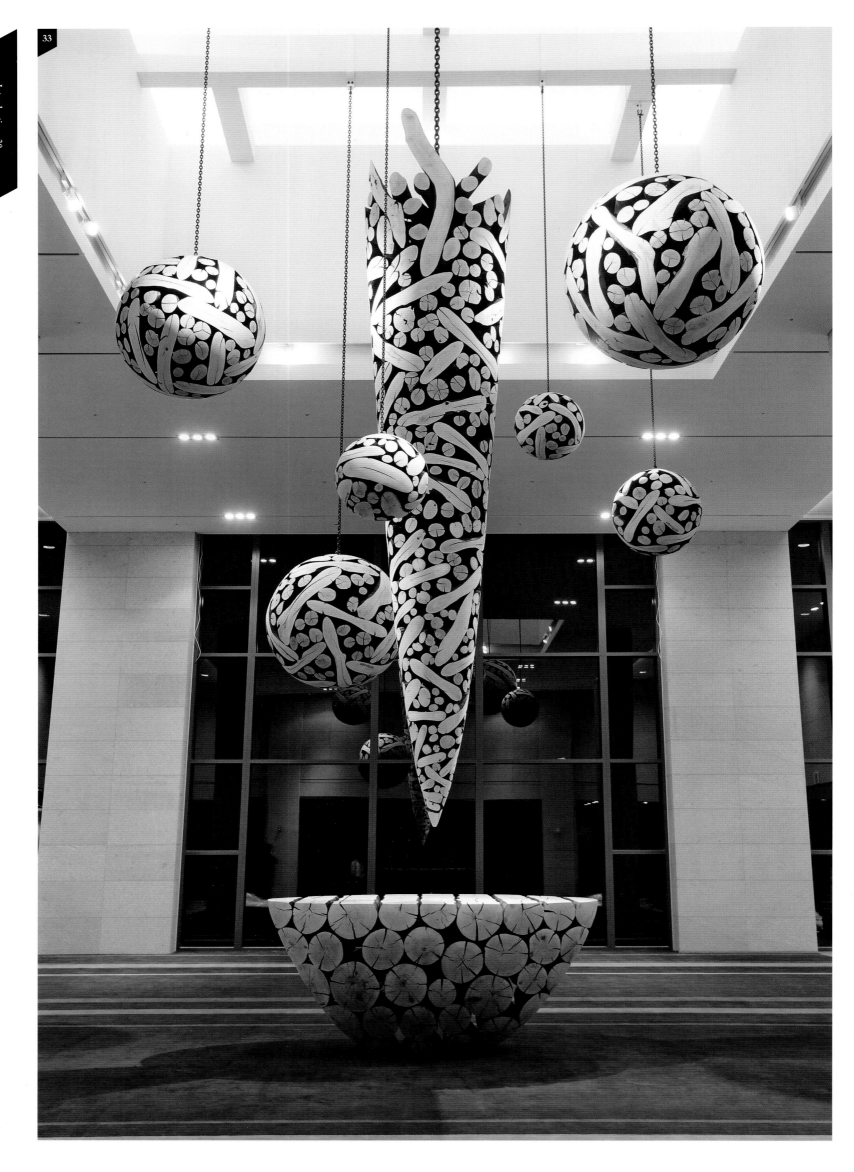

33 Jae-Hyo Lee, *0121-1110=1090312*, wood, 2009.

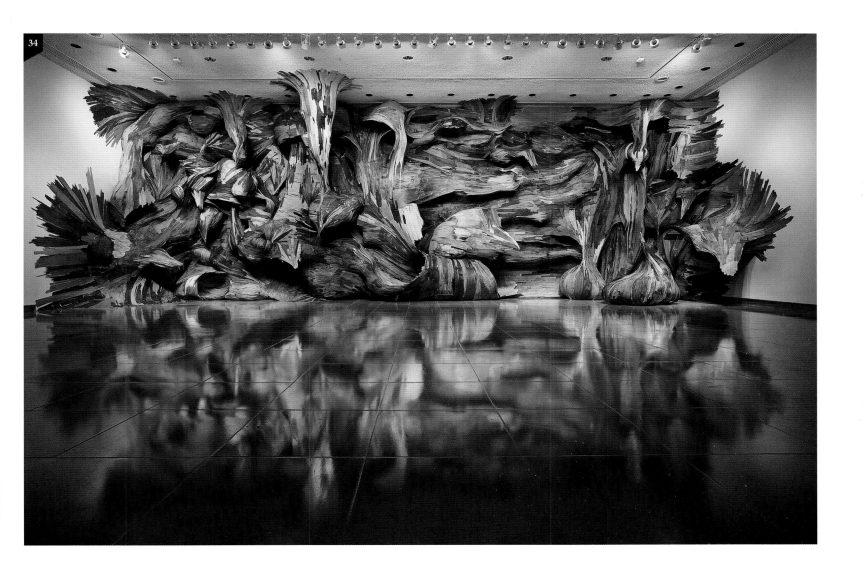

33 Jae-Hyo Lee, *0121-1110=1090312*, wood, 2009.
34 Henrique Oliveira, *Tapumes*, wood, Rice Gallery, Houston, USA, 2009.

Felipe Barbosa

Rio de Janeiro-based artist Felipe Barbosa transforms familiar objects by altering their physical form to create unexpected sculptural compositions and situations. In so doing, he shifts the focus away from the original purpose and use of the items, and allows the viewer to form new interpretations of and associations with the object.

Often these recycled materials are colourful, mass-produced, everyday items that we take for granted. By rearranging them, Barbosa draws attention to their design qualities and cultural meanings. This is exemplified by a series of signature works that incorporate deconstructed footballs, which he sews together by hand to create extraordinary wall pieces and three-dimensional works. By breaking down the constituent parts of a football and reconfiguring them in purely aesthetic ways, the mythic significance of the ball as a symbol of national identity is diffused. Brazil is famed for its devotion to the game; pulling apart used balls and turning them into a patchwork quilt could be seen as sacrilege. Yet in some ways the finished piece celebrates the national passion for this sport by re-imagining footballs as fields of colour and cellular patterns.

Barbosa's work with footballs derives from a fascination with geometry. He had already been working with geometric shapes for a number of years by the time he started his football series in 2003. Interested in projecting two-dimensional designs into three-dimensional space, he transformed hexagonal ceramic floor tiles into solid geometric works. In his work with footballs, he took the opposite approach. Touching on his ball series, he says: 'I believe that the act of turning the three-dimensional space into a flat surface forges a connection with the history of painting – the attempt to fit the real world into a two-dimensional world. My practice of only using balls that were on the market at the time made it possible to do markedly different pieces. Each "painting" is limited to a certain extent by the colour variations available at the time. It would be a painter's dream to have all these new colours and textures to choose from every time they went to buy new tubes of paint.'

In other works, Barbosa uses a broad range of similarly recognizable objects, from bottletops to firecrackers. He is drawn to accessible objects that he can put to playful use – items that can be found at local shops

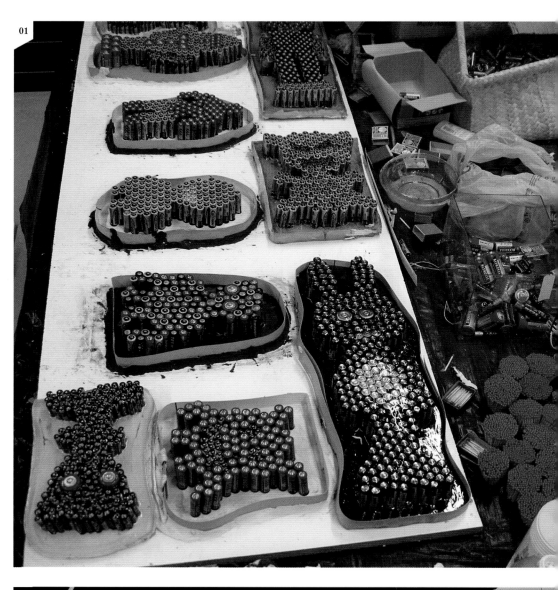

01

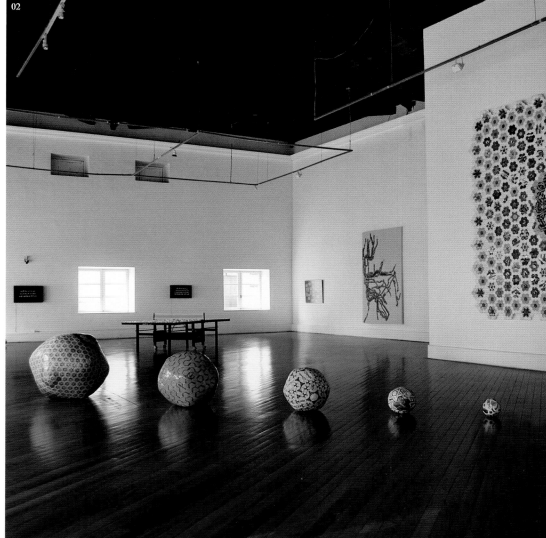

02

01 Works in progress, batteries and resin. **02** 'Imperfect Math' exhibition, Centro Municipal de Arte Hélio Oiticica, Rio de Janeiro, Brazil, 2010. **03** *Rio de Janeiro's Long Term Consumption Map* (detail), a statistical map made from bottletops collected in the city, 2001–10. **04** *Untitled*, five connected balls, 2008.

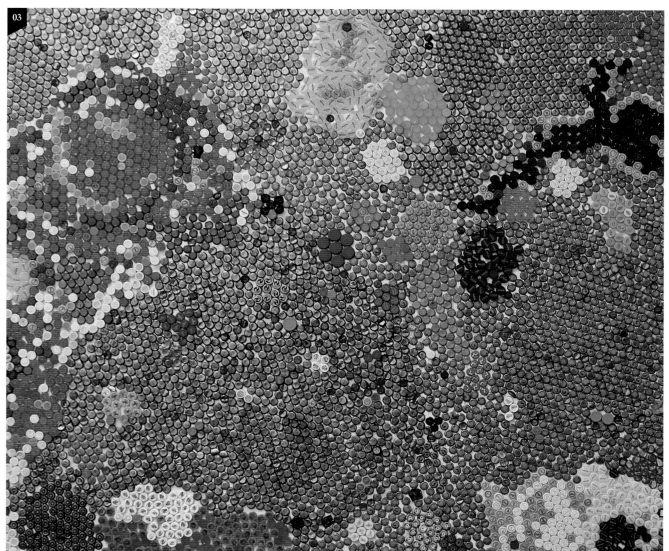

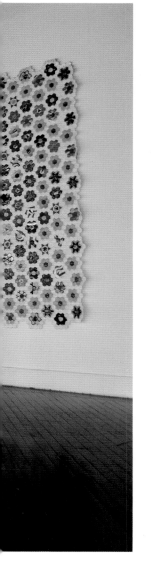

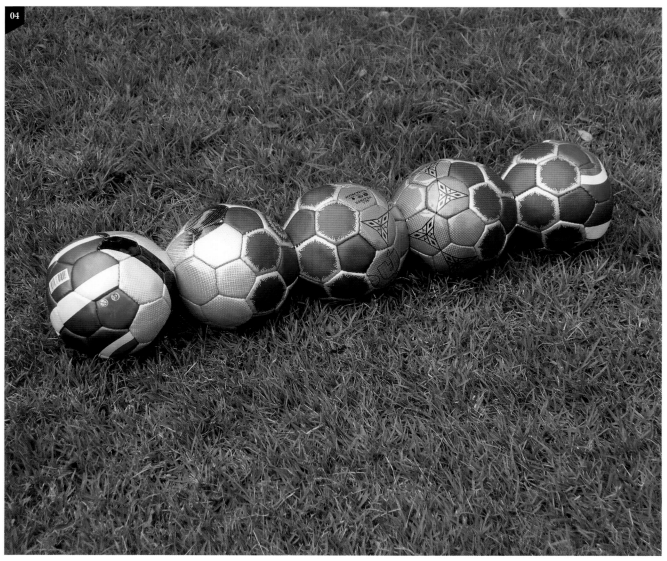

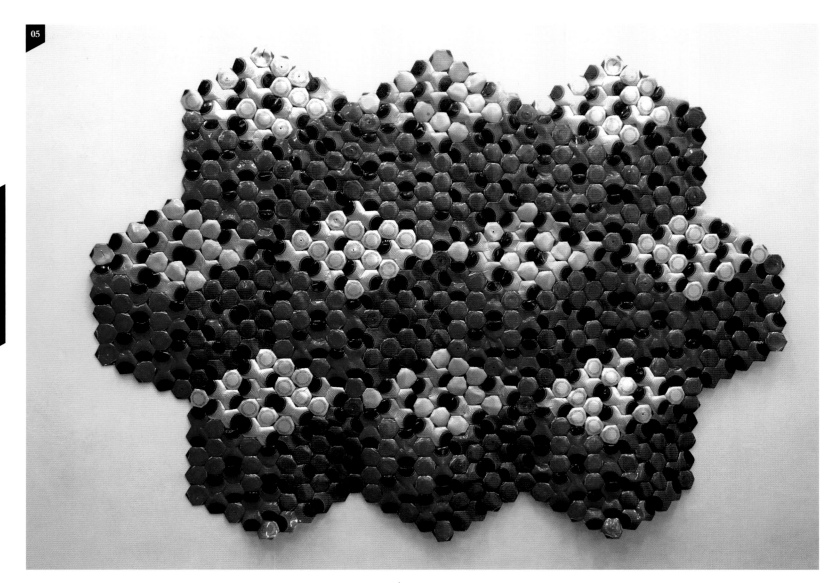

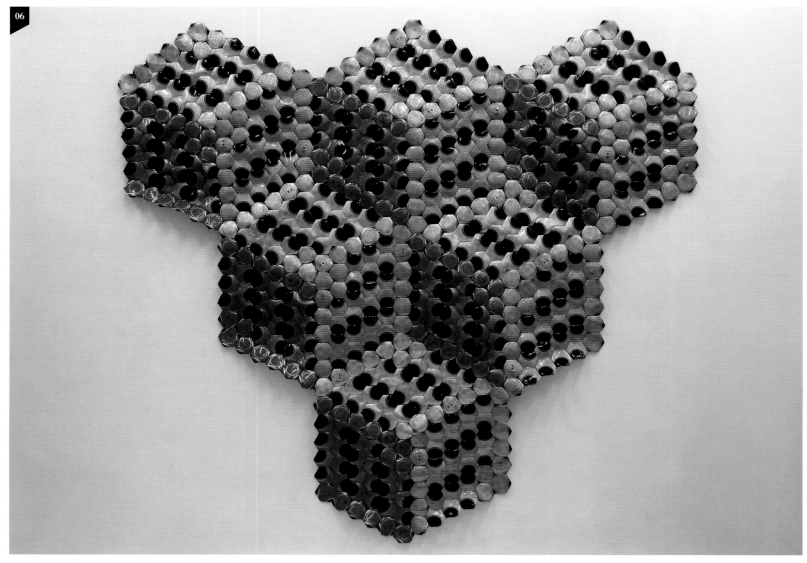

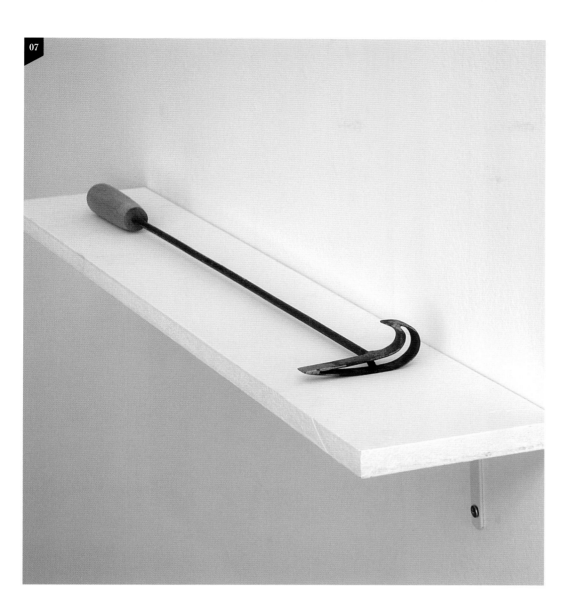

05 *Cubic IV*, panel of sewn footballs, 2008. 06 *Cubic Ball*, panel of sewn footballs, 2008. 07 *Branding Iron*, cattle branding iron with Nike logo, 2006. 08 *Cow Ball*, ball made of cowhide, 2005.

08

or are within the normal experiences of everyday people. In one series, he created pieces that were modelled on stuffed toys but were constructed entirely from firecrackers (2003). Although the finished works looked cute enough to hug, the snaps could have exploded at any time. In another football-themed piece (2000), Barbosa clumped together groups of large matches to form the hexagonal and pentagonal shapes associated with the ball, making a visual reference to the passionate, explosive nature of the beautiful game.

Barbosa often works simultaneously on a number of series that require different resources. The materials that he collects can remain in the studio for years without the artist achieving the desired results. The process of collecting the materials frequently forms an important part of a piece. For one of a series of works with found bottletops, he spent two months walking around Madrid picking up the discarded items. The project (2000) was not only visually arresting, but like a statistical study gave him an insight into which brands were consumed the most. He is drawn to materials that have a history, so that the result is a combination of the viewer's associations with the object and the artist's configuration. 'I transform the material as little as possible because I don't want to lose the previous meaning. It's not just about changing the function of a thing. It's about enhancing its meaning.'

Andrés Basurto

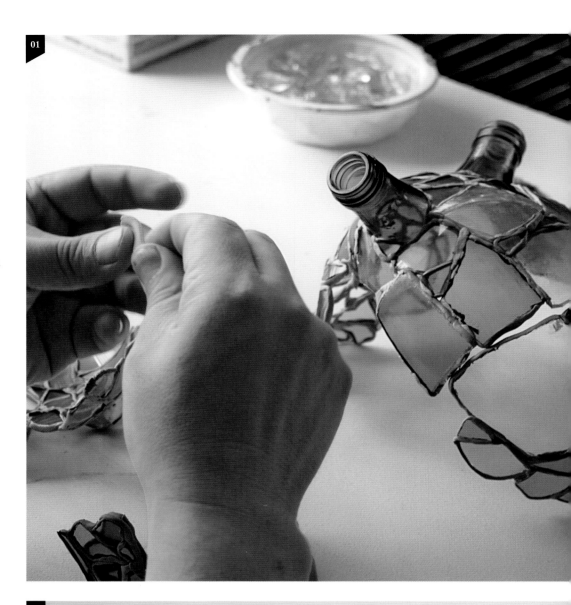

Mexican artist Andrés Basurto creates vibrant mosaic skulls from shards of broken wine and beer bottles. Images of skulls have a long and popular tradition in Mexican culture, from the *tzompantlis* (skull racks) of the Mexicas (Aztecs) and the *calaveras de azúcar* (sugar skulls) of the Day of the Dead to the work of 19th-century illustrator José Guadalupe Posada. Basurto models his skulls on one of the most famous Mexica artefacts, the mask of Tezcatlipoca, now housed at the British Museum, London. It is an object that has always held a fascination for him: 'I saw it in photographs as a child, but only came face to face with it at the Moctezuma exhibition [2009] in London. I almost cried when I saw it.'

As well as celebrating the rich cultural history of Mexico, Basurto casts the skull – a classic symbol of death – in a new light. Rather than dwelling on its traditionally negative connotations, he uses it to reveal beauty in discarded materials and give them new life. 'I am not a religious person, but the Mexican tradition of decorating an altar [for deceased loved ones] during the Day of the Dead has always captivated me for its meaning and beauty,' he says. 'The human skull is beautiful and for me it signifies life more than death. I don't find it morbid or macabre.' While the raw, broken and discarded nature of the glass fragments that make up his skulls – skilfully held together with epoxy resin – creates a poignant reminder of the fragility of life, his stunning mix of translucent and bright printed colours delivers a strong message of hope.

Basurto's interest in making sculptural objects from discarded materials began in 2003, while he was studying at the School of Visual Arts in New York. At first he used found cardboard, which he fashioned into bulls' heads and human hands. He hit upon the idea of working with glass mosaics almost by chance: 'It came from an act of destruction. One night, having had a couple of *caguamas* [beers] and a bottle of wine, in an act of stupidity I threw the empty bottles on the floor and they shattered. The following morning it occurred to me that reconstructing the bottle in its original form might make a good conceptual piece. The next logical step for me was to give it new life and form as a skull.'

As Basurto points out, there are many contemporary artists who have incorporated the human skull into their visual language. When Damien Hirst exhibited his diamond-

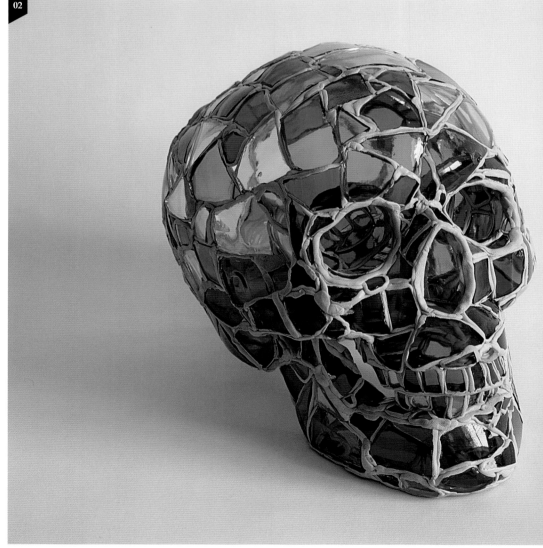

01 The artist at work. 02 *Azul*, broken glass and epoxy putty, 2011. 03 *Verde*, broken glass and epoxy putty, 2011. 04 Work in progress.

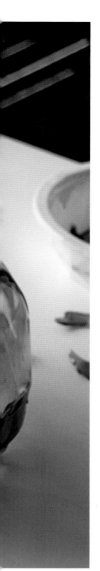

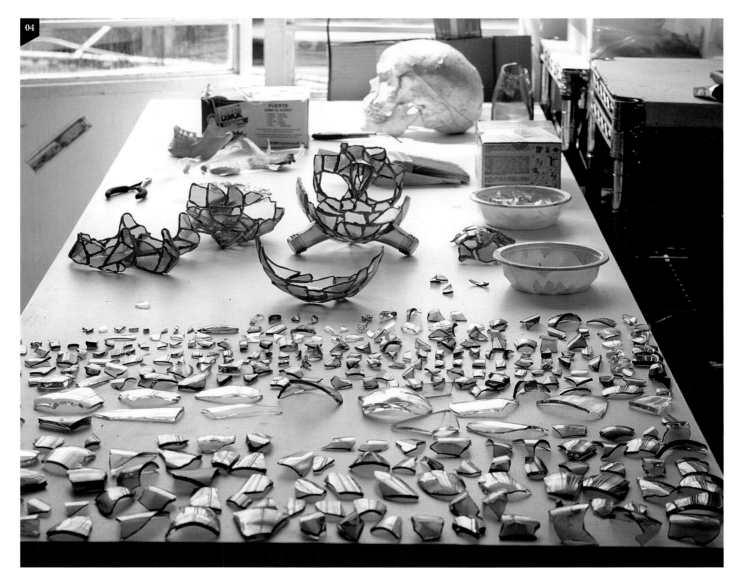

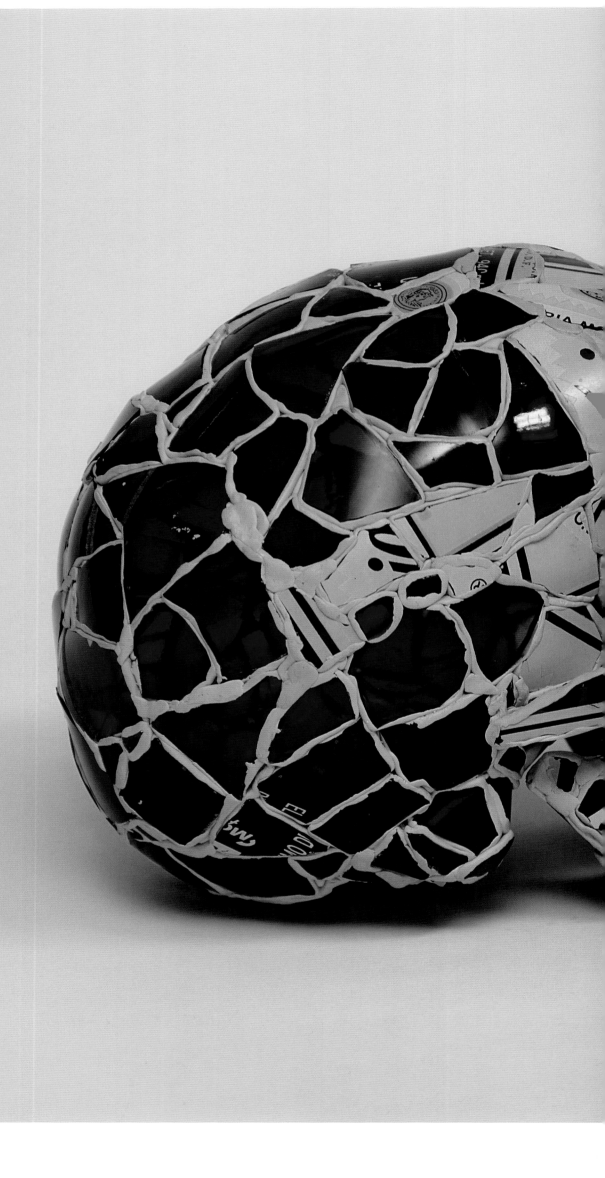

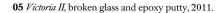

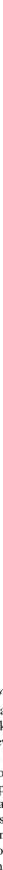

encrusted skull, *For the Love of God*, in 2007, Basurto had second thoughts about whether to continue making his glass skulls, fearing that every piece of art that drew on this subject might be compared to Hirst's 'disco ball'. He soon cast away his doubts, however. While Hirst's memento mori provokes reaction through his extravagant use of diamonds, which renders the skull grotesque, Basurto's works reflect the human desire to preserve life, bringing the long-standing tradition of the human skull in art into the 21st century through his innovative use of recycled glass.

Basurto has shown his skulls in galleries in New York, Paris and his native Mexico City. Although he focuses on sculpture, he is also a skilled painter and finds working simultaneously in these two fields keeps his mind fresh, and the process and end result more exciting. In 2008 he was nominated for the BP Portrait Award, and his entry was exhibited at the National Portrait Gallery in London.

Zadok Ben-David

01

Zadok Ben-David was born in Yemen and brought up in Israel, but has been based in the UK since the mid-1970s, when he studied at Reading University and Central St Martins, London. His roots, experiences and educational background have remained strong influences throughout his work as a sculptor. Recalling the desert terrain of Yemen and the Israeli landscape, his early work was characterized by warm colours and textures, and featured animal forms drawn from childhood stories. During his studies, he was inspired by the work of leading British sculptors such as Anthony Caro, who taught at St Martins, as well as taking selective influence from the prevailing movements of abstraction and conceptual art. Over time the textured surfaces that were initially prevalent in his sculptures have given way to a fascination with silhouetted forms, while his rigorous research has led him to explore themes such as evolution and metaphysics.

With a career spanning over three decades, numerous awards and acclaimed solo shows, Ben-David focuses on installation-based exhibitions, public art commissions and sculptures for private clients at his studio in London. In his working practice he tends to shift between different scales, developing ideas on a small scale and building them up to monumental proportions. This keeps the process fresh and at the same time allows for improvisation and rearrangement as he adapts his work to different situations.

Exhibited at numerous institutions since 2007, Ben-David's celebrated *Blackfield* installation exemplifies one extreme of the artist's playful use of scale. The work comprises up to 20,000 stainless steel botanical silhouettes sitting up to 15 cm (6 in.) high in a bed of white sand. While one side of these etched sculptures is painted matt black, the other is vibrantly coloured, creating an impressionistic and dreamlike effect. Like the original Victorian botanical illustrations that served as inspirations, these delicate works are two-dimensional and yet, placed in a three-dimensional space, create an intriguing field of vision. Although not true to life, the collection of overlapping, exquisitely detailed shapes reminds us of the wonderful gift of nature. For the artist, the work is 'a metaphor for human behaviour and feeling'. 'In hard times,' he explains, 'it's easy to see the world as black and depressing… But with a little effort, if we view things from a different angle, we can find the same world much more positive and optimistic.'

01 *Leftover*, Corten steel, Chatsworth Estate, Derbyshire, UK, 2010.

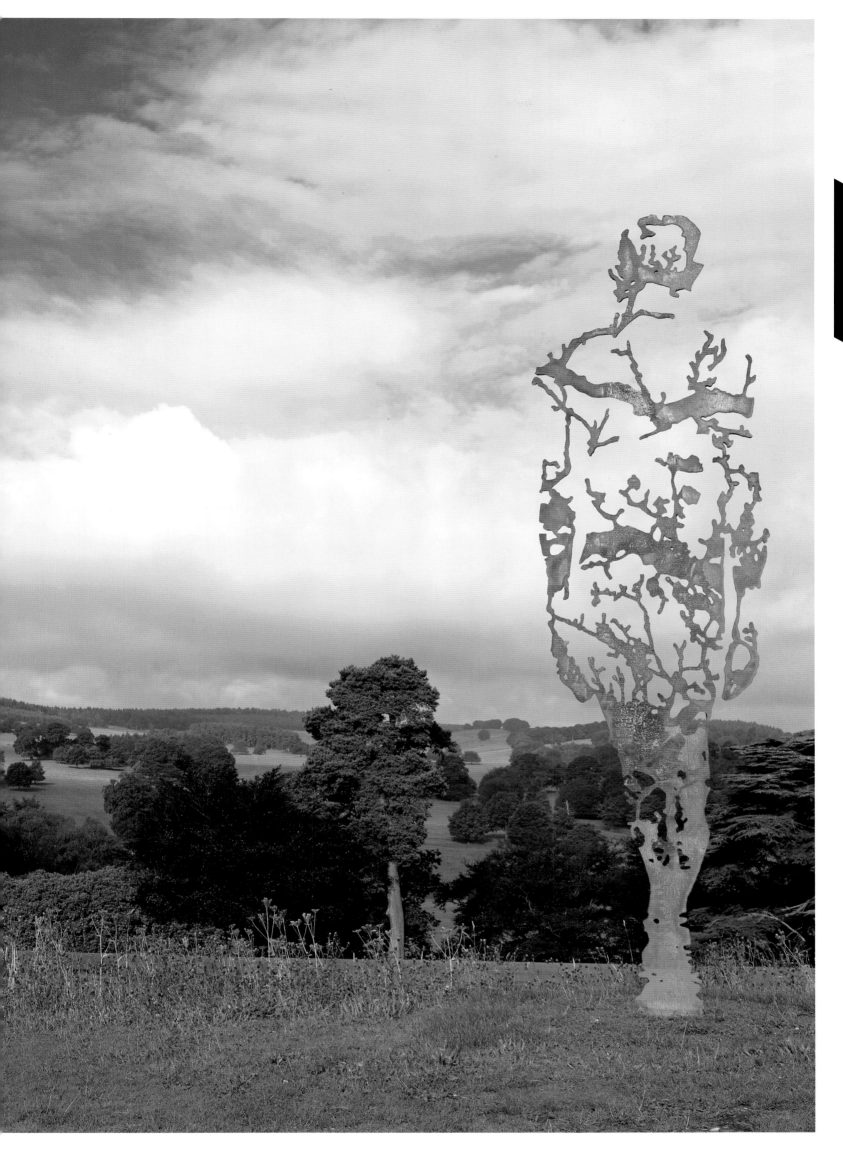

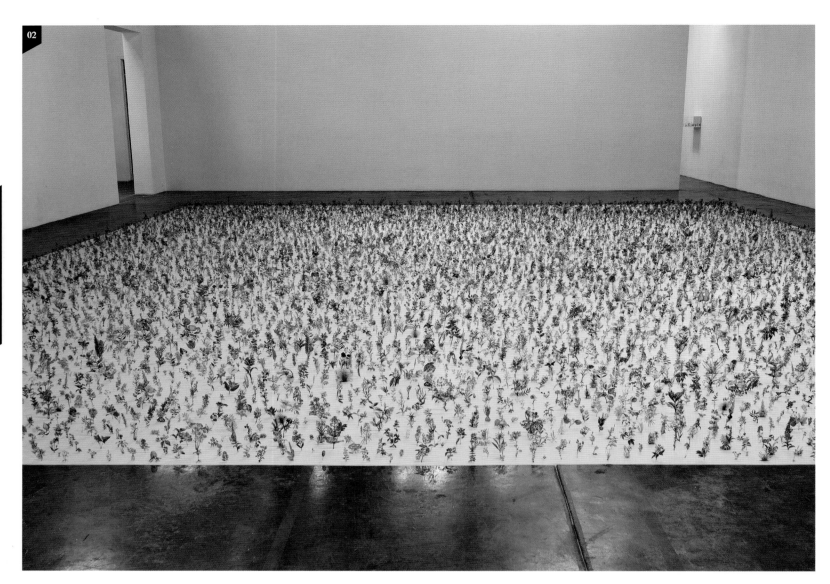

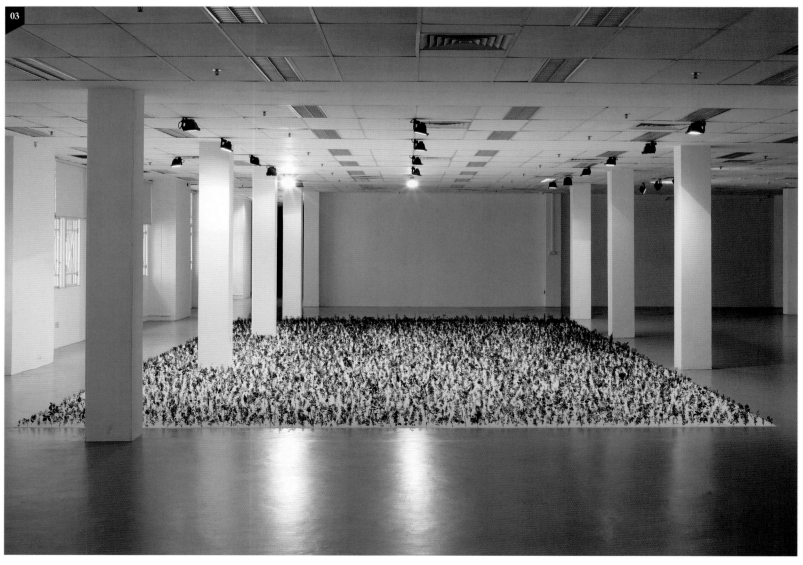

02 *Blackfield*, 12,000 hand-painted stainless steel flowers, Shoshana Wayne Gallery, Santa Monica, USA, 2009. **03** *Blackfield*, 11,000 hand-painted stainless steel flowers, Singapore Biennale, Singapore, 2008. **04** *Blackfield* (detail). **05** *Blackfield* (detail).

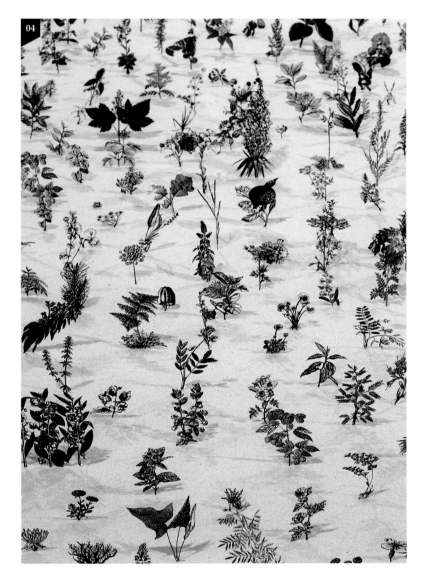

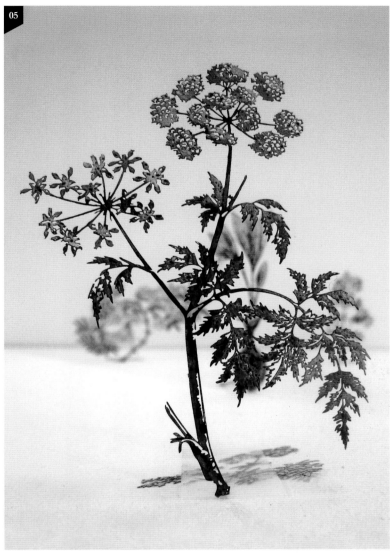

Alongside his explorations of nature, human silhouettes are a long-standing theme in his work and are often juxtaposed with natural forms such as trees, flowers and animals. A key piece in this process of cross-pollination was *For Is the Tree of the Field Man* (2003), which stands at the Yad Vashem Museum, Jerusalem. The foliage and branches of the sculpture, which is constructed from Corten steel and stands over 6 metres (20 feet) high, are made up of hundreds of figures that represent partisans who took refuge in the forest to survive. The tree also symbolizes hope and growth. This

seminal piece led to an ongoing series of works that played on a similar idea, such as *Leftover* (from 2006) and *You Again* (2006), in which the human figure is composed of silhouettes of foliage.

Draughtsmanship is at the heart of all Ben-David's work. Some pieces require thousands of drawings, and through the drawing process new ideas manifest themselves. The overlaying of drawings, for instance, may suggest an accidental image, while adding an outline, or playing with positive and negative space in some way, may stimulate new visual ideas.

Throughout his career Ben-David has worked with numerous materials such as wood, clay and sand, but now creates much of his work in metal. Most of his medium-sized sculptures are made from aluminium, which is hand-cut with a jigsaw blade, while his large outdoor works are made from plasma hand-cut Corten steel, which weathers naturally to create a rust-like appearance. With a steel sculpture it is hard to have the same freedom that a painter enjoys, yet Ben-David has found ways to make work that is gestural and full of life.

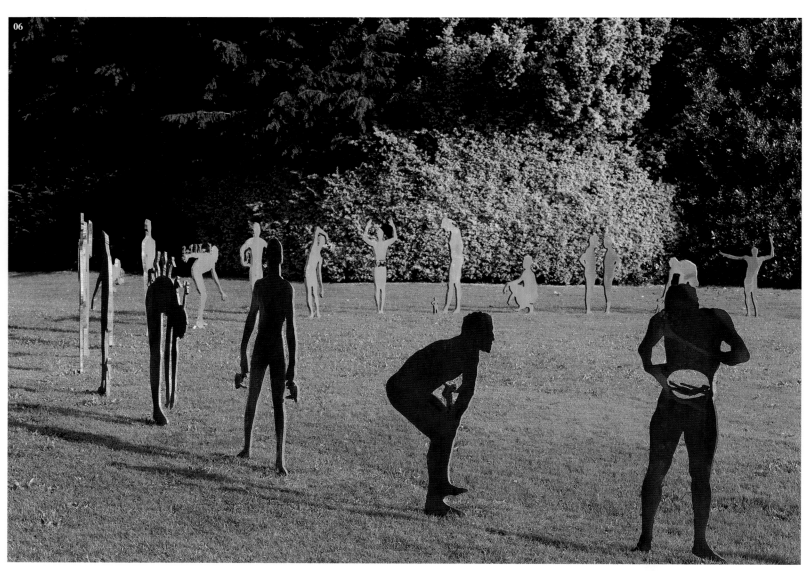

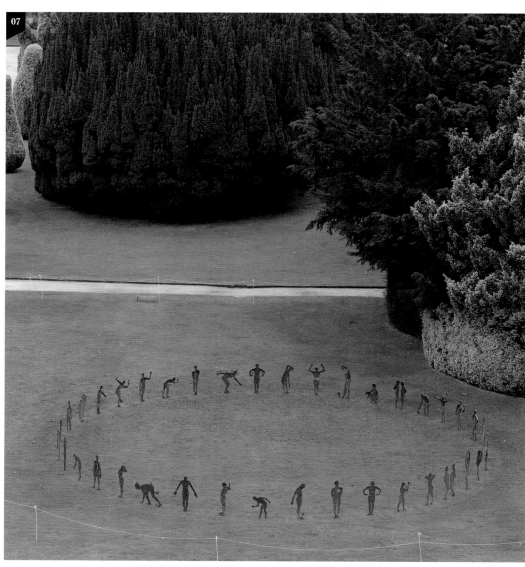

06, 07 *Innerscape on the Move*, Corten steel, Chatsworth Estate, Derbyshire, UK, 2008. **08** *For Is the Tree of the Field Man,* Corten steel, Yad Vashem Museum, Jerusalem, 2003.

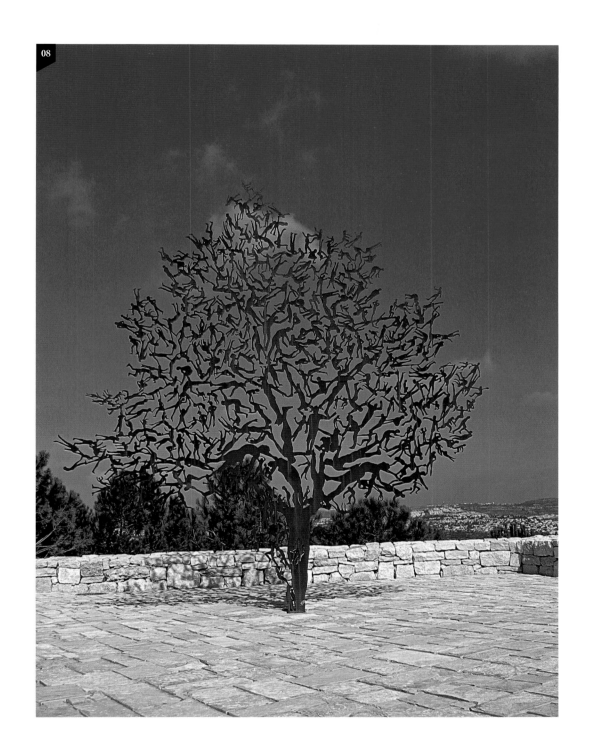

Robert Bradford

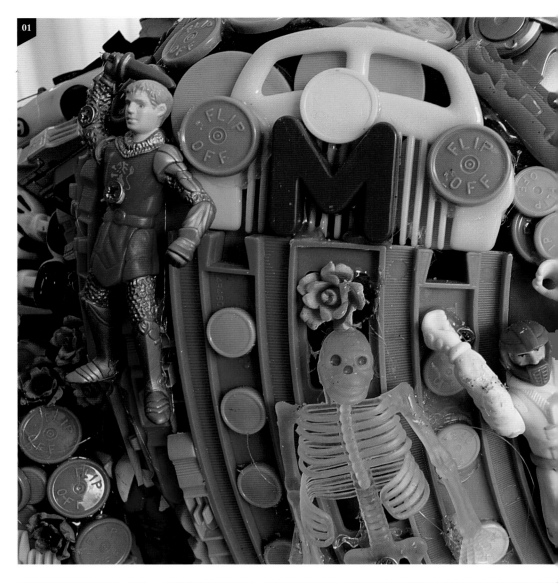

Based in France, British artist Robert Bradford has long focused on unusual approaches to sculpture and has become well known for using sustainable materials and recycled objects to create his pieces. His diverse portfolio includes large-scale works such as *Bombus Bee* (2001–2), a well-loved attraction at the Eden Project in Cornwall; gigantic pyrotechnic figures that are brought to life in a blaze of light; and over-sized wooden representations of creatures such as dogs and birds that have been in high demand as commissioned art for public spaces. Recently he has been working with plastic toys, collecting together hundreds of childhood playthings and using them in intricate arrangements to make sculptures of figures and animals.

The toy sculptures have captured the imaginations of the art world and art lovers alike and have been the main focus of his work since 2004. At his current studio in a small village outside Lyon, every available space is filled with works in progress, and boxes and bags of colour-coded toy ephemera frozen in time and waiting to be used. He hunts for his materials at flea markets and discount shops in the city, but is also given items by people who know of and like his work. The individual pieces are chosen for their colour and shape: 'Articulated figures because they bend round things, a train track because it has straights and curves… Guns I buy because I like the idea of guns that can't really hurt you and they go around shapes well; also there are a huge range of colours and types… Anything of interest that I can find, or consider well designed, or will fit some figurative purpose, becoming muscle, hair, ears, etc.'

Although Bradford likes to keep the construction process simple and low-tech, it can take him weeks to create each sculpture. The base figure is constructed of slices of plywood that form front and side profiles, with extra pieces added for limbs and features where appropriate, which are glued and screwed together to make the whole. The toys are then individually screwed onto the piece. Form is key to Bradford: 'I have no love for work where the form is neglected or is totally subservient to the idea.' Thus the toys' main visual purpose is to reflect and enhance the form of the main figure.

'I like the "detail versus the whole" aspect of the way the pieces look,' he continues. 'Clay, metal, wood, stone, etc, do not have much of a life of their own. It is dead stuff

01 *Sniff Without (Guns or Barbies)* (detail), 2010. **02** The artist's studio, 2010. **03** *Sniff Without (Guns or Barbies)* under construction, 2010. **04** Boxes of materials, 2010.

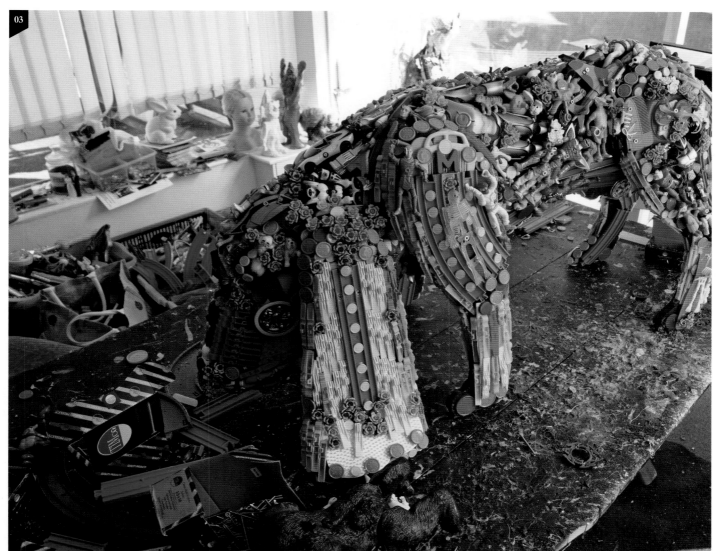

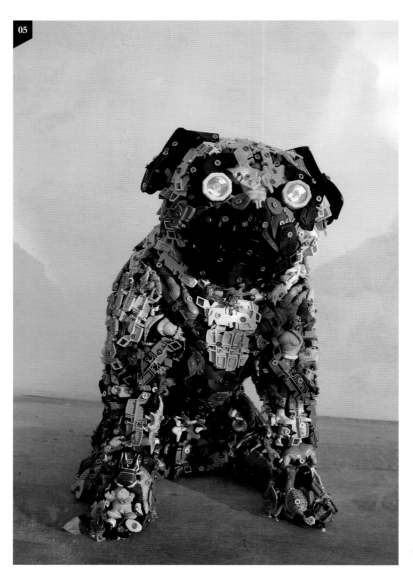

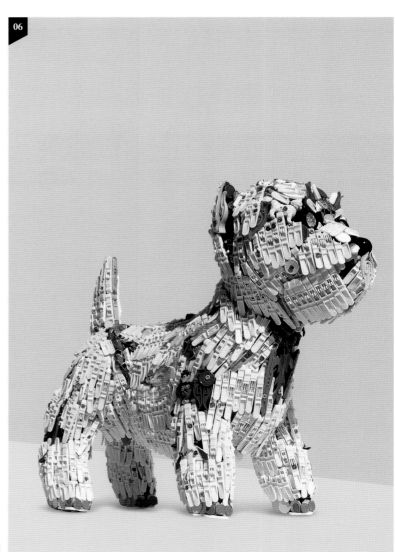

07

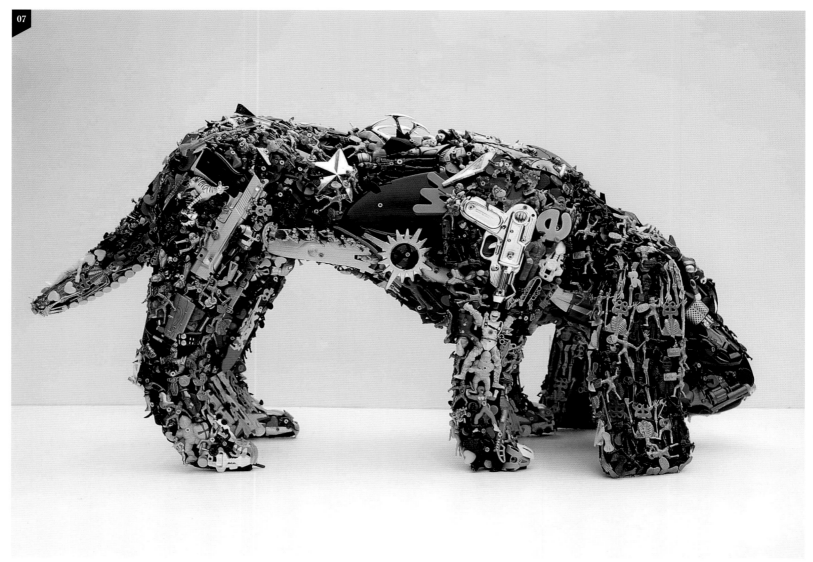

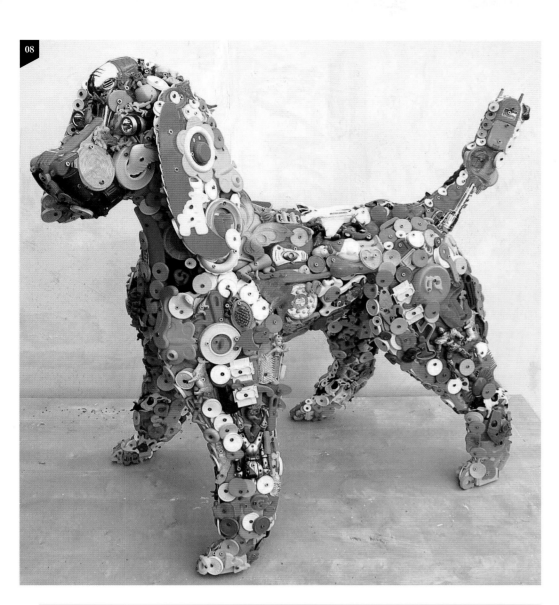

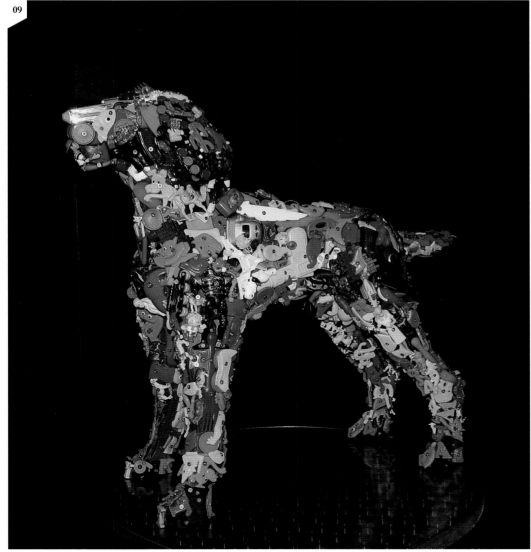

05 *Pug One*, toys on wood, 2009. 06 *Terrierist*, toys and clothes pegs on wood, 2008. 07 *Dark Sniff*, toys on wood, 2010. 08 *Foo Foo*, toys on wood, 2008. 09 *Mini Dog*, toys on wood, 2008.

waiting to have life breathed into it. Used materials have already had a life and suggest the lives they have had. Each individual toy refers to some aspect of life, and recycled ones also have a life of previous usage. My job is often to calm down their references or previous lives in the service of a totality. I want every inch of a work to have a meaning, make some kind of sense, have its own bit of interest.'

While he is not averse to his 'eco' reputation, Bradford is clear that this is not his sole message. 'My choices are more conceptual or aesthetic than moral,' he says, 'and I do like the fact that the sculptures are like historical documents. To use all-new would give them a different feel and meaning.' In the same way that the works themselves have more than one physical layer, so does the ethos of each piece. The main object, be it a dog, gun or human figure, presents us with one perception. Look closer and you find hundreds of smaller individual perceptions, some carrying evidence of their own unspoken histories, others just starting to create theirs within the journey of the piece. Why toys? As Bradford says: 'Can you think of anything else that comes in such a variety and that refers in so many ways to different aspects of existence? I can't.'

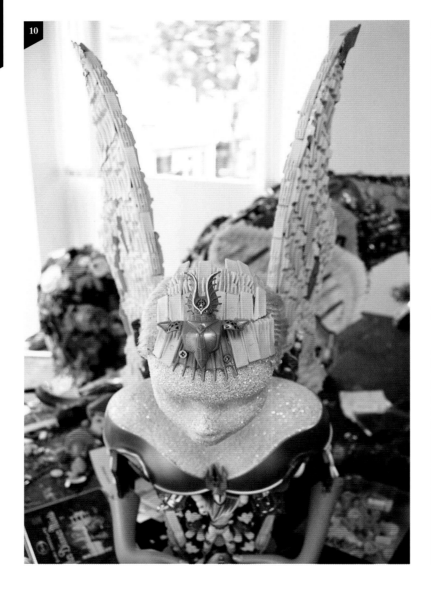

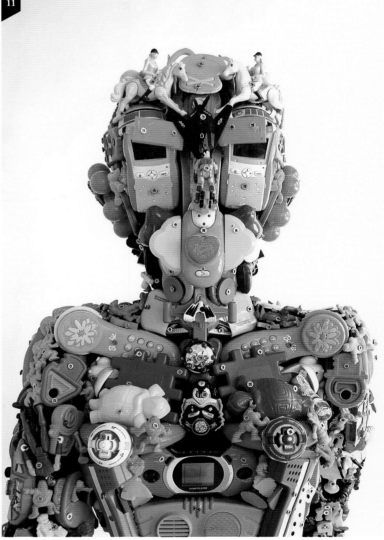

10 *Fairy Nuff One*, reconstituted Barbie hairdressing parts, toys, clothes pegs and glitter, 2011. **11** *Toy Girl*, toys on wood, 2009. **12** *Sniff Without (Guns or Barbies)*, 2010. **13** *Pistol*, toys on wood, 2011.

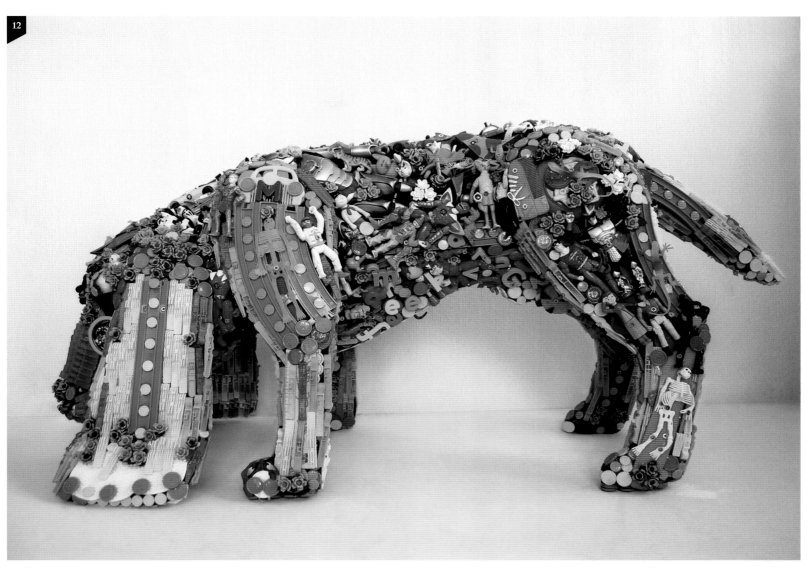

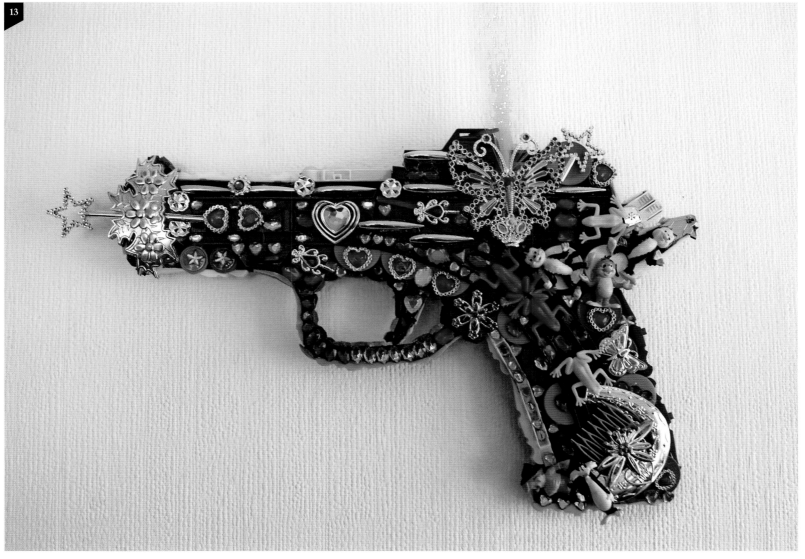

Peter Callesen

Danish artist Peter Callesen delights in conjuring delicate and seemingly impossible sculptures from white paper, focusing on the standard A4 size. For the artist, the attraction of the ubiquitous blank sheet of paper is its spatial and metaphorical neutrality as a starting point, which gives him the freedom to explore through transformation. Carefully considering the contrast between positive and negative space, he cuts out a silhouette and uses the extracted material to create a three-dimensional object that completes the composition. Although he sometimes trims the paper that is removed, he never adds anything: the three-dimensional works are always created from the material that is cut away from the silhouette shape.

With a grounding in architecture, Callesen studied art at the Jutland Art Academy in Aarhus, Denmark, and Goldsmiths College, London. His early career centred on painting, video and performance, but gradually his focus shifted to the paper sculptures and installations that have become his trademark. A turning point came in 2003 when he was invited to participate in the Amorph festival of performative arts in Helsinki. He made a floating white castle of Styrofoam for the show and a template for a miniature paper castle for the catalogue, which the reader could cut out and assemble. The intricate miniature was so small and complicated that it was almost impossible to make. Six months after the show, Callesen returned to the concept: 'I tried to make the castle from the template, and it turned out that it actually was possible. In that way you could say that the impossible became possible.'

The key to Callesen's extraordinary work lies in his ability to transform paper so that it no longer looks or behaves as expected, suspending the viewer's disbelief. He moulds, cuts and shapes the material to do things that seem impossible. Generally he employs very simple tools, producing the majority of works by hand using a scalpel. However, he has also developed his own instruments to help him create curves. Using these special wooden tools he has found ways to expand the fibres of the paper, stretching them through pressing to create complex multiple curves. He also uses old dental tools for detailed work, gluing and general shaping. Most of the sculptures rely on the natural strength of the paper, but with the large-scale works he sometimes uses rolls of paper for support or introduces folds with acid-free glue.

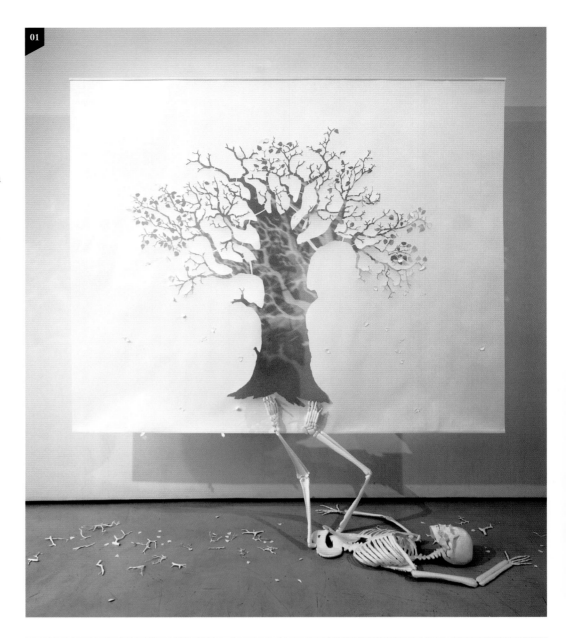

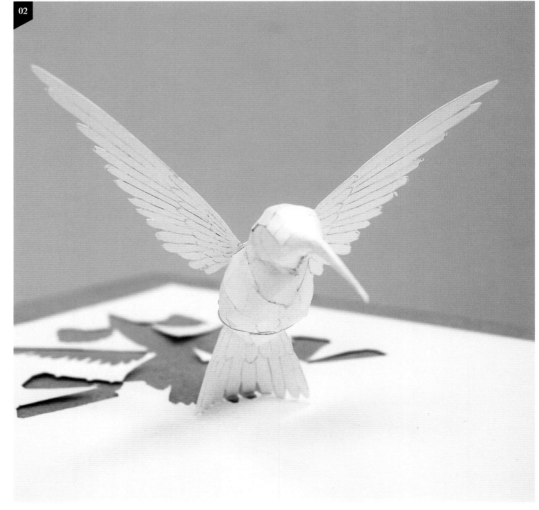

01 *Fall*, 140 gsm acid-free paper. **02** *Distant Wish II*, A4 115 gsm acid-free paper and glue, 2008. **03** *Gennemsigtig Gud (Transparent God)*, 140 gsm acid-free paper and glue, 2009.

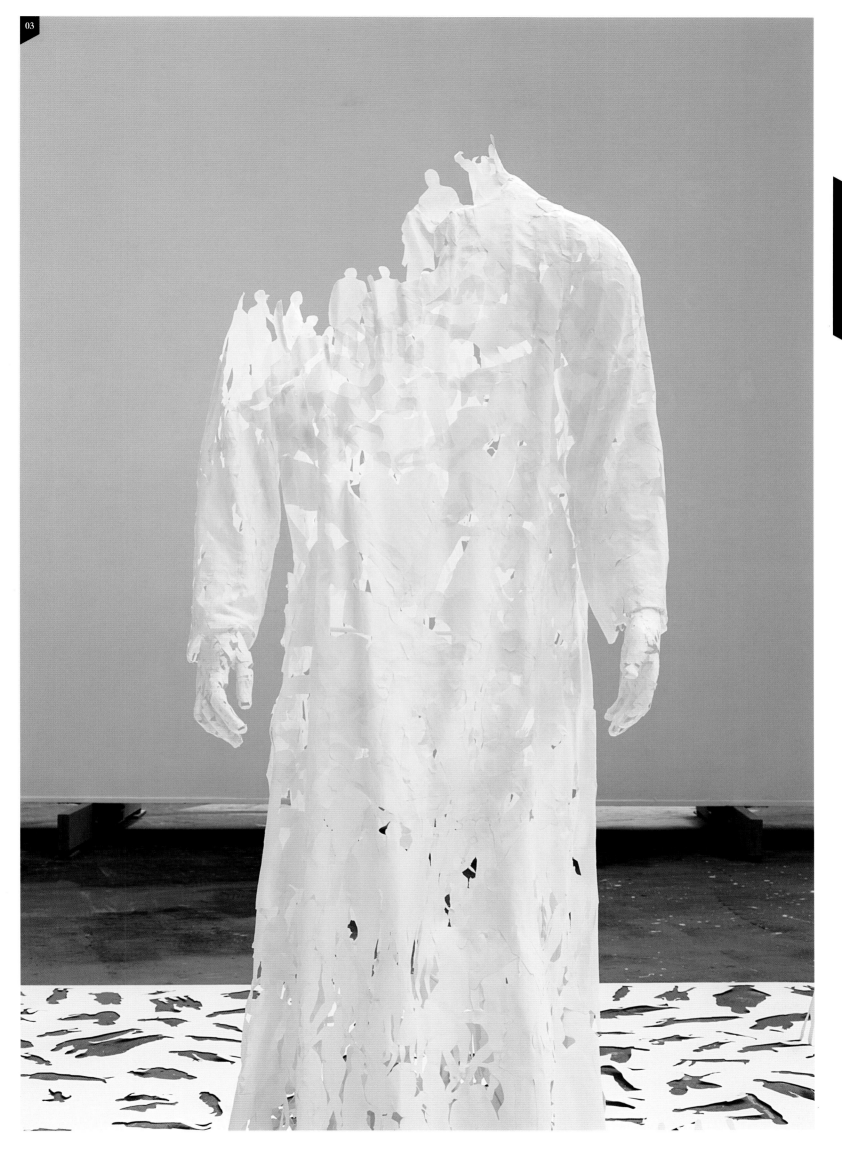

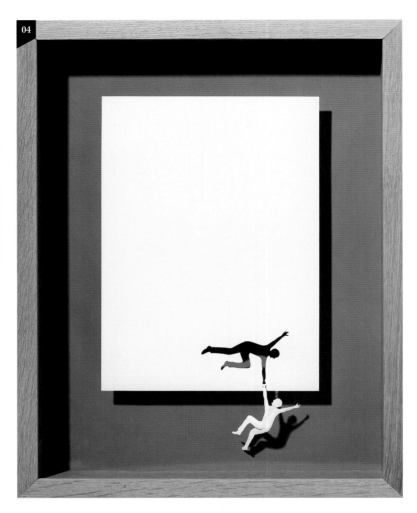

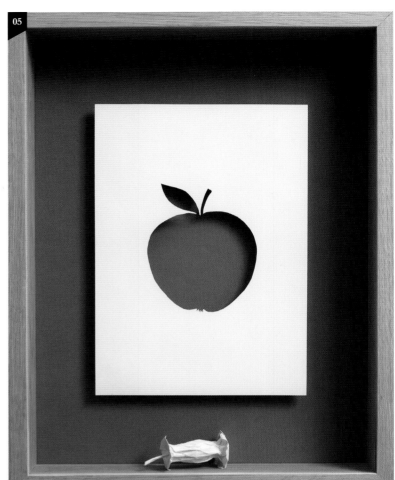

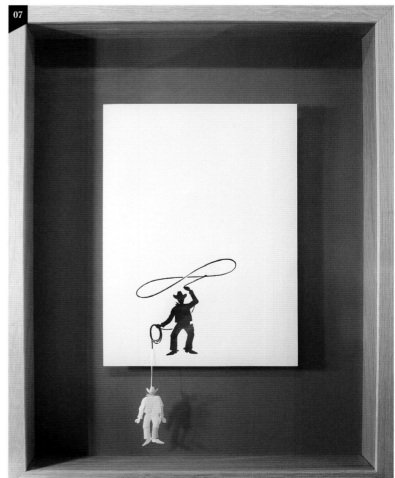

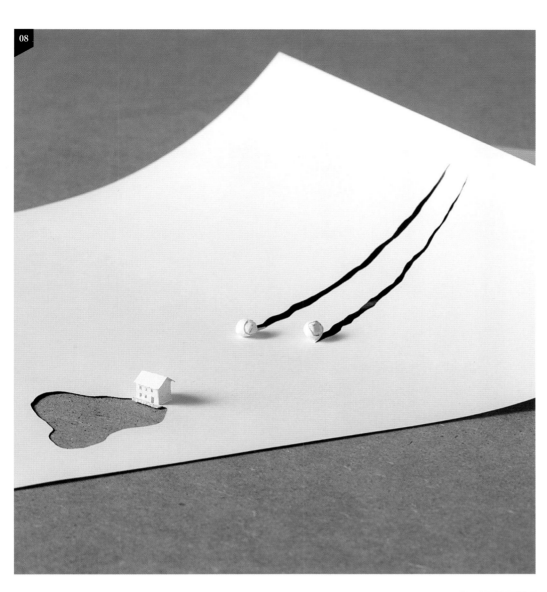

04 *Holding on to Myself,* A4 80 gsm acid-free paper, acrylic paint and oak frame, 2006. **05** *The Core of Everything III,* A4 115 gsm acid-free paper, acrylic paint and oak frame, 2008. **06** *Hanging Image,* 120 gsm acid-free paper, pencil, watercolour, glue and oak frame, 2008. **07** *Cowboy,* A4 115 gsm acid-free paper, acrylic paint and oak frame, 2006. **08** *Snowballs II,* A4 115 gsm acid-free paper and glue, 2006. **09** *Birds Trying to Escape their Drawings,* 115 gsm acid-free paper and glue, 2005.

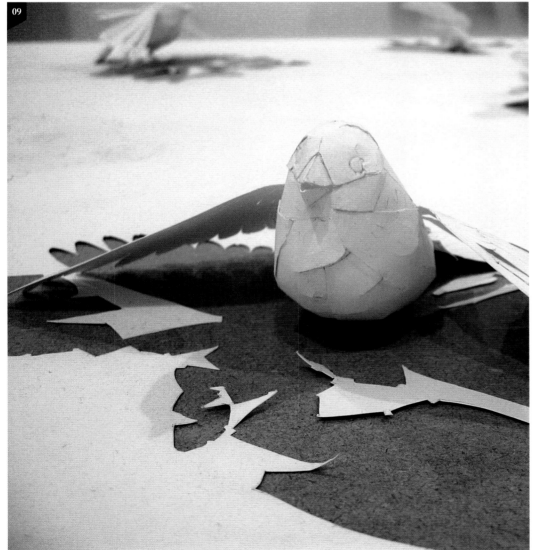

Callesen never ceases to be amazed by the possibilities contained within a sheet of paper. The results of using the same sheet of paper to create both positive and negative shapes can be magical. He always devises a relationship between the two spaces – that is, the paper that he cuts away and makes into a three-dimensional object, and the silhouette that it leaves behind. His work has been likened to animation, with the before and after image creating a dynamic tension. Scale is also important when creating works in a fragile medium and gives his miniatures a dreamlike, fairy-tale quality: 'The thin white paper gives the paper sculptures a frailty that underlines the tragic and romantic theme of my works.'

Beginning with an idea and sketches on paper, he describes his approach and thought process as lying 'somewhere between 2D and 3D', and his work as a 'reversed Magritte image'. Whereas René Magritte aimed to challenge our perceptions by unravelling the illusion of images in works such as *The Treachery of Images (Ceci n'est pas une pipe)* (1928–29), Callesen's work conversely shows the possibilities of an image as a reality or a materialization. Callesen's sculptures play on the relationship between positive and negative spaces and forces, where the absence of one element is as important as the presence of another.

Monica Canilao

American artist Monica Canilao has a truly holistic approach to her art. Fascinated by the concepts of home, community, and personal relationships and histories, she draws from these both literally and metaphorically in her work. She believes that nothing should be wasted and that all waste has a history and is a link to personal experience. She gathers together objects that have been either discarded as trash or neglected over time and uses them directly in her pieces, both resurrecting them and breathing new life into them. 'The beauty of people's efforts throughout time, and their subsequent decay, ends up in my pieces,' she explains. 'Things in abandoned places were once collected and held dear to someone. To collect and recycle things that have been loved before creates such a solid base to build from.'

She works instinctively rather than by plan. However, while she produces work in many different media, all her pieces bear the hallmark of her obsession with the concept of home, roots and personal stories. She describes her work as having 'a feral want for human connection and collaboration with others'. Her own experiences are also woven into her materials, 'the imprint that history has left on me' being a key part of the narrative she creates: 'Many of the materials I pick up, while travelling and at home, serve as tactile memory markers for me of where I've been, seen, experienced. Because the things I use come out of my experiences, I can weld them in a more personal way.'

Canilao's antique portrait collages are typical of her distinctive aesthetic and working methods. Combining found photographs with stained paper and other materials, she assembles abandoned objects in a state of decay. The final compositions redefine the identities of the original subjects, turning them into fetishistic or totemic objects. In these pieces she plays with the notion of reversing the colonization of indigenous peoples through time. What would it have been like, she imagines, if the American settlers had become feral and rejected social convention?

One of her most recent and ambitious works formed part of the *Powerhouse Project* (2010). Six artists were each given a derelict house to work with on a street in Detroit, USA. They had free rein over their space for this project, which could almost have been made for Canilao, embracing as it does the sense of lost community and the imprints of human experience on the walls within.

01, 02, 03 The artist's studio.

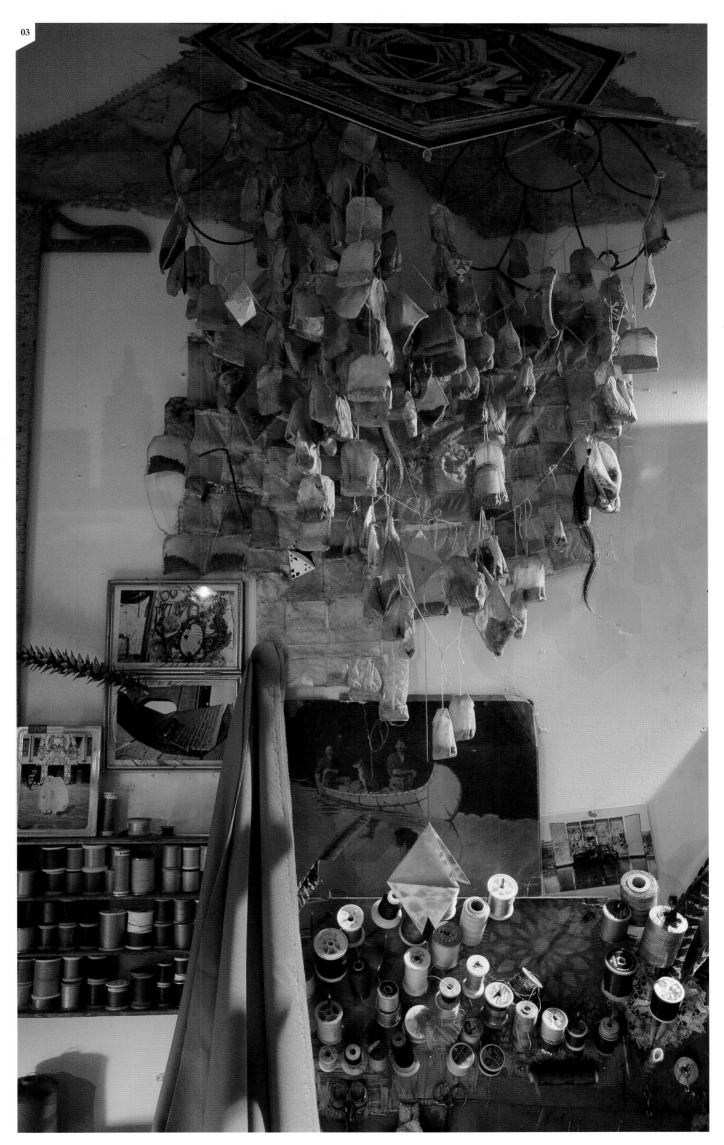

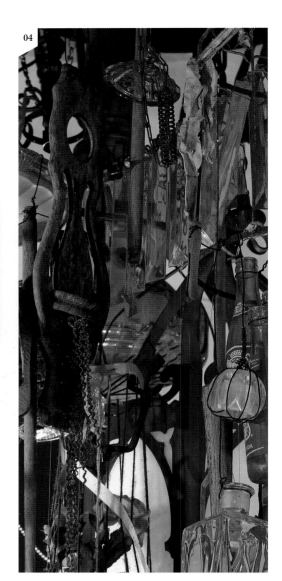

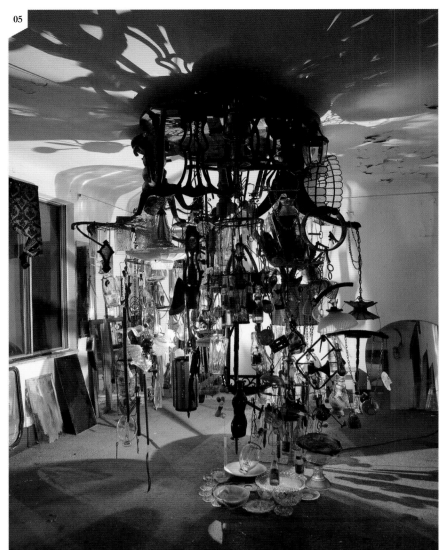

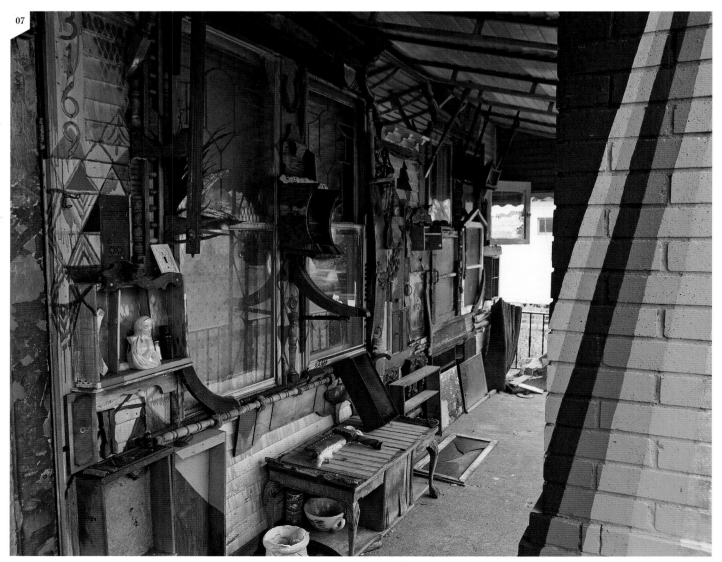

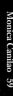

04, 05, 06, 07, 08 *Powerhouse Project*, various salvaged objects, Detroit, USA, 2010.

Overleaf 09 *Doe*, mixed media (portrait series), 2010. 10 *Untitled*, mixed media (portrait series), 2010. 11 *Lost Boy*, mixed media (portrait series), 2010. 12 *Veil of Salt*, mixed media (portrait series), 2010. 13 *Forget Me*, mixed media (portrait series), 2010.

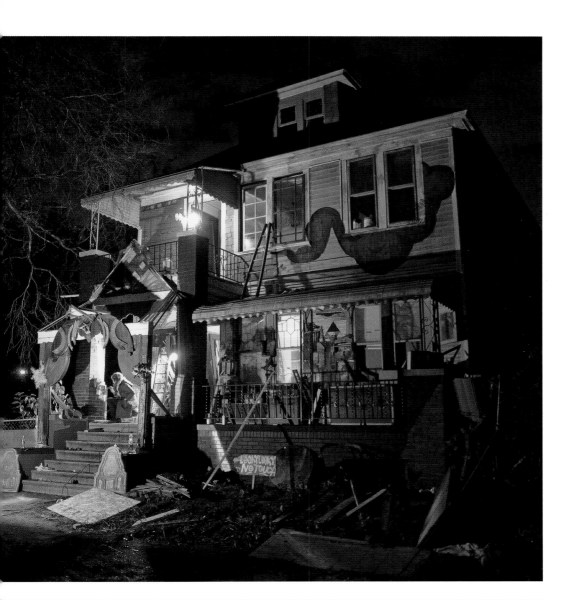

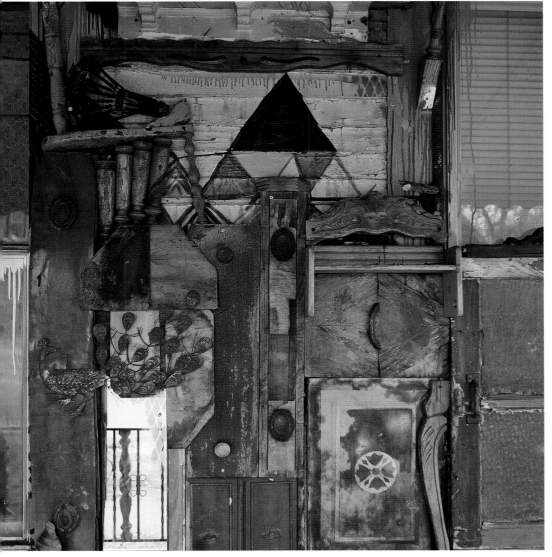

She foraged the areas surrounding the house and gathered items ranging from rusty metal fragments to discarded lightbulbs to old torn drapery that had once hung with pride in family homes – everyday ephemera that had seemingly completed its journey until Canilao intervened.

She interwove many of the smaller items into a huge chandelier-style installation that took up most of the second floor of the house. Larger items were reworked into sculptures and installations on the ground floor. Some objects even found their way onto the front of the house, where they became part of an elaborate collage also comprising painting and cut wood that interlinked into a mosaic-style formation. In her own sensitive way, Canilao had not only brought human experience back into the house but also the wider community by choosing materials that at one time had belonged to people whose lives were touched by the immediate area.

The artist continues to take her work in exciting new directions: 'The more I experience, the deeper I dig, the more I realize is possible, and that means I can't always predict where I am headed.'

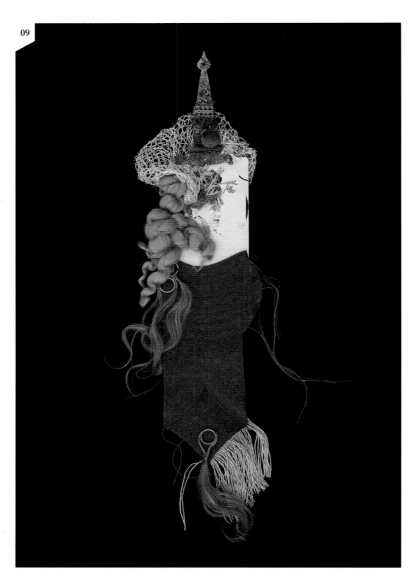

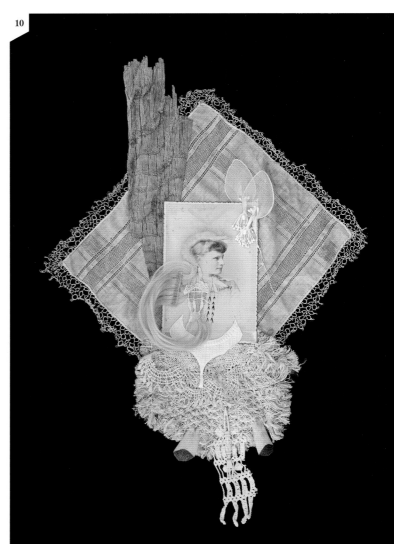

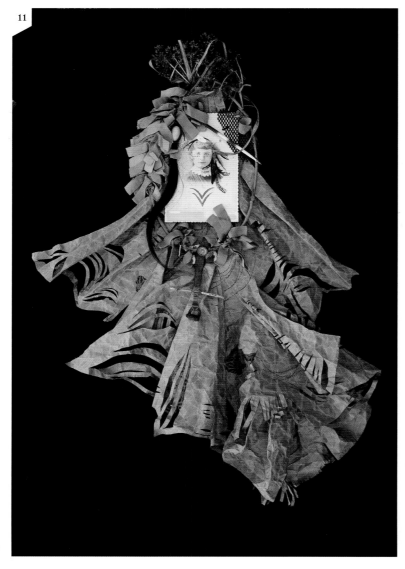

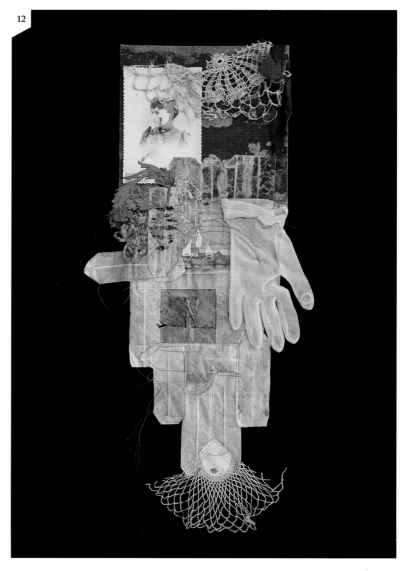

14 (*above*) *When this smog clears from our throats we will still be in love with the same things*, mixed-media collage. **15** (*opposite*) *Owned Worker*, mixed-media collage.

Overleaf **16** *Stranded, Saved* (detail), mixed-media collage.

Klaus Dauven

Klaus Dauven's work is often referred to as 'reverse graffiti' or 'anti-graffiti'. Unlike graffiti, which contributes to the rich layers of the urban environment through the writers' use of spray paint, reverse graffiti is a subtractive process of cleaning in which artists create detailed compositions by carefully wiping away the grime and dirt that coat our cities. Unconnected to the graffiti movement, the German artist's working practice is rooted in his experience as a draughtsman. He views all his works essentially as drawings, regardless of scale or media.

For years he has pushed himself as a draughtsman, experimenting with different techniques and tools. His motives and subjects are invariably dependent on the technique he chooses. In 1997 he stumbled across a method of making reverse marks on dirty surfaces. His attempts to enlarge a small charcoal drawing were proving unsuccessful. In frustration he wiped the charcoal until it became a homogeneous layer over the whole sheet of paper. It was so dirty that he thought it best to vacuum it before throwing it away, and it was then that he noticed interesting traces on the paper. This marked the start of many experiments with reverse drawing techniques.

In 1999 he took these experiments outdoors, using a wire brush to draw on a dirty concrete wall and bridge near his hometown of Düren. The results, although simple compared to his more recent works, caught his imagination. Over the years his work became increasingly intricate and ambitious in scale, and in 2007 he was invited to make his biggest piece to date at the Oleftalsperre Dam in Germany. The moss- and dirt-covered walls of the dam presented Dauven with a huge canvas for his reverse drawings. He chose as his motifs ten animal silhouettes to reflect the wildlife in the surrounding area. After making some preliminary drawings and plans, he set about the mammoth task of reproducing their outlines using a high-pressure water hose. No detergents or chemicals were used, to ensure that the process was environmentally friendly. The end result was arguably the largest drawing in the world with a surface area of more than 3,000 square metres (32,000 square feet).

In 2008 Dauven was asked to produce a similar work at the Matsudagawa Dam in the Tochigi Prefecture of Japan. After careful consideration, he chose azalea petals

01, 02 Work in progress, Matsudagawa Dam, Tochigi Prefecture, Japan, 2008. **03** The finished piece, entitled *Hanazakari (Full Bloom)*, Matsudagawa Dam, Tochigi Prefecture, Japan, 2008. **04** Work in progress.

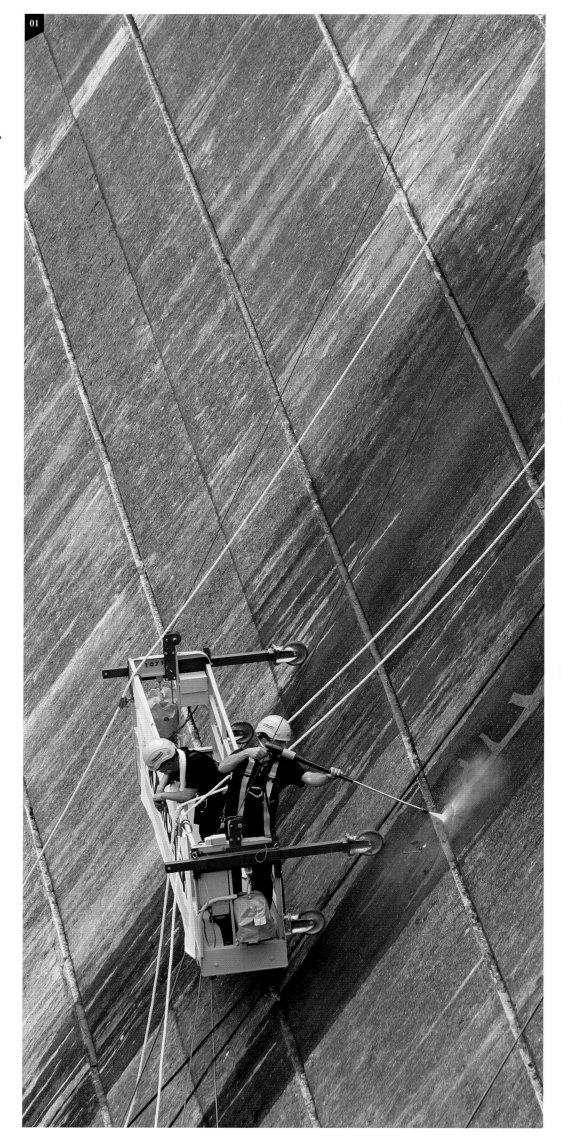

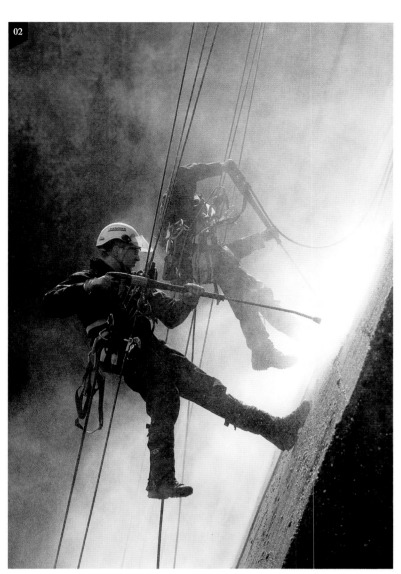

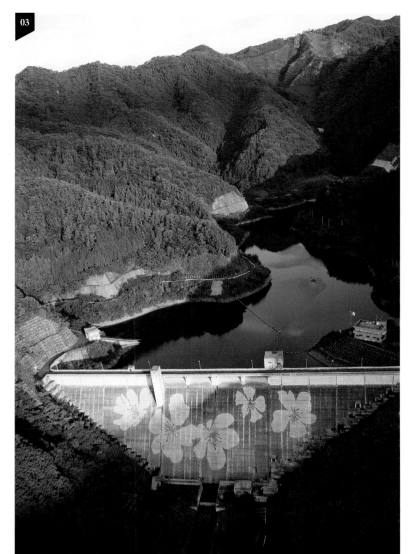

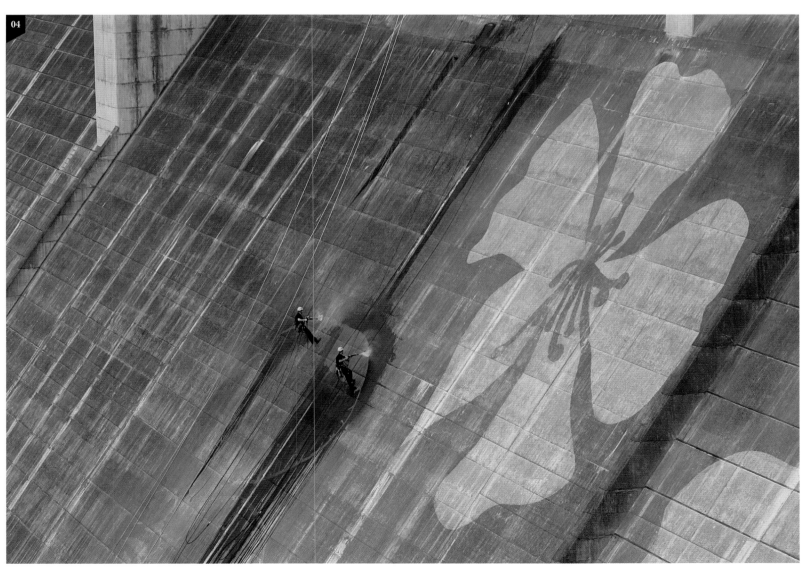

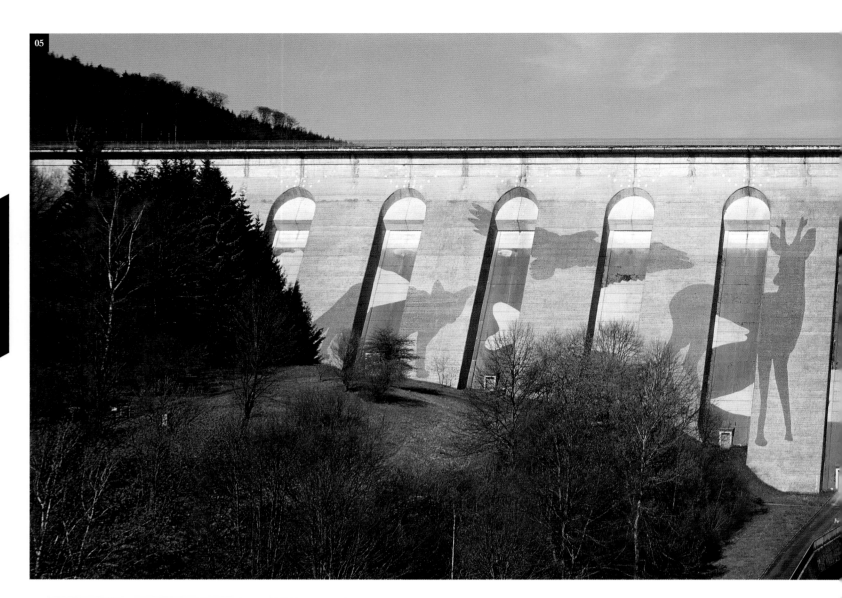

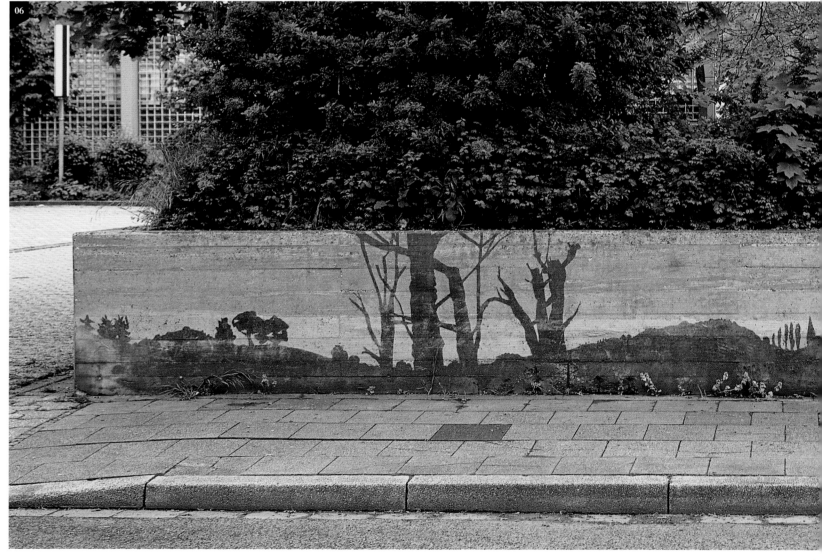

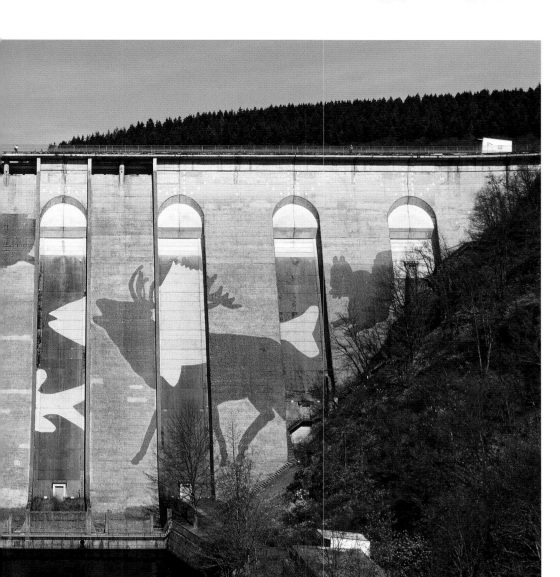

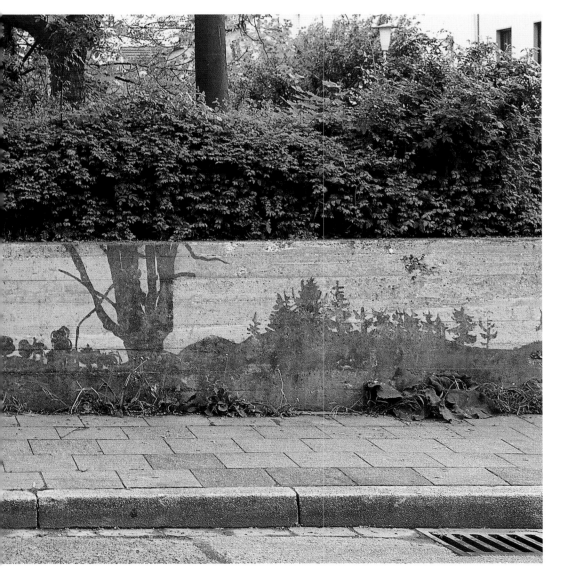

as the recurring motif of the work, which he called *Hanazakari (Full Bloom)*. He had originally planned to depict endemic species but, as flowers are a universal symbol of nature, abandoned the idea in favour of something more recognizable. When the work was complete, the contrast between the manmade and natural environments was breathtaking. As Kazuhiro Yamamoto, director of the Tochigi Prefectural Museum of Fine Arts, points out in his critique of the piece, 'Dauven's work goes beyond the conventional framework of art to quietly actualize dichotomies of beauty and ugliness, of good and necessary evil. His choice of dam serves to make us directly aware of the earth's environment.'

Underlying Dauven's imagery and techniques is a quiet and understated environmental message. The wonder we may feel on encountering his work in natural and urban spheres is tempered by a subtle appeal to consider the fragility of our environment. Dauven's intrinsically ephemeral work reminds us of the pollution that coats our roadsides and nature's capacity for reclaiming a foothold in the most inhospitable urban environments, effectively conveying nature's troubled survival on the one hand and its immense power on the other.

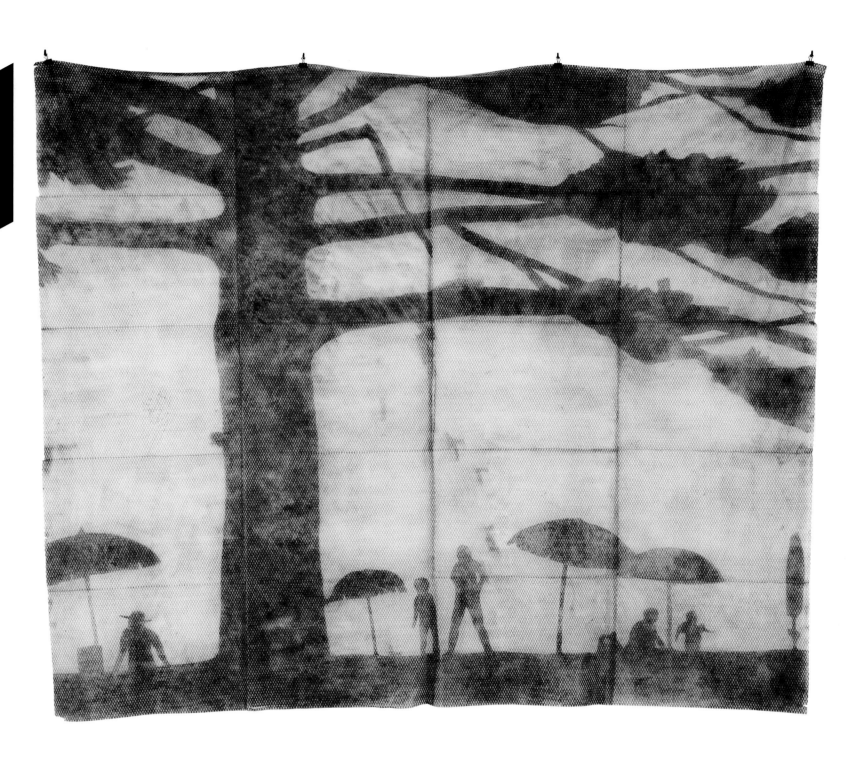

07, 08 (*above* and *opposite*) *Lido III*, dirt applied to
sewn dishcloths, then partially removed with a Kärcher
high-pressure cleaner and stencil, 2010.

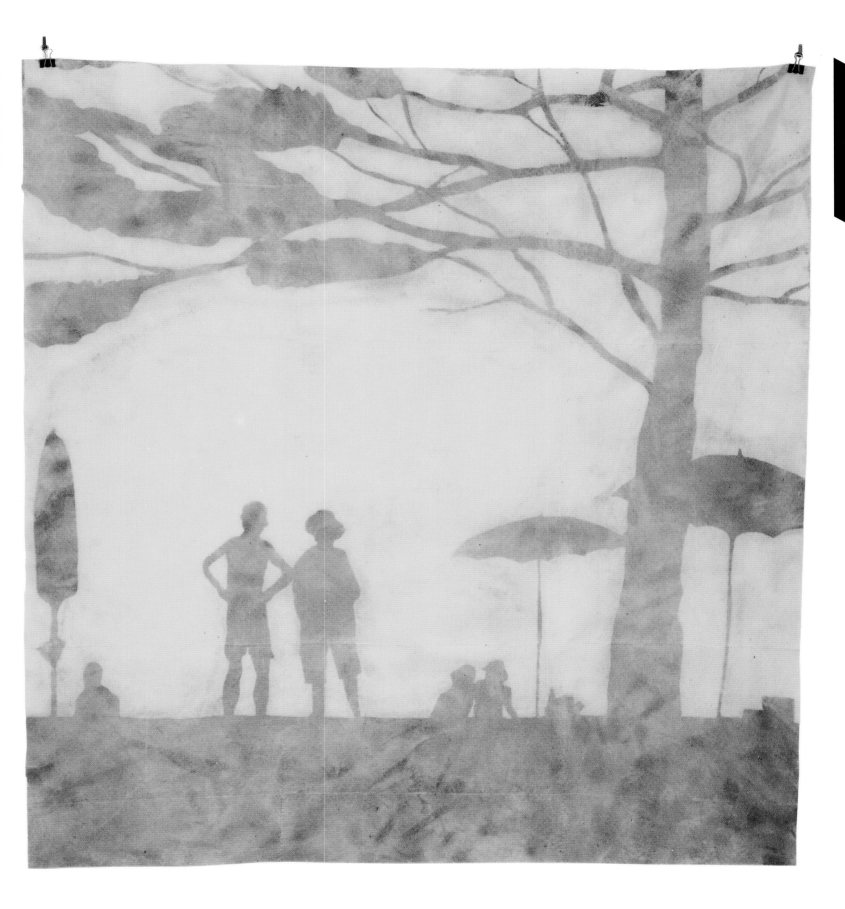

Gabriel Dawe

Gabriel Dawe combines optical art, form and tactility to glorious effect. Using thousands of multicoloured threads, strung over hundreds of hours, he creates beautifully prismatic installations that shift perceptually depending on one's viewpoint in the room. Born in Mexico City, Dawe grew up surrounded by the traditions and crafts that infuse Mexican culture and now filter into his own work. His mother had an eye for high-quality handicrafts and brightly coloured embroidery, which she collected from different regions. On a memorable trip to Chiapas with his family, he was struck by a geometric motif that the women traditionally embroidered on their blouses as a representation of the universe, later adopting it in a piece for his thesis.

Dawe's latent interest in textile crafts developed gradually. 'The desire to experiment with embroidery came from the frustration of growing up in a society where machismo is the norm,' he explains, 'and as a boy I couldn't help but feel inadequate for wanting to embroider.' In 2007 he created his first series of hand-embroidered pieces, entitled *Fear*. The following year, having spent several years working as a designer in Mexico City and Montreal, Canada, he moved to Dallas to study and focus on art. 'When I came to Dallas I continued working with embroidery and started the *Pain* series, which isn't embroidery but I see it as a continuation of that work. I see the large-scale thread pieces as an extension of the embroidery work because the process is very similar in its repetitive motion.'

Dawe created his first large-scale work in thread in preparation for the 'Transitive Pairings' show in Dallas (2010). The premise of the exhibition was to partner an artist with an architect to explore the relationship between architecture and fashion. There were three pairs of artists/architects in total. Dawe's response was to fashion an architectural structure with thread, which developed into an ongoing investigation. Subsequent installations have all been site-specific, designed to work with the limitations of a particular space. Each work is planned with a sketch, which is then reinterpreted as an isometric projection. There are no particular mathematical formulae involved, just careful planning

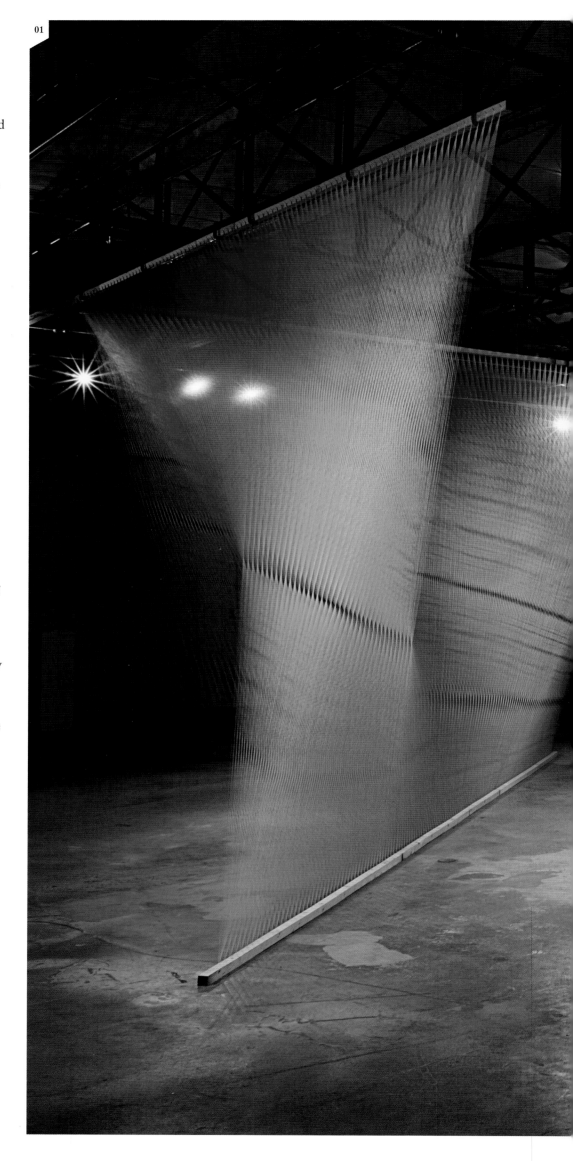

01

01 *Plexus no. 4*, Gütermann thread, wood and nails, Dallas Contemporary, Dallas, USA, 2010.

Overleaf **02** *Plexus no. 4* (detail). **03** Studio materials.
04 *Plexus no. 4* (detail). **05, 06** *Plexus no. 3*, Gütermann thread, wood and nails, GuerillaArts, Dallas, USA, 2010.

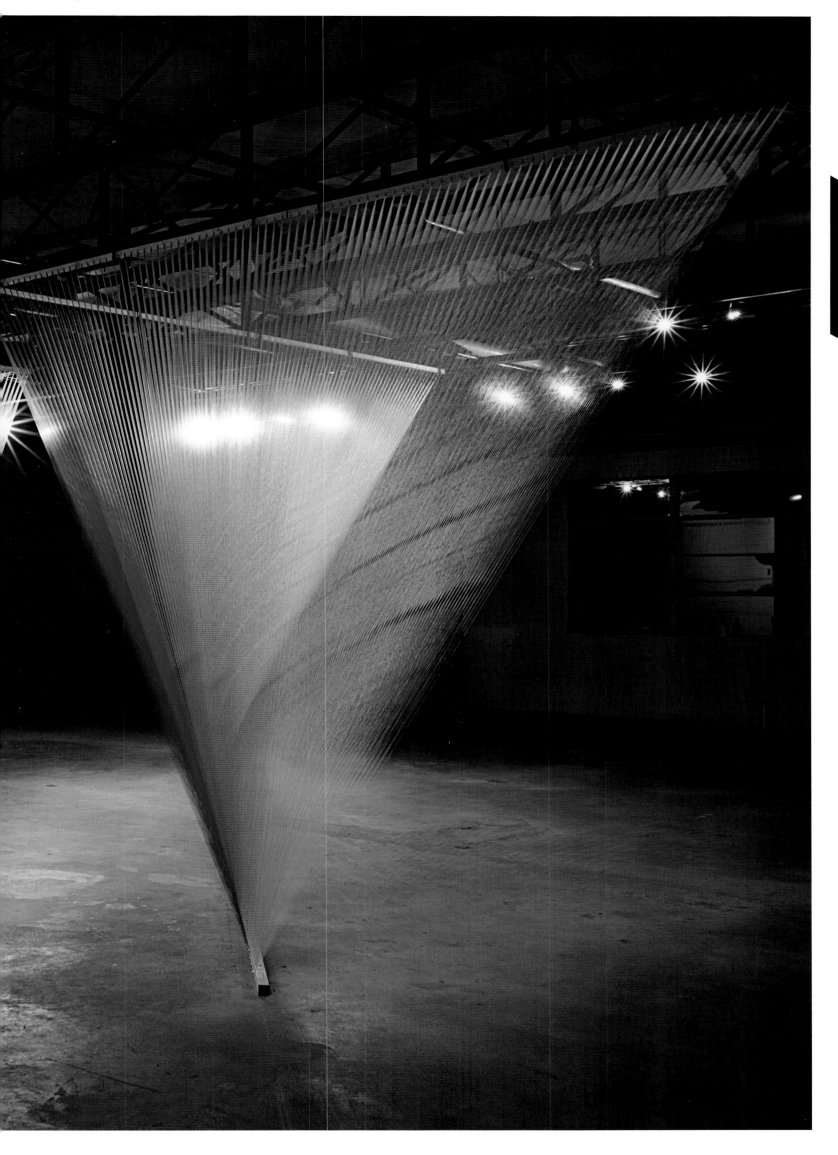

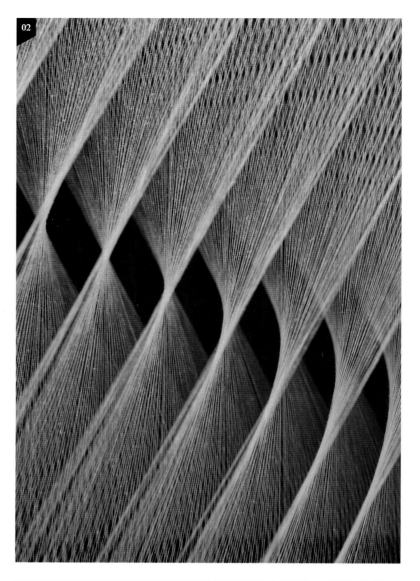

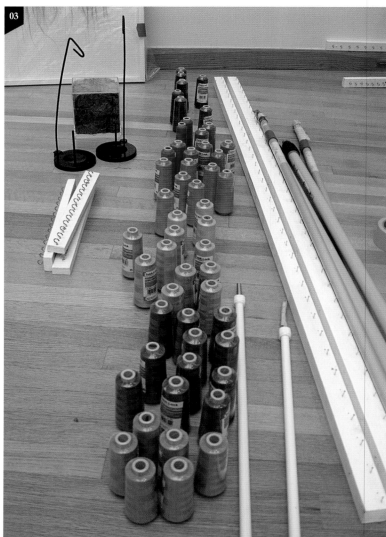

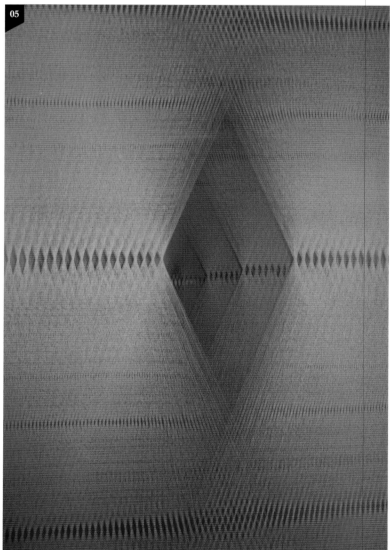

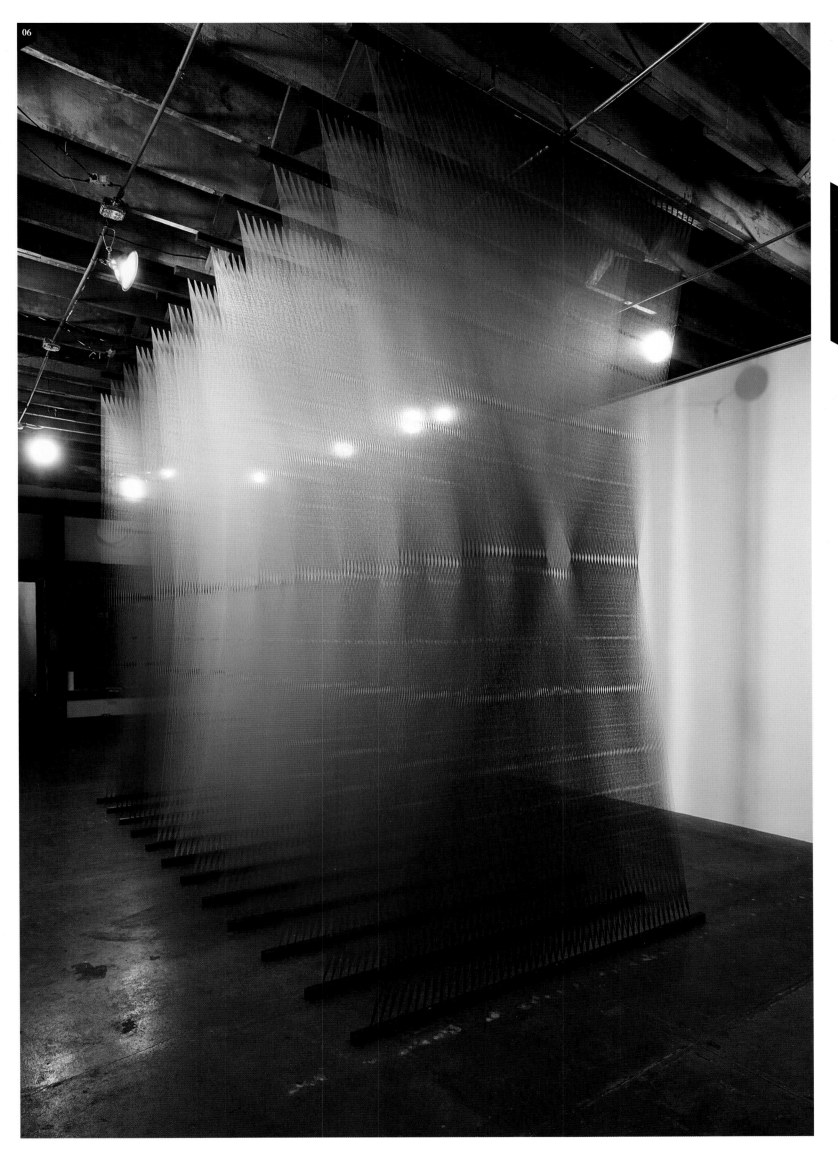

07

08

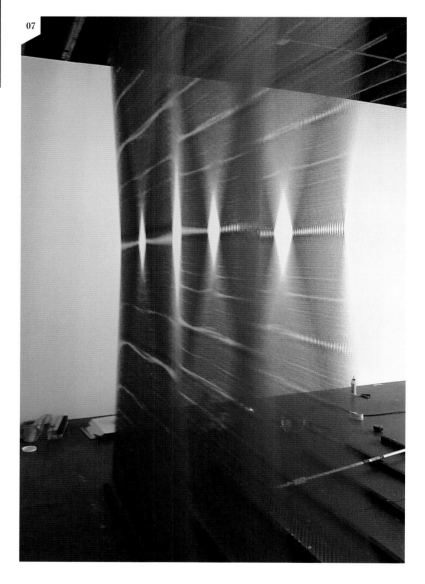

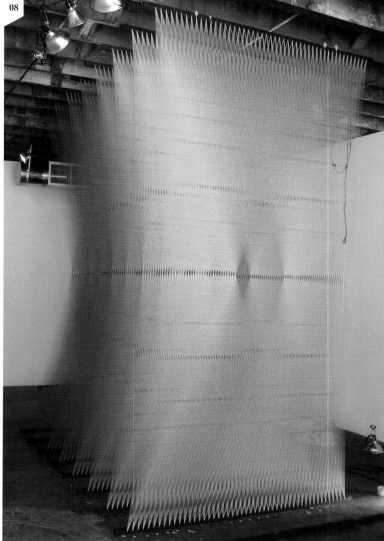

07, 08 *Plexus no. 3* (work in progress), Gütermann thread,
wood and nails, GuerillaArts, Dallas, USA, 2010. **09** *Plexus
no. 4* (work in progress), Gütermann thread, wood and nails,
Dallas Contemporary, Dallas, USA, 2010.

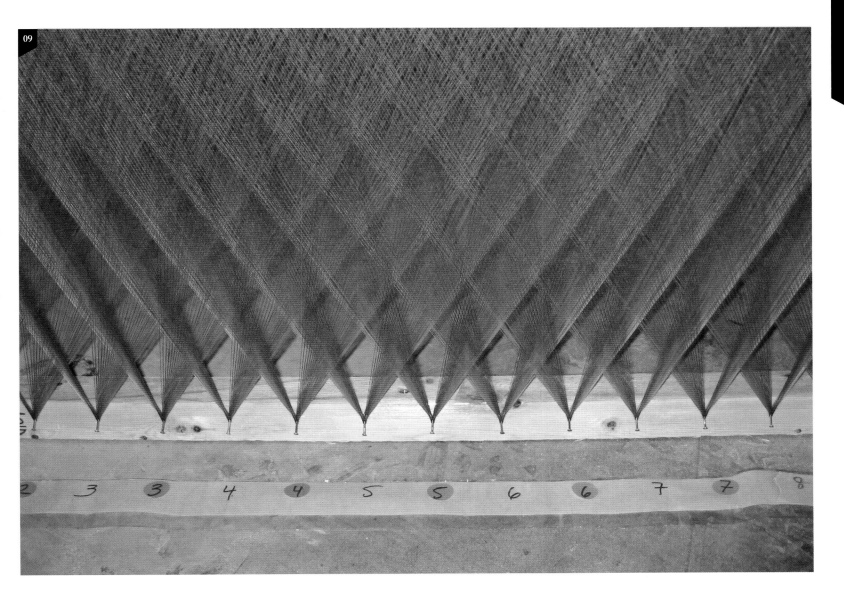

09

and measuring to calculate the spacing between nails, the thread count and the height. The final production of the work remains intuitive. By employing fine threads associated with women's work to create physically demanding, large-scale structures, Dawe subverts the traditional use of the material and challenges the concepts of masculinity and machismo ingrained in Mexican culture.

Besides being mesmerizing to experience, these intricately woven structures can also be viewed symbolically. They remind us that weaving and architectural construction are fundamental human inventions, sharing

intrinsic structural forms that are also found in nature. For the artist, they reflect our basic human needs for clothing and shelter from the elements as well as the social constructions that are essential to our survival as a species.

'The idea of social constructions came from reading Michel Foucault,' he explains, 'and having read evolutionary theorist Robert Wright, I feel that they are both addressing the same issue from different points of view. Foucault sees social constructs as an artifice held in place by networks of power and as a means of control. Evolutionary theory is about genes and game theory, which I came

to see as a network of events that led us where we are, as well as invisible structures that have led our existence to where it is today. I think there are structures in place in nature that allow for life and nature to exist, and I see these installations as an attempt to portray those structures. Conversely, sometimes it is hard to see structure in a world that is increasingly chaotic, yet behind the uncontrollable aspects of life, there are the unchanging laws of the universe. It is paradoxical and that's one of the reasons I like doing this work so much.'

Baptiste Debombourg

Combining unusual materials such as cigarette butts and staples with a sense of absurdity and forthright opinions, French artist Baptiste Debombourg has been described as an idealistic troublemaker. His extraordinary output illustrates his love of making work in unorthodox ways, placing it in unexpected contexts and using destructive techniques. By his own admission, the more something is forbidden, the more he feels drawn to it regardless of the risks. However, the notion of 'beauty' in the nonsensical is also very important in his work, where we find it in the least likely places.

For Debombourg, 'art has always been a way to escape from rules'. Initially he produced paintings, but over time he found that he could express his ideas more naturally through sculpture and other three-dimensional work. In keeping with his unconventional approach to art, he often uses discarded scrap materials found on the street as opposed to pristine purpose-made media. Sometimes these found materials are further degraded or dissected by the artist. In his *La Redoute* series (2005), he sculpts the well-known mail order catalogues in such a way that they resemble the contours of a map.

Finding inspiration in everyday life, he often takes objects and materials that are ubiquitous and familiar and transforms them in original ways. In the *Aggravure* series (2007–9), Debombourg – inspired by *The Four Disgracers* (1588) by Hendrick Goltzius after Cornelisz van Haarlem – used up to 35,000 staples on a wall as a physical interpretation of a classical engraving. *Air Force One*, the first work in the series featuring the protagonist Icarus falling from the sky, combines the pathos, beauty and unnatural movement of the Italian Mannerists with the covert aggression of the staple gun and what the artist calls 'the profane utility of everyday life'.

Aside from the physical properties of his chosen media, Debombourg tends to be drawn to items and materials that provoke in some way. In a society that centres on mass consumption, many day-to-day objects represent wish fulfilment and our ideas of a perfect life. He is fascinated by the emotional connections we make with objects that are part of this consumer dream. In a recent interview, he made the following observation: 'In a bar you can hear gossip,

01 *Air Force One*, 35,000 staples on a wall, *Aggravure* series, 2007–9. 02 *Air Force One* (detail). 03 *La Redoute*, La Redoute catalogues framed in plexiglas, 2005. 04 *La Redoute* (detail).

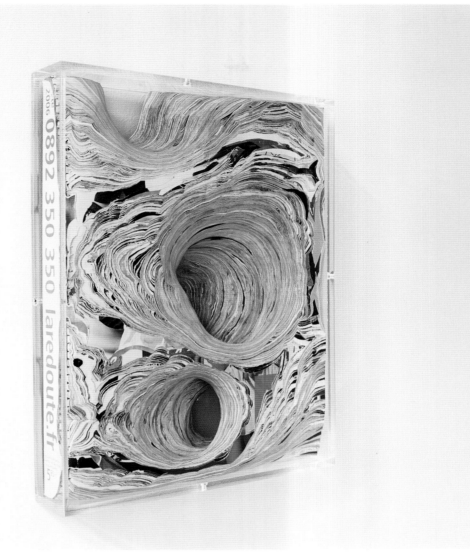

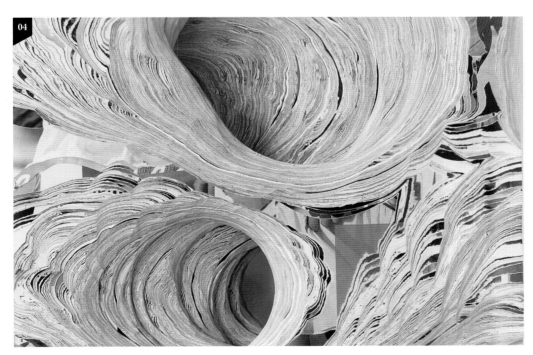

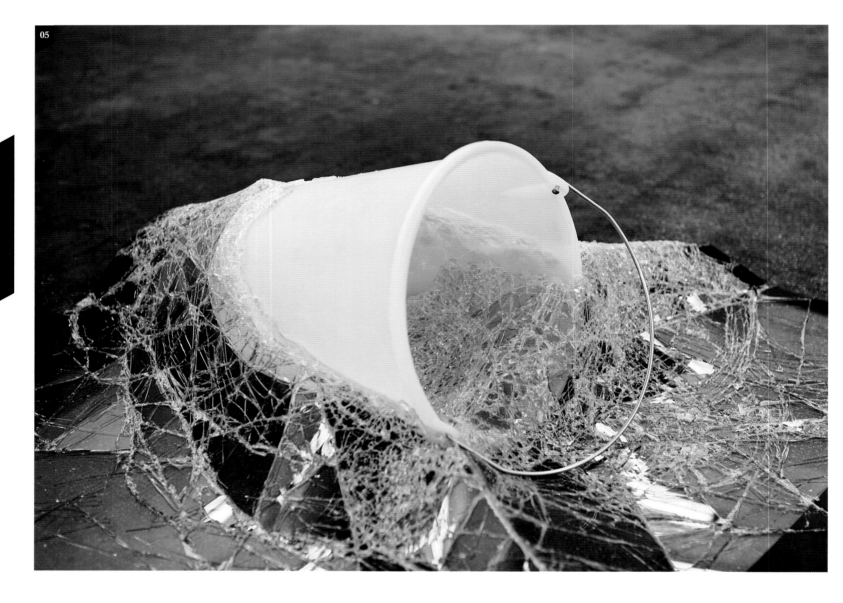

everyday philosophy, but also about god and destiny, and all this happens during the time it takes to smoke one cigarette. Those details, like old cigarette stubs, are very small but at the same time very full of life. It is garbage that carries our lives, or let's say, that fingerprints our lives. These fragments of reality also represent for me a human sense of scale.'

The process of destruction is a recurring theme in Debombourg's work. An important part of this is the gesture itself: destruction, like construction, is a human expression, and although we are all equally capable of both, displaying our destructive nature breaks a conventional taboo. Normally, when we have used an item, we throw it away. Reacting to

this throwaway culture, Debombourg often uses objects that he has broken down as a starting point for his works. Through their destruction, the construction and function of otherwise unremarkable objects is indirectly reappraised; through their reconstruction, the objects naturally become imperfect and in some ways more true to humanity.

He explains that all his projects 'are somehow linked to an aspect of human relationships; our mistakes, our doubts, our desires, and the perceptions we have of some of our realities. My work is based on the exploration of our psychology in connection with objects, looking for a conduit between reality and the ideal that we are trying to reach.'

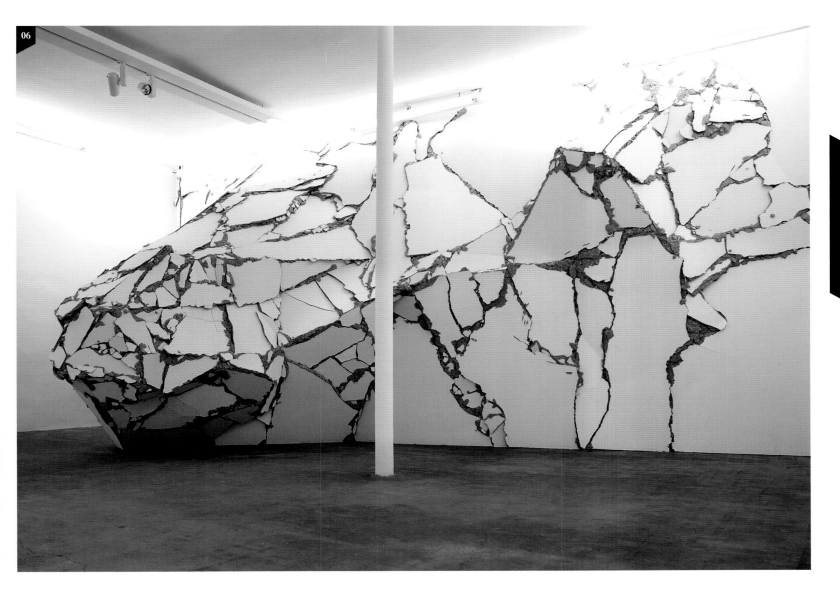

05 *Untitled with Plastic Bucket*, plastic bucket with
windscreen, Galerie Patricia Dorfmann, Paris, France,
2009–10. **06** *Turbo*, wood, Galerie Patricia Dorfmann,
Paris, France, Galerie HO, Marseille, France, and
Galerija10m2, Sarajevo, Bosnia and Herzegovina, 2007–9.

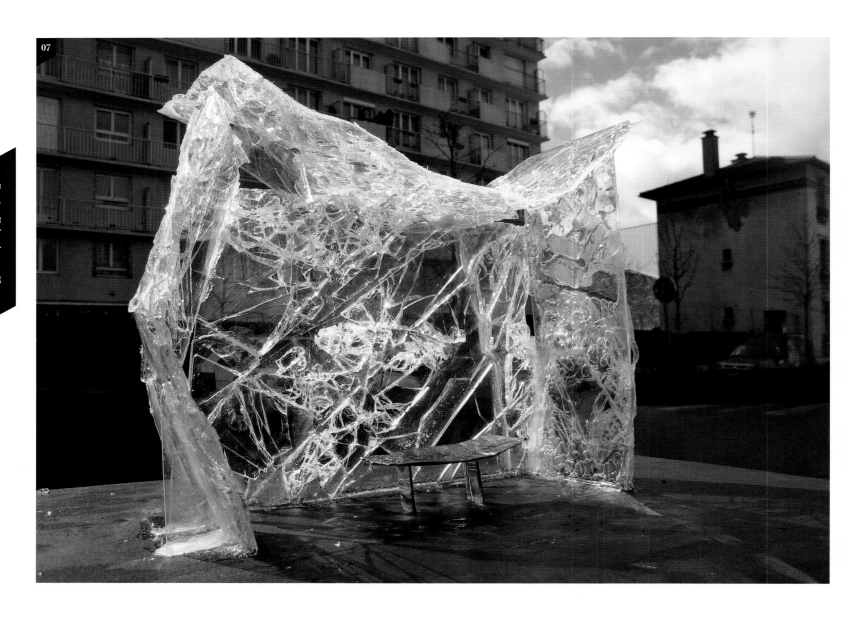

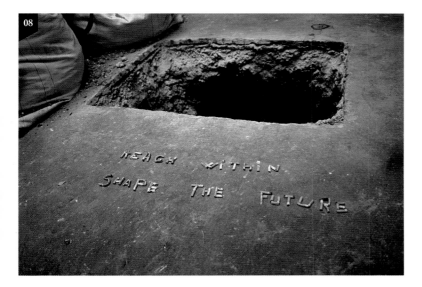

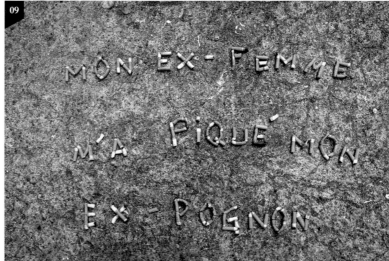

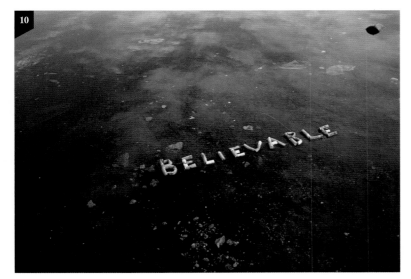

07 *Crystal Palace*, metal structure, laminated glass, safety
glass and UV glue, 2008. **08** *Reach Within, Shape the Future*,
Social Philosophy series, 2008. **09** *Mon ex-femme m'a piqué
mon ex-pognon*, *Social Philosophy* series, 2008. **10** *Believable*,
Social Philosophy series, 2008. **11** *Winner Takes Nothing*, *Social
Philosophy* series, 2008.

Brian Dettmer

In the digital age the physical book, while still revered, has begun to lose its power as a repository of information, surpassed by the vast wealth of images and up-to-the-minute hypertexts online. American artist Brian Dettmer's work takes increasingly anachronistic objects of communication such as books, and through sculpture transforms them into something that is both a work of art and a revitalization of content and context. 'The book as a form of communication will never die,' he says, 'but I do think that the role of many books, mostly non-fiction, has dramatically shifted. I want my work to celebrate the physical qualities of the book, the history and role it played, and to have the viewer think about the position books are in now.'

Originally from Chicago, Dettmer studied at Columbia College, where he focused on painting. To get through college he took a part-time job in a sign shop, and after graduation continued to work in this field during the day while creating art at night. The experience began to influence his work both physically and conceptually. 'I was working with letters and text as objects. A physical manifestation of text really illustrates the wide gap between meaning and material in communication. I also had an X-Acto knife in my hand about 50 per cent of the day, which allowed me to become very comfortable with the tool.' It eventually led him to create more tactile and abstract work, at first applying ripped-up books onto canvas. Although he felt guilty about using books in this way, they captivated him as a medium, and around 2001–3 he started work on his altered books series. As his work achieved greater critical success, he was able to quit his day job and concentrate on his art full-time.

Dettmer's sculptural processes have been described as lying somewhere between archaeology and surgery. After hunting down a book that he feels has potential, he starts by deciding how he will transform its form. Using clamps, weights and ropes to hold everything in place he seals its edges, thereby locking in its content and setting the structure. He then approaches it as a solid material. As he dissects the book with knives, tweezers and surgical tools, an element of chance affects the images that will be revealed. Nothing is ever moved, coloured or added to the piece; elements are only ever taken away. Currently he is interested in pushing the work sculpturally. As he explains: 'The image and text are

01, 02, 03, 04 The artist's studio.

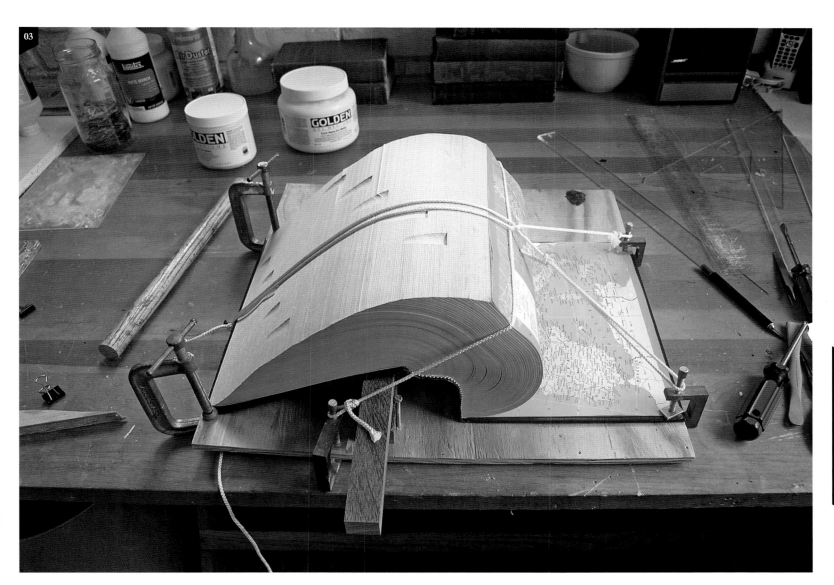

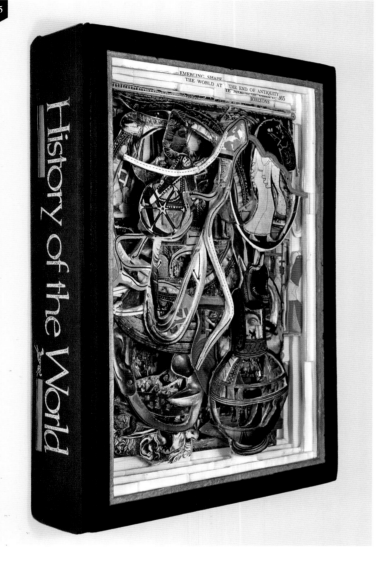

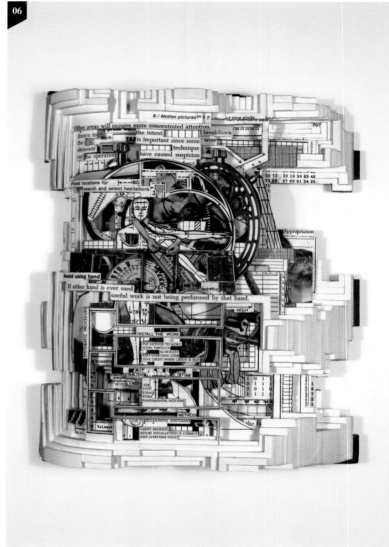

Brian Dettmer 86

05 *History of the World*, altered book, 2010. **06** *Motion and Time Study*, altered book, 2009. **07** (*opposite*) *Totem*, altered set of vintage encyclopedias, 2010.

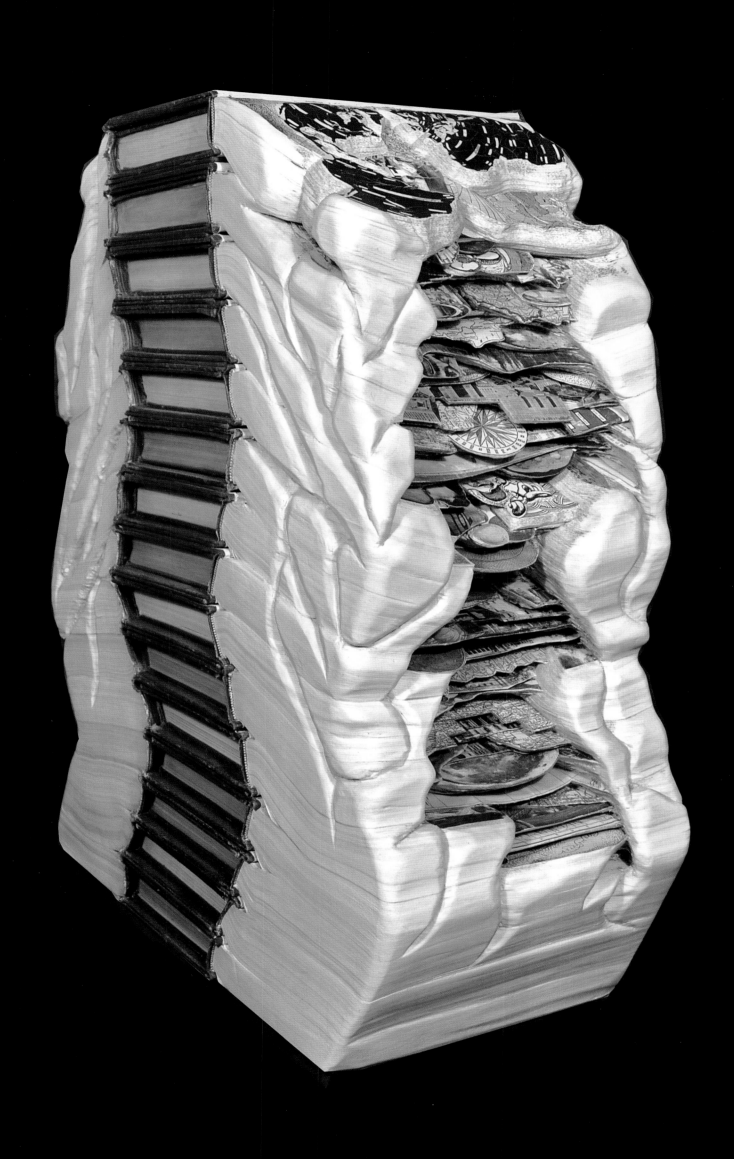

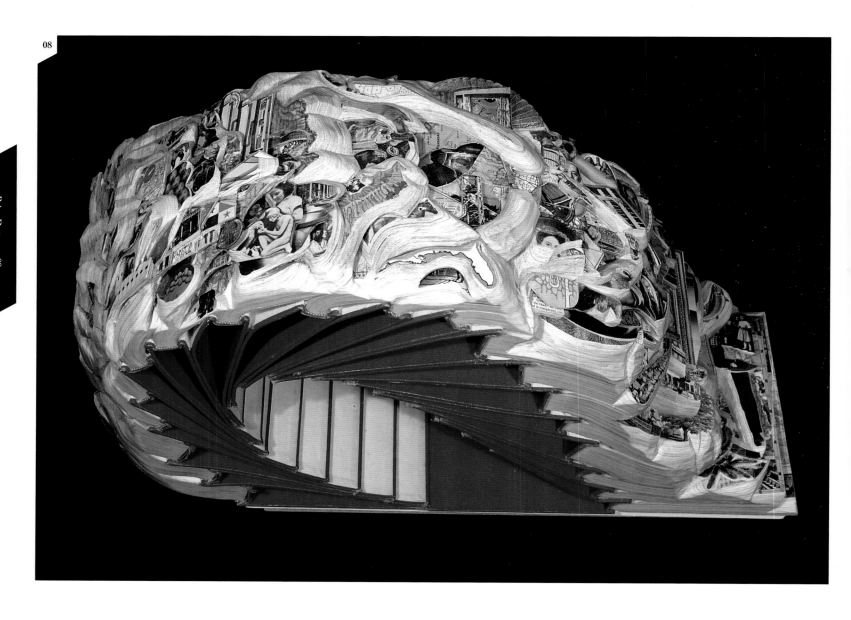

still dictating what happens, but the initial forms are becoming more complex, and the sculptural echoes from the content are as important as the content itself because they reveal the structure and inner architecture of the forms.'

Book lovers might naturally view Dettmer's work with some trepidation. The price of these wonderful sculptures is the death of a book, but at the same time it becomes a new and treasured object. Rather than acting like an archivist, he has suggested that perhaps he is an anti-archivist,

redefining, manipulating and distorting books. As he recycles materials, he also recycles their meaning: 'I like the idea that I am taking a solid narrative or idea and breaking it apart into fragments, singular elements or experiences and the viewers can approach the work and apply their own ideas and interpretation to it. They can reconstruct fragments conceptually, and small stories and relationships can emerge, or they can view the rest of the piece as a sculptural form. In this way, the content goes full circle and the viewer becomes a participant.'

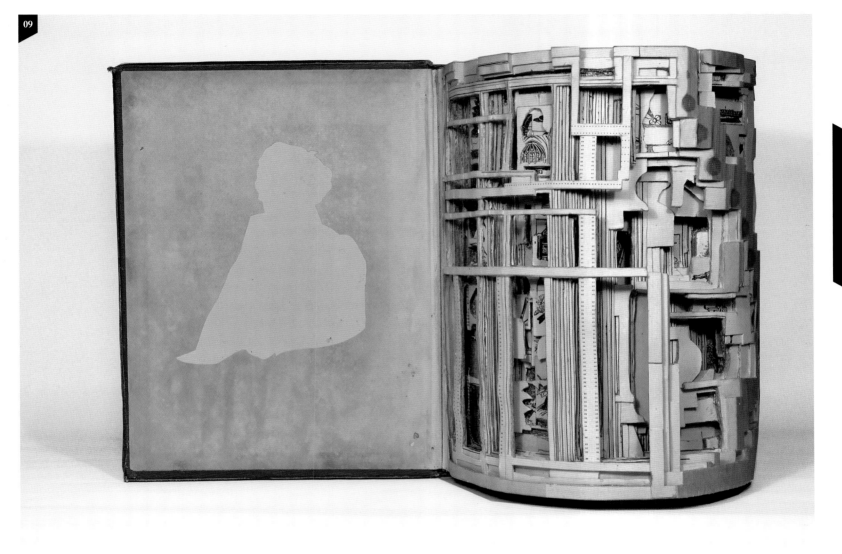

08 *World Series*, altered books, 2009. **09** *Webster Withdrawn*, altered book, 2010.

Elfo

Elfo is the pseudonym of Andrea Bonatti, an artist based in northern Italy. His artistic roots lie in graffiti writing, but his contemporary work is more closely linked to land, conceptual and performance art. It might also be described as street art, although he executes his pieces in both rural and urban spaces. Often juxtaposing the natural with the manmade, he creates sculptures, installations, performances and texts using recycled materials. He also uses irony in his work to highlight more serious issues.

While he has exhibited in formal gallery settings, the location of his work is usually a matter of chance. As he explains: 'I don't know what my next work will be or where it will be. I find a location as a result of a chain of events and, when I find it, it triggers the idea for the work.' The unexpected encounter with a particular situation or photo opportunity suggests the medium or form: a sculpture, a sign, a performance or whatever the right 'ingredient' might be to realize the visual narrative. Once the work has been documented, it is primarily disseminated online so that it remains freely available to all.

Much of Elfo's work has a Duchampian influence. 'I'm the New King of Ready-Made', he declares in one piece (Marcel Duchamp coined the term readymade to describe an everyday found object presented as art). Elfo believes that all modern art is a progression from what is arguably the French artist's best-known readymade, *Fountain* (1917). Other pieces by Elfo make reference to the work of Belgian artist René Magritte and the Surrealists, who sought to release the creative potential of the unconscious mind through practices such as the irrational juxtaposition of images. Natural and urban environments are Elfo's playing field, and with minimal intervention he is able to manipulate a situation so that it can be read in a completely different way, whether it is changing a road sign, placing fur rugs in the middle of the road or writing 'Help Alive Inside' on a goldfish bowl.

Elfo's work is highly ephemeral. Photographic documentation provides the only record of his interventions. In *Packed Food for Vulture$*, originally performed in 2008 and re-enacted in 2010, he attached himself to a tree by wrapping himself head to toe in cling-film around the trunk, thereby creating a human cocoon. Using the simplest methods, the work presents a stark contrast between natural and manmade materials.

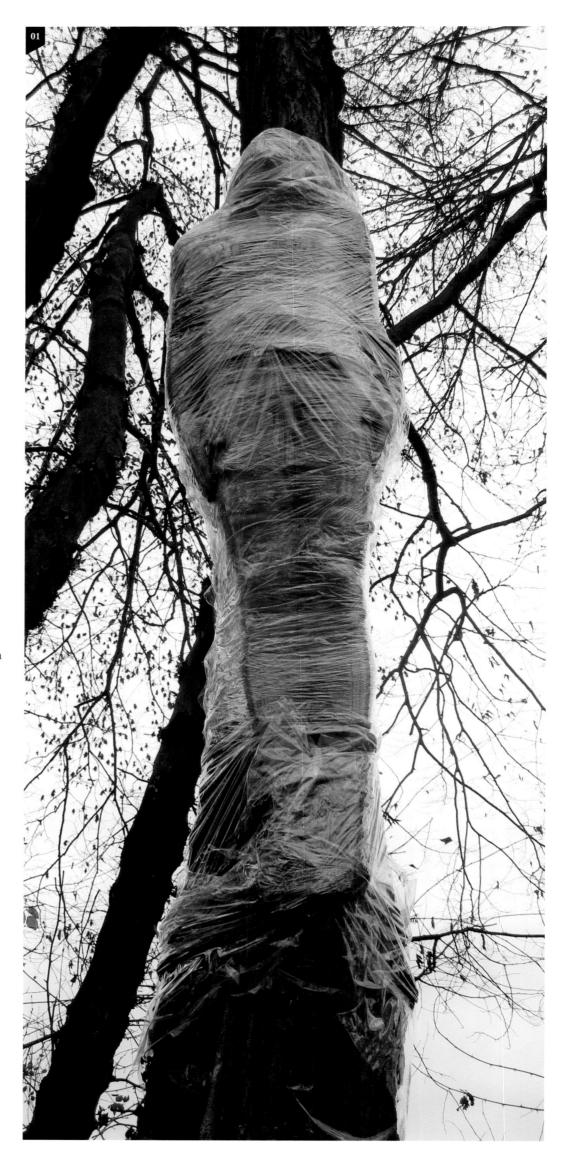

01, 02 *Packed Food for Vulture$* (performance), 2010.

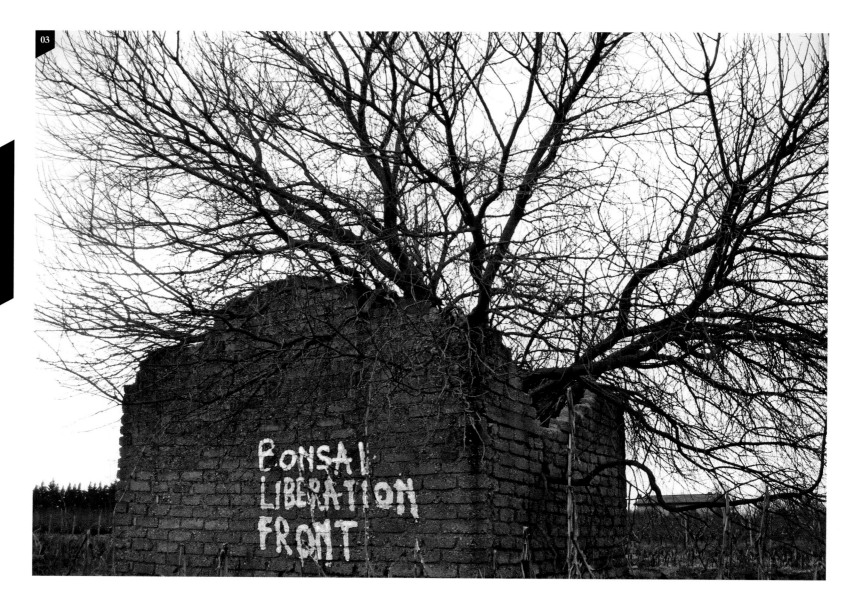

03

03 *Bonsai Liberation Front*, paint on wall. **04** *I Trust in*
Swedish Design, paint on cardboard.

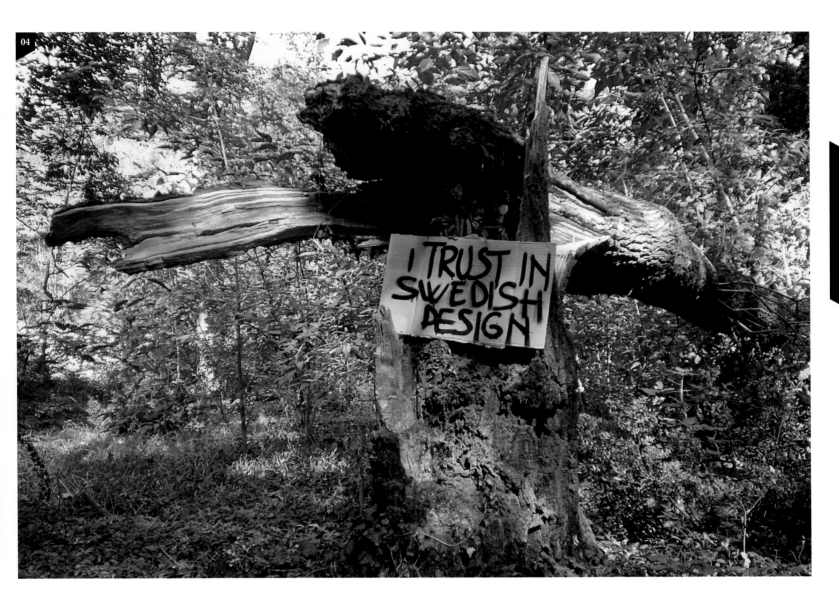

Viewers take a sharp intake of breath at the sight of the trapped figure denied oxygen and are relieved when he emerges as if reborn.

The title of the performance came from a story by Elfo's friend Nihil, loosely based on the Greek myth of Prometheus. The performance touches on themes such as the creation of mankind and our place in nature, but the artist prefers to keep the possible interpretations open. For him it is important that all his work retains a sense of irony because he wants people to 'think and smile, or not smile after thinking'.

Ron
van der Ende

Dutch artist Ron van der Ende has a very down-to-earth approach to art. His work draws on everyday life and popular culture. However, while his subjects are seemingly mundane, his treatment of them is anything but. One of his recurring subjects is the car, a ubiquitous icon of the modern age, which he reinterprets in the form of ingenious bas-relief sculptures constructed from found wood. In his own words: 'Cars evoke our individuality but at the same time they are the symbol of environmental catastrophe.' His references are often photographs of scrap vintage automobiles, which he finds in real life or online. Attracted to the shapes and colours of rusting vehicles, he evokes their natural sculptural corrosion in recycled wood, a material that has its own imperfections and process of decay.

Van der Ende's early sculptures incorporated a wide variety of materials, ranging from wood to steel to plastic. Realized in three dimensions, his pieces were created to look as realistic as possible. As a result, viewers often assumed that all the parts were shop-bought rather than handmade. In response to this, he chose to restrict himself to recycled wood, a material that was 'imperfect and bearing the markings of an earlier life', giving him the chance to 'safely exercise my perfectionism within this strict visual boundary'. His wooden sculptures initially took the form of ships and submarines, before he turned his attention to cars. But after spending two months trying to render an Opel Kadett in wood, he remained deeply frustrated by the results.

Then he had his eureka moment: why not use a foreshortened perspective? This would take less time, make better use of his skills and produce a greater visual impact. 'It was a very exciting time,' he says. 'I worked feverishly and could hardly sleep. It felt (and still feels) like I had discovered a whole new continent to explore.' Using an overhead projector, some sketches and photographic references, he constructed his first photorealistic bas-relief car in three weeks. It was relatively crude compared to his previous and subsequent work, but the effect of the perspective distortion was dizzying.

01, 02 The artist's studio. **03** *727*, bas-relief in reclaimed timber, 2008. **04** *Axonometric Array*, bas-relief in reclaimed timber, 2008.

Overleaf **05** *Ørnen (De Adelaar/The Eagle)*, bas-relief in reclaimed timber, 2007. **06** *Grytviken (Whaler's Lodge)*, bas-relief in reclaimed timber, 2007. **07, 08** The artist's studio. **09** The artist at work.

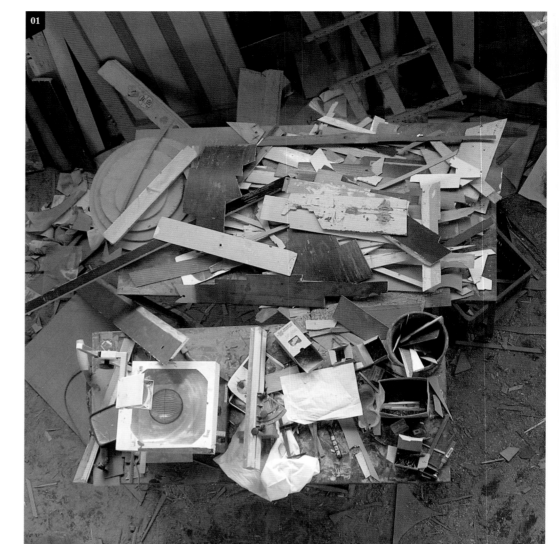

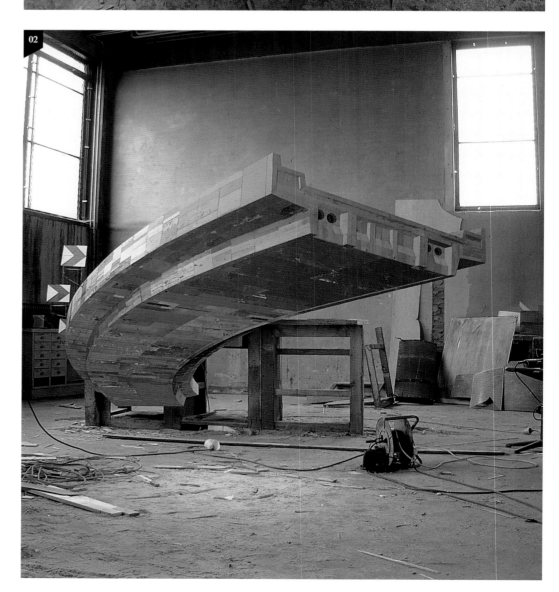

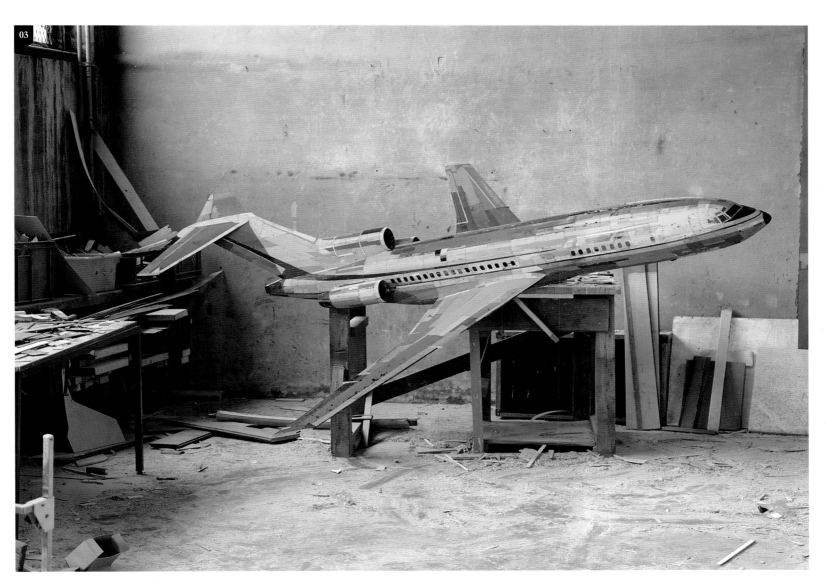

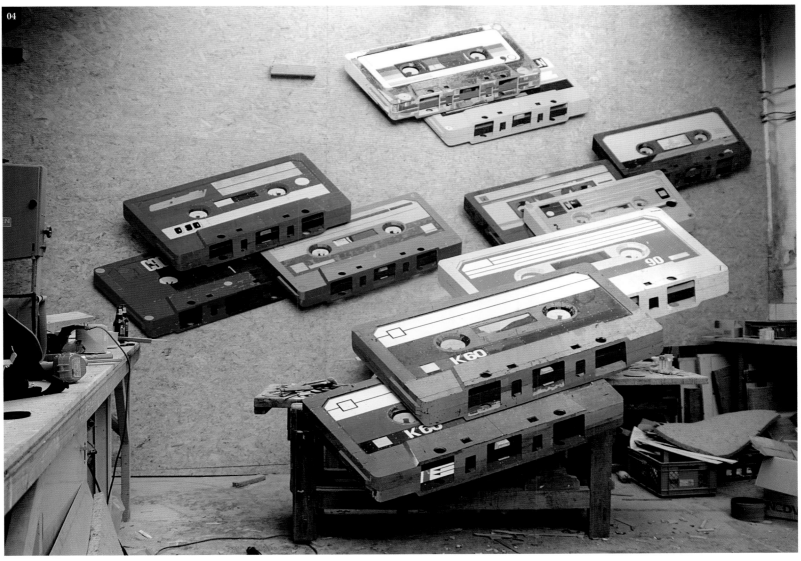

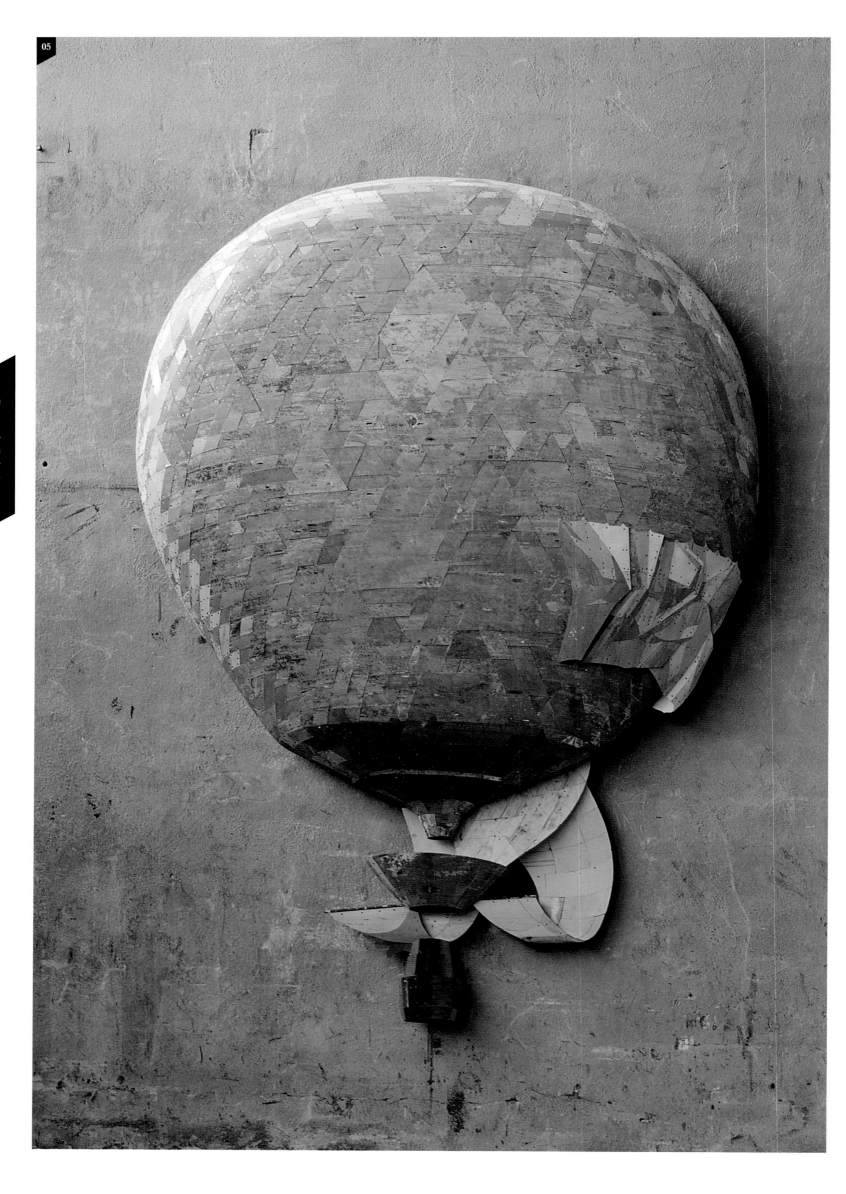

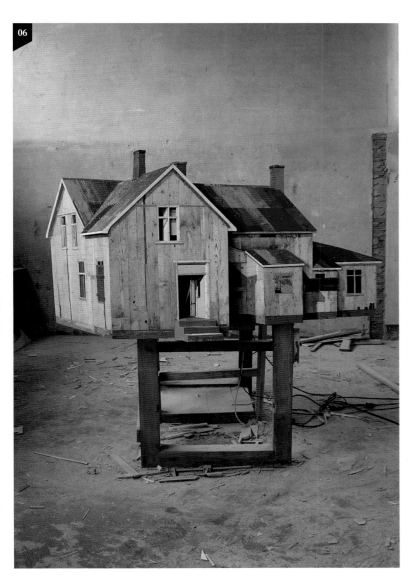

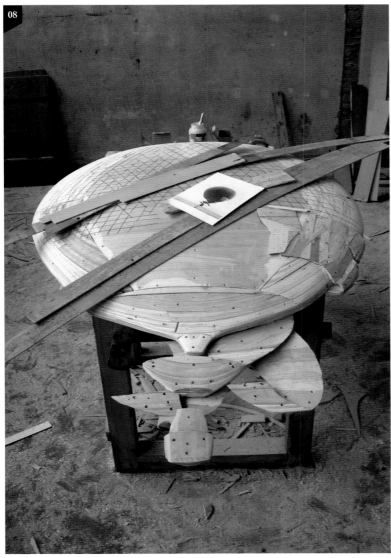

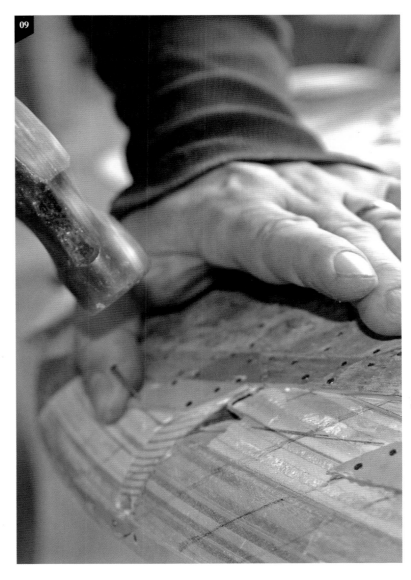

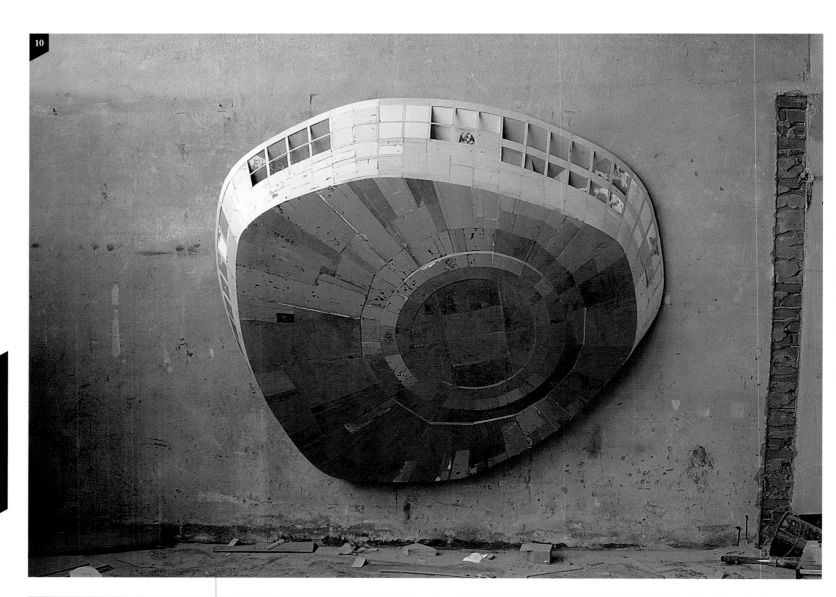

10 *Euromast*, bas-relief in reclaimed timber, 2005.
11, 12 The artist's studio. **13** Reference material.
14 The artist's studio.

Today he continues to perfect his craft, experimenting with scale and perspective in each piece. 'The combination of size and perspective provides an inherent vantage point. This might imply that the viewer is very big or very small, close or far away, or flying high up in the air. In the first bas-reliefs I did, I tried to maximize the 3D effect of these objects by choosing a perspective that would place its vantage point in a very normal way. Later I found that I could play around with this to great effect.' Van der Ende's materials often derive from old doors, which he strips down to produce 3 mm layers that are applied like a mosaic. He does not repaint the doors but takes advantage of existing colours on the found wood.

Van der Ende has since branched out from the manmade to include natural subjects, while his use of colour is more painterly. He is an artist who clearly loves his process and materials. The choice of recycled materials, he says, gives unique qualities to his work. 'It is almost impossible to fade between colours or tones,' he explains. 'One could not apply colour to, say, a cylinder or cone shape. I am at the mercy of the material I find; it becomes a collaborative effort. It is very rewarding when the object starts to come alive on its own. It would be much harder to get this kind of input from manufactured materials made to be standard, neutral and characterless.'

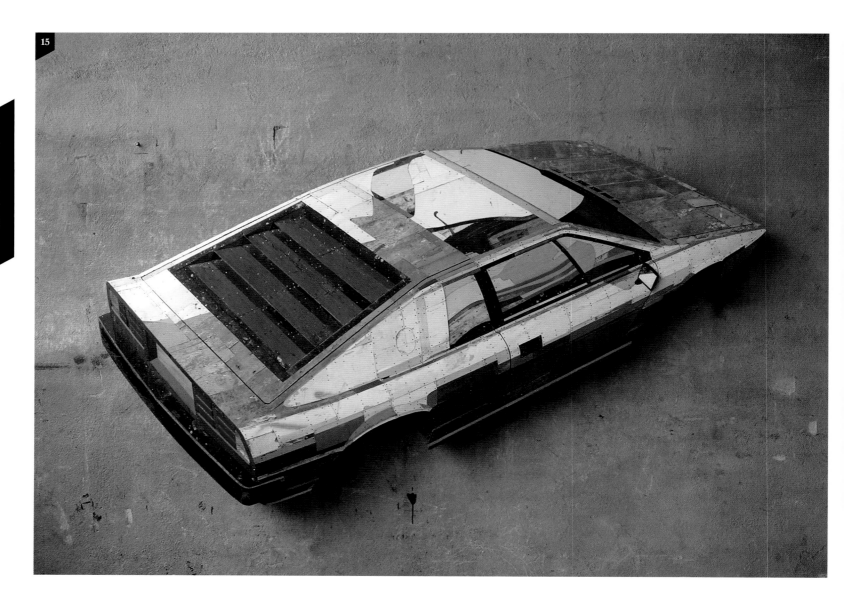

15 *Silver Machine (Lotus Turbo Esprit 1983)*, bas-relief in
reclaimed timber, 2007. **16** *Still Life*, bas-relief in reclaimed
timber, 2010.

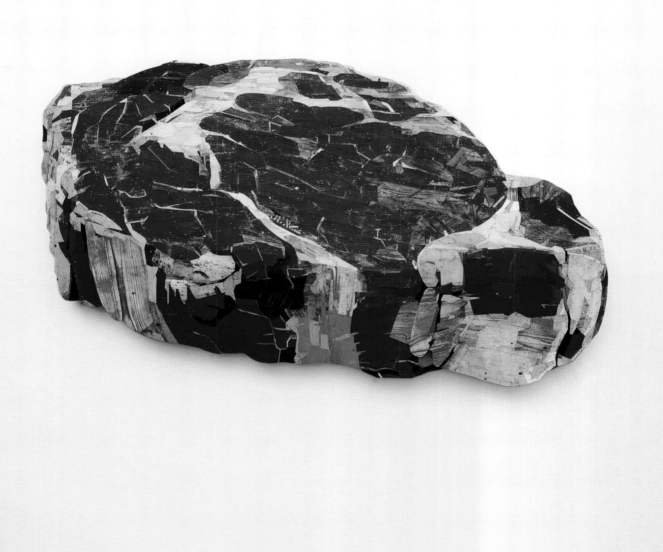

Faile

Inspired by weathered textures, layers of torn posters and the process of decay encountered on the streets, Brooklyn-based art duo Faile take a deconstructive and textural approach to their art. Patrick Miller and Patrick McNeil first started to develop their unmistakable visual vocabulary as street art collaborators in the late 1990s, mixing vintage graphics, typography and word play in enigmatic silk-screen posters and stencils of collaged images. By installing the work on city walls, they assimilated other graphic language from posters, tags, signage and the chaotic nature of the streets. In recent years, as their distinctive visual language has flourished, they have also sought to explore more tactile materials such as wood in the creation of sculptural works and installations.

Applying their assemblage aesthetic to three-dimensional work has been a gradual process. For a number of years the artists had been experimenting with screen-printing on wood, often on found boxes and later on wooden pallets. Then, in 2008, Faile installed their first *Prayer Wheel* on the streets of Brooklyn to an unsuspecting public. Hand-carved from merbau wood and mounted on a steel base, the wheel was designed to spin and featured hand-painted designs from the Faile lexicon. This and subsequent *Prayer Wheels* were built to withstand interaction from passers-by. As sculptural objects, the *Prayer Wheels* were an elegant way to bring Faile's cryptic texts and intricate designs into relief and contemplative movement.

Successive projects have seen Faile working increasingly with three-dimensional objects, sculptures and installations. In 2010 they were invited to create an ambitious work entitled *Temple* at the Portugal Arte festival. The piece comprised a full-scale church structure in 15th-century style, using authentic materials such as stone, ironwork, tiles and moulded sculptures. While the ruined temple looked authentic installed at Praça dos Restauradores in Lisbon alongside genuine architecture, on closer inspection all its features were furnished entirely with Faile motifs and iconography. In their next exhibition 'Deluxx Fluxx' (2010), held in London and later in New York, they surprised audiences once more by presenting their work in the form of arcade games. Fully playable with their characteristic graphics and branded coinage, the arcade games digitized their visual world, creating an

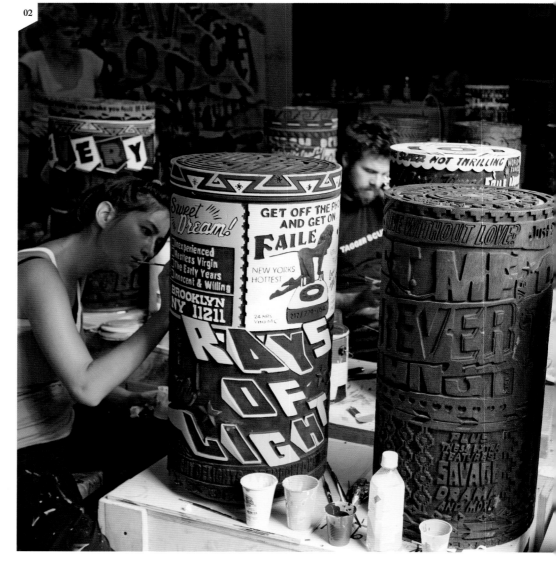

01 *Block Paintings* (work in progress), 2010. 02 *Prayer Wheels* (work in progress), 2008. 03 The artists' studio, 2010. 04 *Prayer Wheels* (work in progress), acrylic paint on hand-carved merbau wood, mounted on steel base, 2008.

Overleaf 05 *Block Paintings* (detail), paint and silk screen on wood.

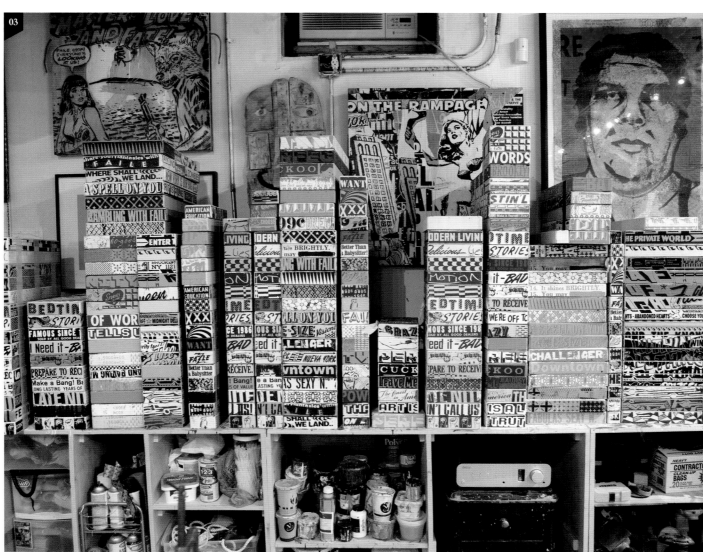

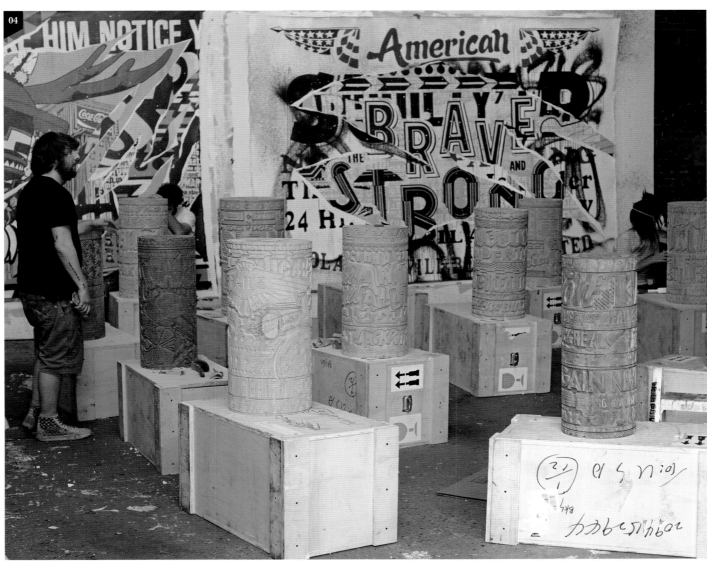

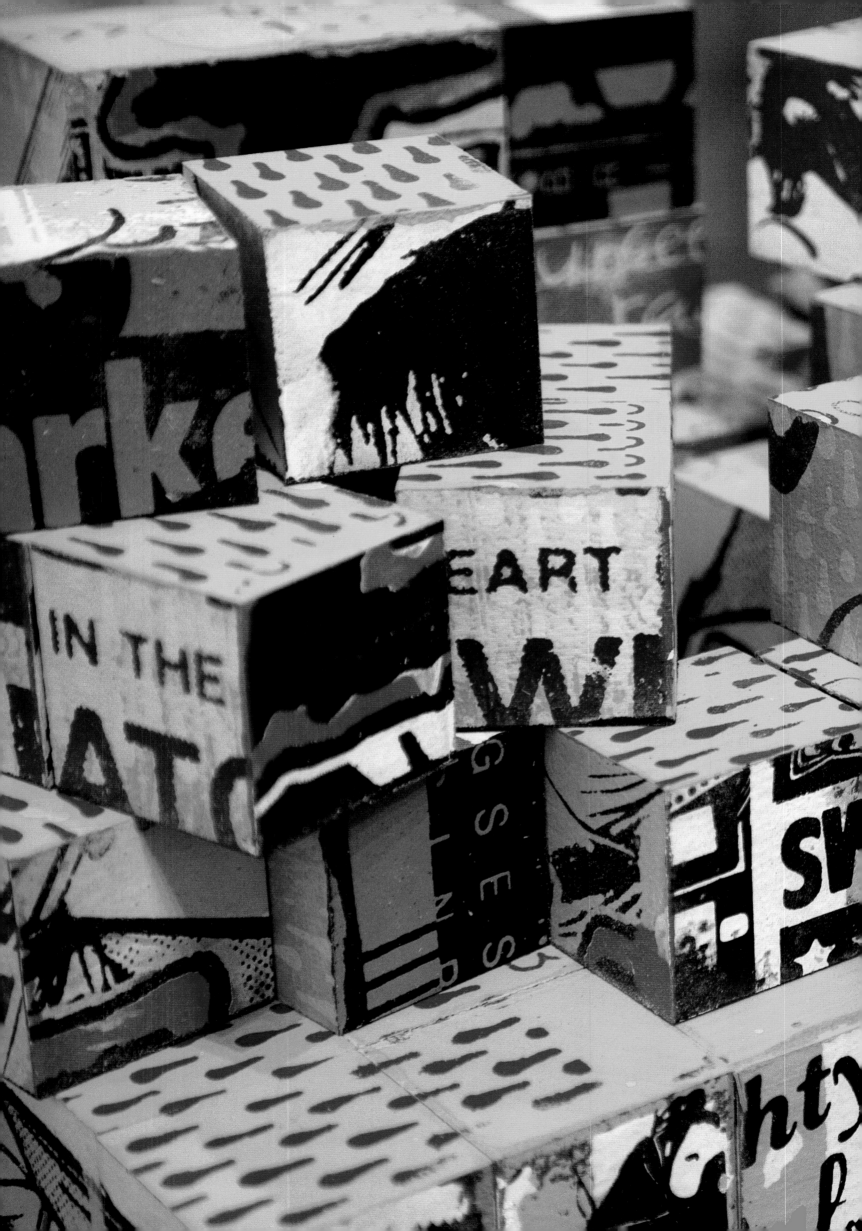

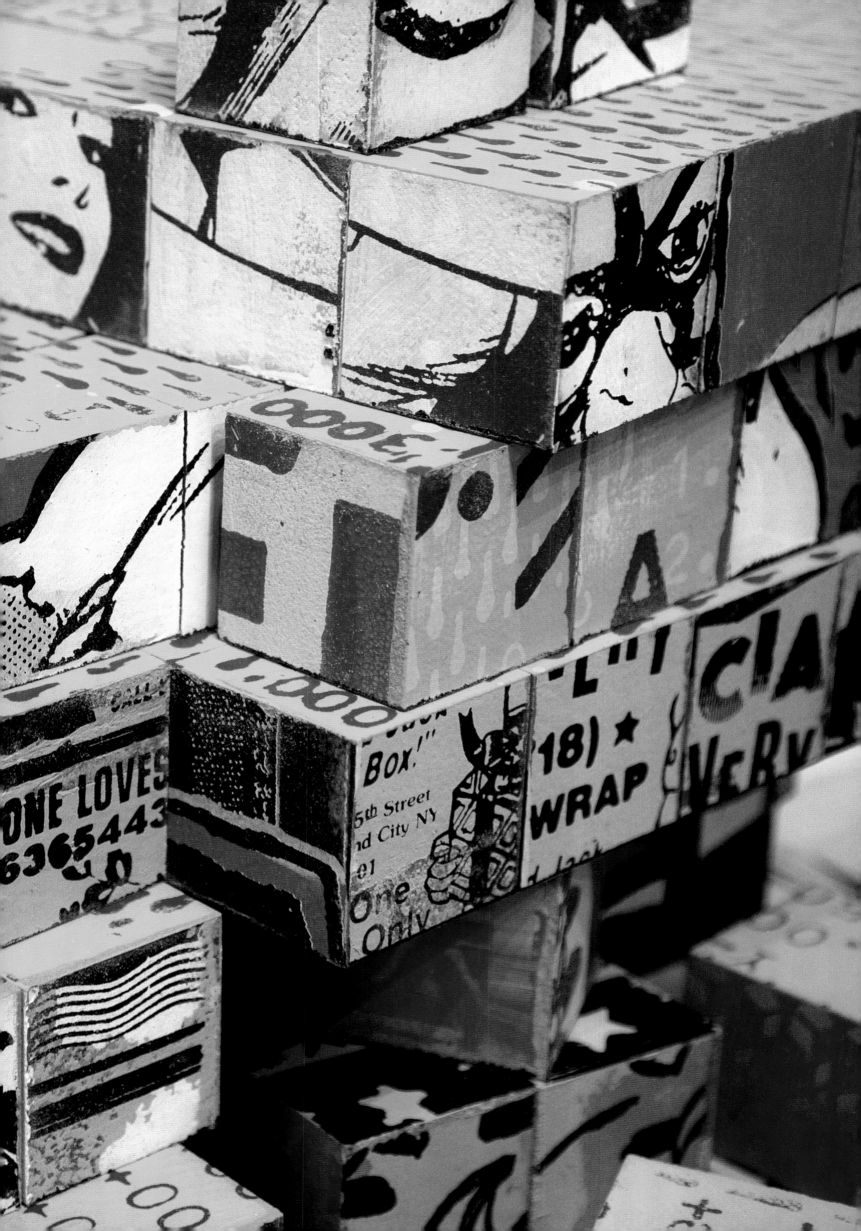

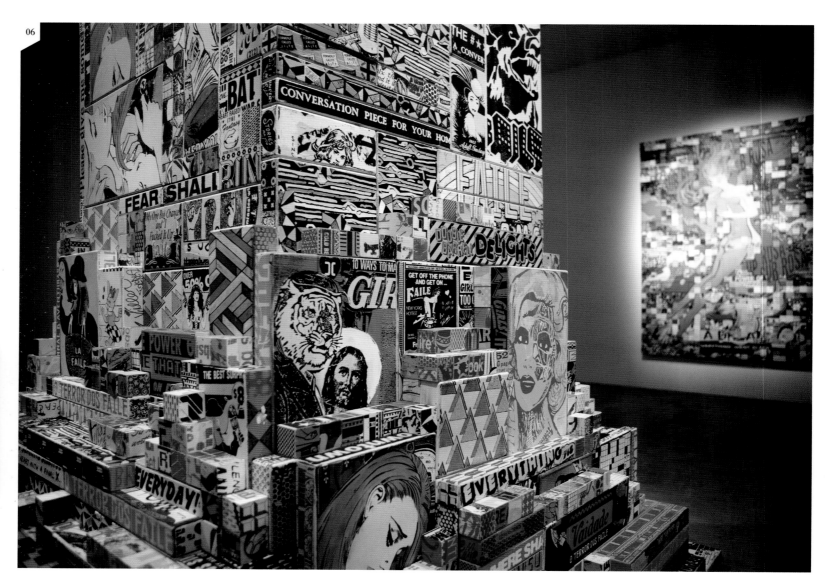

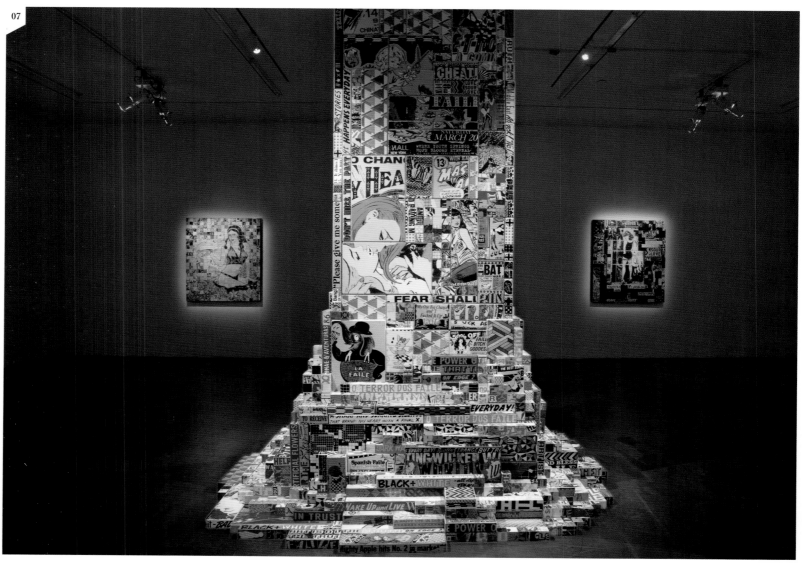

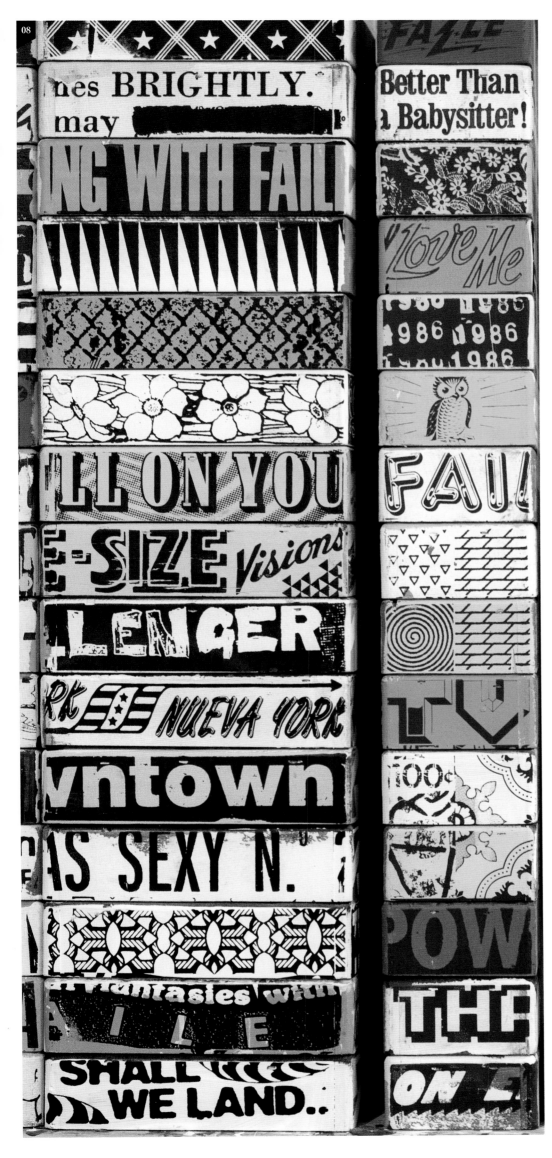

08

06, 07 *Faile Tower*, paint and silk screen on wood, 'Bedtime Stories' exhibition, Perry Rubenstein Gallery, New York, USA, 2010. 08 *Block Paintings* (detail), paint and silk screen on wood.

interactive experience. From Renaissance-style architecture to 1980s retro-gaming, the duo have shown an appetite for challenging and meticulously detailed projects as they explore new possibilities for their work.

In late 2010, for their 'Bedtime Stories' exhibition at Perry Rubenstein Gallery in New York, the artists returned to the medium of wood. Having previously experimented with small puzzle boxes, they conceived the idea of working on numerous wooden blocks that could be pieced together to create large-scale works. Traditional American quiltmaking was a clear influence in their production of graphic quilts with wooden blocks.

These *Block Paintings* required painstaking work. The blocks were laid together and screen-printed with a complete image, so that one side of each block formed part of the whole. The blocks were then rotated and the process repeated until all planes were covered with pieces of a visual puzzle. This allowed Faile to get back to their original cut-and-paste ethos and stay loose in the creation of images. Also true to their aesthetic were the possibilities for weathering and creating different textural surfaces through washing, staining, sanding and painting. As the number of blocks of various sizes increased, so too did the possible combinations for regrouping them into new compositions. The results are multi-planed, deconstructed objects with a nostalgic handcrafted quality, which collectively resemble a graphic playground.

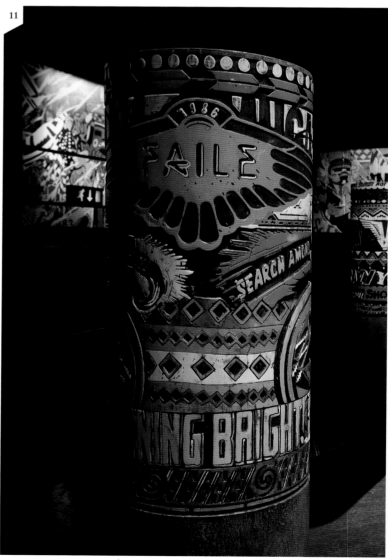

09, 10 *Prayer Wheels*, acrylic paint on hand-carved merbau wood, mounted on steel base, 2008. **11** *Prayer Wheel*, acrylic paint on hand-carved merbau wood, mounted on steel base, 'Lost in Glimmering Shadows' exhibition, Lazarides, London, UK, 2008. **12** (*opposite*) *Prayer Wheel*, acrylic paint on hand-carved merbau wood, mounted on steel base, 2008.

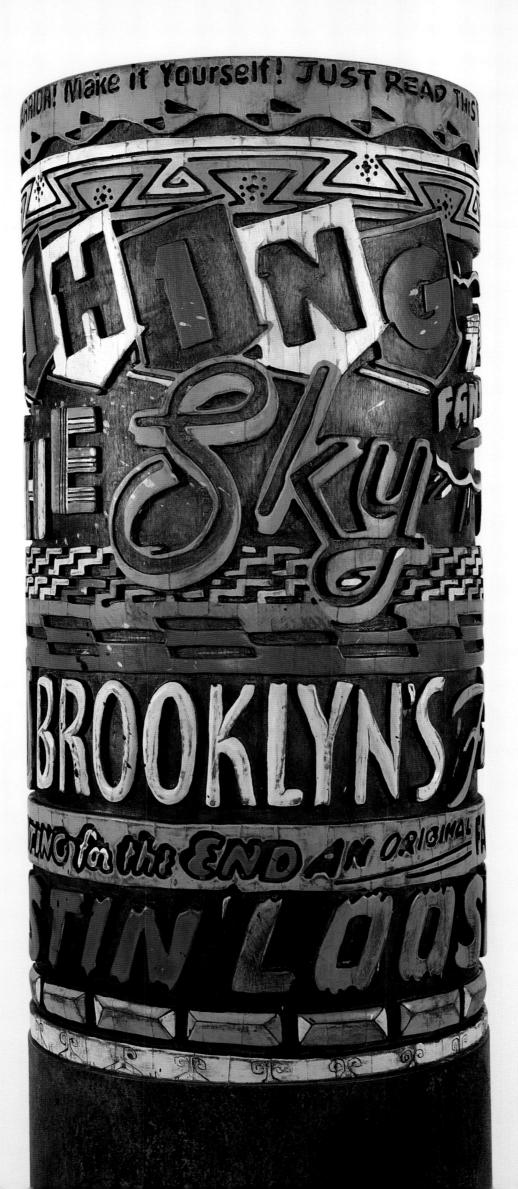

Rosemarie Fiore

American artist Rosemarie Fiore's work is fascinating on many levels. Her original and inventive techniques produce unique pieces that combine both the force of her own artistic imagination and the force of elements beyond her control. The results are stunningly beautiful, bearing a lyricism only possible when full authority over the work is relinquished and the processes and materials are allowed to express themselves freely.

Fiore graduated with a Master of Fine Arts from the School of the Art Institute of Chicago and a BA from the University of Virginia, Charlottesville. She currently lives and works in New York. Her early work centred on kinetic sculpture, which led her 'to remove the machine's physical presence in the finished work altogether and focus on its actions'. She spent many days driving around in her car thinking about how to develop her new direction until inspiration came to her from the car itself. She took rubbings from the car engine, created works using the tyre treads, and employed the rear windscreen wiper as her brush by filling its water bottle with various fluids and activating it against the paper-covered car window.

Further experimentation brought her to one of the techniques for which she is most famed: using live fireworks to create intensely vibrant and colourful work. She explains: 'The concept for my *Firework Drawings* came to me on 4 July 2002. I was in residence in Roswell, New Mexico, and had bought an assortment of fireworks. A lit blue smoke bomb had slipped out of my hand and rolled on the cement floor outside my studio. As soon as I saw the dotted blue line I grabbed some large sheets of paper from my studio and began igniting the fireworks on the paper.' After a period of experimentation repeating this 'accident', she moved on to containing the fireworks in cardboard tubes as they blew, and then to attaching them to long poles and various vessels such as buckets and cans. 'In addition to the inconsistent discharging, the dragging movement is bumpy, uneven and difficult to direct,' she reports. 'I like it because it is very awkward. It forces me to rely on my intuition almost entirely. I control my mark-making as much as I can, but keep in mind that it is a balance between chaos and control and that too much control suffocates the work.'

Another project embodying Fiore's unique approach to her materials is the *Scrambler Drawings*. Rigging up cans of paint with air compressors and attaching them under the seats of a Scrambler fairground

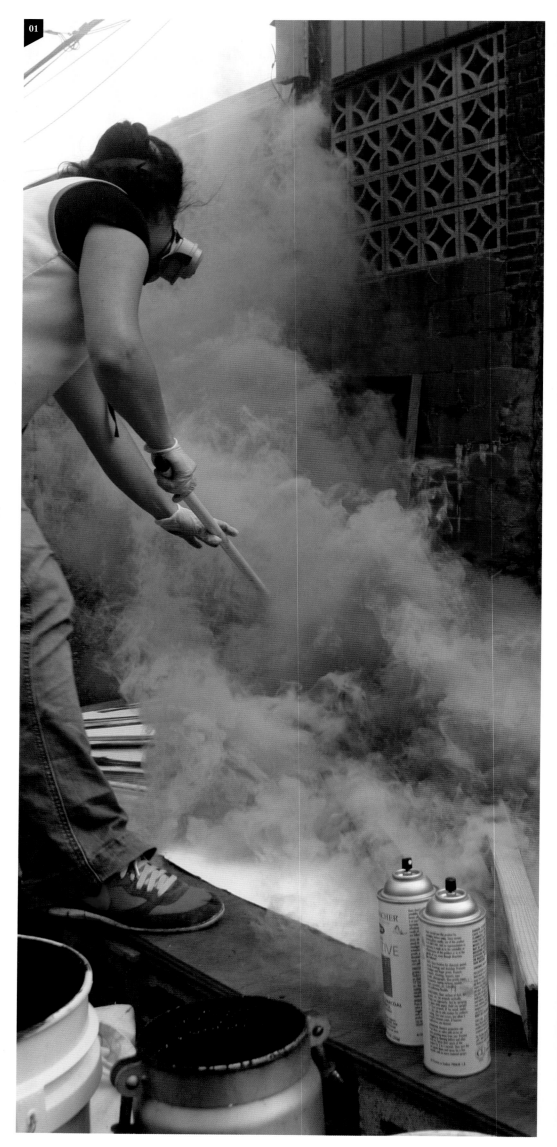

01, 02, 03 The artist at work on the *Firework Drawings* series, 2009.

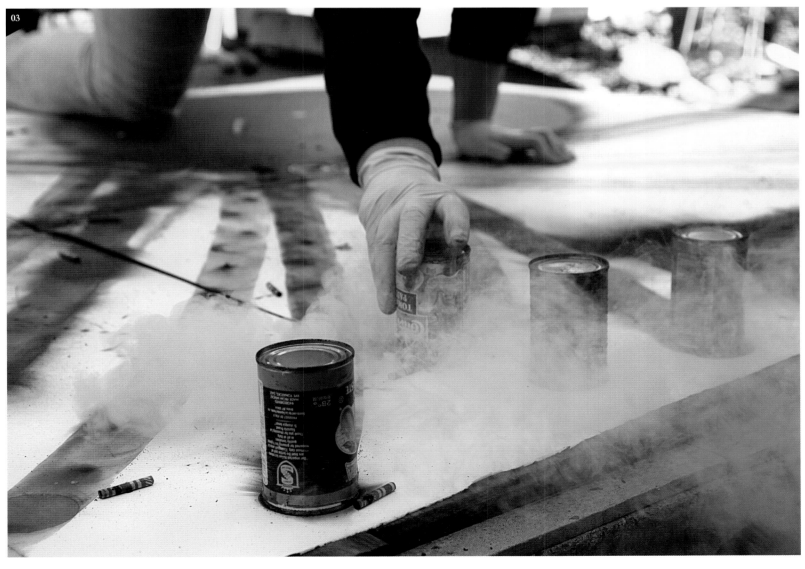

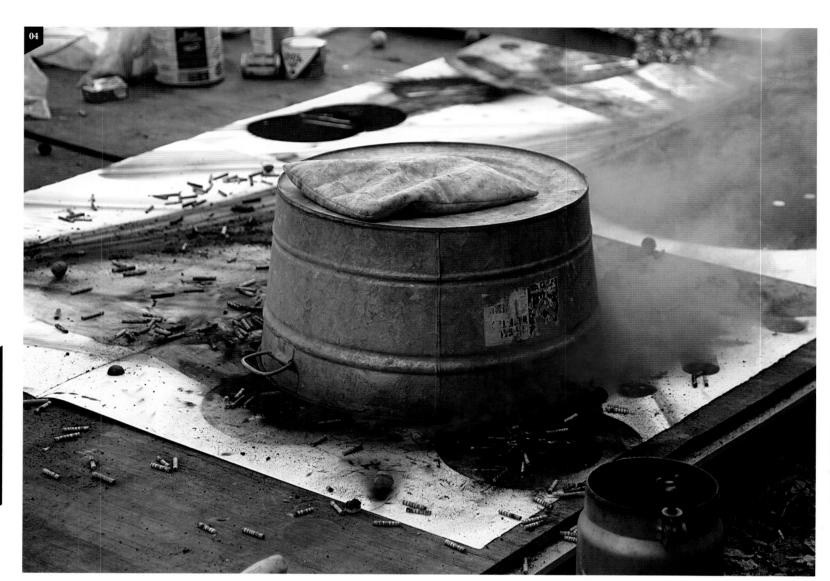

06

07

ride, Fiore generates patterns so intricate that, ironically, they look meticulously planned. The idea came to her while she was on a ride, inspiring her to study the machine's spirograph-like motion and translate it into visual form. Fiore shares the credit for her art with the objects she chooses to work with, describing her method as a 'conversation' and 'collaboration of sorts' between herself and her tools and materials. It is her openness to new ideas that allows her to see the potential in these objects, while her energy, drive and passion ensure that the conversation never stales but continues to develop and lead her to new places. As she says, 'There is always something new to explore. One idea brings me to another. It is very exciting and sometimes overwhelming. I have to slow myself down – that's the hardest part.'

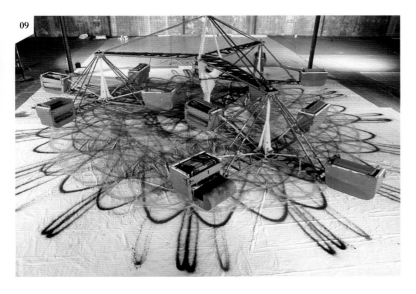

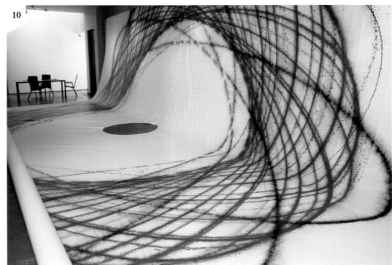

08 *Firework Drawing #25*, lit firework residue on paper, 2009. **09** *Good-Time Mix Machine*, 1964 Eli Bridge Scrambler ride, generator, compressor, bucket, acrylic paint on vinyl, and video camera, *Scrambler Drawings* series, Grand Arts, Kansas City, USA, 2004. **10** *Good-Time Mix Machine,* acrylic paint on vinyl, and video projections, *Scrambler Drawings* series, Queens Museum of Art, New York, USA, 2004. **11** *Good-Time Mix Machine*, Grand Arts, Kansas City, USA, 2004. **12** *Good-Time Mix Machine*, Queens Museum of Art, New York, USA, 2004.

AJ Fosik

AJ Fosik likens his work to 'those balsa wood assemble-yourself toys from a museum gift shop taken to an insane level'. Each work is meticulously constructed out of hundreds of individually shaped pieces of plywood, which he stains, varnishes and paints to create the multicoloured facets of the finished product. With their vibrant colours and evocative poses, the magnificent creatures and figures that emerge through this painstaking process have as much character and vitality as their real-life inspirations.

Fosik grew up in Detroit, where he was involved in the graffiti scene from a young age. He moved to New York to study illustration and it was there that he first began to experiment with three-dimensional pieces. 'We were making these intricate wooden constructions,' he explains, 'part signage, part found material sculptures, and then just bolting them up wherever. It was this marriage between the sign imagery and the construction that led me to my current way of working. In a certain sense it wasn't a conscious choice initially: it grew out of having rather limited means and trying to figure out how to realize a piece with a crappy scroll saw and salvaged plywood.'

Although influenced by the mask arts of places such as Mexico and Bali, North American totems, and the myths and gods of indigenous peoples, Fosik is keen to ensure that his pieces are not so much a homage to mythical ancestry as a means to stimulate thought. His fascination lies in 'the need of and devotion to the idea of a creator and the many manifestations of that concept… It's absurd when you think how much energy the human race has spent trying to fabricate meaning for our existence. Every one of them is tragically missing the point – that existence is its own virtue. I'm just another in a long tradition of these con artists, only I'm putting it all on the table. My "gods" represent an embrace of uncertainty, doubt and the absurd. The sorts of questions I'm wrestling with now are more about the random, chaotic and arbitrary nature of existence.'

Fosik hesitates to classify his work as sculpture, believing it conjures up an image of him chiselling or carving something from a block, when in fact he works in reverse, taking many small pieces and creating one form. He says: 'I like my pieces to wear the process on their sleeve and for me that means forcing the 2D into the 3D. Even after having acquired better tools and access to better materials, it's still how I work, from basic structure to increasing complexity.'

01 Hundreds of individually shaped pieces of wood are used in the construction of each work. **02, 03** Paint and stencils in the artist's studio. **04** *Ursine Brawl*, wood, paint and nails.

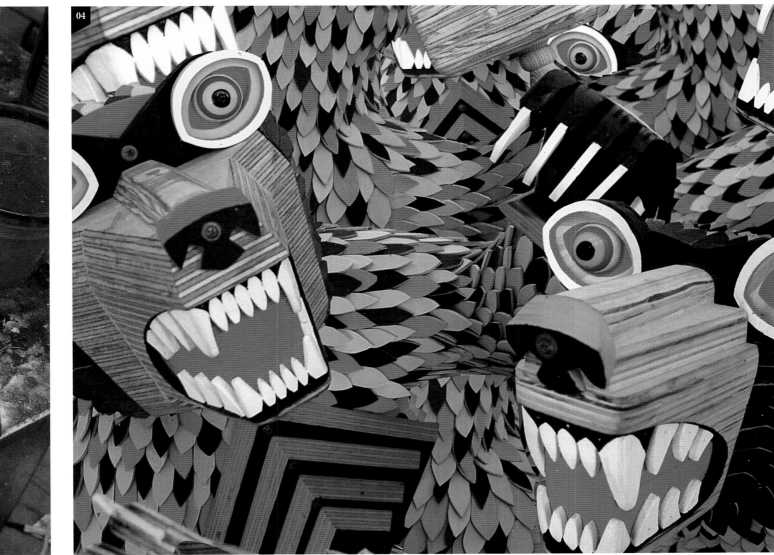

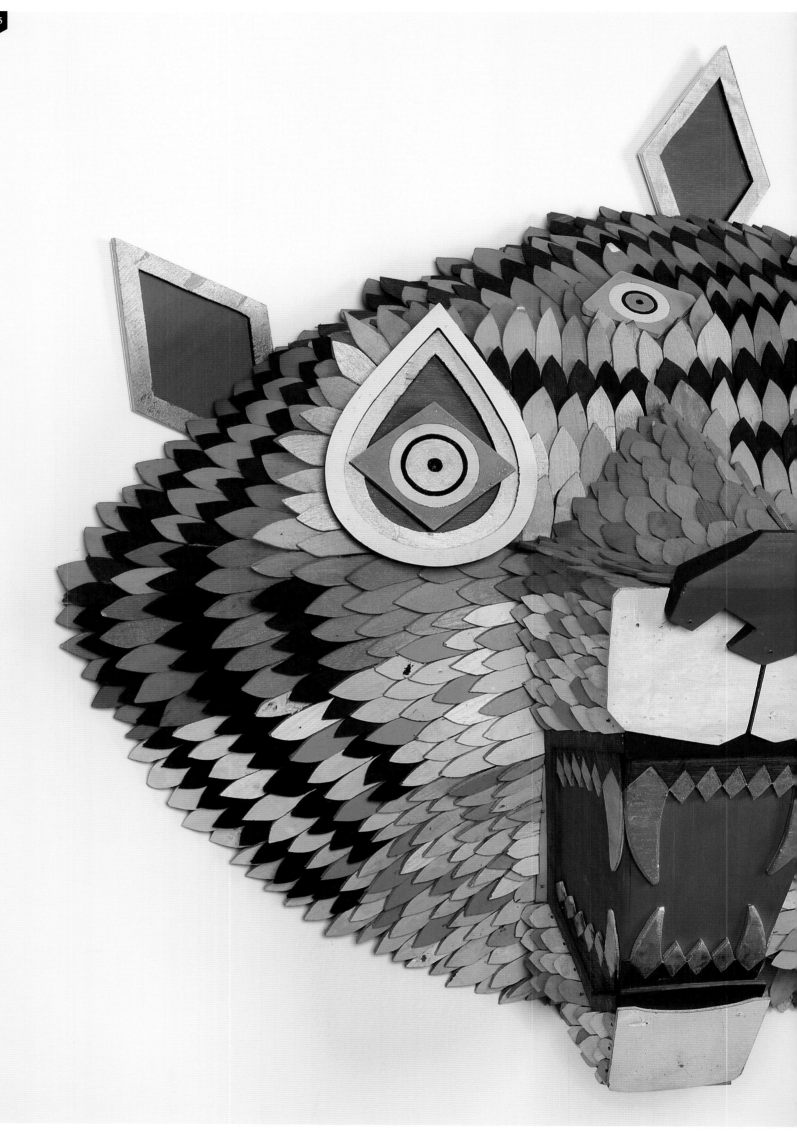

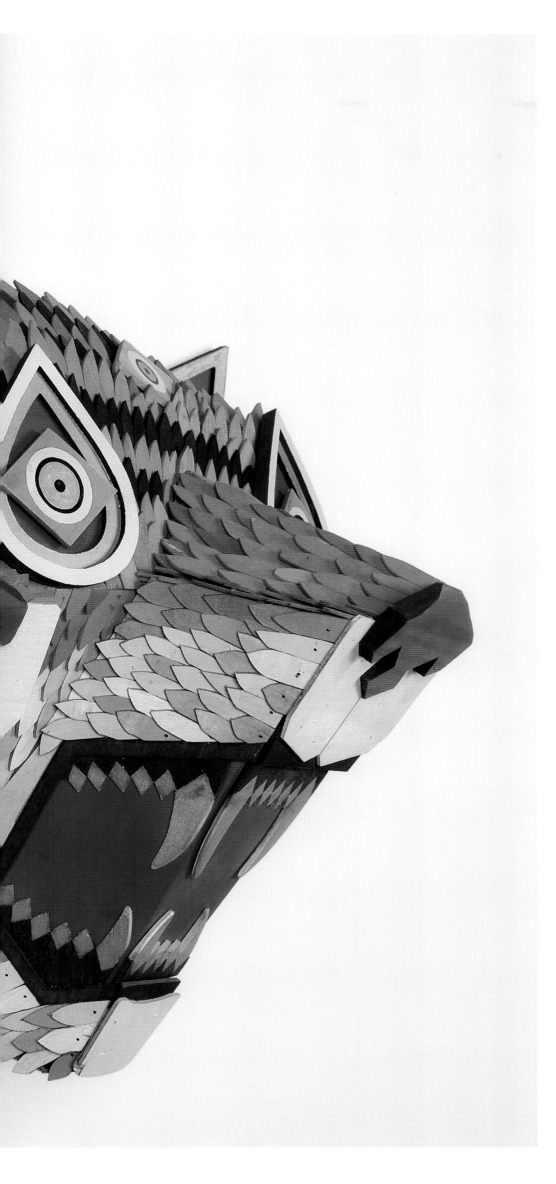

This process he describes as a 'gestation': his creatures grow from 'a wooden skeleton and framing nails, on top of which go plywood and gold screws forming muscle and sinew, another layer of wooden flesh over that, and finally I skin the beast with lauan chips'.

The physical complexity of Fosik's work is awe-inspiring and a challenge that he clearly relishes. 'Finding new ways to push myself every day is a very rewarding struggle and where I think great work comes from,' he says. 'I think all artists eventually find themselves in a position where they have boxed themselves in, in terms of the problems they have chosen to address. If you are lucky, you will eventually find your box.' And what is the price of these incredible contemporary icons? 'Five splinters per hand, more or less.'

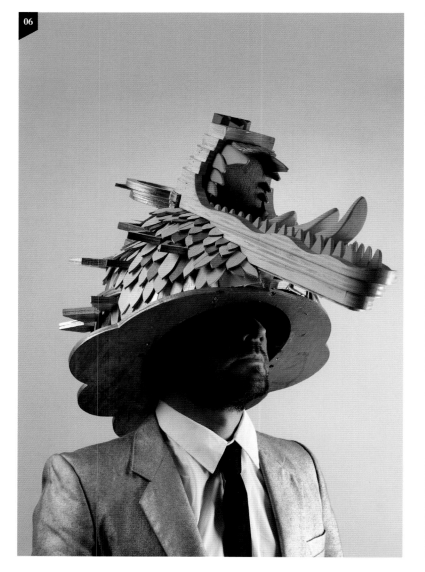

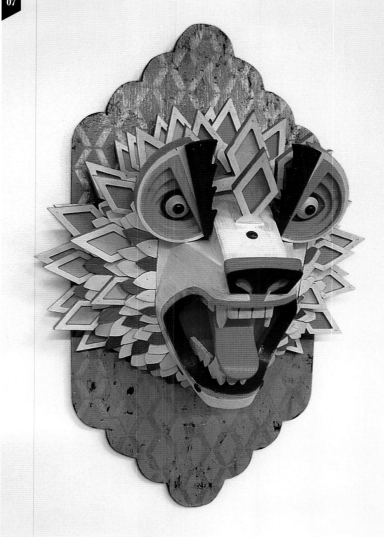

06 The artist models one of his works, 2010. **07** *One Hundred Percent Savage*, wood, paint and nails, 2009.
08 *The Third Way Out*, wood, paint and nails, 2009.

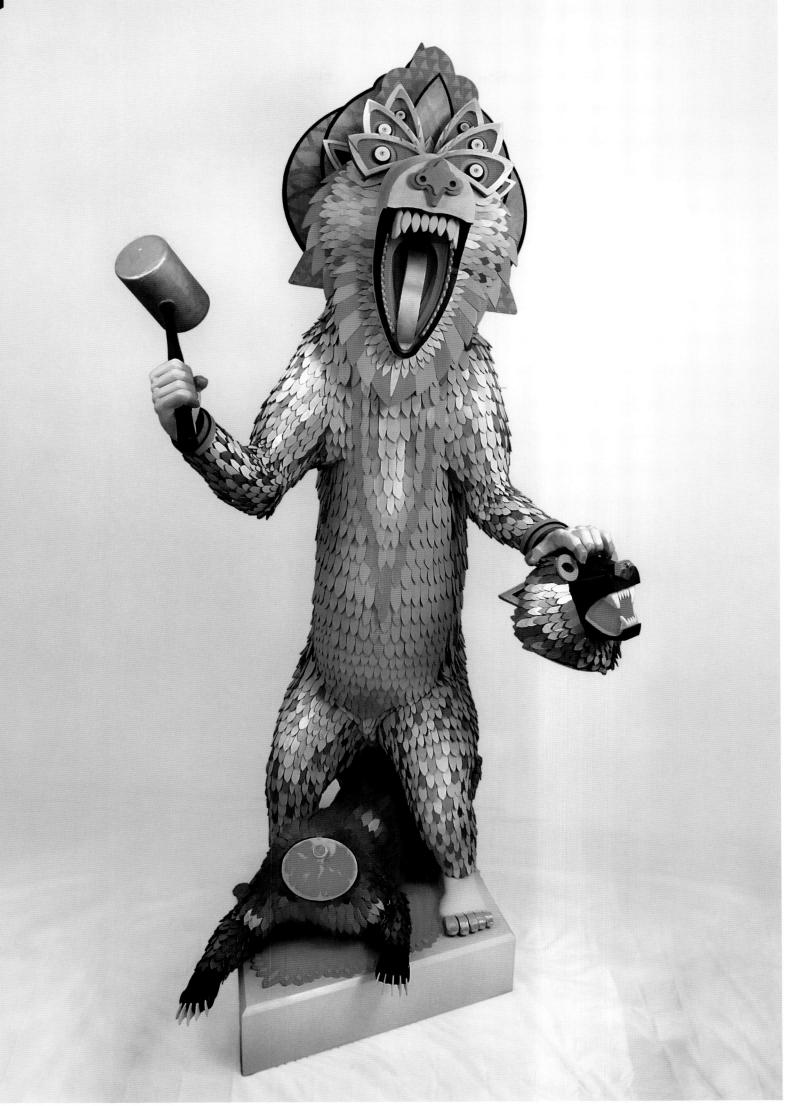

Fumakaka

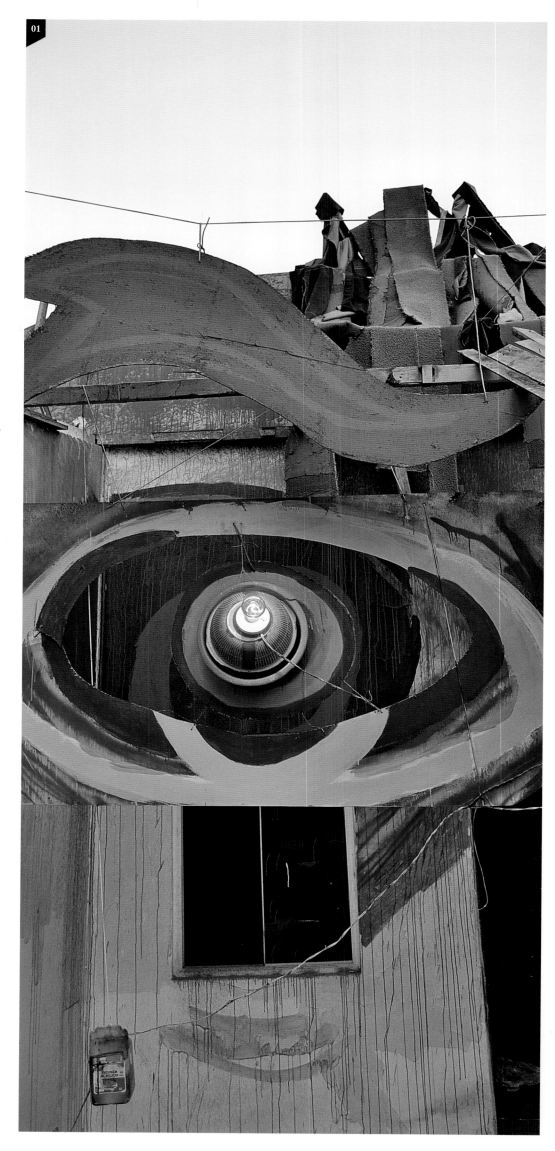

Peruvian artists' collective Fumakaka have been transforming waste materials into sculptural installations both on and off the street since 2000. Although they see themselves as a group of friends having fun, their aim is to create artworks that take over the street and interact with the public. The collective's individual members, who go by the monikers Ioke, Meki, Oso, Naf and Seimiek, have backgrounds in graphic design, architecture and anthropology, but are largely self-taught in art: 'By questioning, exploring and exchanging ideas, we develop new forms and techniques. We believe that creativity is not found within a given speciality but rather at the nexus of different disciplines.'

Based in Lima, Fumakaka initially formed to produce collaborative murals but soon found that painting was not enough for them: 'So we started experimenting with new techniques and materials, making sculptures, mechanisms, vehicles and videos, looking to develop other forms of communication that would connect us further with the people. This eventually led us to take our art back to the streets, where it all began.' The collective views an individual work as a game, where the process is more important than the end result: 'We work on things we like, which enables us to feel free to express ourselves and experiment. Each project is an opportunity to try new forms and materials, leading us to new paths and to grow as a group. Throughout this process, we mix symbols and images in an inconsistent fashion, only following our own intuition. The urgency to convey something often leaves all explanations and reflections about our work to the very end.'

Fumakaka take all their materials from derelict sites and dumps. Most are found already broken into pieces, each piece with its own history and energy, and the artists try to work with these existing characteristics. Gradually the group has expanded its practice and incorporated features such as movement, sound and lighting into its sculptures in order to encourage more interaction with the people. All their interventions are accessible to the public, whether they are on the street, in disused places, or in parks and museums, and most are interactive. The collective believes that if art is a medium of communication, then the more public and mainstream it is, the more powerful it becomes.

01, 02 *Monster*, Lima, Peru, 2011. **03** *Demolition Portal*, paint, 2008. **04** *Devil*, reclaimed materials, 2009. **05** *Presence in the House*, reclaimed materials, 2010.

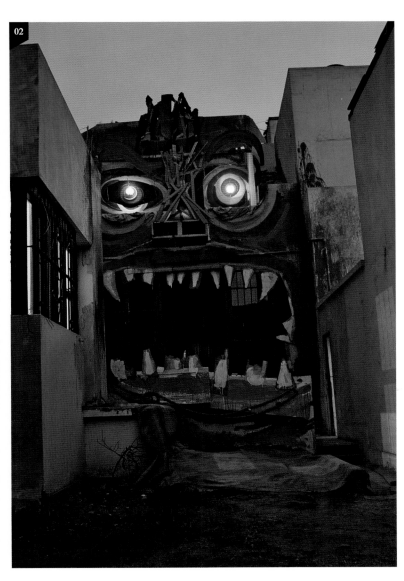

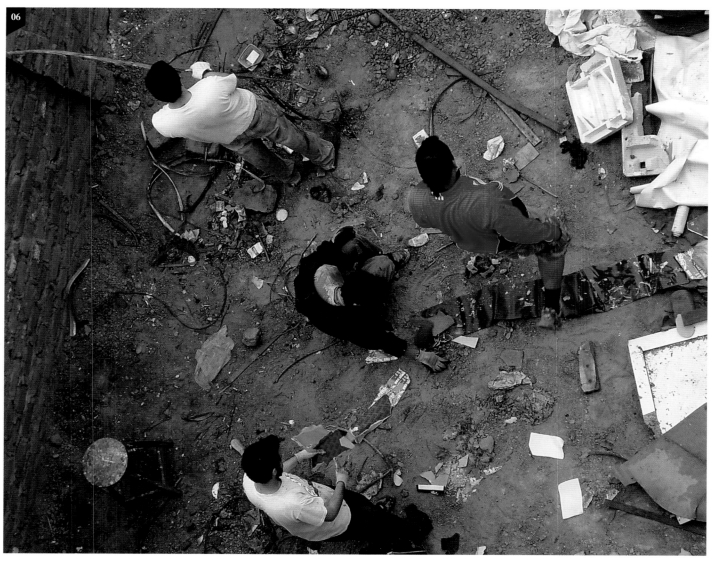

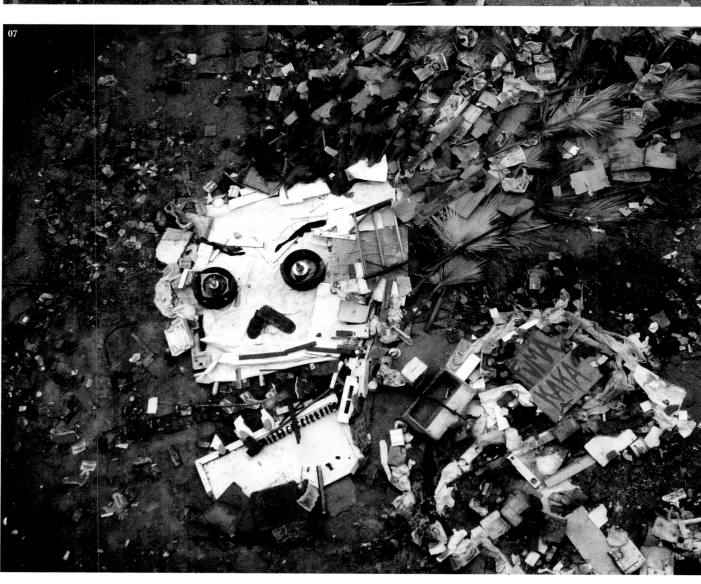

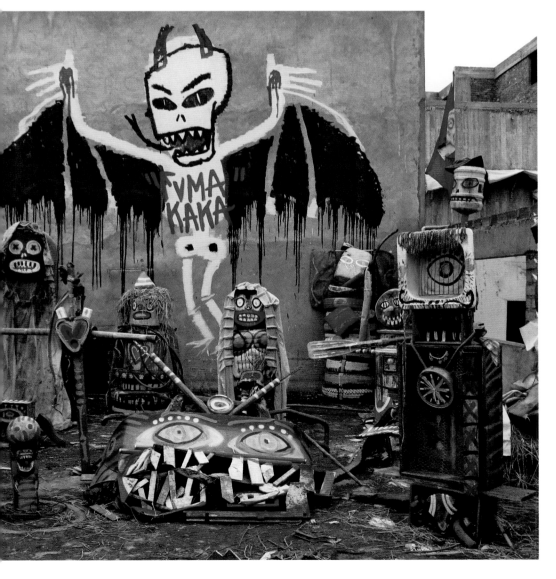

Many of Fumakaka's sculptures, installations and interactive objects take the form of demons, skulls and monsters, revealing influences such as shamanism, magic and Santería, Latin American rituals. Through these terrifying, deathly figures that are created from recycled objects and placed in destitute settings, the artists confront the viewer with the waste generated daily and the grim realities of a culture of excessive consumption: 'When one comes across these images in dumps, dilapidated buildings and piles of junk, they reveal the corpses, ghosts and skulls that are hidden behind scavenged materials. The creation of these images is an exercise in composition in which each piece comes to life to tell a horror story.'

These gruesome images are also a reflection of Lima's turbulent history, particularly between the early 1980s and early 1990s, when internal political conflicts, murder, kidnapping, blackouts and car bombs were commonplace: 'Even today, the city of Lima and the country as a whole remain wrapped in a culture of violence and chaos that is embedded in our daily lives. This is the city we live in, the city we love and the city that inspires our work.'

Sayaka Kajita Ganz

Japanese-born sculptor Sayaka Kajita Ganz creates organic forms by weaving together odd-shaped recycled plastics and other discarded objects. She admits to feeling a strange sympathy towards found materials, which can be traced to the Japanese system of beliefs and traditions known as Shinto that fascinated her as a child. In Shinto all objects and organisms have spirits, and Ganz says that many children of preschool age are taught that objects discarded before their time weep at night inside the bin. With this image in mind and her later travels to different countries, she developed a strong desire to make the people and objects around her work together in harmony.

Her enrolment on the zoology course at Indiana University Bloomington in the USA could have taken her on a very different path, had she not switched to art studies almost immediately. Although she eventually specialized in printmaking, she also learned to weld and started to make animal forms out of scrap metal. Her passion for sculpture gradually began to dominate as she realized that she could never lose herself in the work as a printmaker in the same way she could with sculpture.

While she continues to work with scrap metal, her recent works have mostly been created from used plastic materials such as kitchen utensils. By integrating these materials into the form of a living creature that is presented mid-motion, she hopes that each object will transcend its origins. Although the elements in her sculptures appear to be free-floating, they are built on an armature that forms the skeleton of the piece. In the case of her larger works, this structure is made from welded steel, while wire fencing that has been shaped and twisted into place is used in smaller pieces.

The sculpture is always in some way determined by its constituent parts, even if there may be infinite ways to arrange them. As she points out, 'The difference between moulding your own forms and working with pre-existing forms is that in the former the artist is acting, deciding what the materials do, and in the latter the artist is reacting to the objects, the forms they provide, and the physical limitations. I use objects that have interesting visual characteristics. Finding the materials is a major part of my process. I go to thrift stores and look for objects that "want to become animals". These objects start to take on human qualities, and I work with

01 *Japonica*, reclaimed objects (mostly white plastic), 2007.

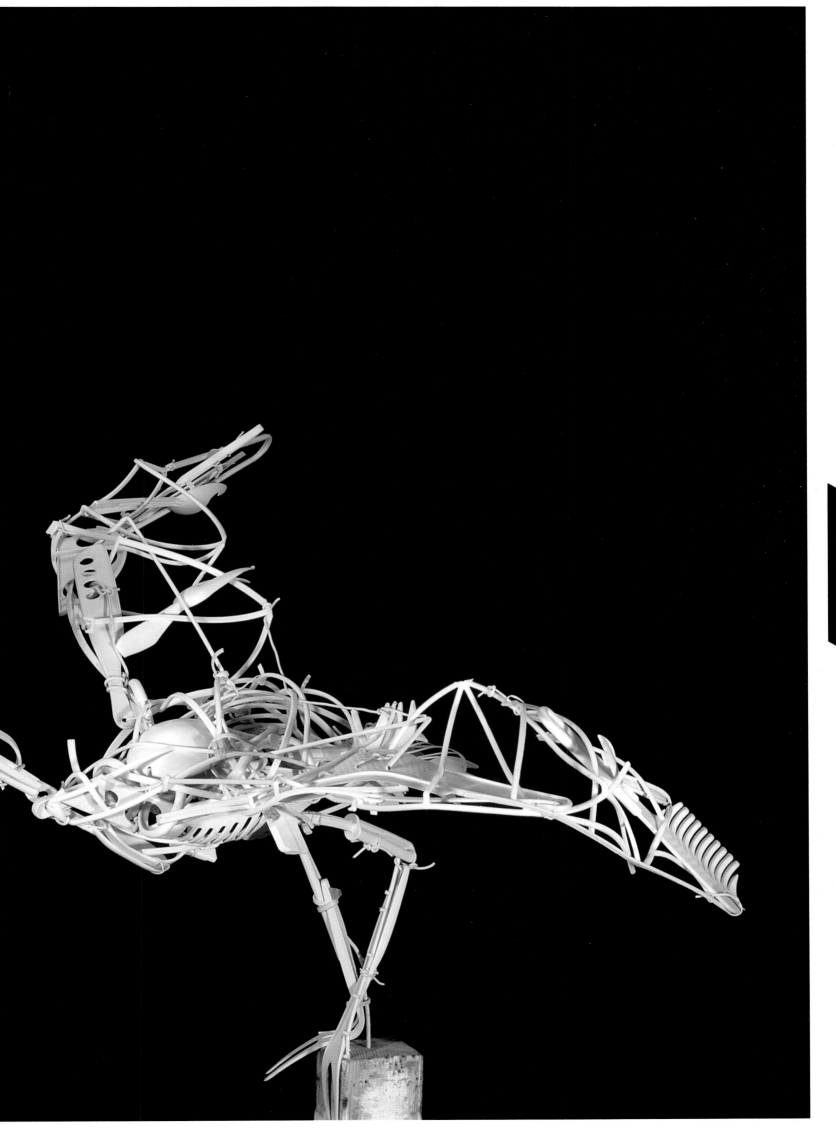

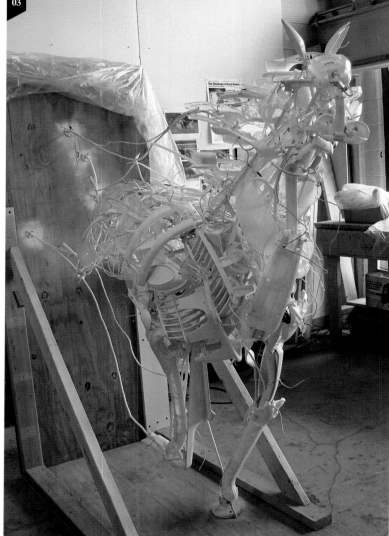

02 The artist at work. **03** *Emergence (Wind)*, reclaimed
objects (mostly white and clear plastic), 2008. **04** *Emergence*,
2008. Two-piece installation: *Night*, reclaimed objects
(mostly black and clear plastic); *Wind*, reclaimed objects
(mostly white and clear plastic).

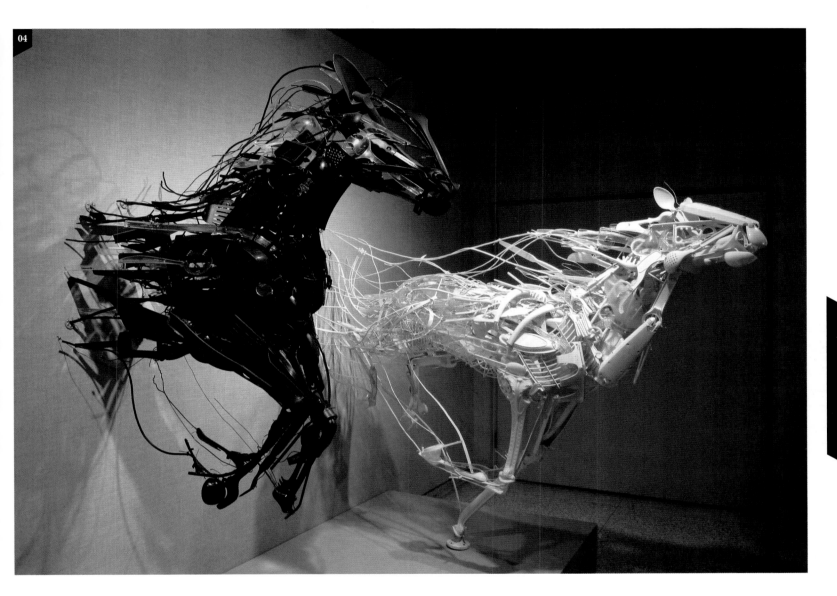

them as if I am working with collaborators.' Working on large-scale pieces such as the horse sculptures (*Emergence*, 2008) changed her approach to the individual parts. As she explains, 'I was less likely to find a single plastic object that looks like a horse's whole tail, for instance. I was also becoming more interested in portraying the motion instead of the physical form of the body of an animal, so the objects became more like indicators for the direction of motion, long brushstrokes that create a sense of speed.'

Through building these sculptures, Ganz tries to understand the human situations and relationships that surround her. She likes to think of the objects she uses as having human qualities. They all come in different shapes and sizes and have their own histories. 'When I incorporate them into a sculpture,' she says, 'it almost feels like trying to persuade a group of people to do something together. Some are very stiff and stubborn, others are flexible and pliable. Some areas will have very close connections between objects, and others will have larger gaps. If we can share a vision, even if the details don't become completely seamless, we can create something beautiful together.'

José Enrique Porras Gómez

Mexican artist José Enrique Porras Gómez pushes the boundaries of printmaking. While his work is experimental, it is rooted in traditional techniques and skills he has learnt through practical investigation. After completing an undergraduate degree in visual arts in Mexico City, he worked as a teaching assistant in an art history and theory class. This experience, along with a desire to develop his own visual language, inspired him to continue his studies at the Polytechnic University of Valencia in Spain.

Much of his ongoing experimentation is focused on drawing and installation art. A recent work entitled *Ola Ganando Espacio (Wave Moving Through Space)* explores both genres. Completed in 2010, it was developed during his nine months in Valencia. The title describes in part the physical and mental construction process that the project entailed. At first Gómez had the idea of constructing a small wave in the corner of his rented room. However, gradually the structure began to consume the room, taking up more and more space until, eventually, the artist's bed was the only piece of furniture that remained. 'This wave', he says, 'slowly swelled out of my brain and started to fill the physical space. I ended up surrounded by my work.'

The construction process was gradual, with the artist using wood that he had found around the city. The first stage was to build a floor for the installation to extend the surface of the wave visually and give the sense of walking on water. At first he considered carving the wood of the installation as if it were a woodcut. 'I wanted to use the wave as a 3D matrix,' he explains, 'but I realized that each board already had its own texture and a particular story, so I decided to record the project through the technique of frottage [taking a rubbing from an uneven surface]. That way, I could preserve the graphic spirit of my work.' As well as using frottage, the artist recorded the entire construction process of the wave in a series of photographs. The frottage print was intended to be a direct reference to 19th-century Japanese artist Hokusai's renowned *Great Wave* wood-block print, which is underlined by the physical structure of the completed wave installation.

Wood is a material that has always interested Gómez owing to its colours,

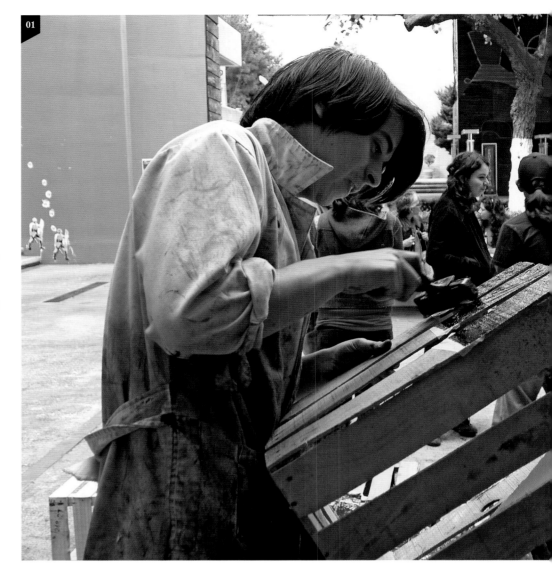

01, 02 The artist at work. **03** *Productos de exportación (Export Products)*, engraved wooden crates, 2008. **04** *Productos de exportación (Export Products)*, engraved wooden crates and woodcut print, 2008.

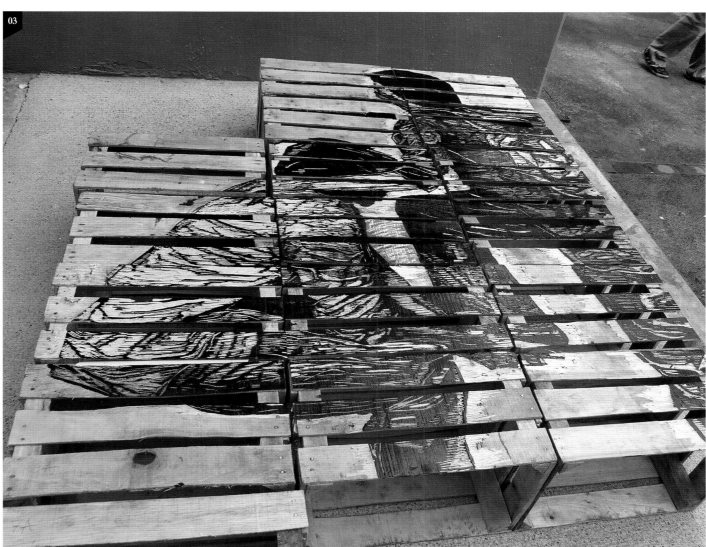

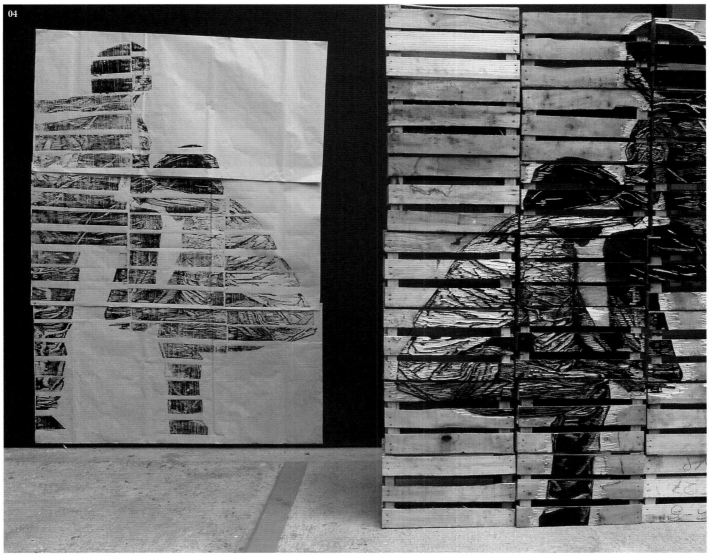

05, 06 *Ola Ganando Espacio (Wave Moving Through Space)* under construction, 2010. **07** *Ola Ganando Espacio (Wave Moving Through Space)*, wood, nails and ink, 2010. **08** *Ola Ganando Espacio (Wave Moving Through Space)*, frottage on paper, 2010.

textures and possibilities for construction. In Valencia he was surprised to see so much wood being thrown away and decided to reappropriate as much of this material as possible. One project, *Productos de exportación (Export Products)* (2008), made use of found wooden crates to address the controversial issue of migration. The crates (*guacales*) in the work are typically used to transport agricultural products such as fruit and vegetables. Gómez's idea was to carve into the crates scenes that are played out on the borders of Mexico every day: migrants crossing the border, and relatives waiting for loved ones returning home. The life-size images made a striking visual impact, particularly when displayed side by side, generating a sense of repetition that mirrored the real-life situation.

Hiroyuki Hamada

Japanese-born, US-based artist Hiroyuki Hamada creates sculptures that blend organic and industrial elements to great effect. His elegant forms are reminiscent of weather-beaten industrial objects, with beautiful smooth lines and richly textured surfaces. Although minimalist in shape and colour, they have a highly complex structure and intricate surface detail.

When his father changed jobs, Hamada relocated from Tokyo to West Virginia with the rest of his family. He was a teenager at the time and initially found it extremely challenging adapting to a completely new culture and language. However, at college he was introduced to art and was inspired by the possibilities of line, shape, tone and contrast. Slowly his practice evolved from painting to experimenting with layering, three-dimensional canvases and, eventually, sculptural objects.

Working in a studio that is surrounded by woods on Long Island, New York, Hamada immerses himself in the complex yet methodical processes of his practice. Sketching is the starting point for all his sculptures, allowing him to brainstorm. Once an idea has taken form and the exact shapes and scale have been decided, he makes a rough structure from wood and foam that he continues to refine. He then applies a plaster shell to a skin of hessian canvas, which creates the surface of the sculpture. When the plaster has dried, he begins the surface treatment using oil and enamel to stain and give the work different textures and earthy tones. The surface is then variously scoured and drilled to create pattern and depth.

This painterly texture is very important to the final work, as Hamada explains: 'Markings can effectively add layers of history, time, environment or function on top of the other visual narratives of the object. The result can be extremely powerful, with richly layered visual messages. It's a variation of the improvisational approach of many modern painters who find the theme as they go along, using their own visual vocabularies.' Although his sculptures do involve preparation, improvisation plays a key part in the work as a whole: 'Sometimes I feel like what I do is merely to dig those pieces out of some mysterious place where they are buried. The only thing I can do is to let myself go and just admire and wonder as they reveal themselves in front of my eyes.'

Although Hamada's sculptures are not representational, they are often reminiscent

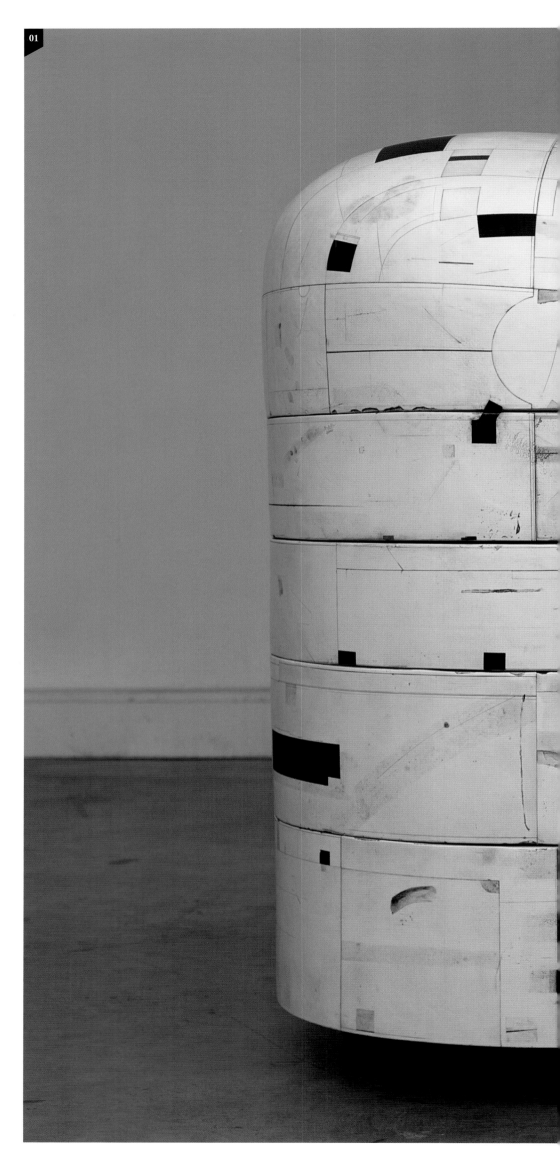

01 *#63*, hessian canvas, enamel, oil, plaster, resin, tar, wax and wood, 2006–10.

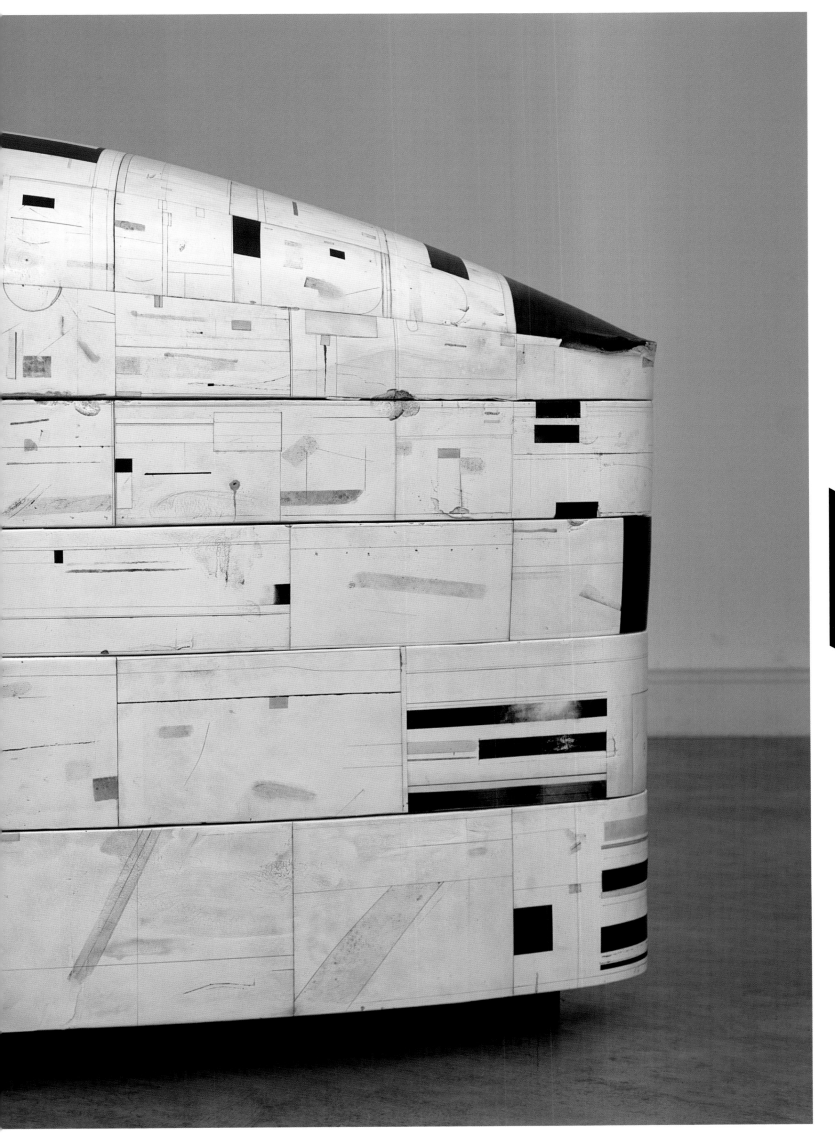

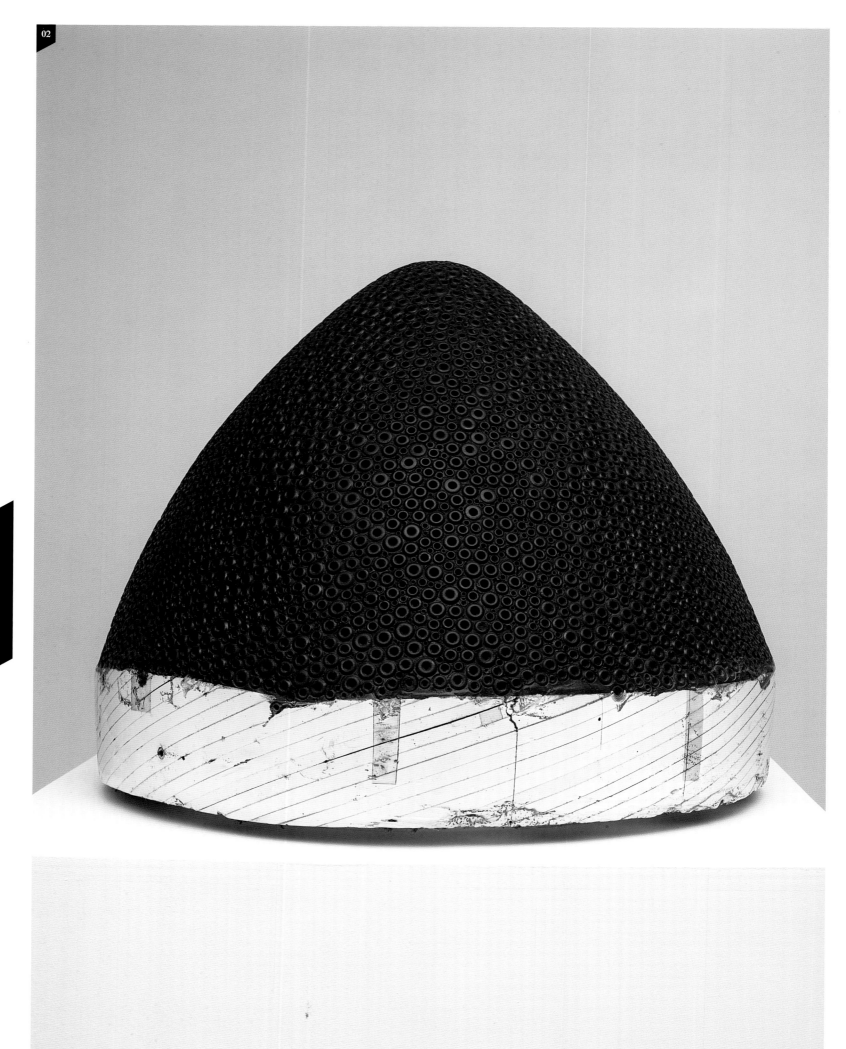

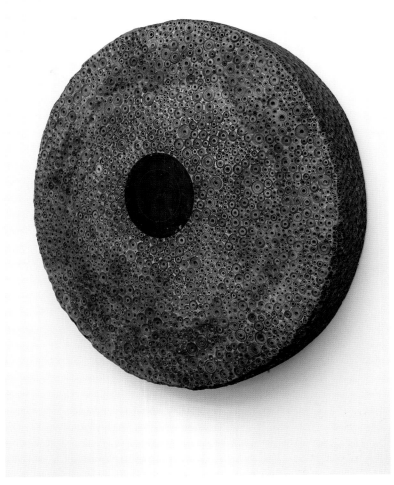

05

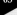

02 *#45*, hessian canvas, enamel, oil, plaster, resin, solvents, tar and wax, 2002–5. **03** *#45* (detail). **04** *#47*, hessian canvas, enamel, oil, plaster, resin, solvents, tar and wax, 2002–5. **05** *#35*, hessian canvas, enamel, oil, plaster, tar and wax, 1998–2001.

06 Work in progress, foam, wood and hessian canvas.
07 Work in progress: a plaster shell is applied to the
structure. **08** Studio materials. **09** Work in progress, foam
and wood. **10, 11** Electric drills (*left*) are used to create
texture (*right*).

Overleaf **12** *#53*, enamel, oil, plaster, tar and wax, 2005–8.
13 *#59* (detail), enamel, oil, plaster, tar and wax, 2005–8.
14 (*left*) *#52*, enamel, oil, plaster, tar and wax, 2005–8;
(*right*) *#59*. **15** *#56*, enamel, oil, plaster, tar and wax, 2005–10.

of specific forms: some look like seeds
or polished sacred stones; others like
architectural fragments and mechanical
parts from a spacecraft or aeroplane.
While he is inspired by many different visual
references including architecture, movies
and artworks, once he is in the studio these
influences are emptied into the essence of
whatever he is working on. He describes it
as 'a strange process of capturing something
very, very elusive… It's more like making
music perhaps. I try to tell visual stories by
putting together various formal elements,
sort of like musicians putting together
sounds, rhythm, timbre, and so on, to come
up with profound experiences.'

Hamada's ultimate aim is to create self-
contained structures that have a beauty,
integrity and virtue in their mechanism and
function. He does not want these structures
to require any references or background
knowledge on the part of the viewer; instead,
they should be able to stand independently
as objects in their own right.

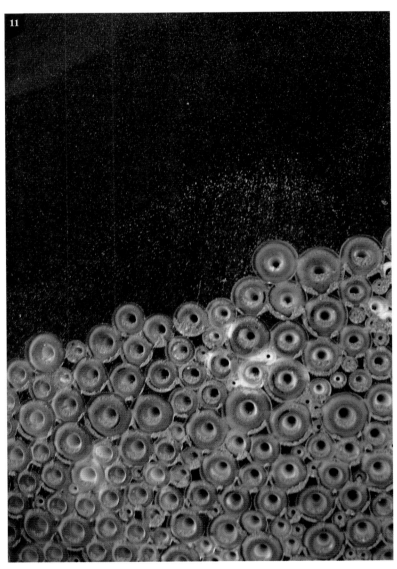

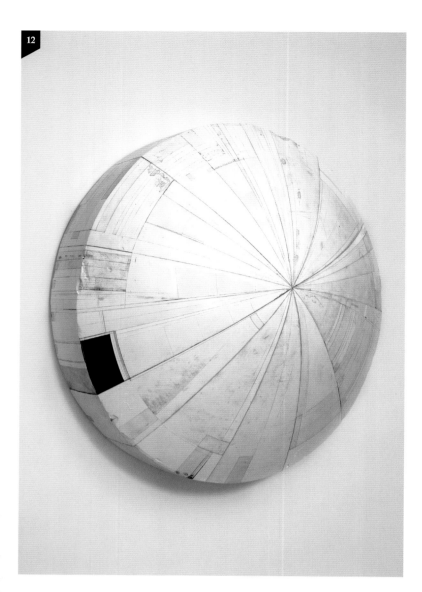

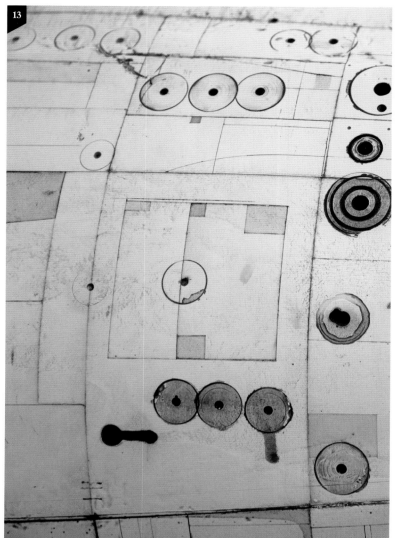

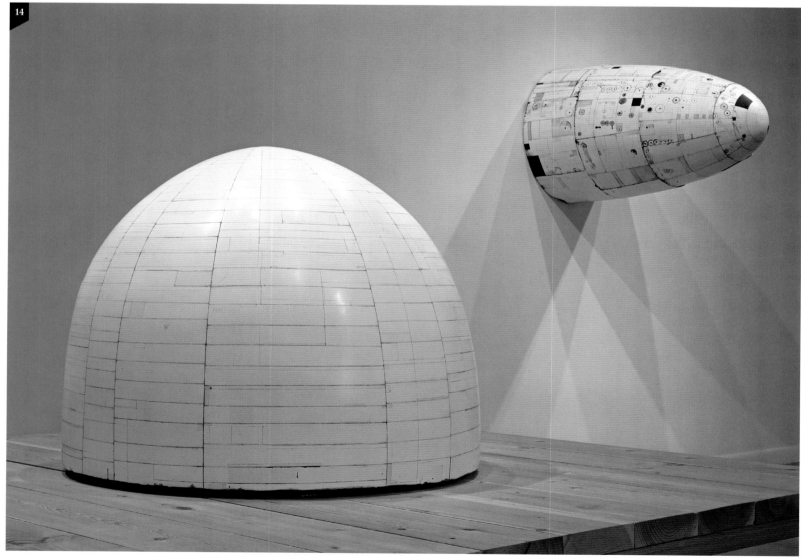

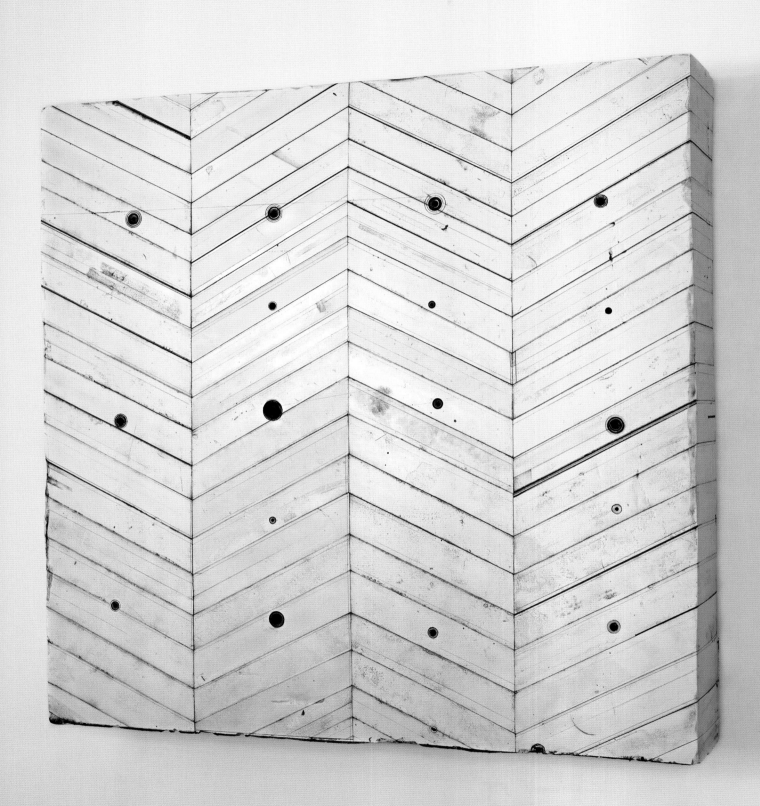

Haroshi

Tokyo-based artist Haroshi reclaims parts from old and neglected skateboards and turns them into new and beautiful objects. His choice of materials comes from a profound respect for skateboarding culture and the equipment associated with it. Having been infatuated with skateboarding since his early teens, he remains a passionate skater today. 'I see my artworks as a collaboration between two useless partners, namely the worn skateboards and myself, the wannabe pro skater,' he says. 'By reworking the broken skateboards and giving them a second life, I feel that I'm paying the same respect to those skaters who worked hard on their skills with those decks.'

Around ten years ago, he began collecting broken skateboard parts and found himself reluctant to throw them away. It seemed a natural progression that he should want to recycle them and transform them into something new. Since he was not an academically trained sculptor, his early works, he confesses, were 'truly terrible'. But in the spirit of a skater learning new tricks he persevered, and with the help of friends he learnt carpentry and the other necessary skills to create his original, handmade pieces.

Key to Haroshi's sculptures is his wooden mosaic technique. To expand the three-dimensional properties of the thin processed skateboard decks, he stacks them into many layers using a fixative. The resulting material is cut and polished into a new shape. Layering the boards requires great skill since decks have different curves, but Haroshi's encyclopedic knowledge of skating brands helps him find the perfect fit. He also pays careful attention to the outer edges of the boards to make the most of the colours, which remain as found rather than being applied. His finished works tend to be quite polished, but occasionally he incorporates naturally broken boards to create a textural contrast between smooth silhouette and splintered, raw edge.

The mosaic technique adopted by Haroshi is similar to the method used to construct traditional Japanese wooden Buddha statues. In 12th-century Japan, master sculptor Unkei used to place a crystal called Shin-gachi-rin (meaning 'new moon circle') where the statue's heart would be, representing the soul of Buddha. Haroshi takes a similar approach in his creative process, as many of his sculptures contain a broken metal skateboard part concealed within the layers that 'gives soul' to the work.

01 Used skateboards, 2009. **02** The artist's studio, 2009.
03 *Apple* sculptures in progress, 2009.

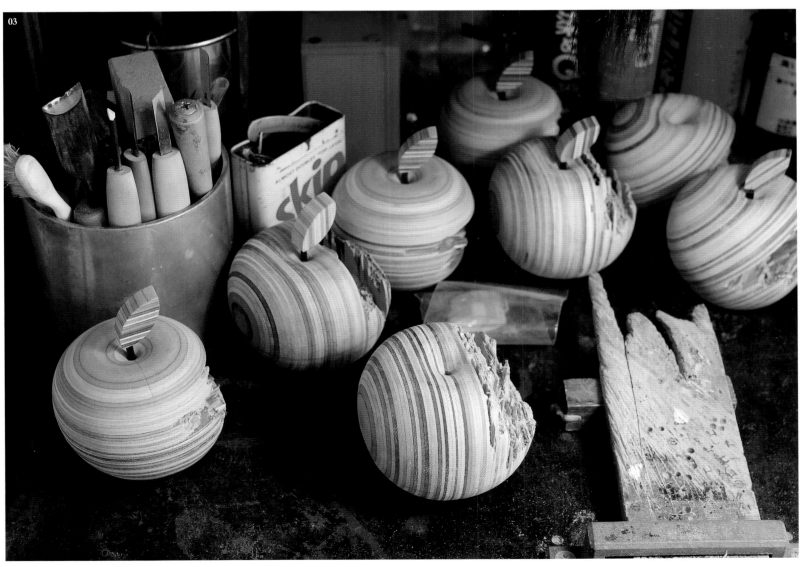

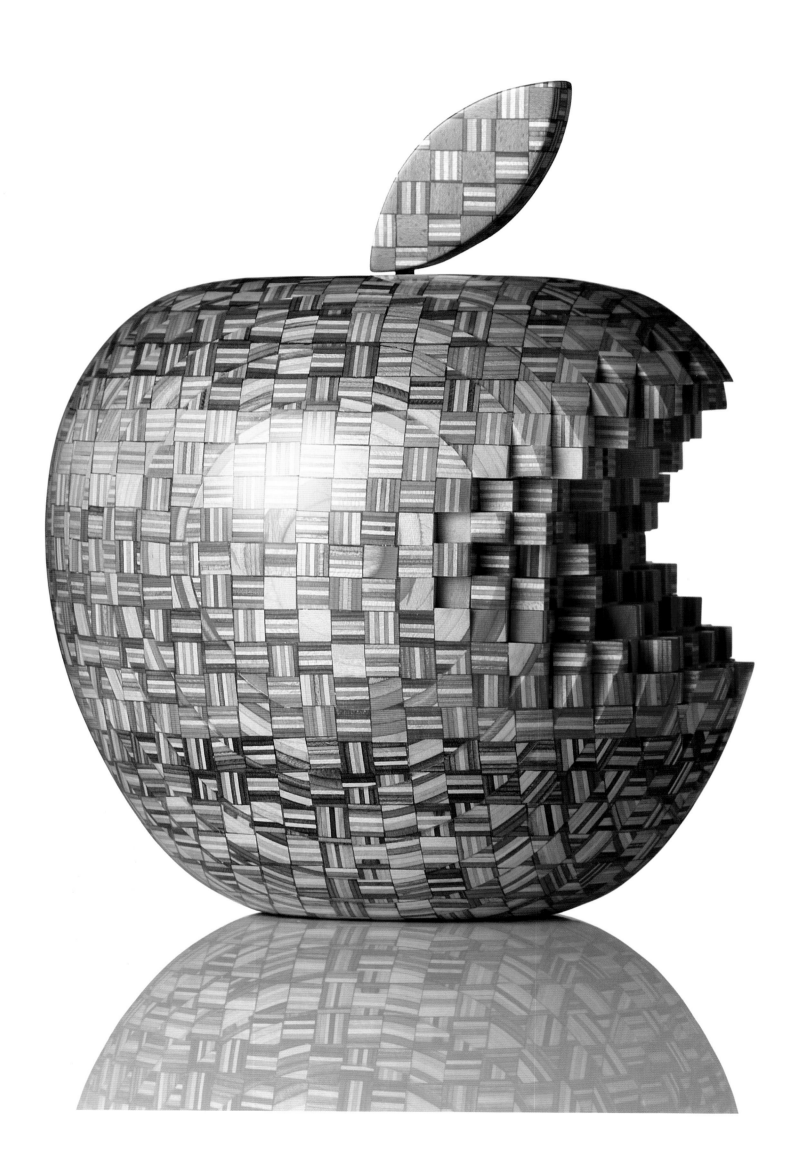

While Haroshi's art reflects the modern world, through his meticulous working methods and philosophy his work shares the spirit of traditional Japanese crafts.

Numerous themes in Haroshi's work make a direct reference to skateboarding, including broken hands and feet, fire hydrants (an iconic prop, particularly in the USA) and bottles of Olde English malt liquor, traditionally drunk from brown paper bags. Although the fire hydrant and the 40 oz bottles are foreign objects and not found in Japan, for the artist they are symbolically associated with the folklore of the skate scene worldwide. Another recurring theme is the apple, a tribute to Apple Computers. One day, having overdosed on flat-screen devices, Haroshi decided to make the Apple logo in three dimensions with broken decks, symbolizing the real as opposed to the digital world.

06 *Screaming my Foot*, used skateboards, 2010. **07** *Screaming my Hand*, used skateboards, 2010.

Valerie Hegarty

The process of creation can be viewed as a cycle of renewal, with all things having their natural life span from birth to decay. The work of New York-based artist Valerie Hegarty is concerned with this cyclical progression and, in particular, what she describes as the 'transformative energy in destruction'. 'Things have to break down before something new can occur,' she says. We may try to protect the things we value from the inevitable ravages of time, but even our most treasured possessions are at their mercy. Hegarty makes art that is already distressed, burnt and broken, thereby creating a more accurate representation of the world – one that reflects the reality of societal, cultural, political and natural forces.

In recent years her work has involved reproducing and then partially destroying iconic American paintings by artists such as Mark Rothko and the landscape painter Albert Bierstadt. The resulting pieces such as *Bierstadt with Holes* (2007) present an object that is gouged out and torn apart, with scattered pieces on the floor. These works are the opposite of what one might expect to view in a gallery, yet there is a beauty in the effect and a fascination in the process. In a recent interview she noted: 'People seem to really respond to the aggression and the energy, the forcefulness in the action of things being ripped or burned. There's an attraction to that kind of energy, a shock or surprise, which is perhaps pertinent to the emotion in the world at the moment. My work is fractal, broken down, but poised to grow like a crystal.'

A powerful recurring motif in Hegarty's work are twisted and scorched branches or roots, which are seemingly fused together with the frames and canvas stretchers of destroyed paintings. The effect is haunting and macabre – a reminder that the things we hold dearest are only on loan to us for a brief period of time until they too break down and return to nature. Rather than sprouting fresh leaves, the intertwining branches and roots are in the process of regeneration. For Hegarty, the triumph of nature is its regenerative power and continual evolution, which give rise to new possibilities. This potential is especially evident in nature's destruction, where the seeds of new life and transformation can be found. Hegarty's methods simulate destructive forces, creating the seeds for new objects or paintings.

Expanding this idea, the artist plays with the concept of forging a connection between

01 *Autumn on the Hudson Valley with Branches,* fibreglass, aluminium rod, epoxy, treated plywood, vinyl, acrylic paint and artificial leaves, 2009.

02 *Cracked Canyon*, foam core, paper, paint, wood, glue
and gel medium, 2007. 03 *Rothko Sunset*, foam core, canvas,
paper, paint, glue, wire, tape, sand and gel medium, 2007.
04 *Pollock's Flying Carpet*, paper, glue, tape and paint, 2010.

a landscape painting and the earth itself, so that the work seems to become part of the landscape. For instance, *Unearthed* (2008), in which she combines the top of a gilded frame with intertwined roots, looks like it has been pulled from the ground. In her own words: 'I like that idea of a painting sprouting from nature, along the lines of early American landscape painting, when America was struggling with forming a national identity and artists tried to show that God was present in the spiritually imbued American landscape. There was this implication that paintings were representing these truths in nature that underscored cultural and political agendas. So I started thinking about how a painting can literally be born out of nature.'

While much of Hegarty's oeuvre is exhibited in white gallery spaces, she has also produced a site-specific outdoor public artwork. *Autumn on the Hudson Valley with Branches* (2009), displayed at New York's High Line Park between 2009 and 2010, reiterates the idea of a landscape painting becoming the landscape itself. She based the painting on Jasper Francis Cropsey's *Autumn on the Hudson River* (1860), a vision of the local landscape from a more romantic and unspoiled time. Through her destructive processes she ripped the canvas and exposed the stretchers, which she reverted back to branches, 'as if nature has become the artist, altering the idealized image of the early American wilderness to be a more layered representation of the area and times today'.

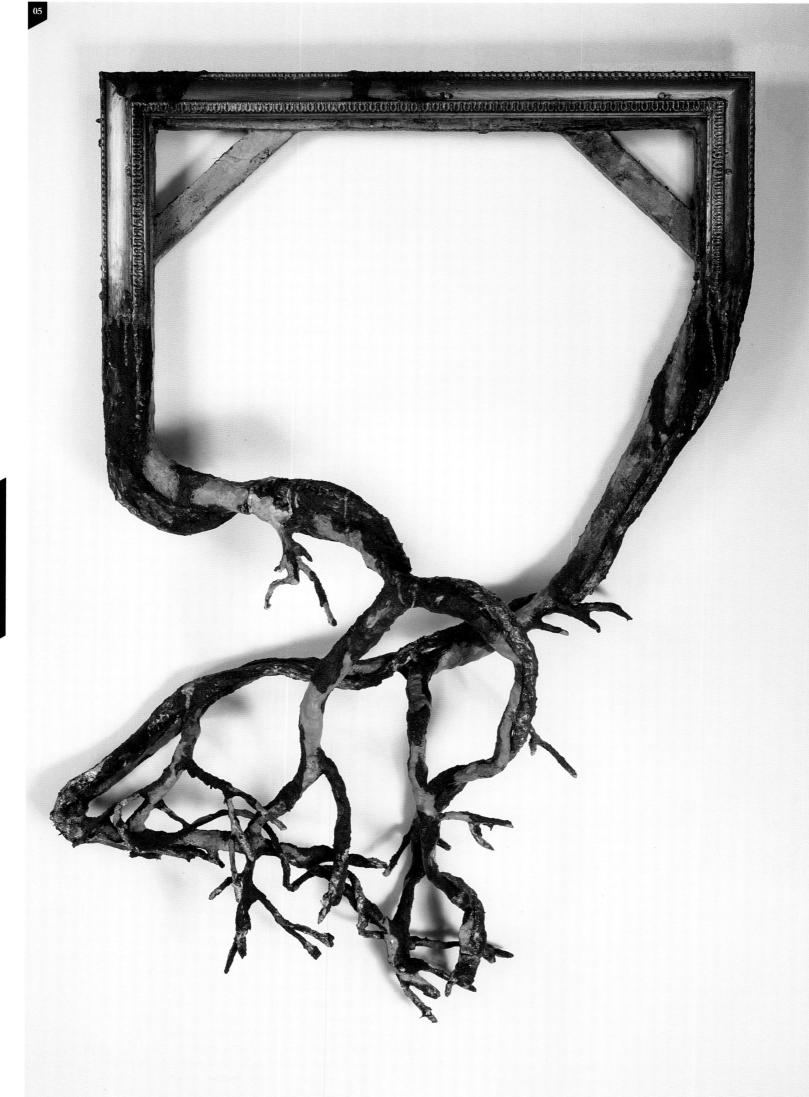

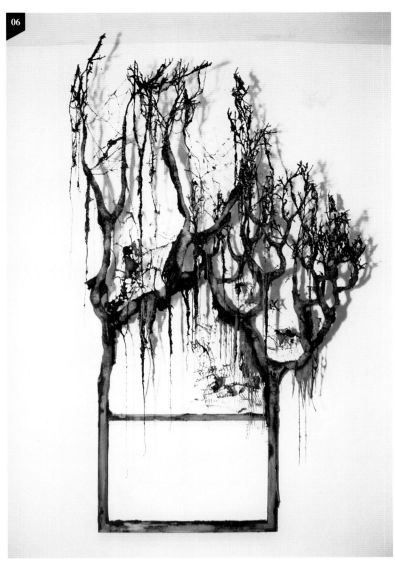

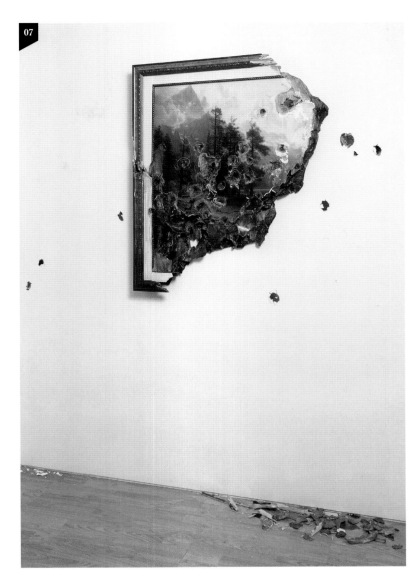

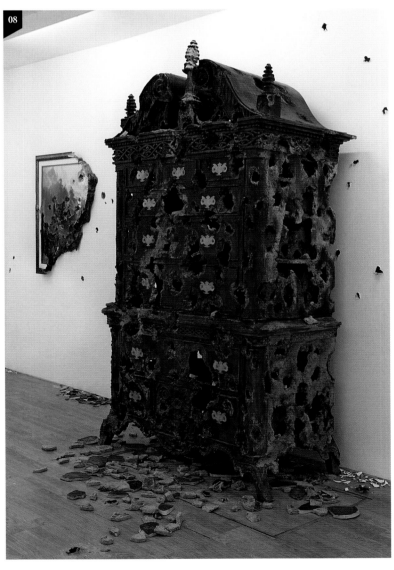

05 *Unearthed*, wood and mixed media, 2008. **06** *Cathedral*, wood, armature wire, wire mesh, Magic Sculp, papier-mâché, plastic, canvas, wood glue, gel media, thread and sand, 2010. **07** *Bierstadt with Holes*, foam core, paper, paint, wood, glue, gel medium and plexiglas, 2007. **08** (*left*) *Bierstadt with Holes*, (*right*) *Chest of Drawers (Early American) with Woodpecker*, foam core, paper, paint, wood, glue, gel medium and sawdust, 2007.

Luiz Hermano

Once upon a time we turned to story-tellers to explain how the cosmos and its creatures were created. Artists brought those visions to life. Now that we rely on science for explanations, Brazilian artist Luiz Hermano seems intent on reclaiming the world of science for art. His constructions weave patterns that recollect the works of nature, from atoms to the solar system, and amoebae to man. Man being a creature of culture as well as nature, modern culture too can become part of the pattern. Although a prolific producer of drawings, prints and paintings, Hermano is particularly known for his three-dimensional works that blend the old and the new, marrying traditional craft techniques and unexpected materials in novel forms.

Born in Preaoca, Ceará, in the north-east of Brazil, in 1954, Hermano grew up watching the beads of the rosary slip through his mother's fingers. The image has never left him, and references to it abound in his work. He became familiar with local crafts such as basketry and mask-making for festivals. It was there that he first gained an appreciation of the craftsman's ability to shape any material that came to hand. As a young man he studied engraving with Carlos Martins and had a first taste of metropolitan life in Rio de Janeiro. In 1979 he moved to São Paulo, where his work began to appear regularly in exhibitions. It soon attracted notice outside Brazil. He had solo exhibitions at Galerie Debret, Paris, in 1984 and at the Brazilian-American Cultural Institute, Washington DC, in 1987. As the opportunity to travel arose, Hermano was able to view the work of European artists. Continually innovating, he introduced the idea of 'wearable sculptures' in 1994. This was just one of the new ideas that appeared in his continual exhibitions in Brazil through the 1990s and 2000s, interspersed with occasional shows in Germany.

Recycling the detritus of modern life, Hermano makes use of old capacitors, strung together on wire like beads, which he also uses. Capacitors store electrical energy and make it possible to change the pattern of electrical signals through a current. Thus Hermano delivers a visual pun. He pulls apart the technology on which we rely but seldom fully understand, and shows us the elegance of the concept. Comments on modern living appear in his linkage of other products of mass production, such as plastic toys. The classical notion of sculpture was of a solid form chipped out of a block of stone,

01 The artist at work. 02 *Tikal*, capacitors and wire, 2007.
03 *Sadu*, electrical components and wire, 2006.

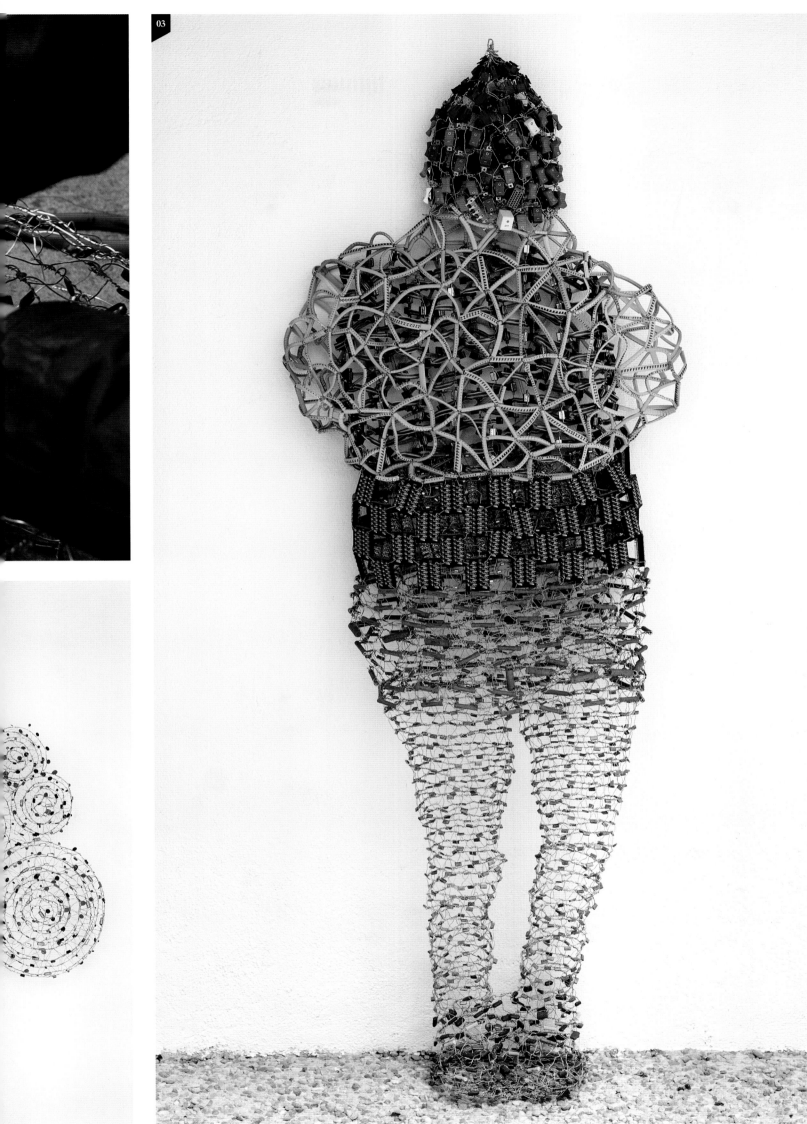

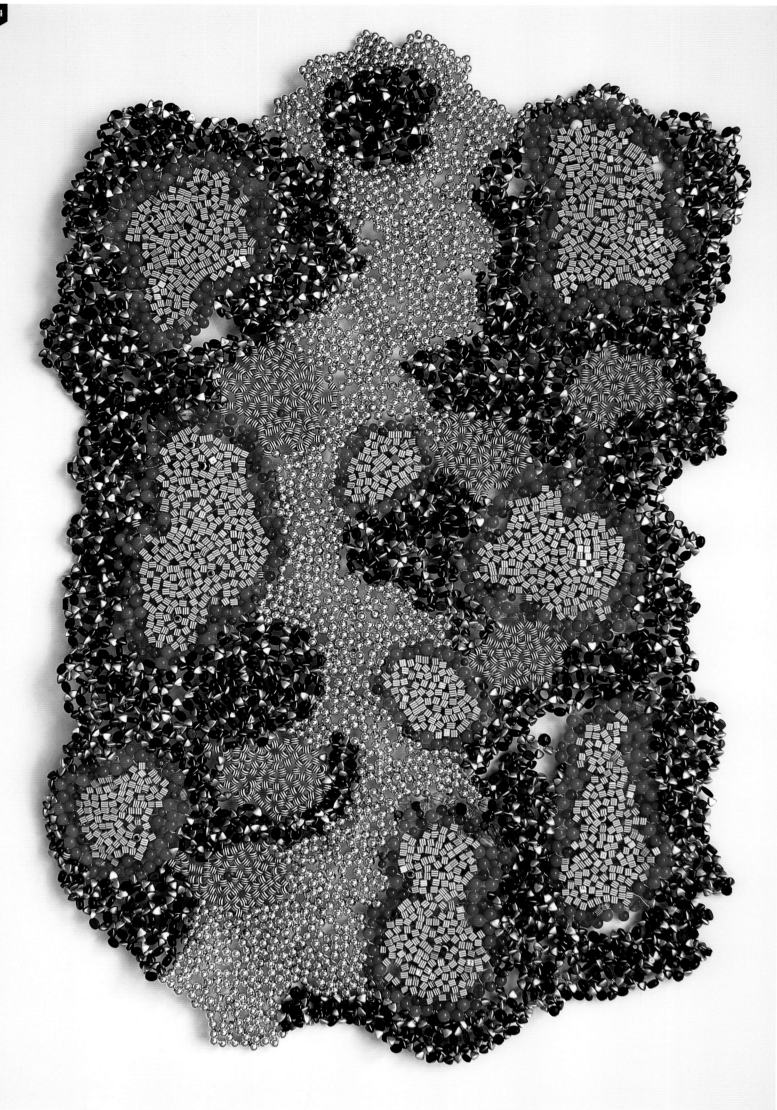

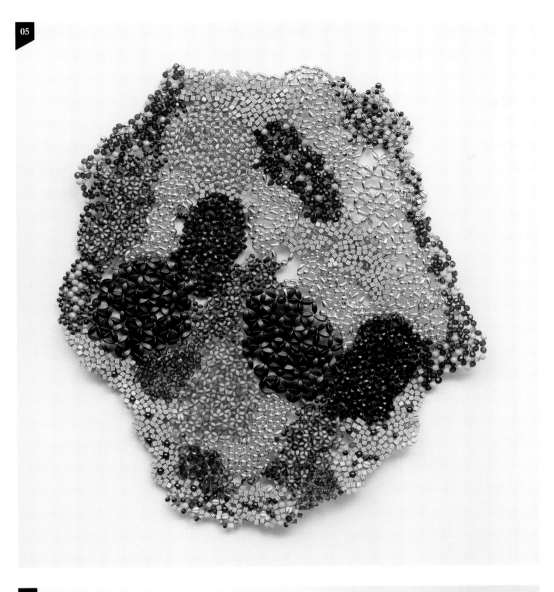

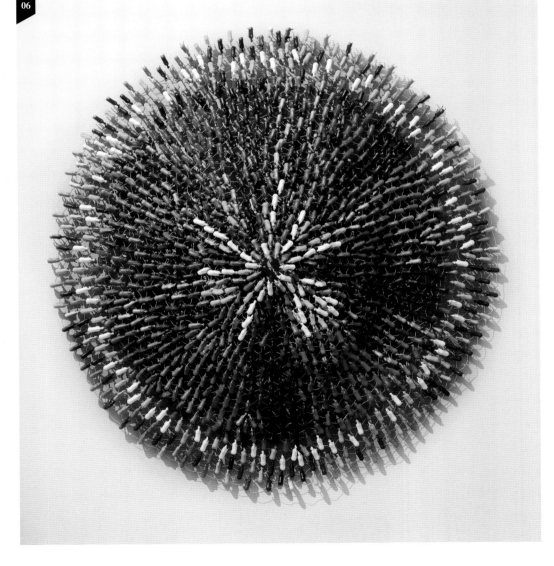

06

or cast in bronze, with little or no piercing. Hermano's constructions can be equally large scale, but are completely different in concept. He creates intricate volumes with porous, interwoven and thick surfaces.

This innovative artist seems interested in both the contrast between technology and biology, and the similarities. While his sharp-edged, rectangular weaves echo the works of man, many of his forms are rounded or honeycomb-shaped, bringing to mind the works of nature. Capacitors here could stand for living energy, woven into the cycle of life.

Several works are constructed through the assemblage of plastic toys of animals, letters of the alphabet and other shapes that reflect our contemporary methods of teaching children about the world. In one work, *Clínica* (2009), Hermano clusters these components as cultural references around male and female figures that might have come from a toy biology set, with skeleton and organs visible. In the combination of these different elements, we see what goes into the creation of modern man and woman, through nature and nurture. Most telling are the human figures. Once they might have been toy soldiers. As pieces of this work, they make our imaginations roam wild with Spiderman and spacemen.

07 *Clínica*, plastic and wire, 2009. **08** *Pracinha*, plastic
and wire, 2007.

Florentijn Hofman

Dutch artist Florentijn Hofman celebrates the icons of the animal kingdom through large-scale sculptures in public spaces. Colourful and playful, his massive constructions dominate a neighbourhood and become its focal point. He likes to consult the local community before letting his imagination run loose, so that the end product speaks for them as well as the artist. 'I make work that people adopt and talk about to their friends and relatives,' he says. 'These people are proud of their neighbourhood.'

Hofman initially studied art in the Netherlands and went on to complete a Masters at the Berlin-Weissensee Art Academy in Germany. On his return to the Netherlands in 2001, he immediately made his mark by stencilling more than a hundred koi carp on a vast dry dock in Amsterdam-North. Other sites demanded a three-dimensional response. In 2003 he placed 210 paper sparrows in a glasshouse at the botanical gardens in Amsterdam. His first large-scale animal sculpture entitled *The Giant of Vlaardingen* (2002–3) – a rabbit made from salvaged wood – was displayed in several locations, including the Robodock festival in Ijsselmonde (Rotterdam). It was followed a few months later with *Max* (Leens, 2003), a German Shepherd made from wooden crates and pallets, straw, rope, wire and red shrink foil. Large-scale animal sculpture remains an integral part of his oeuvre, from *Lookout Rabbit* (Nijmegen, 2011), a giant bunny of concrete, sand, grass, metal, wood, paint and cement coating, to *Steelman* (Amsterdam, 2011), a concrete bear with a pillow tucked under its arm.

Although best known for his animal sculptures, the artist takes many different subjects as inspiration and often uses colour to draw attention to urban features that go unnoticed. By using latex emulsion paint to transform a brick-paved street into a yellow brick road (*Yellow Street*, Schiedam, 2003) or a disused building into a blue monolith (*Beukelsblauw*, Rotterdam, 2004–6), he encourages passers-by to reconsider their environment. In another iconic project (*Signpost 5*, 2006), he created three giant grand pianos and displayed them on a beach on the island of Schiermonnikoog as if they had been washed up on the shore. The work

01 *Max*, potato crates, pallets, wood, straw, rope, metal wire and shrink foil, Leens, Netherlands, 2003. 02 *Pig Juggling with Strawberries*, wood, concrete, corrugated iron and paint, Veghels Buiten, Netherlands, 2010. 03 *Lookout Rabbit* (detail), concrete, sand, grass, metal, wood, paint and cement coating, Nijmegen, Netherlands, 2011. 04 *Lookout Rabbit*.

Overleaf 05, 06, 07, 08 *Signpost 5*, three grand pianos, wood and nails, Schiermonnikoog island, Netherlands, 2006.

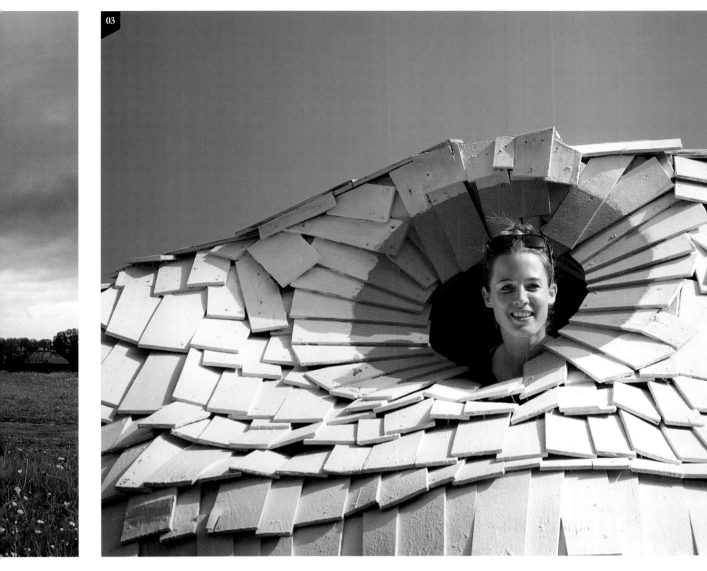

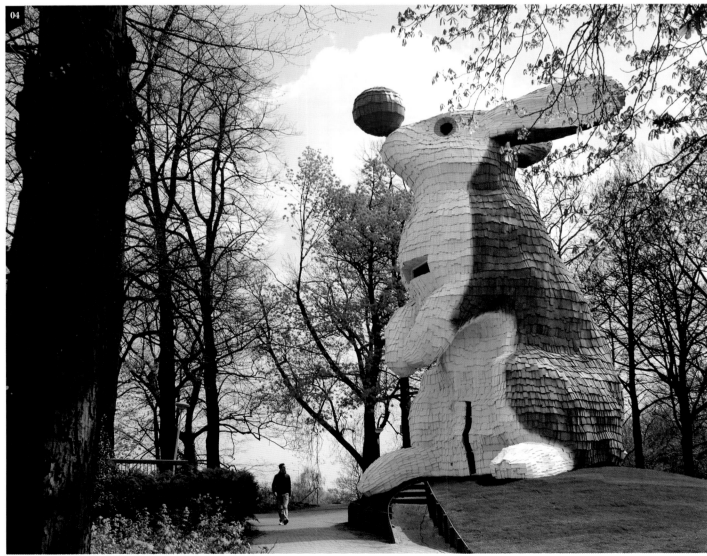

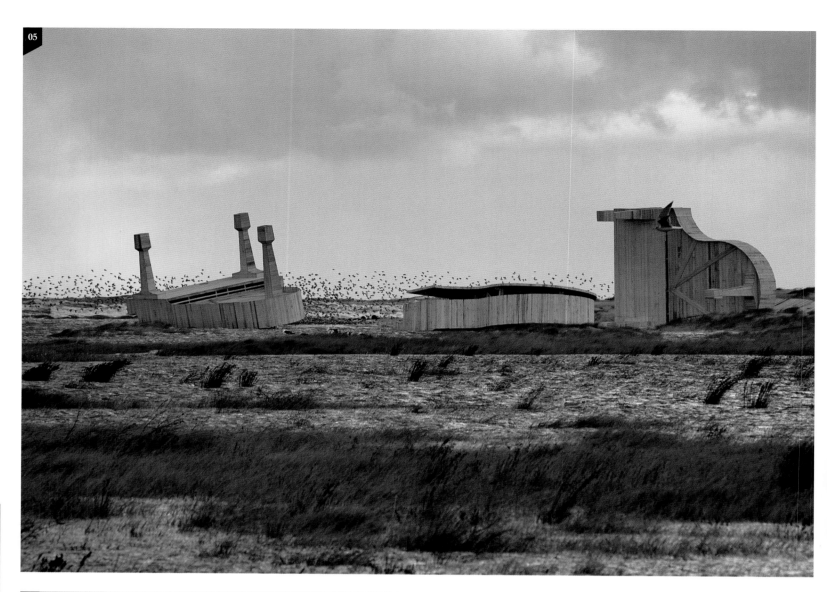

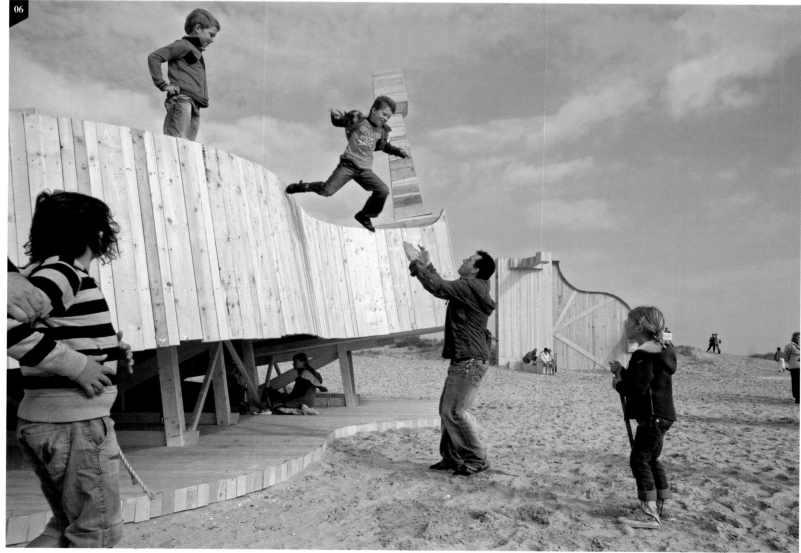

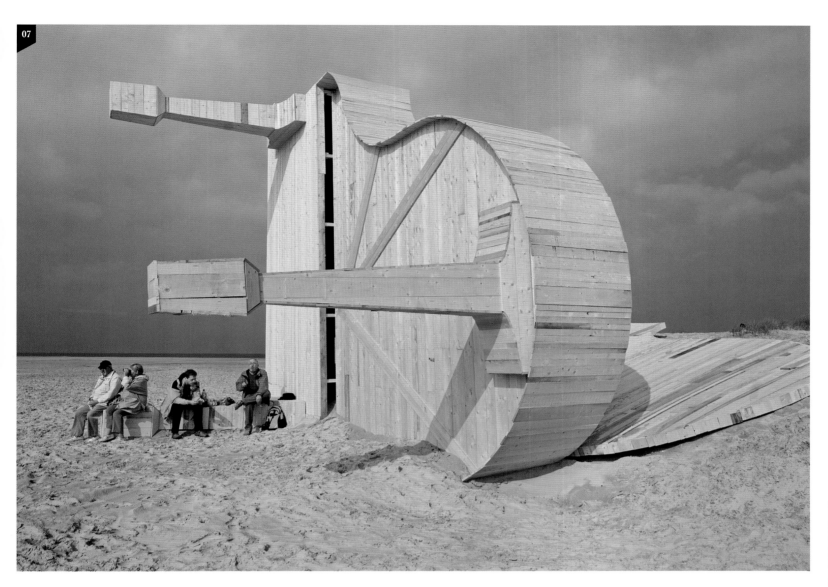

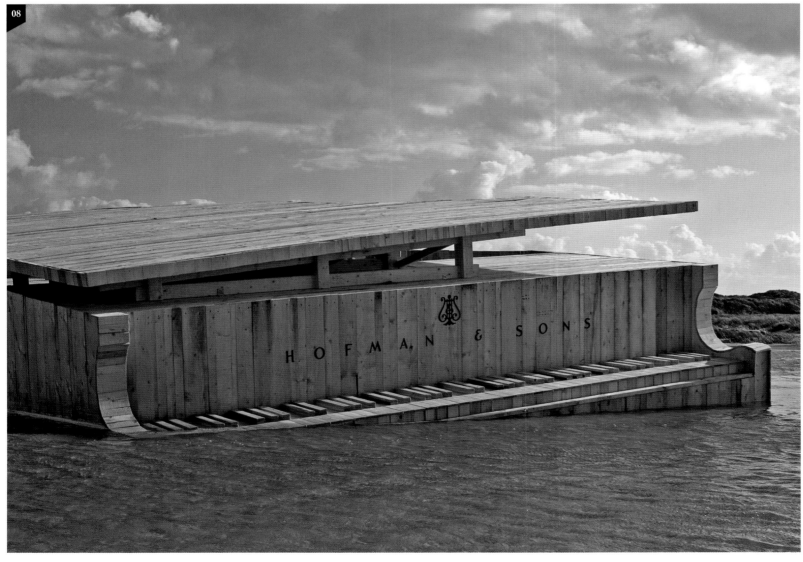

09, 10, 11 *Fat Monkey*, inflatable and flip-flops,
São Paulo, Brazil, 2010.

created a social space where islanders could
view their beach in a brand new light.

Hofman is not afraid to experiment,
working with a remarkable variety of
materials. However, many of his installations
are so huge that they require careful
planning. He consults experts at the concept
phase and often works with assistants. For
example, *Fat Monkey* (São Paulo, 2010),
constructed from an inflatable and flip-
flops, was made with the assistance of local
students. The paper birds displayed at the
botanical gardens in Amsterdam, on the
other hand, were made from photocopies
of a sparrow model kit that the artist had
sent to contacts all over the world for them
to construct and return. The collaborative
aspect of Hofman's work makes him unusual
among artists. He enjoys the interaction with
local people. Whether they lend a hand or
make a comment, their input contributes to
the development of a project. With *Steelman*,
locals felt that a plain giant bear was too
aggressive for their neighbourhood, so the
artist added a pillow to soften the image. A
fierce beast was transformed into a creature
from a children's story.

In environments that man is used to
dominating, Hofman delights in confronting
us with creatures that tower over us and
take us by surprise. Who would expect to
see a giant yellow rabbit in a town square or
a rubber duck as high as a house peacefully
floating on a river between skyscrapers? The
whole world is Hofman's playground.

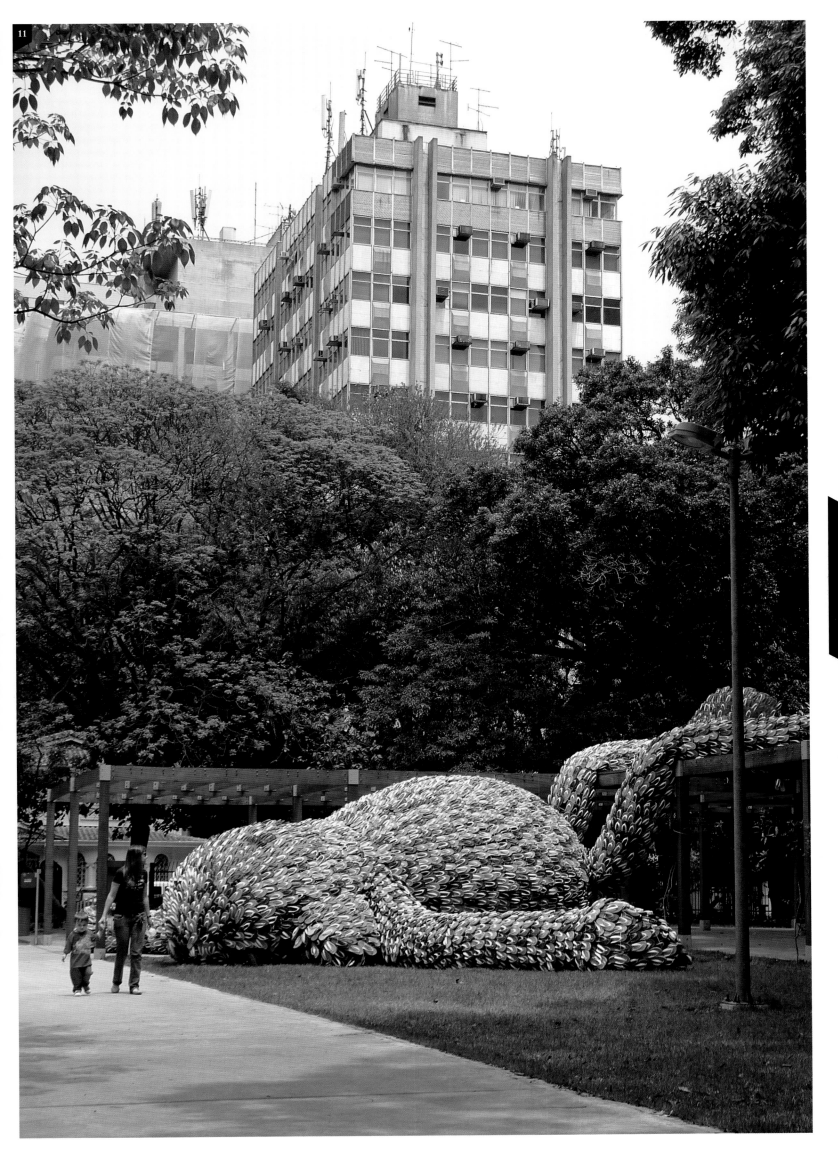

Michael Johansson

Swedish artist Michael Johansson scours flea markets for unusual materials to use in his work and is particularly drawn to 'doubles of seemingly unique, though often useless objects'. His compact sculptures are made from piles of everyday items, which he assembles and fits together precisely in a new context like pieces of a jigsaw. 'The main reason I use older items in my work is that I am interested in their history,' he explains. 'You can see traces of past decades not only in their design, but also in the way they have been used. It is something about the knowledge that there is only a limited number of these particular objects left that increases the unlikeliness of them being morphed together with such a precise fit.'

In Johansson's compositions, the function of each object is transformed: the objects are essentially stripped of their original meaning. He is intrigued by life's coincidences, when, for instance, the same colours and patterns appear on two very different objects, or two people dressed in the same outfits pass each other on the street. These are the elements he considers in the organization and colour coordination of the assembled objects. He used to collect items of a similar type, but in more recent years he has branched out. For example, he has been assembling objects connected to a certain place – a living room, for instance – into a cubic geometrical unit. 'This concentration of objects of different origins into one imaginary image of a fake reality addresses questions of history, life and space, and their original functions are forced into submission by notions of colour and shape,' he says.

For Johansson the context of a specific place determines how the work will come together, whether it is in a domestic setting, a museum or outdoors. Frequently the size and shape of a work are suggested by the parameters of a dominant component, which governs how much space is left for the other objects that make up the piece. In site-specific works, he often uses objects found at or connected to the particular location. Recent exhibitions at Den Frie Centre of Contemporary Art, Copenhagen, and the Archaeological Museum, Bologna, both in 2011, featured works made entirely from objects found in storerooms at those venues. In all his works it is important for him 'that the context and the objects are talking the same language'.

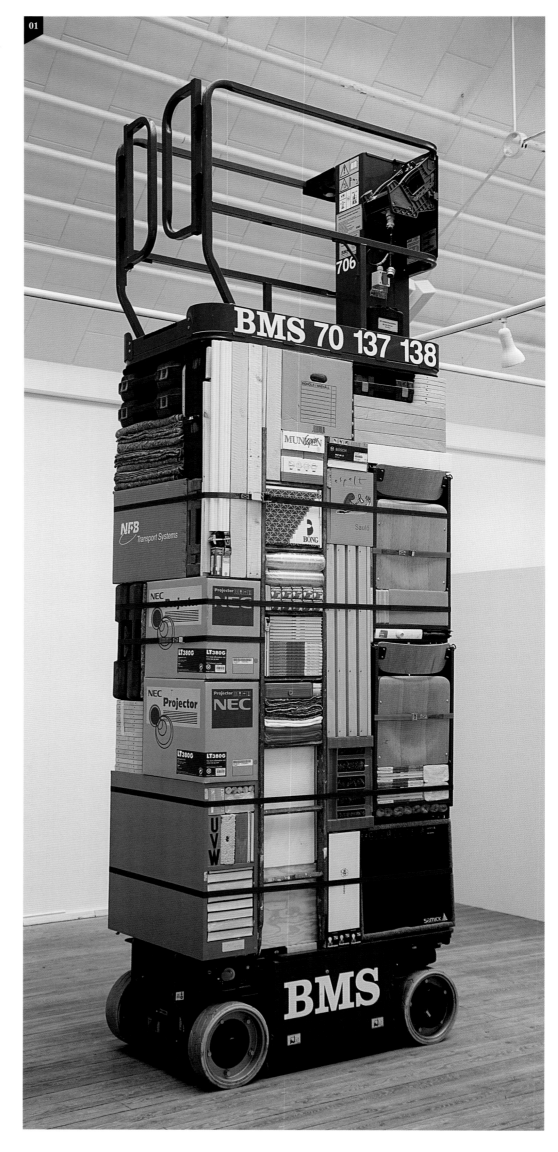

01 *Cake Lift*, objects from the storeroom of the Aarhus Art Building, Aarhus Art Building, Aarhus, Denmark, 2009. **02, 03** *Rubiks Kurve (Rubik's Curve)*, various objects, metal boxes and wooden wall, Svartlamon, Trondheim, Norway, 2010.

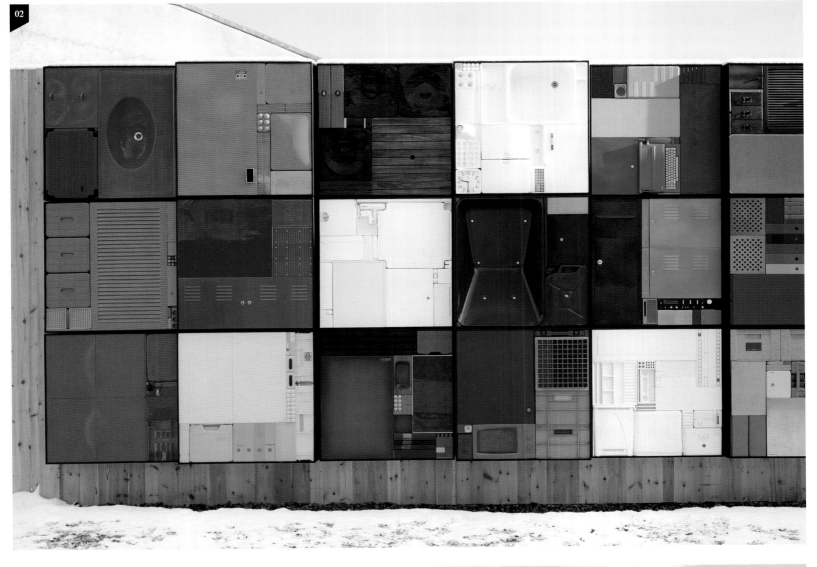

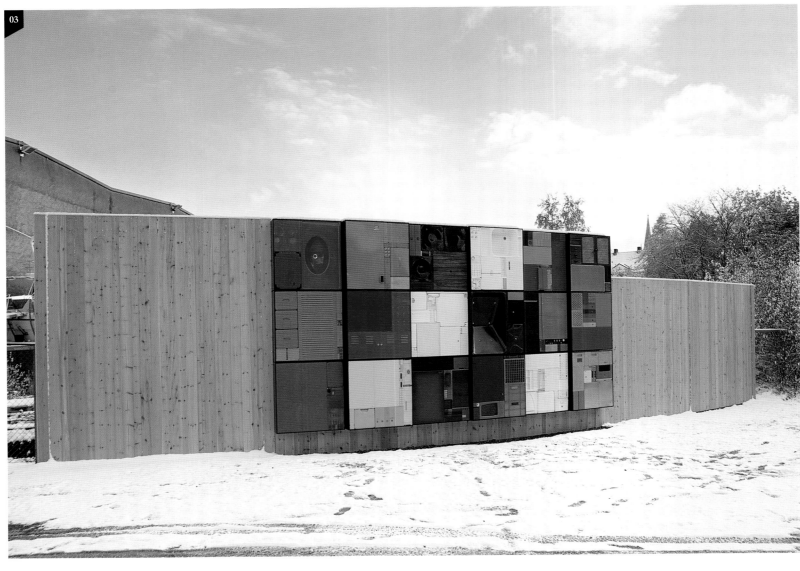

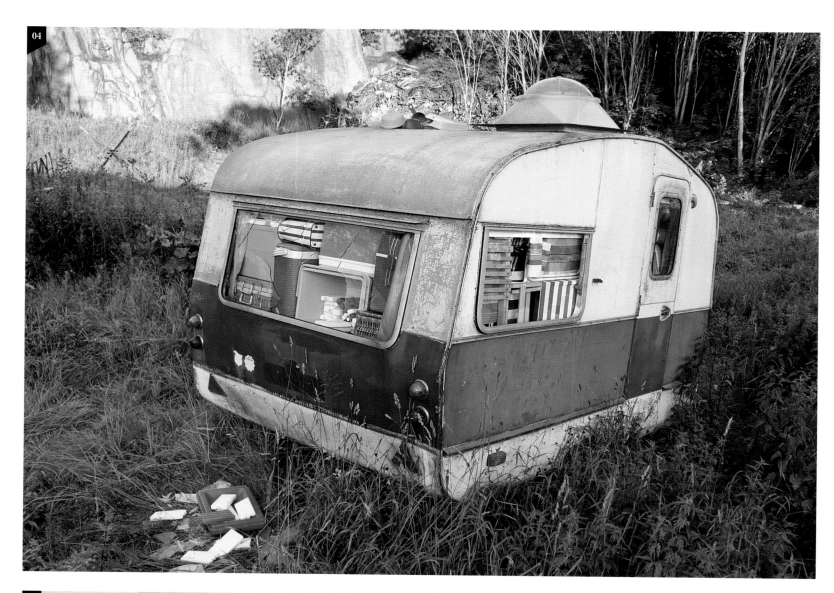

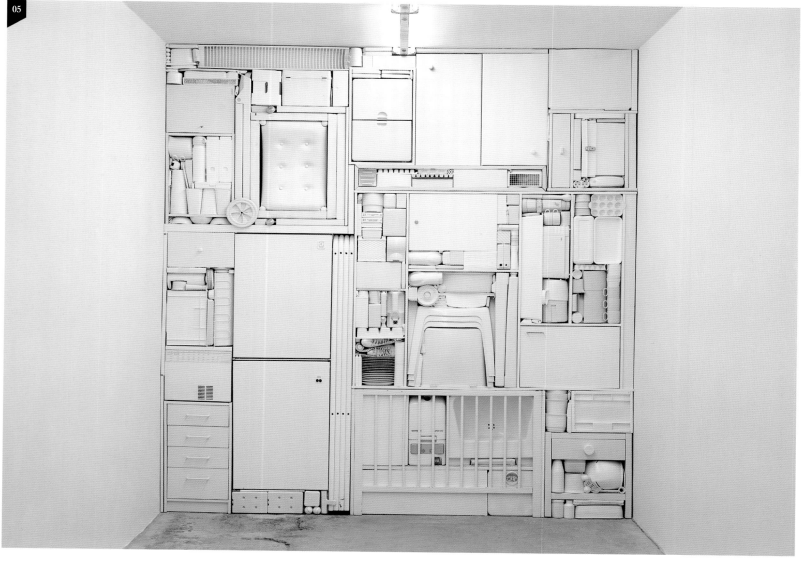

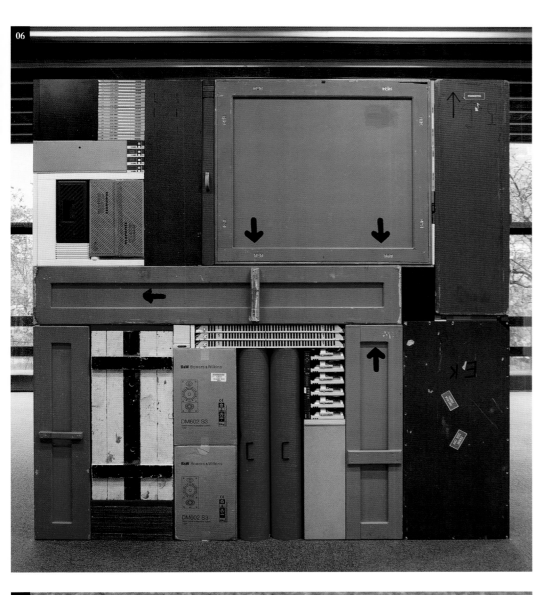

04 *Vi hade i alla fall tur med vädret (At least the weather was nice)*, various materials including a caravan, portable coolers, ice packs, deckchairs, camping equipment and thermos flasks, Bottna Kulturfestival, Gerlesborg, Sweden, 2006. **05** *Ghost II*, various white objects, Arnstedt Östra Karup Gallery, Båstad, Sweden, 2009. **06** *27m3*, objects from the storeroom of Bergen Art Museum, Bergen Art Museum, Bergen, Norway, 2010. **07** *Green Piece*, green outdoor equipment, 2009.

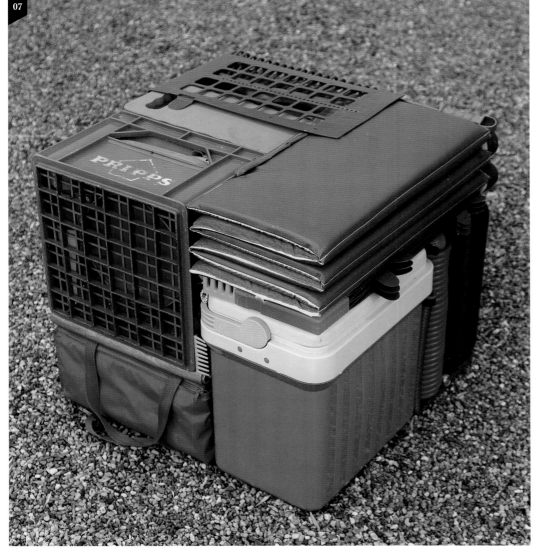

Johansson believes that 'objects gain their value through the situations in which they are placed – in other words, what defines the value of an object is not the material it is made from or the function it serves, but its position in a context. It may be that an originally worthless object becomes invaluable due to its unique status or that a costly mass-produced article is considered worthless almost immediately after purchase. But it may also be that, by reconstructing the settings for an item, you change its context and therefore its value, setting it back to zero.'

Part of the wonder and excitement we feel in experiencing this artist's work lies in his presentation of familiar objects in an unusual and surprising way. 'One of the main reasons I started to use everyday objects in my practice – things we can all relate to – was in the hope of opening a dialogue with the viewer, creating a bond that might lead to discussions within a wider context. Of course, I realize that the memories or individual meanings that viewers may attach to each object within a work also make it more likely that their interpretation will differ from mine, but I appreciate it when someone gives me their personal take on my work.'

Michael Johansson 171

08 *Frusna Tillhörigheter (Frozen Belongings)*, various objects including an armchair, a typewriter, books, boxes and a clock, 2010. **09** *Domestic Kitchen Planning*, kitchen stool and equipment, 2010. **10** *Strövtåg i tid och rum (Strolls through Time and Space)*, various objects including an armchair, books, bags, boxes, a radio and a clock, 2009.

Anouk Kruithof

Dutch artist Anouk Kruithof has a background in photography. Since graduating from St Joost Academy, Breda, in 2003, she has divided her time primarily between Rotterdam and Berlin. While photography is her main medium, she also works with video, installation, artist's books, collages and socially engaged, in situ pieces. A repeated theme in her work is the study of people's emotional and mental states and how these manifest in behaviour and impact society.

She has long been interested in exploring the limitations of photography as a medium, in part by using it in combination with installation and performative actions as well as through the creation of artist's books and newspapers. In a recent interview she explains: 'Rarely is a photo the final result to me. I want to escape from the character of the medium and stretch its boundaries. I have a love–hate relationship with photography. Installation seems to be the medium I feel most comfortable with, so I have always made photo installations. I consider an exhibition space, a publication, a webpage, a single wall, all as "scopes" where I want to create a "whole", with a strong physical and mental impact on viewers.'

A recent project, *Fragmented Entity* (2008–11), presented in a show at Art Rotterdam, is a pertinent demonstration of her ongoing dissection of photography. All the installed works were made through a process of recycling piles of hand-printed photographic prints that had been produced by the artist over a period of ten years. By cutting out recognizable parts from the photographs, the artist rendered the prints abstract and used them to make new photographs, objects and videos. A picture of a stack of old prints became a 'giveaway' poster entitled *Never ending pile of a past* in an edition of 10,000 copies, which were placed in a pile on the floor of the space.

In this project Kruithof takes the fixed frame, a key limitation of photography, and expands it spatially in different ways. For example, some works are collages made up of pieces of the original photo paper and photographs of the artist's collage. Others are light-jet prints on aluminium. She also expands the medium through video installations, using shredded pieces of photographs left over from the project. In one video, the shredded paper is seen

01 'Fragmented Entity' show, Art Rotterdam, Rotterdam, Netherlands, 2011. **02** *Clear Heads*, C-print on aluminium. **03** *Photos from Photos*, light-jet prints and light-jet prints on aluminium. **04** *Everything's Metaphor (Criss Cross)*, light-jet print on aluminium.

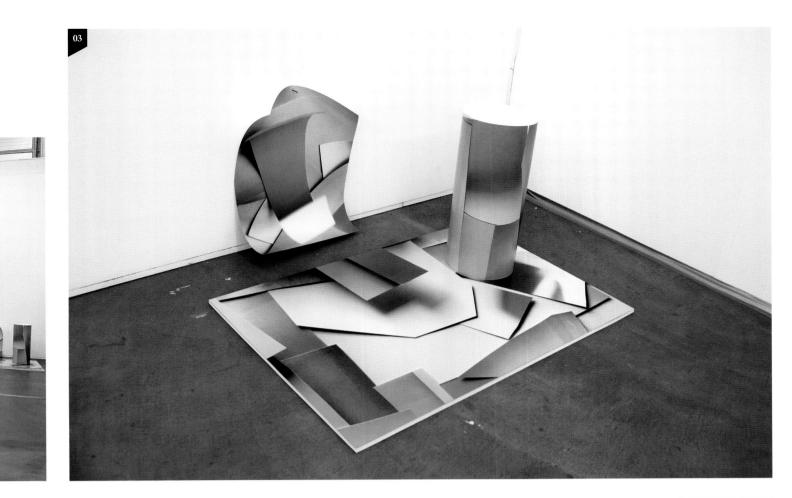

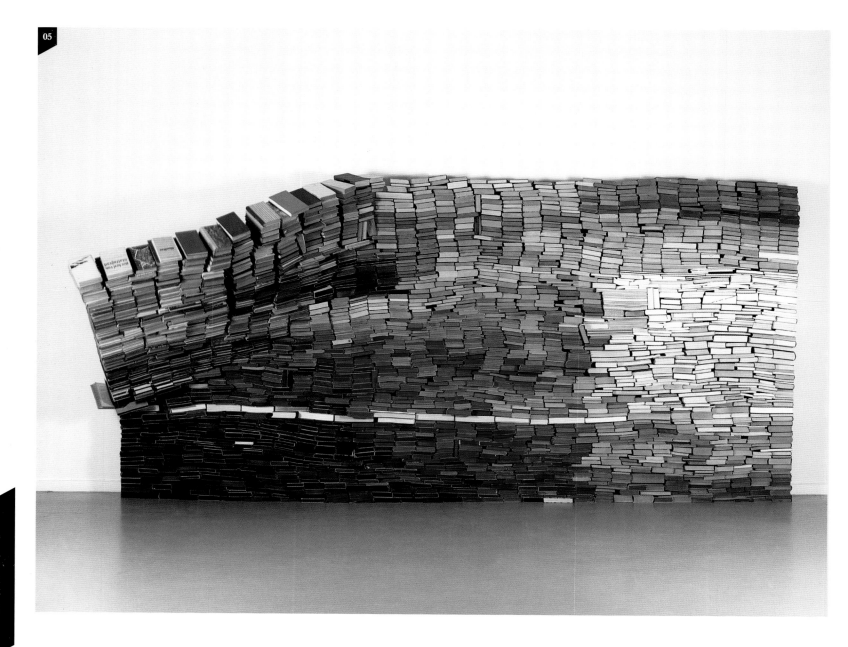

05, 06 *Enclosed Content Chatting Away in the Colour
Invisibility,* found coloured books, Künstlerhaus Bethanien,
Berlin, Germany, 2009.

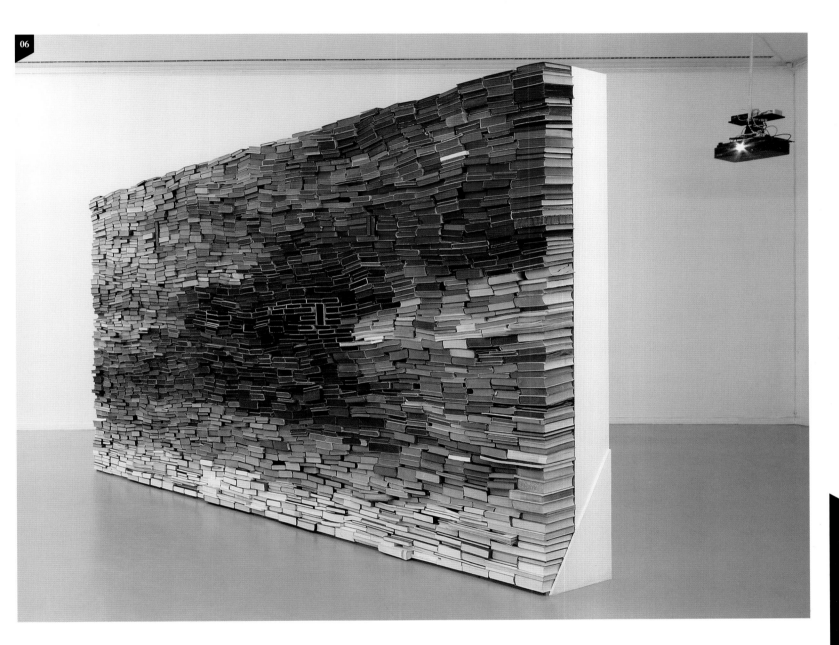

exploding and floating in the air, a sequence that is projected on an exposed but blank photograph. In another, a mountain of paper is shown imploding. For Kruithof, these explorations are a way of letting go of memories, recycling the past to acquire new meaning in the present. In contrast to the image overload in our information age, the installation slows down the pace of our image consumption by making us look at photography in material terms through fragments of cut paper and the ambient hues of film grain.

In the digital age we are not only changing the way we view images, but also the way we read texts. While it is too early to signal the death of the printed book, it is no longer our principal means of gathering information. In *Enclosed Content*

Chatting Away in the Colour Invisibility (2009) Kruithof plays with books as a sculptural material. Using up to 4,000 found books, this installation was made and reconstructed six times in museums and galleries in Germany and the Netherlands, including the Künstlerhaus Bethanien in Berlin, Museum Het Domein in Sittard and Galerie Adler in Frankfurt. With each installation, the work changed depending on the books available and the arrangement of coloured paper edges. Alongside the installation, a video was projected onto a stack of books against a white wall. Playing on a loop, it is designed to give the viewer a shock: in the film there is a bang and the book wall falls down, while the real books in the exhibition space stand firm. Through this work, Kruithof breathes new life into an increasingly neglected material.

Jae-Hyo Lee

South Korean artist Jae-Hyo Lee creates unique sculptures and installations from a range of natural materials, including wood, leaves and stone, by refining them into geometrical and curvilinear shapes such as spheres, hemispheres and cylinders. Throughout his works he demonstrates a deep respect for the innate beauty of natural forms, accentuating and preserving their characteristics while shaping them to his will.

Since graduating from Hongik University in 1992 with a degree in plastic arts, he has devoted his life to sculpture and, in particular, woodwork. Texture is extremely important in his work. Through crosscutting, carving and planing, he reveals the rich detail of the grain. The elegantly rounded surfaces of his wooden pieces are echoed in the curvature and growth rings within the wood itself. The fluid forms of the sculptures charm us, while the interplay of the patterns and details found is naturally intriguing.

Lee's artworks have been shown in numerous galleries, museums and sculpture parks around the world. He has also produced a number of prominent public artworks and, at a different scale, has created many pieces that emulate furniture such as chairs, couches and tables in his signature biomorphic style. These furniture-inspired sculptures are not intended to be functional; rather they are idealized or parodic creations that borrow from everyday forms that are familiar to us.

Lee has spent most of his career working with wood and stone, but over the last five years he has increasingly used metal, in particular steel bolts and nails. In contrast to his usual natural media, these materials are the products and lynchpins of industry. He uses them principally to create texture and pattern and inscribe images by setting them into burned wood that is polished flat. Some of the most striking works are reminiscent of ferrous meteorites, with the metal components set against a ball of scorched black wood. As the light catches the metal, they seem to ripple like water or sparkle like distant galaxies. While organic patterns predominate in Lee's art, not all his references are to nature. Some of his wood and metal works are adorned with typographic patterns based on the western alphabet. Like modern-day Rosetta stones, they have a mystical and monumental quality.

Especially apparent throughout Lee's work is the meticulous care taken in its creation and the great level of craftsmanship.

01 *0121-1110=1091212*, stainless steel bolts, nails and wood, 2009. **02** The artist at work. **03** *0121-1110=110101*, bronze, 2010. **04** *0121-1110=106111*, wood.

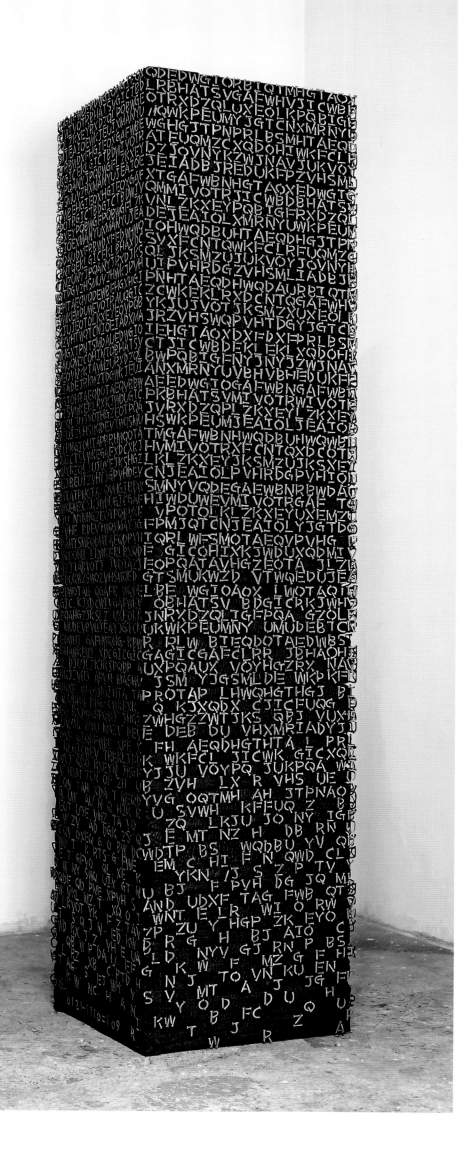

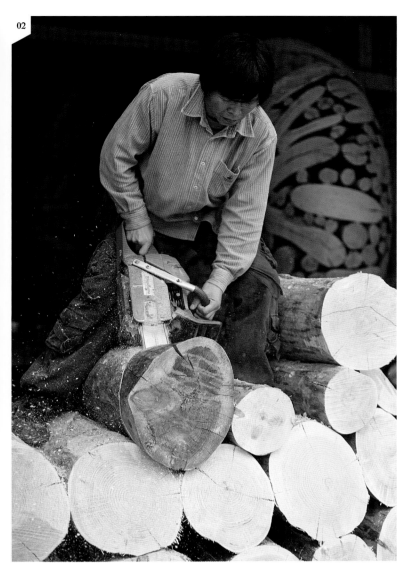

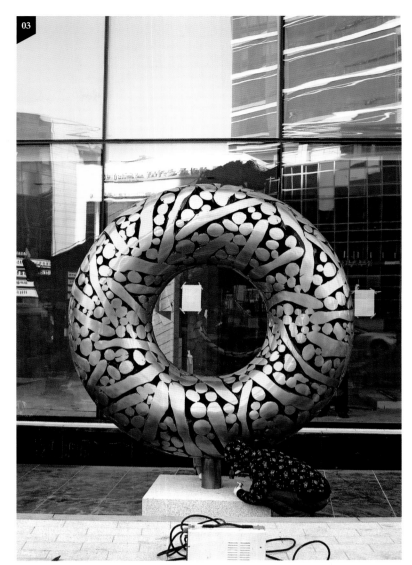

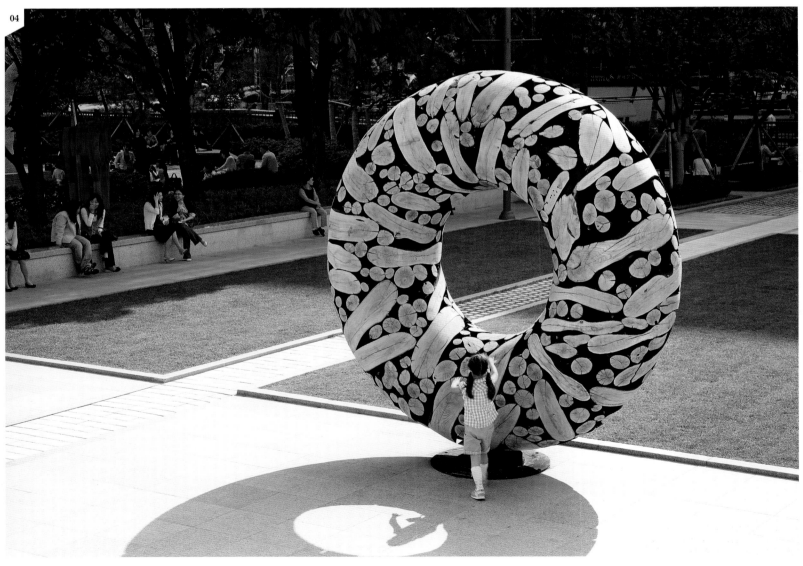

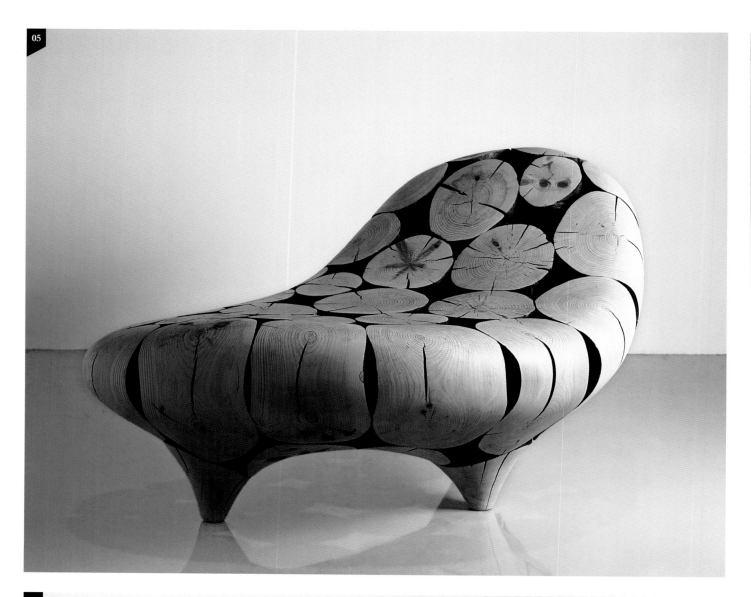

07

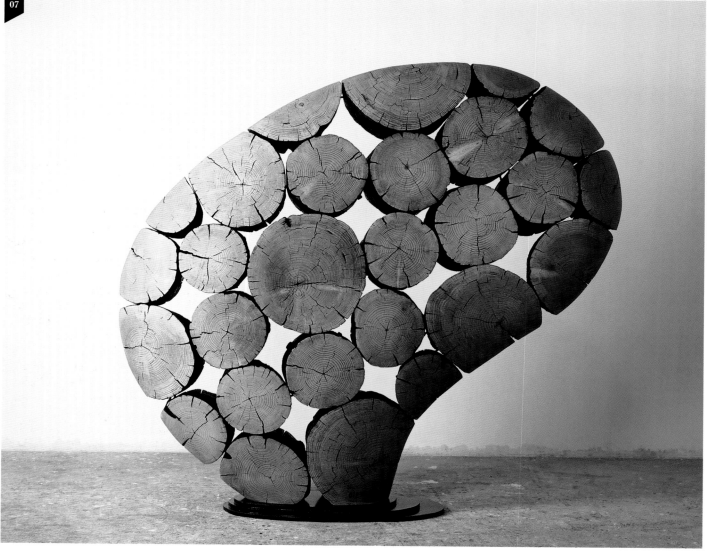

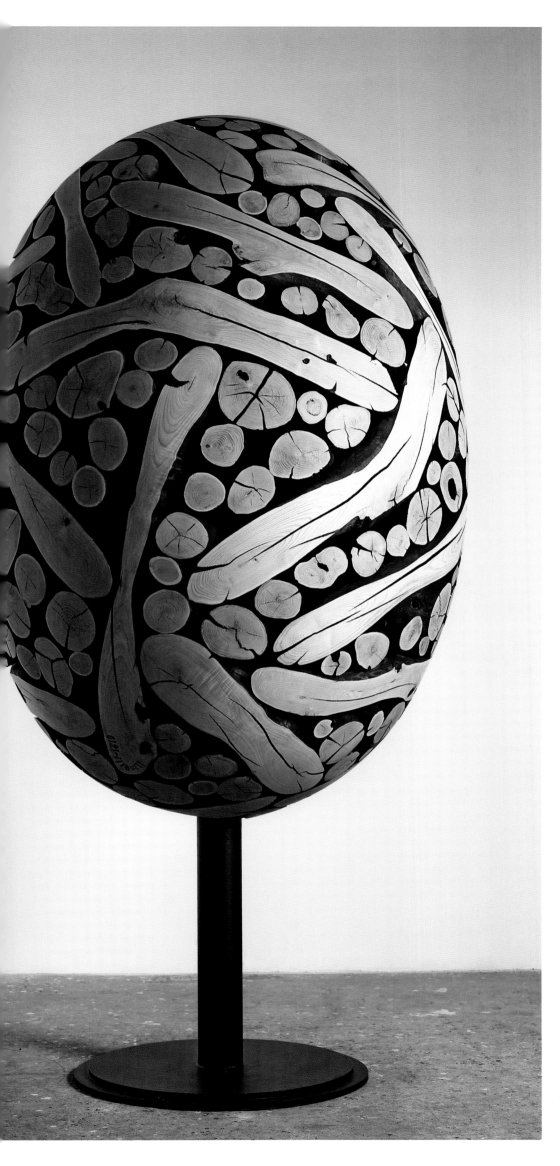

05 *0121-1110=1100810*, wood, 2010. **06** *0121-1110=111038*, wood, 2011. **07** *0121-1110=110011*, wood (Douglas fir), 2010.

Jae-Hyo Lee 179

Each piece is also the result of many hours of hard physical labour. To achieve his prolific output, particularly in the case of his nail art designs, he uses a number of craftsmen to help him with the laborious process. The artist's sense of humour can also be detected in the way he plays with shapes in relation to their constituent materials. At the same time there is an innocence in many of the forms he chooses, such as egg-like shapes, tunnels and doughnuts, as if the works are part of a magical narrative or children's story. The pure and minimal shapes that are characteristic of his pieces remain open and accessible, with little sense of the great efforts involved in their construction.

In his work Lee conveys a balance between the forces of man and his natural surroundings. 'My art is about the material: everything begins and ends with the material,' he explains. 'I simply want to show the nature of common raw materials such as wood and nails…to discover a different way to present them.' In this regard, it is clear that he has succeeded.

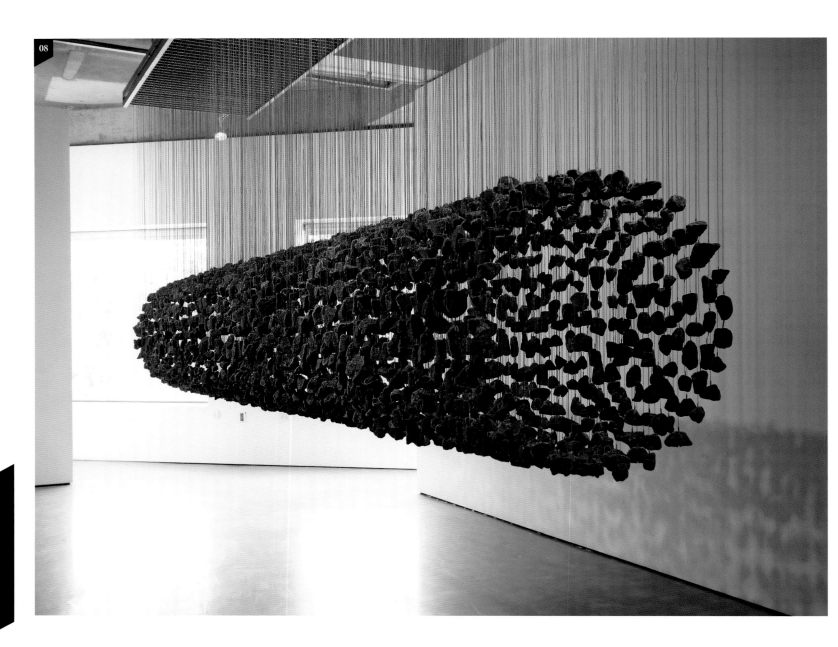

08 *0121-1110=1080815*, stone, 2008. **09** *0121-1110=105102*,
stainless steel bolts, nails and wood.

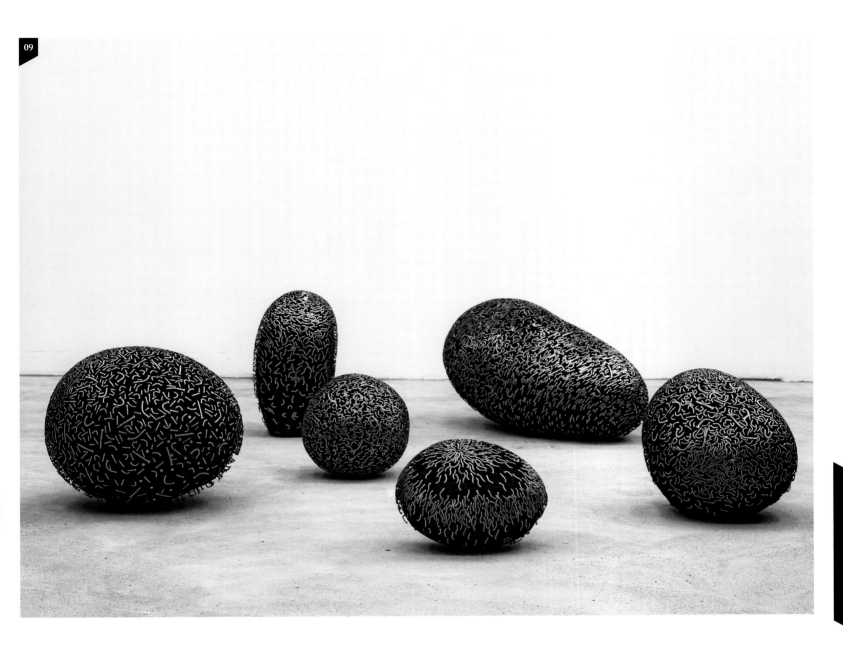

Luzinterruptus

The anonymous Spanish collective Luzinterruptus is known for light art in public spaces. Coming together under the cover of darkness, its members combine their skills in fine art and photography to create and document their stunning interventions. Their name is a construction of Latin origin, meaning 'interrupted light', which is a reference to the short-lived nature of their work: as they leave lights on in the city, other people turn them off or take them away.

The artists made their first forays in the darkest corners of Madrid at the end of 2008, with the simple idea of using light to focus people's attention on problems in the city that they felt went unnoticed. Since then they have been creating work prolifically across Europe and, in 2010, gained international recognition for their *Literature versus Traffic* project, which was created in the early hours on the streets of Brooklyn, New York. With this intervention they wanted literature to 'seize the streets and become the conqueror of public spaces, which for a few hours of the night will succumb to the modest power of the written word'.

Their projects are not all overtly political or socially motivated. Sometimes the inspiration is purely aesthetic, to highlight architectural or natural features, as in *An Almost Ephemeral Autumn* (2009): illuminating piles of yellowing leaves, the artists created mysterious nocturnal shadows. Using light affords great visual impact, changing the interpretation of an environment without having a lasting effect on the city.

In addition to LEDs, the group tends to use found and recycled materials such as plastic bags as props for its installations. 'Minimum resource use, maximum efficiency' is the artists' motto. Unfortunately they have not found anything more efficient and long-lasting than LEDs to create light, and so buying them in bulk remains the most costly part of their work. They are looking into photosensitive materials as a more ecological alternative, but at the moment these are difficult to control, and the other option of using a naked flame would be too risky.

Working with tiny flashes of light in an ever-changing urban environment is a challenging prospect. Although the team often plans how a project might look, much of the creative process is improvised in covert conditions as the works are predominantly unauthorized. For maximum impact the artists look for spaces that are poorly lit in

01

01, 02, 03 *An Almost Ephemeral Autumn,* fallen leaves, wire and LEDs, 2009.

04 *The Wind Brought Us the Crisis*, LEDs and eighty financial papers, Madrid Stock Exchange, Madrid, Spain, 28 April 2009. **05** *Literature versus Traffic*, LEDs and 800 found books, New York, USA, 2010.

Overleaf **06, 07, 08, 09** *Floating Presences*, LEDs, balloons and fabric, Rizoma Festival, Molinicos, Spain, 2010.

a city that is largely contaminated with light, which makes their work harder.

As well as their clandestine work, they have also had the opportunity to carry out large-scale, commissioned installations. In one such project, they were engaged by Madrid's City Hall to produce Christmas illuminations (*Caged Memories*, 2010), which were suspended in cages. However, as it was funded with public money, they invited local residents to participate by bringing along a well-loved possession to be caged with the

illuminations. Although they had not set out for it to be a cathartic exercise, it effectively became one as each person was eager to share the reasons for his or her choice of object.

With *Floating Presences* (2010) – a work commissioned for the Rizoma Festival of film and music in Molinicos, a small village in the Spanish province of Albacete – they set themselves the task of creating an army of lit 'beings' that floated in the river flowing through the town. The town was the setting

of cult Spanish film *Amanece, que no es poco* (1989), and Luzinterruptus wanted to reflect the surrealist atmosphere of that film. The installation lasted a week, and the river was left as it had been found.

Luzinterruptus help to restore public spaces for citizens and resist the rising tide of savage urbanism that is often detrimental to our quality of life. They leave their work as 'a small gift with an implicit message: that the street is for everyone, and with respect you can express yourself freely in it'.

07

10, 11, 12, 13 *Caged Memories*, 400 golden cages, personal mementos and LEDs, Plaza de los Ministriles, Madrid, Spain, 2010.

Maria
Nepomuceno

Woven, braided and threaded into being, Brazilian artist Maria Nepomuceno's vibrant sculptural installations trail across the spaces they occupy, sometimes suspended in mid-air or climbing up the walls like multicoloured rainforest creepers. Using a mixture of materials such as rope, straw and beads, her interconnected organic forms are based on a spiral construction that is reminiscent of DNA. This spiralling constructive process is not only practical but presents endless creative possibilities. For the artist, the spiral represents 'the deepest place of my being and infinite mystery. It is the movement of the umbilical cord, of cyclones, planets, DNA, galaxies, the universe.'

Nepomuceno's work has often been influenced and shaped by first-hand experiences. When she was 10 years old, her stepmother taught her how to knit simple braids. 'I enjoyed making braids and, then, braids of braids,' she recalls. 'Afterwards, I sewed a thick braid into a spiral, which was an early version of my work nowadays.' Encouraged by an uncle who was a painter, she studied drawing and painting at the School of Visual Arts at Parque Lage and then industrial design at the University of Rio de Janeiro, specializing in sculpture. Later, immersed in the personal experience of pregnancy, she began to reflect on the transformation of her body, 'especially the umbilical cord, the temporary organ able to connect worlds and generations, connecting space and time. I introduced ropes in my work as a representation of the umbilical cord.'

Rope became a signature feature of her sculptures: not only was it culturally and metaphorically symbolic, but it also had a simple, everyday quality that the artist admired. This attraction to down-to-earth, natural materials eventually inspired her to explore weaving techniques with straw. 'I'm fascinated by the possibility of using dry leaves to make baskets, as well as using wet earth to produce other things. That's why I decided to use braided straw in my work. It's a very interesting technique, which in Latin America was invented by indigenous peoples. When I started to work with the artisans from the north-east of Brazil, I realized that it is becoming extinct.'

Conceptually, Nepomuceno's sculptures draw inspiration from the fundamental

01 *Untitled*, ropes and beads, 2010. 02 *Untitled* (detail), sewn ropes and beads, 2008. 03 *Untitled* (detail), ropes, beads and fabric, 2010. 04 Performance, 2008.

Overleaf 05 *Untitled*, ropes, beads and fabric, 2010.

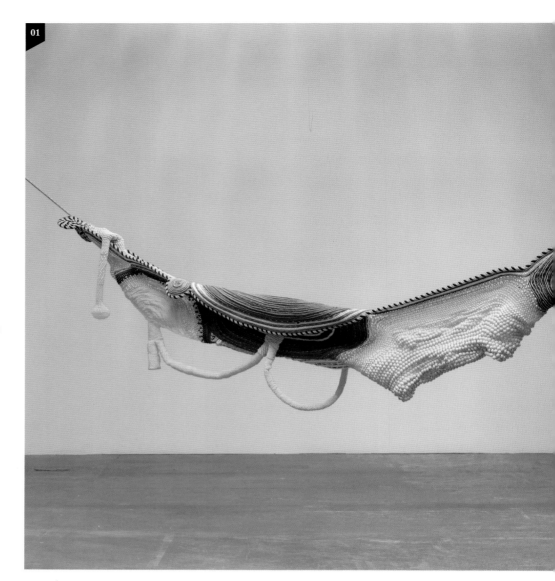

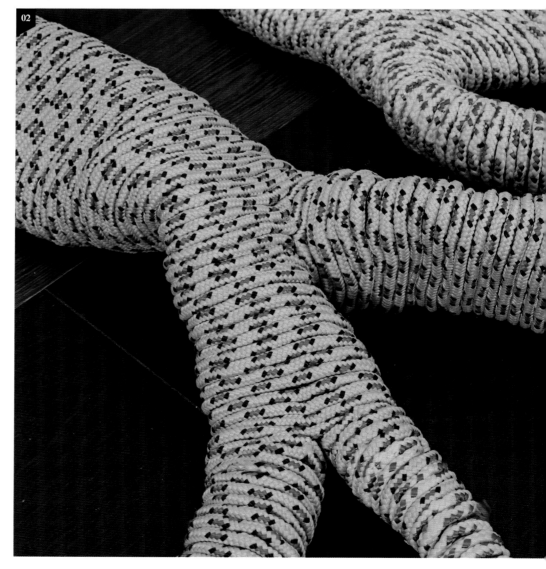

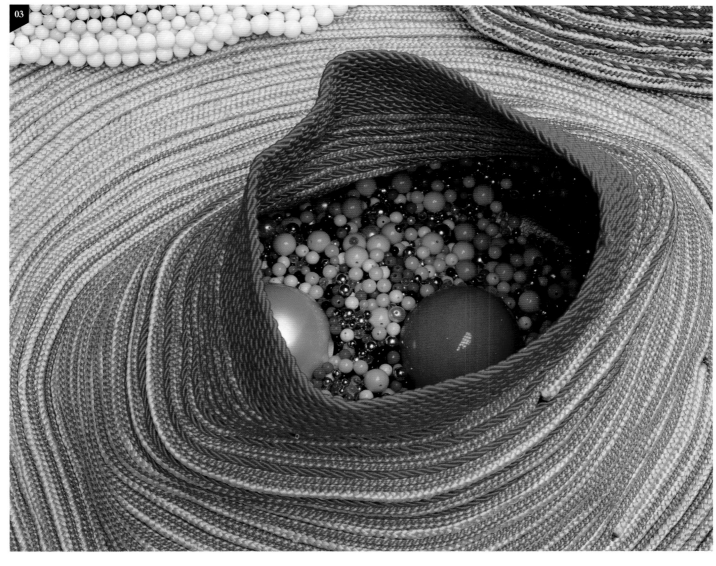

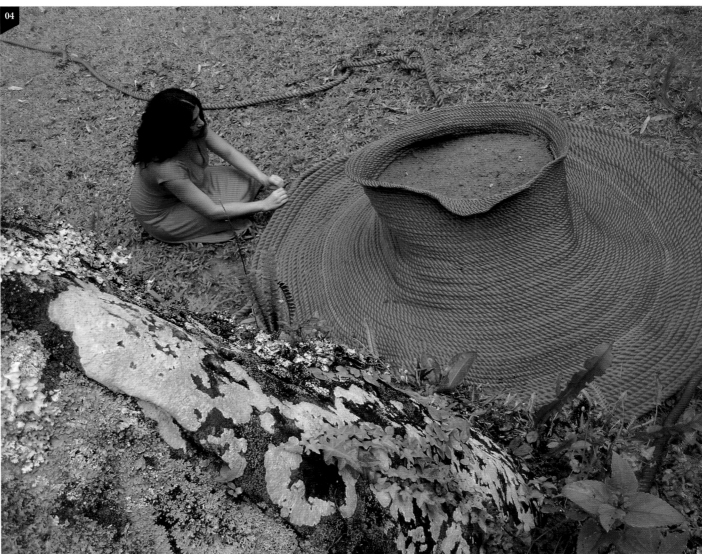

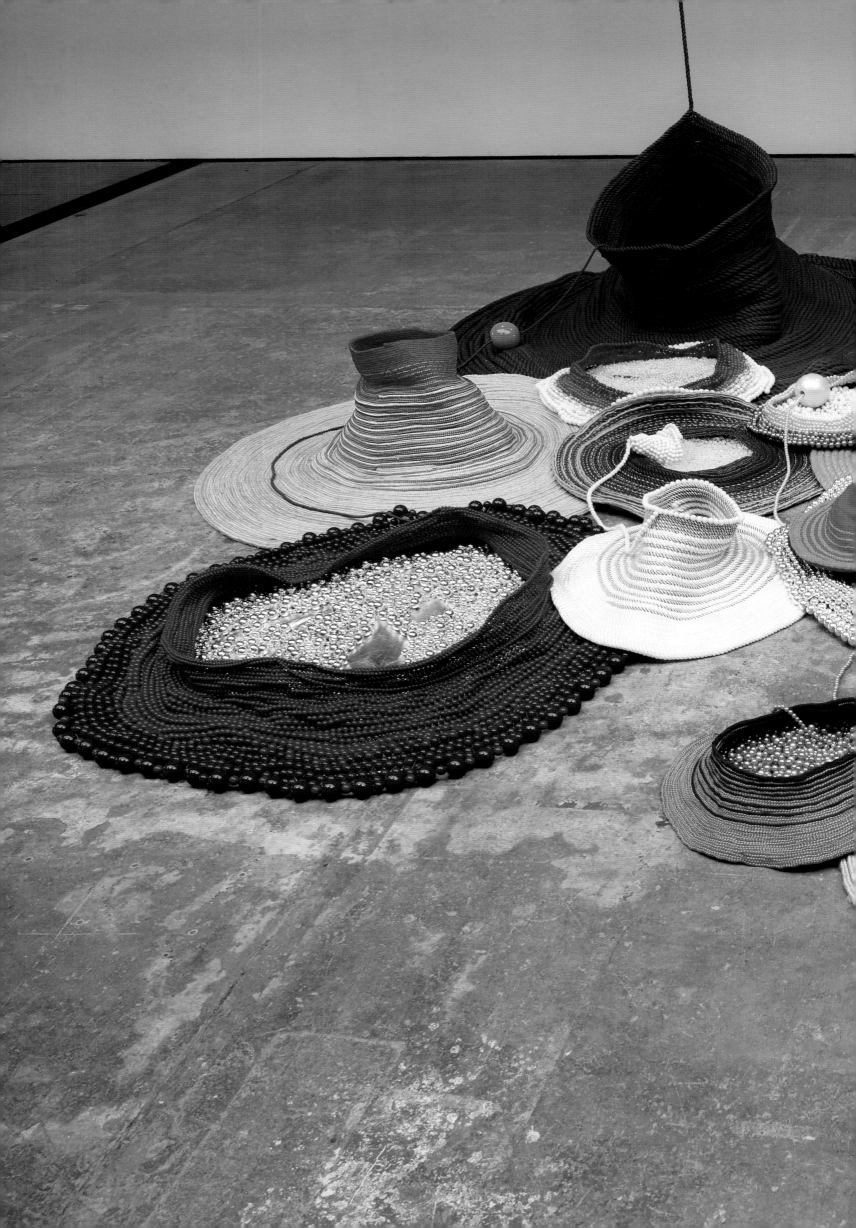

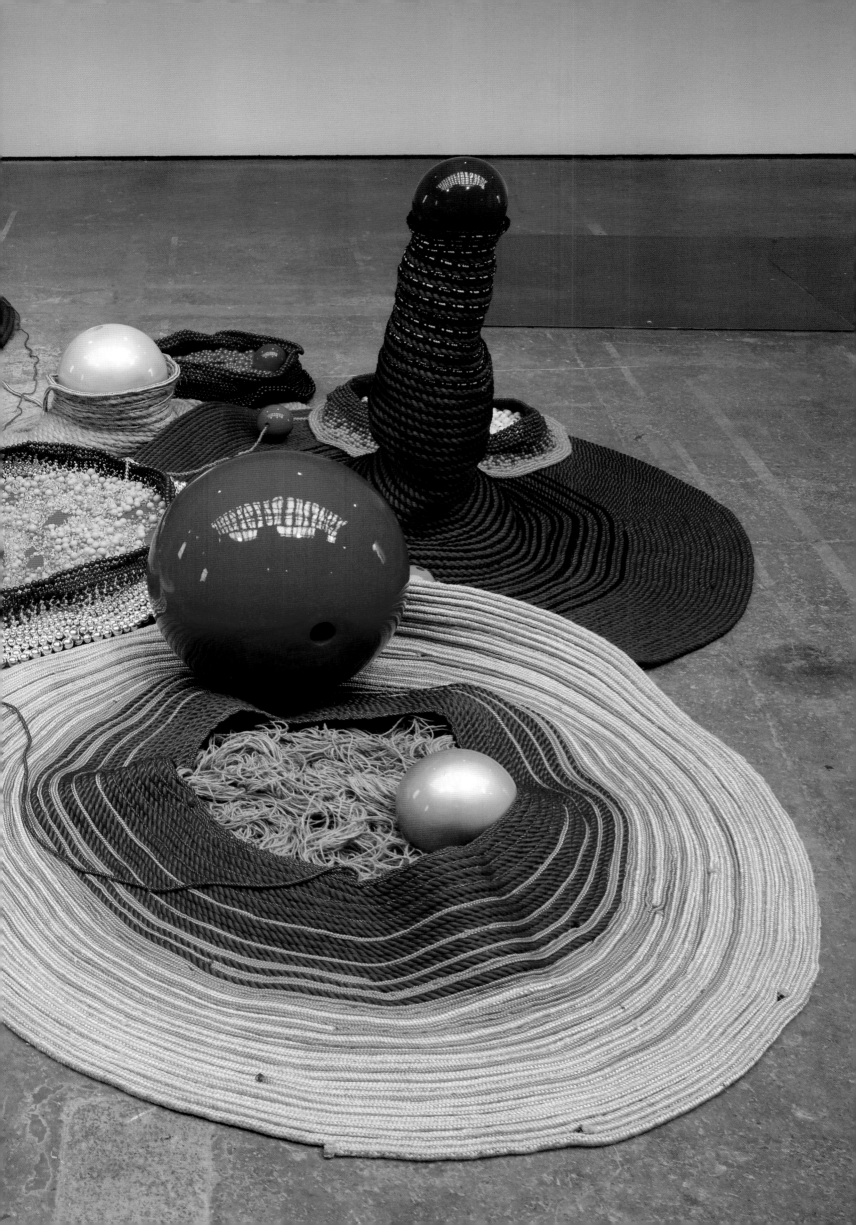

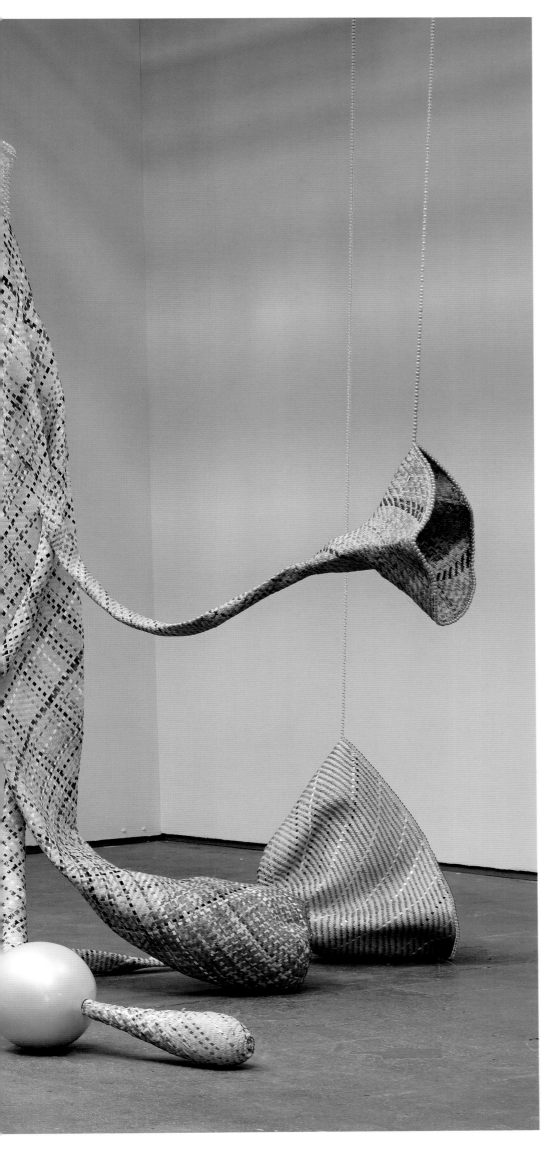

06 *Untitled*, braided straw, ropes and beads, 2010.

Overleaf 07 *Untitled*, sewn ropes and ceramics, 2008.
08 *Untitled*, sewn ropes and beads, 2008.

principles of nature, of DNA and the interconnectedness of life. Visually her amorphous forms remind us of microbes and body parts or perhaps relationships between people. Rope is used to represent an umbilical cord or a line that connects things, while beads can be seen symbolically as fertile points where infinite new beginnings are made possible. The materials and techniques she uses have an innate cultural significance through their indigenous use. The forms of her pieces often also have a connection with ancient traditions. She uses hammock-like forms, for example, to explore her fascination with their movement and the contrast between tension and relaxation.

In keeping with complex craft techniques, all the methods she has adopted are by hand. Before creating a piece she does simple drawings, but often makes decisions as she works. 'The colour and forms are always in a process of transformation,' she explains. 'Passing from one colour to another and from one size to another helps me keep the work in a state of infinite movement. Structurally, my intention remains the same when constructing sculptures: to make them in a spiral. Sometimes I think that I'm thinking more and more like a painter because I see the sculptures as three-dimensional areas of colour, where the colours are responsible for the balance of the volumes.' With a painterly eye, Nepomuceno presents us with a sensational world of budding forms that remain disarmingly attractive and mysterious.

Henrique Oliveira

The work of São Paulo-based painter and sculptor Henrique Oliveira is inspired by both urban living and forms found in nature. As a student he became attracted to the possibilities of a type of plywood that was ubiquitous in the city but at the same time went unnoticed. Known as *tapumes*, Portuguese for 'fencing' or 'boarding', this cheap laminated wood is used widely for temporary hoardings on building sites. Usually made from pinewood, the thin laminates are glued together, alternating the direction of the wood grain vertically and horizontally. Oliveira was drawn to the way this material would gradually crack, curl and peel when exposed to the weather to reveal layers of faded wood in different shades.

Oliveira had always been attracted to texture. Before working with plywood he had experimented with building up the surfaces of his paintings with newspaper and sand mixed with paint. At first he used the plywood in a similar way, but was soon struck by the potential of the tones and textures that occurred naturally in the material. As the wood deteriorates, the laminates separate into layers and colours, which he sees as similar to brushstrokes and the process of painting. This inspired him to use the material in both a sculptural and painterly way. A long process of experimentation and development followed: from two-dimensional art and collage, his work gradually became more three-dimensional.

Tapumes are flexible, but in order to build structures Oliveira needed something more pliable and strong. He began by using PVC tubes to create structural skeletons around which he moulded the plywood sheets, then later experimented with bender board, which also worked well. Today his base structures consist of wood alone or in combination with tubes and wire cages. He applies layers of wood, which he moistens to bend them into place. Over time these three-dimensional pieces have grown ever more ambitious in scale and architectural quality. While some of the smaller examples are comparable to abstract paintings created from undulating wood, his larger works combine the aesthetic of a painting with a sculptural installation.

One of his largest works to date, *Túnel (Tunnel)*, was created at the Instituto Itaú

01 The artist working on the sculpture *Coisa*, wood, PVC, gauze, cement, beeswax and polyurethane, 2008. **02, 03, 04** *The Origin of the Third World* (work in progress), wood, PVC and metal, São Paulo Biennial, São Paulo, Brazil, 2010.

Overleaf **05** *Tapumes – Casa dos Leões*, wood and PVC, 7th Mercosul Biennial, Porto Alegre, Brazil, 2009. **06** *Untitled*, wood and PVC, Centro Cultural São Paulo, São Paulo, Brazil, 2006. **07** *Paralela*, wood and PVC, São Paulo, Brazil, 2006.

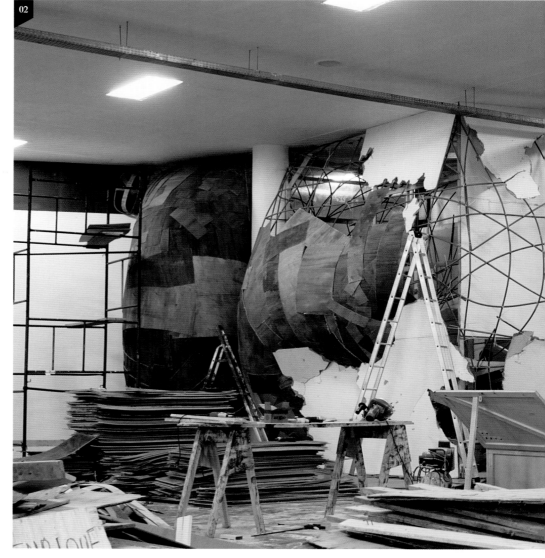

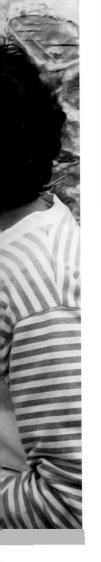

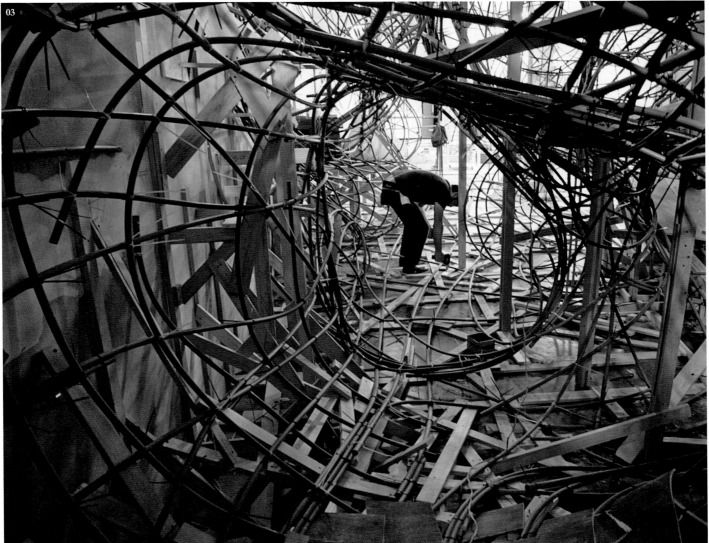

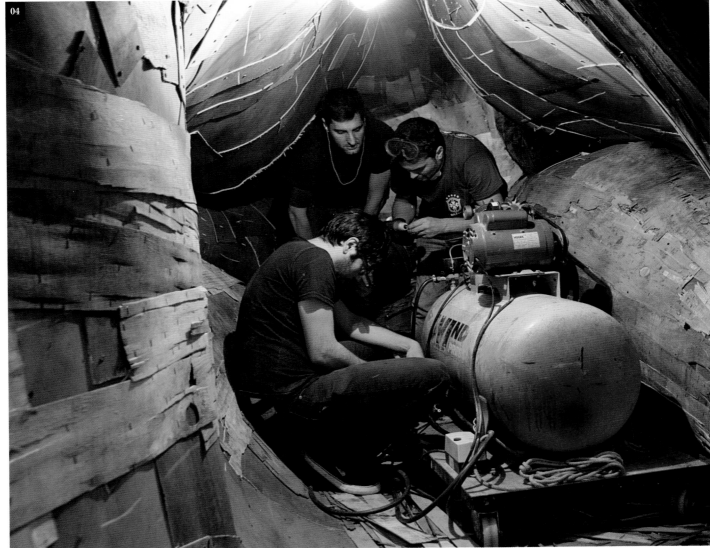

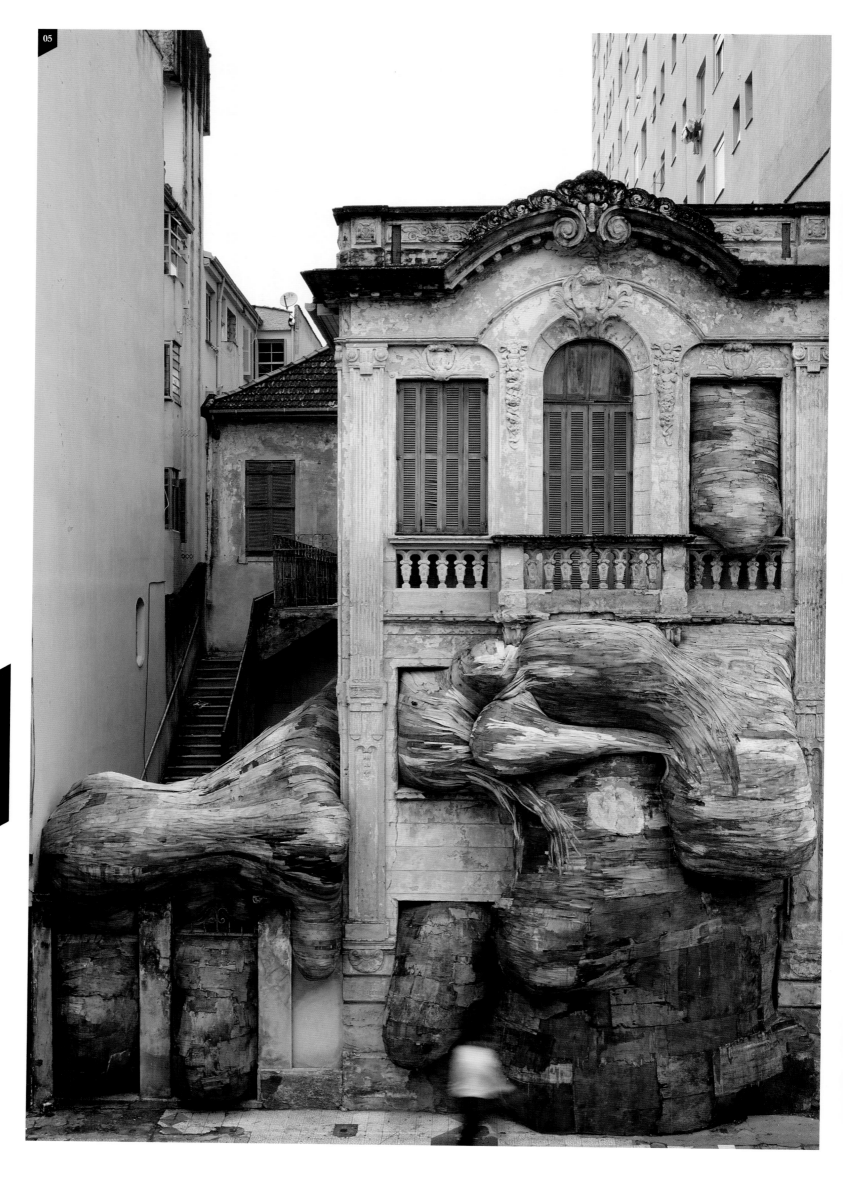

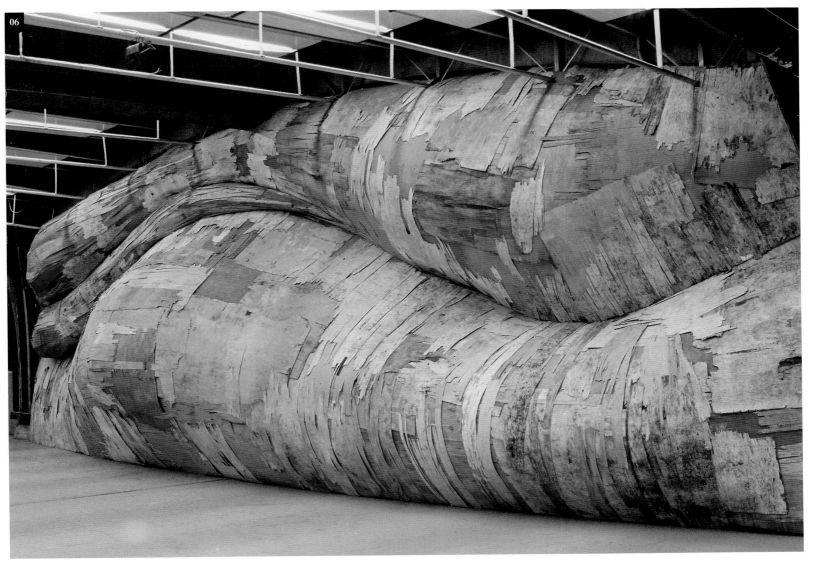

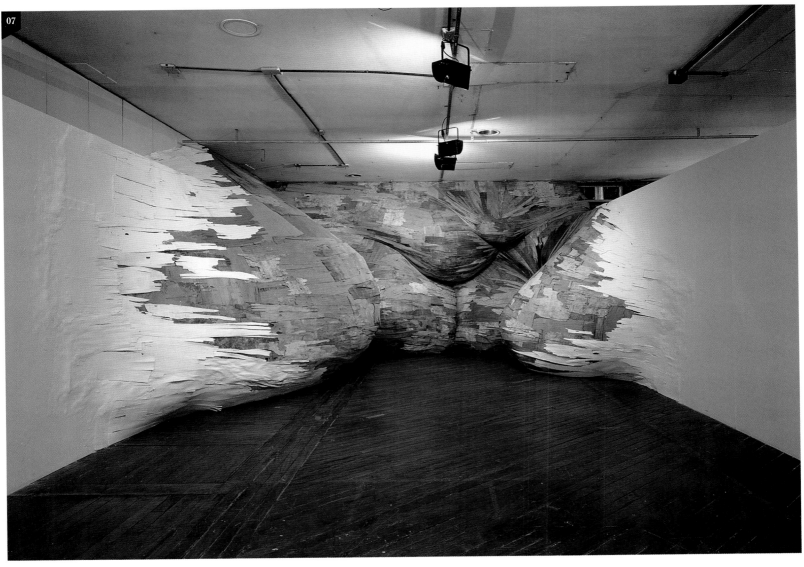

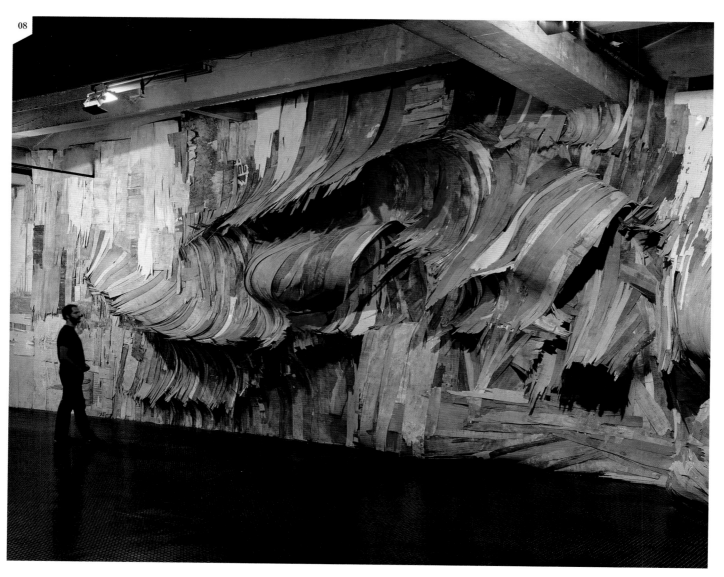

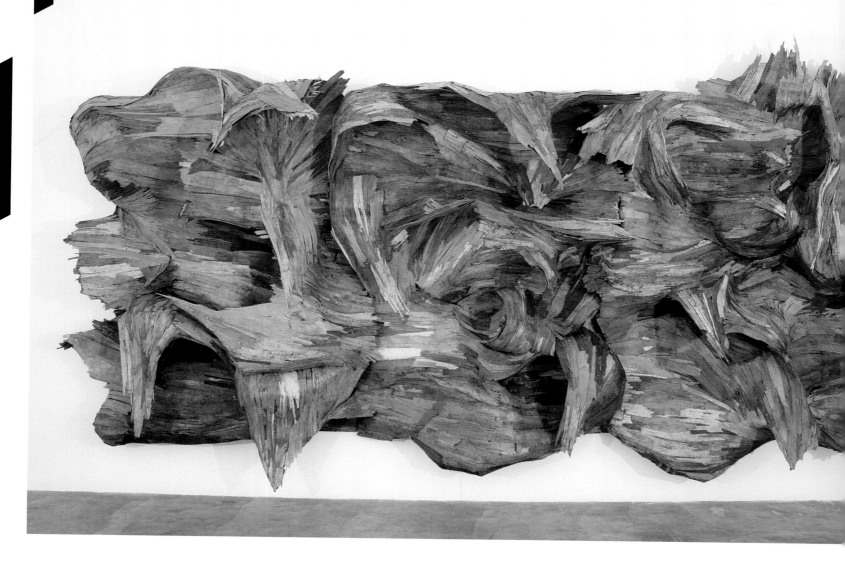

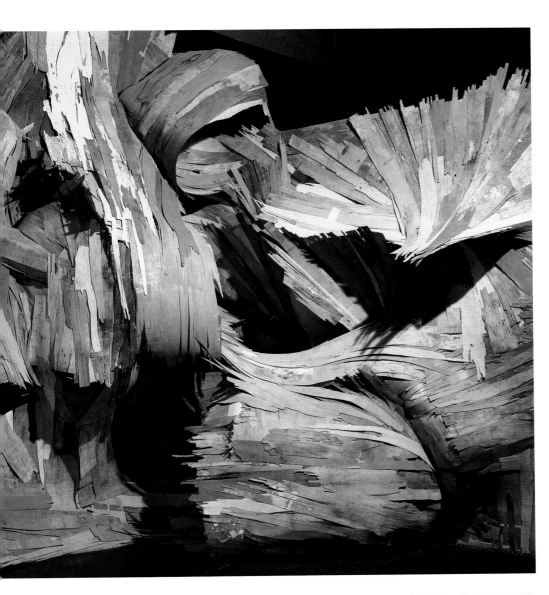

08 *Tapumes*, wood, Fiat Mostra Brasil, São Paulo, Brazil, 2006. **09** *Tapumes* (detail). **10** *Tríptico*, wood and PVC, 2008. **11** *Untitled*, wood, 2009.

Overleaf **12** *Túnel (Tunnel)* (entrance), wood, PVC and beeswax, Instituto Itaú Cultural, São Paulo, Brazil, 2007. **13, 14** *Túnel (Tunnel)* (internal view). **15** *Túnel (Tunnel)* (exit).

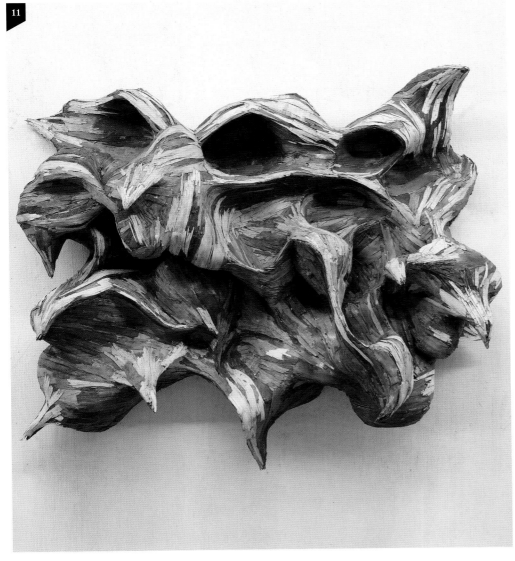

11

Cultural, São Paulo, in 2007. Made for the exhibition 'Future of the Present', it was a fully immersive environment that visitors were invited to walk into and in which they could feel and smell the materials. While it was built with an architectural logic, it kept its essence of sculpture. Ramps led viewers from the entrance to a small room covered with beeswax, or a closed-in space, or a narrow passage on the other side of the room.

Most of Oliveira's works stand in stark contrast to the pristine environments of galleries. In 2009, as part of the 7th Mercosul Biennial, he was given the opportunity to produce a sculpture that burst forth from an old colonial-style building in the centre of the city of Porto Alegre, Brazil. Entitled *Tapumes – Casa dos Leões*, the sculpture was built as if it had grown there. The rottenness of the wood in the work had a similar quality to the decaying walls of the building. As he observes, 'The once processed and industrialized wood somehow goes back to nature, to a transmuted form of nature. And it assumes an almost surreal look when it appears in the urban context.'

Oliveira continues to scavenge for plywood and other materials on the street or at the city's dumps. This activity is as inspirational as it is practical, since his observations of the process of decay in scrap materials and architecture are an influence on his work, while he also draws on the impressions and experiences of his formative years in the rural interior of Brazil.

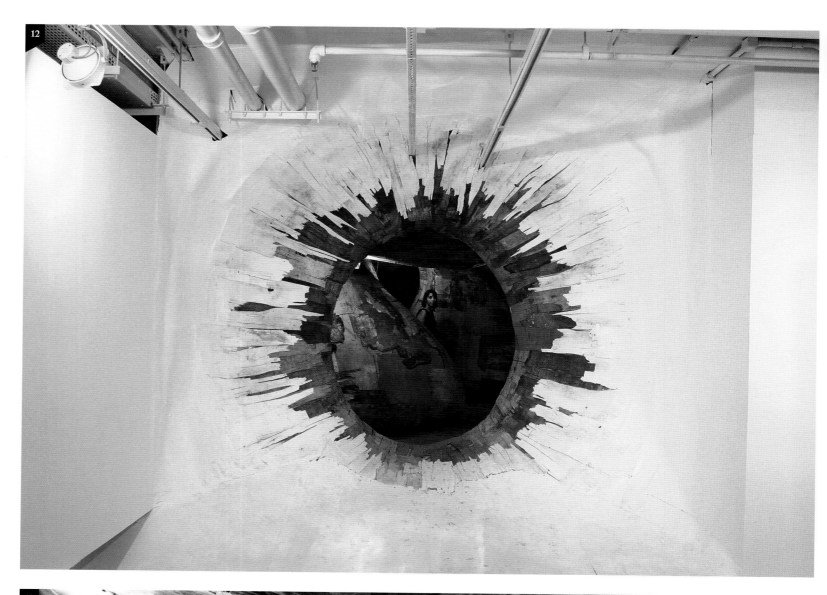

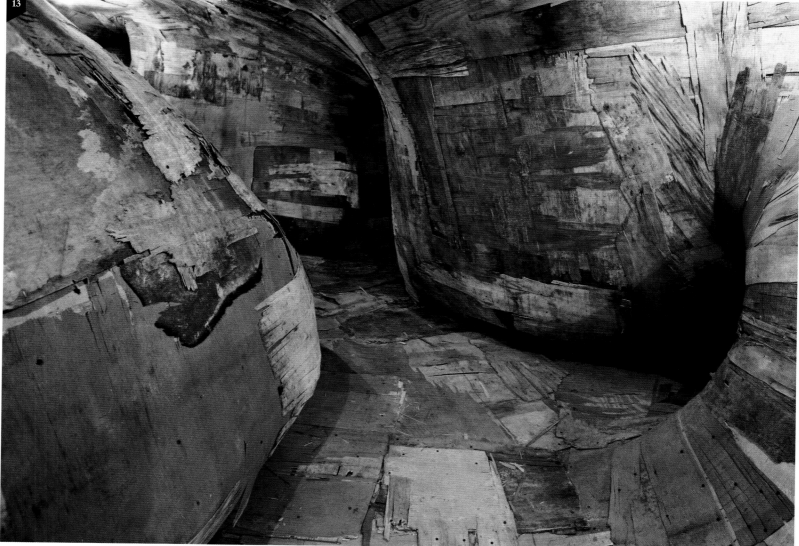

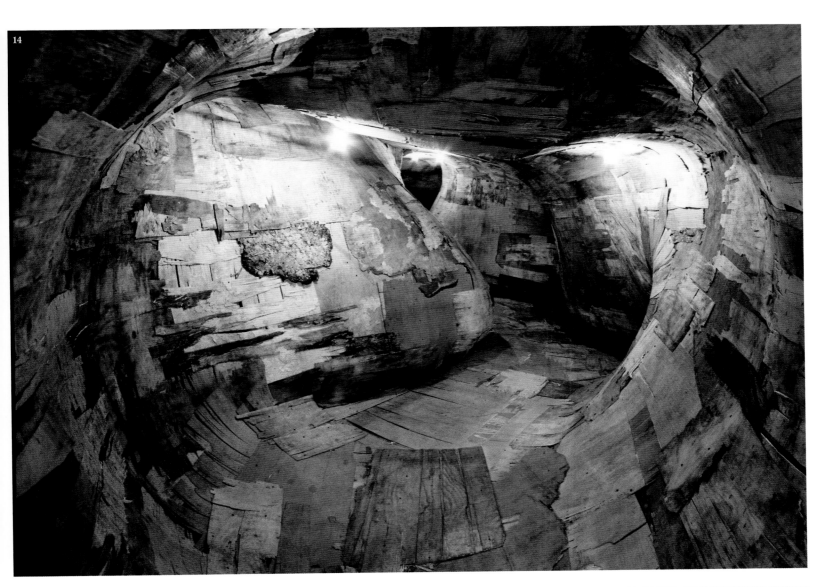

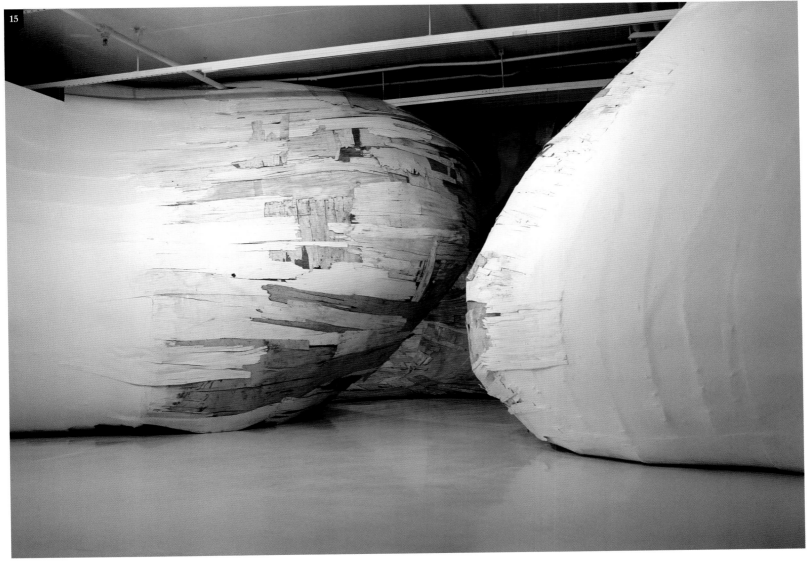

Erik Otto

Erik Otto is a San Francisco-based artist who works with reclaimed paint and materials to create installations and mixed-media paintings that are both conceptual and expressive. In addition to his art practice, over the years he has designed and constructed large-scale installations, theatre sets, retail shopfronts and independent film sets. He considers scavenging for useful trash an integral part of his artistic process. While he searches for suitable materials, he reflects on the concepts for the work he is about to create. In his own words: 'I often leave the initial stages of my work open and uncertain, while intuitively working out a resolution that will decide its final outcome based on the suggestive qualities of the medium and materials at hand.'

Every piece of material that Otto gathers has its own history and unique qualities that add an element of the unknown and allow more improvisation in his work. 'When I came across an abandoned tricycle,' he explains, 'I just knew I had to take it back to the studio and turn it into something. I repurposed it in a piece entitled *Slow Journey (Phase I)* for 941 Geary Gallery, where it was fashioned to look as if it towed a huge house behind it. This happens a lot. I am always looking to connect the things I come across with an upcoming project so that the time between them being discovered and being put to use is relatively brief – otherwise the studio begins to look like a dump.' In a more recent experiment he attaches lightbulbs to his paintings, an idea inspired by the work of Robert Rauschenberg. Instead of painting light, he thought it would be interesting to incorporate a real lightbulb, which gives it a more homely glow.

Mixing paintings, which he sees as clusters of ideas, with sculptural installations, Otto seeks to open a dialogue between different pieces in his shows, and his use of three-dimensional work, especially at a large scale, allows the viewer to take a more active role in the art. One running theme in his work centres on a beautiful dream that is being compromised by an undercurrent of destruction – a symbol of our living in a turbulent world: 'My goal is to take the viewer to a place where chaos meets peace and looseness meets refinement, and to depict the struggle to connect the awakened

01 *Collective Force* (blue), house paint, spray paint, screen print and pencil on panel with lightbulb, 2010.
02 *Dreamcatcher Phase I*, house paint, spray paint, reclaimed wood, glass window and arrows, 2010.
03 The artist with materials. **04** *Road of Prosperity (The Start of a New Beginning)*, recycled wood, house paint, spray paint and fishing line, 2010. **05** The artist's studio, recycled wood and house paint, 2010.

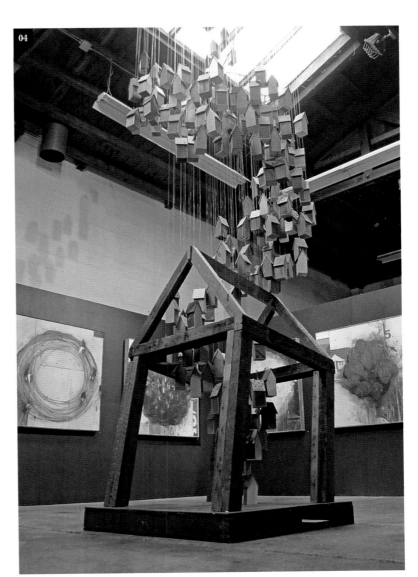

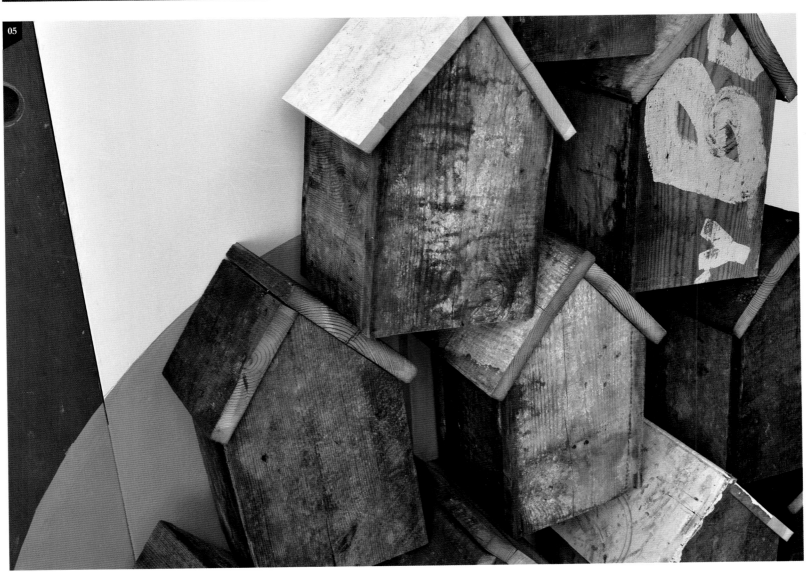

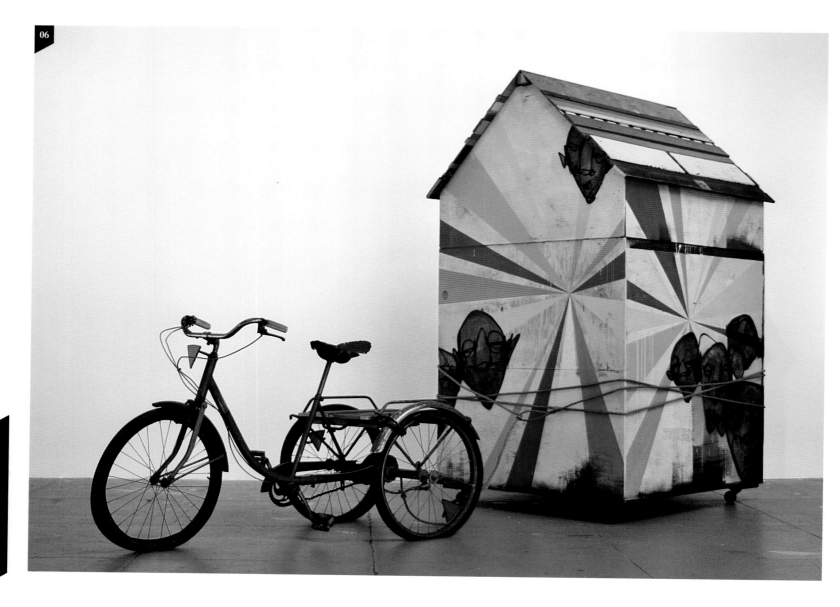

state to the desires found within. Drawing from a pool of symbolic imagery, I aim to create an honest reminder to pursue a life of significance and live out our dreams.'

One particularly personal symbol, which illustrates his central theme of living in the moment, is the house: 'The house is one motif that has stayed with me over the years, and even though some days I feel like moving on, some new disaster hits and the symbolism and possibilities of it grow even deeper. I believe that a lot of personal struggles can be resolved through creativity, but one needs the means to do so. It is said that in order to be creative you need to feel comfortable and safe, and the house is a symbol of just that. Other recurring motifs are the ever-evolving clouds and waves that represent the seasons of life and the reality that nothing in life is constant. Recently my work has involved circular motion and circles symbolizing the cycle of life and peace.'

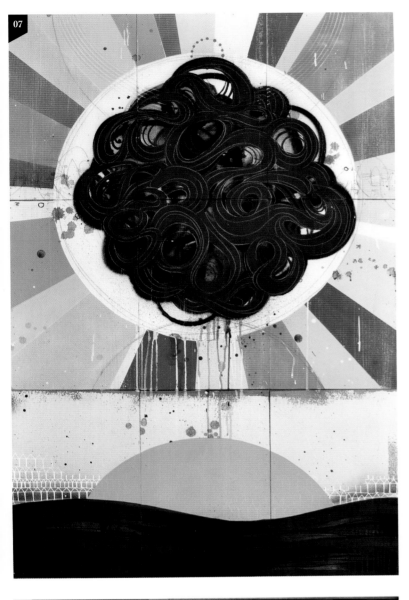

06 *Slow Journey (Phase I)*, house paint, spray paint, reclaimed wood, caster wheels, rope and found tricycle, 2010. **07** *Immunity*, house paint, spray paint, screen print and pencil on nine panels, 2010. **08** *Moment of Victory*, house paint, spray paint and pencil on scrap wood, 2009. **09** *Silence Speaks Volumes* (detail), house paint, spray paint, reclaimed wood and twine, 2009.

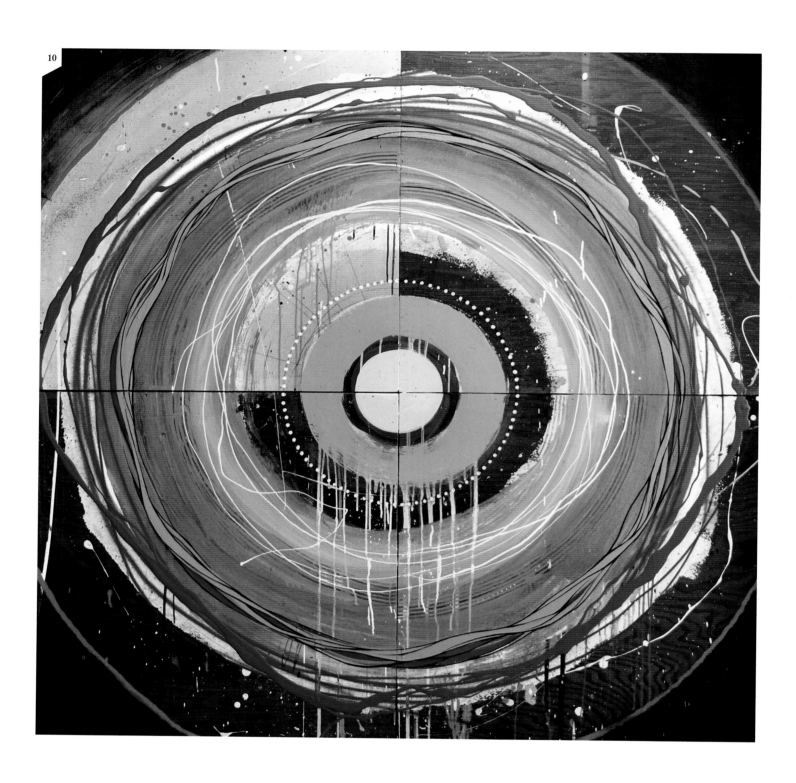

10 *Centripetal Force*, house paint, spray paint and pencil on four panels, 2010. **11** *Collective Force* (red), house paint, spray paint, screen print and pencil on panel with lightbulb, 2010.

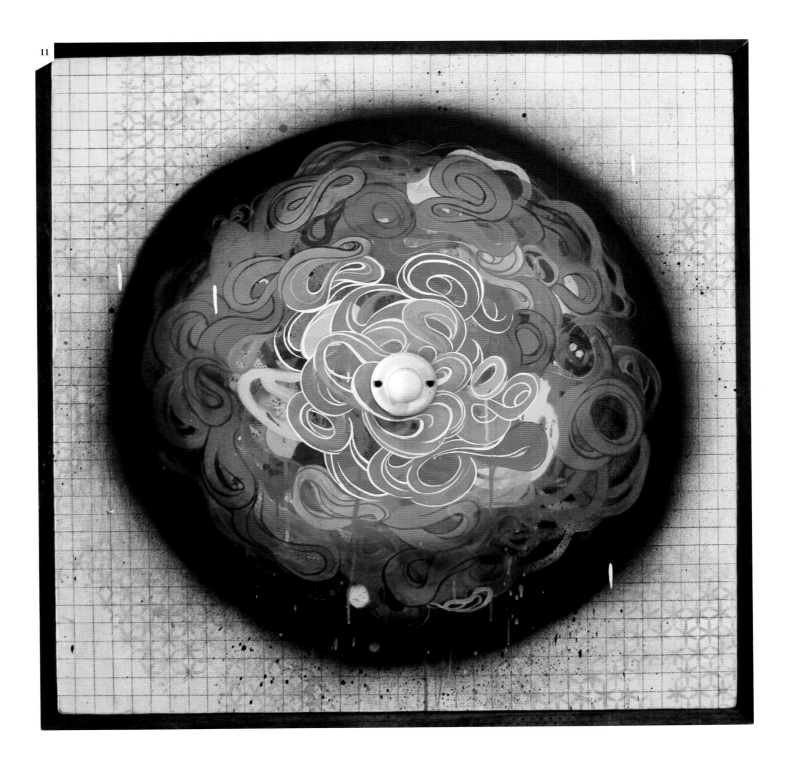

Mia Pearlman

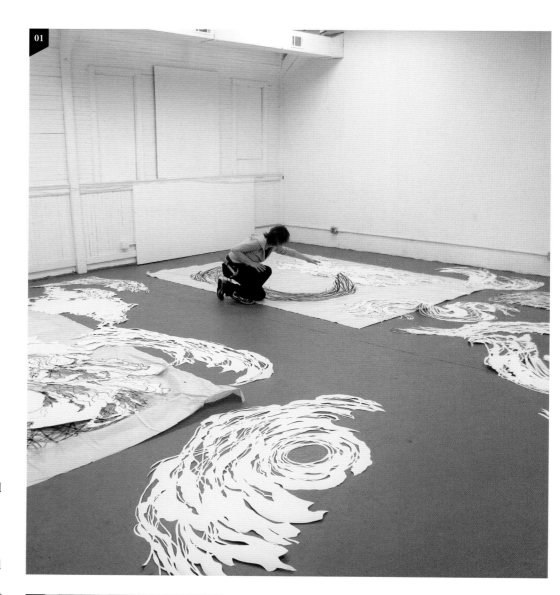

Brooklyn-based artist Mia Pearlman finds inspiration in the energy and beauty of natural forces and organic forms such as cloudscapes, icebergs, spider webs and tornados. In response to these natural wonders she creates atmospheric installations, collages and glass sculptures, as well as drawings and works on paper. Her gigantic cut-paper installations in particular have captured the public's imagination and have been exhibited in numerous galleries and museums. Referring to the works as imaginary weather systems, she describes them as 'ephemeral drawings in both two and three dimensions that blur the line between actual, illusionistic and imagined space'. Playfully interacting with exhibition spaces, these sculptural works burst through walls and windows or appear to hover in a corner as if frozen in mid-motion, often glowing with natural or artificial light.

Pearlman began drawing cloudscapes in graphite on paper in 2004–5 and later moved on to painted versions in tempera and gesso. In 2007 she started to make sculptures from her works on paper. The idea began when she planned to create some cloudscapes in a monoprinting technique using a knot-shaped paper cut-out as a resist. She enjoyed the process of cutting out the paper so much that she began to lose interest in the prints and instead tried out ideas with paper collages. One night she left a stack of cut-paper layers pinned to a wall. The next day they had come undone and by chance created a sensational hanging effect in the space. Within a week she was inspired to create her first cut-paper installation, *Whorl* (2007).

Since then she has continued to experiment with cut-paper sculptures and has established an intuitive working method based on spontaneous decisions. 'I begin by making loose line drawings in Indian ink on large rolls of paper,' she explains. 'Then I cut out selected areas between the lines to make a new drawing in positive and negative space on the reverse. Thirty to eighty of these cut-paper pieces form the final installation, which I create on site by trial and error, a 2-3 day dance with chance and control.' The cut-paper pieces have an unstable, finite existence, lasting the length of an exhibition, and are in a constant state of flux. Through this process of continual change, the artist reflects on themes such as creation, destruction and the transience of life.

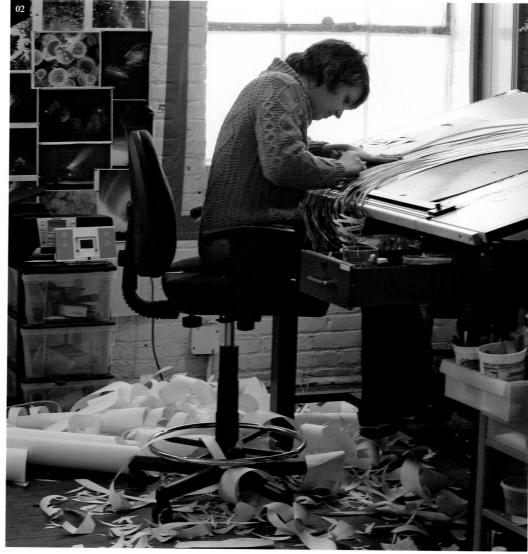

01 The artist at work at the Islip Art Museum, Long Island, USA. 02 The artist at work in her studio. 03, 04, 05 *Penumbra*, paper, Indian ink, paper clips and tacks, Plaats Maken, Arnhem, Netherlands, 2010.

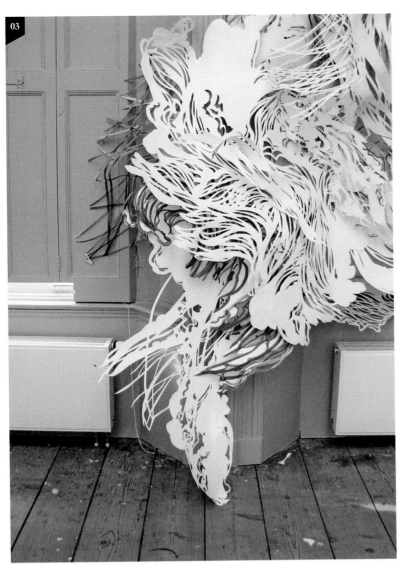

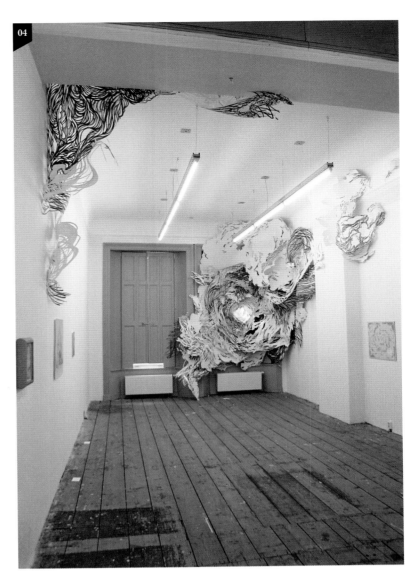

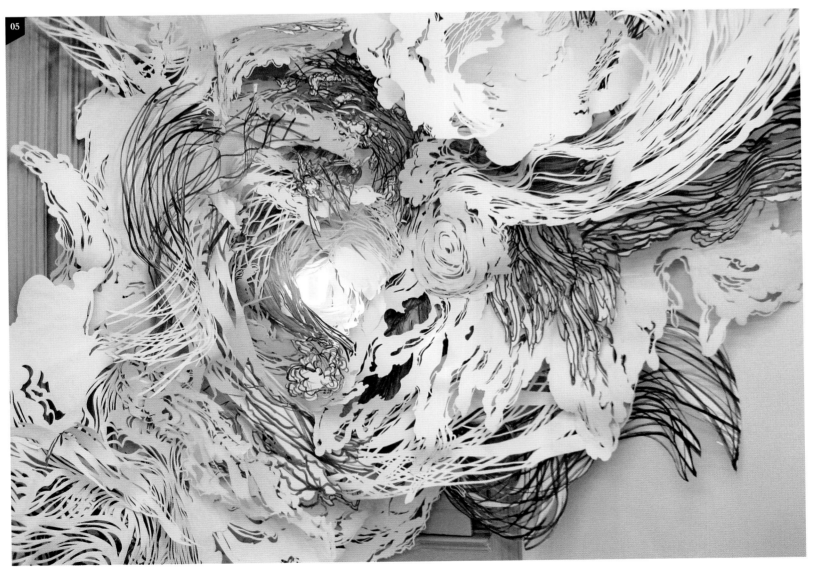

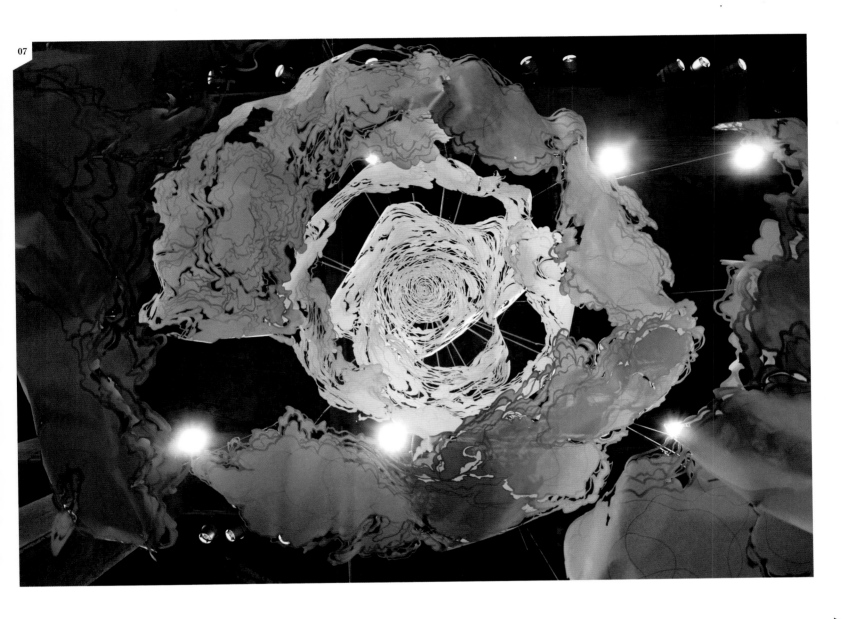

The changeable nature of paper is what attracts Pearlman to this material. It has a life of its own: rather than being passive, it curls, rips and sags of its own accord. Working with paper provides an element of chance that is integral to the process. The challenge is to see how far the material can be pushed before it falls apart. As she reflects, 'The installations come apart at the end only to become a new piece in a different show. The material is always in flux, as is everything else. There is such an attachment to making "things that last", or heirlooms that can be sold or passed down. While I understand the attraction of owning something for a long time, it's really just an illusion. Nothing lasts forever… It's only a matter of time. I embrace the absurdity of our desire for control when really life is pretty much up to chance. We can deny it, accept it, or never get out of bed. I try to allow these opposing but related aspects of reality to remain in conversation.'

From a formal perspective, Pearlman's work is essentially about space. Paper allows her to play with two and three dimensions by taking something flat and transforming it into volumetric forms without losing the qualities of the drawing. In her own words: 'There is space in the flat drawing, and flat drawings in the three-dimensional sculpture. I like toggling between the illusion of form and form itself.'

06, 07 *Maelstrom*, steel, aluminium, paper, Indian ink, monofilament and wire, Smack Mellon, Brooklyn, USA, 2008.

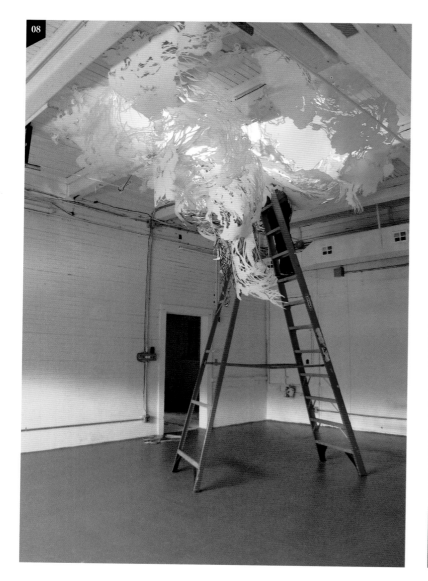

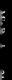

08 Islip Art Museum, Long Island, USA. **09** *Gyre*, paper, Indian ink, tacks and paper clips, Islip Art Museum, Long Island, USA, 2008. **10** *Influx* (detail), paper, Indian ink, tacks and paper clips, Roebling Hall Gallery, New York, USA, 2008.

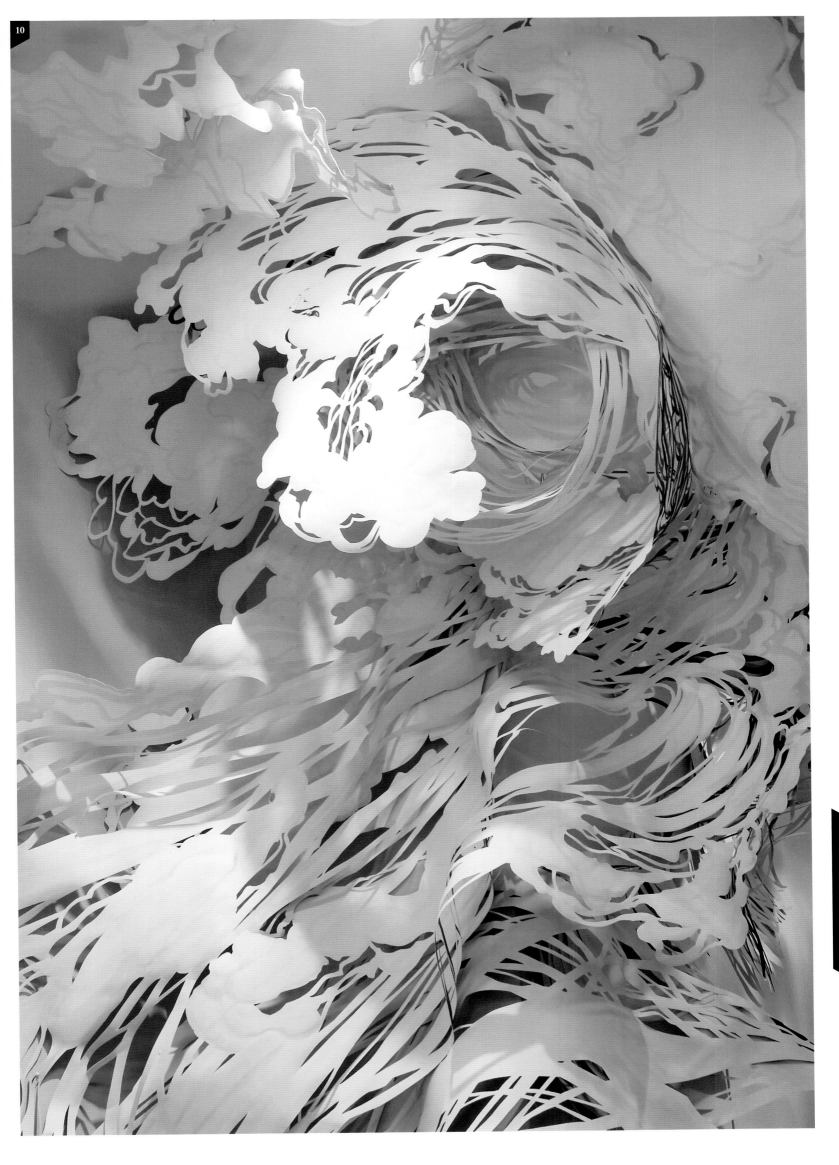

Lionel Sabatté

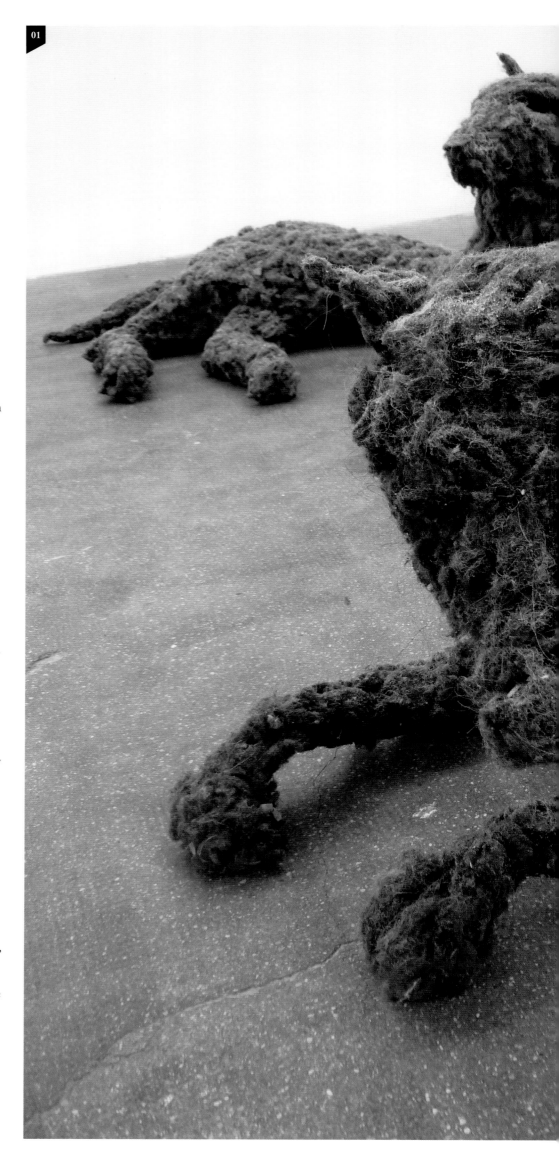

Living in Paris, Lionel Sabatté works across a broad range of media, including painting, drawing, sculpture and animation. Often his ideas and realizations are the result of spontaneous or improvised processes reminiscent of the postwar COBRA movement or early 20th-century Dadaist techniques such as assemblage. Predominant in his work is the idea of reuse: whether it is an outdated motif, organic detritus such as skin and nails, or ignored materials like dust, he uses concepts and materials as a sign of the passing of time and as a way of questioning artistic practices.

In his provocative and playful work, Sabatté often uses materials that are refreshingly unusual, be it in their ordinariness or their potential to shock or surprise. In a recent series of paintings, which includes *Souffles oxydants (Oxidizing Breaths)* of 2010, he combined two solutions – one iron-based, the other oxygen-based – in his work on canvas. The mixture began to rust very quickly as if time had been sped up. The result is the chemical equivalent of organic decay, with the fabric of the canvas also becoming distressed and aged. As the paintings blister and corrode, they can be seen as a subversive interpretation of the vanitas theme in art, reminding us of the transience of life.

Similarly the artist is attracted to dust as a material since it contains within it evidence of the passing of time. Largely made up of hair and dead skin, dust in the home or other interior spaces is the result of a continual process of regeneration (human beings renew all their constituent cells in around a month) and as such contains a strong existential dimension. Using dust carefully gathered from Châtelet – Les Halles Métro station, where large crowds congregate every day, Sabatté incorporates it into his work, forming it into a series of wolves and other figures. He chose this place to collect the dust as, in his own words, 'a huge number of people pass through there every day. Paris is also the most tourist-orientated city in the world, so in view of both of these facts, this dust is the most amazing collection of particles left behind by living people! It's a poetic way of collecting a wide social and genetic sample.'

Using this strange harvest, carefully dated, the artist presents this debris in suspension, affording it a new materiality, and giving concrete sculptural form to the elusive nature of passing time. Like Marcel Duchamp

01 *Février* and *Septembre*, wolves made from dust collected in the Paris Métro, 2006. **02** *Février, Août* and *Septembre*, wolves made from dust collected in the Paris Métro, 2006. **03** *Août*.

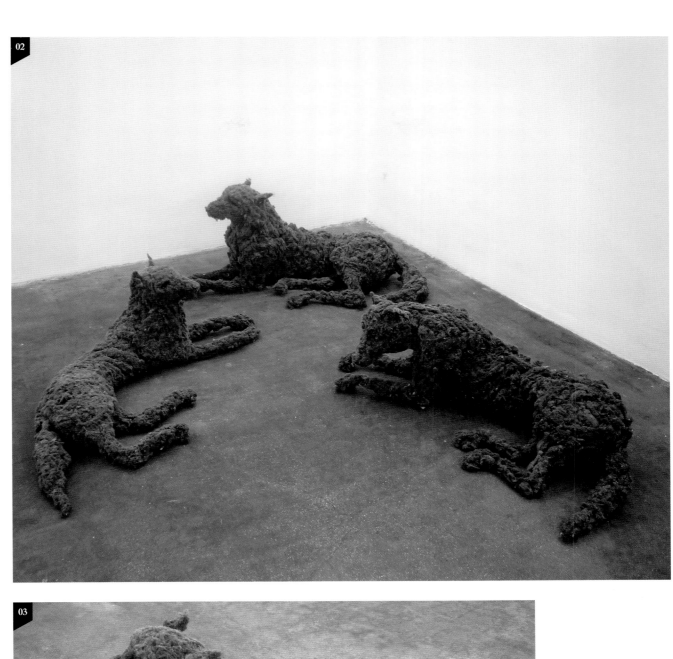

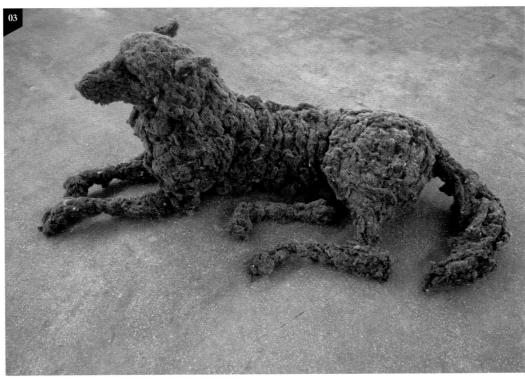

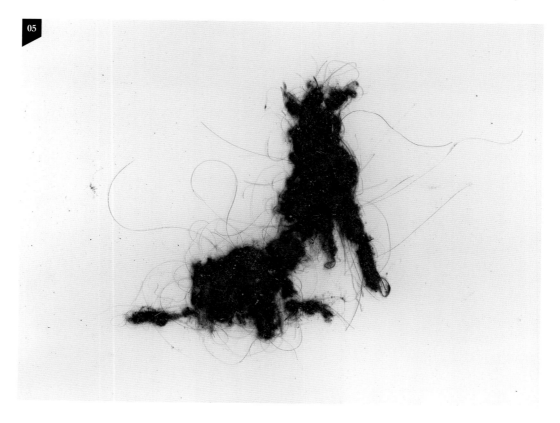

04 *Étude à la poussière II (Study in Dust II)*, graphite and dust on paper, 2010. **05** *Étude à la poussière IV (Study in Dust IV)*, graphite and dust on paper, 2010. **06** *Hells Angels no. 1*, in collaboration with Baptiste Debombourg, natural pigeon and artificial feathers, 2009. **07** *Hells Angels no. 1* (detail).

and his *Dust Breeding*, immortalized like a lunar landscape in a photograph by Man Ray (1920), Sabatté introduces the idea of duration into his work, and imprisons it like the sand inside an hourglass. As well as its existential dimension, Sabatté was initially attracted to the soft and light texture of this medium. The inspiration for the work first came from looking at a dust ball at home, called a 'dust sheep' in French. This gave him the idea of making a miniature wolf from dust, the same size as the ball, and later his

larger wolves. What had started out as a play on words became a multifaceted project: 'I realized that the joke was more layered than I had at first thought. Dust embodies the idea of disappearance and death too. Using dust as a construction material was kind of a way of thumbing a nose at the passing of time.'

Sabatté shares similar preoccupations with fellow French artist Baptiste Debombourg (also profiled in this book), which led to the cooperative project *Hells Angels no. 1* (2009). In this work Debombourg

concerns himself with the volume and space in sculpture, while Sabatté focuses on painting and the flow of colours. Made from road-kill pigeon preserved through taxidermy and decorated with artificial feathers, this piece is not for the squeamish and reminds us of our inevitable mortality. Rubbish and detritus tend to have a stigma attached to them that can make us feel uncomfortable. By reusing these materials, Sabatté conveys basic environmental truths and the mortal nature of all things.

Chris Silva

Based in Chicago, Puerto Rican-born Chris Silva developed an early interest in art through his love of graffiti and street art. His formative years were shaped by his experiences of creating art on the street, his passion for 20th-century art history and, later, formal training. This diverse background is reflected in his active search for 'opportunities in accidents, unusual combinations of materials, the unpredictable outcomes of collaboration and the general adventure of the creative process', which he pursues through mural and public art commissions as well as multimedia installations. While his work has a recognizable style and approach, he views art as a way of thinking and acting in the world rather than a stylistic or material practice.

Silva's work fuses pictorial painting with three-dimensional constructions created from found materials, in particular weathered and highly textured objects made from wood. In practical terms he compares this process to making an oversized three-dimensional collage: he assembles and screws together the pieces, paints them, and then adds cutout figures and drawn elements. The overall effect is like viewing a snippet of a story. Silva likens one work, *Projections & Delusions* (2006), to 'a snapshot of a strange cartoon episode based on environmental abuse, financial pursuit and greed'.

The artist finds working with discarded materials hugely rewarding and compares it to a game: 'The materials are already full of energy and a mysterious history. People I don't know had some part in their design, selected the paint colours, and then maybe different people lived with the objects for a period of time. Perhaps the wood was painted over numerous times, and those layers are then exposed decades later by the demolition of a building. Then of course there's all the additional richness and patina added by the elements. I feel good about going to work in my studio since there's a level of warmth and aesthetic appeal in the materials that surround me before I even get to arranging them into individual pieces.'

Silva and his partner Lauren Feece lived near a beach in Puerto Rico for several years and produced an extensive body of collaborative work, often using materials found washed up on the shore. A large installation on a secluded beach in Aguadilla, which took five days to complete, was the culmination of their oeuvre during this period.

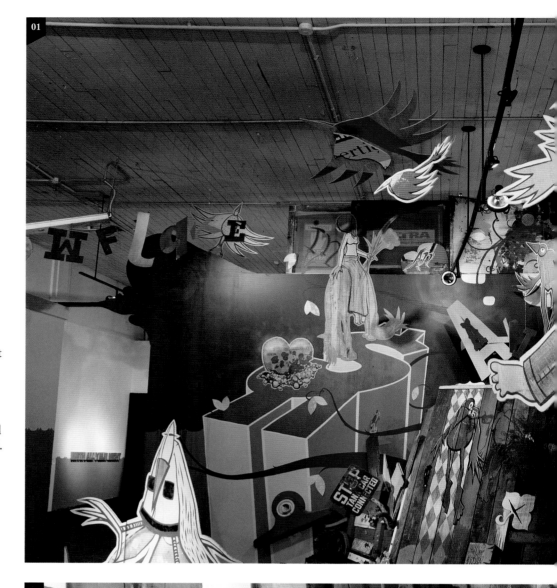

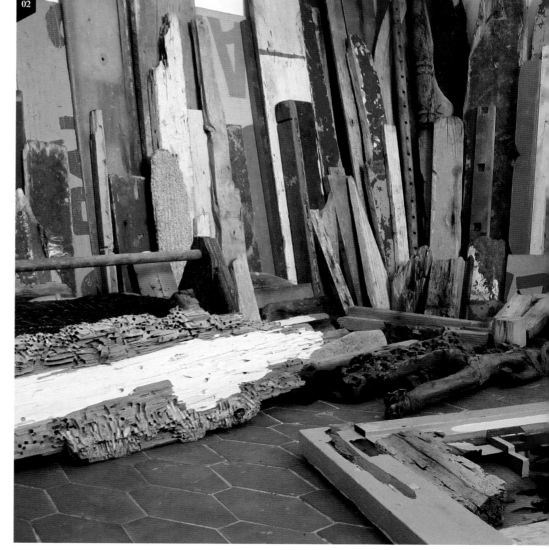

01 *No Snowflake In An Avalanche Ever Feels Responsible*, Walker's Point Center for the Arts, Milwaukee, USA, 2006. **02** Studio materials. **03** Work in progress. **04** *Projections & Delusions* (work in progress), 2006.

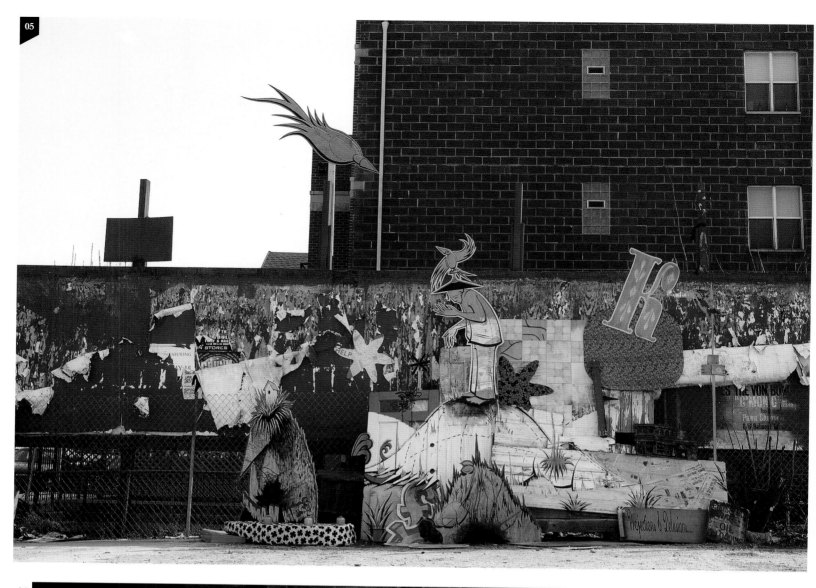

Virtually all the materials used in the installation were found on the beach, with much of the driftwood coming from boats. Part of the attraction lay in the transformation of colourful rubbish in a new context, something they describe as an 'extreme beach trash makeover'. They left the work in situ for three weeks and found it mostly intact on their return, so they decided to ship the work home.

Silva puts far greater weight on the collective consciousness than the individual ego. As a result, collaboration and community

are key elements in his work. This is true not only of the way he works with others, but also of his approach to the materials. 'It's very important to me to leave part of the original surface exposed when I paint an object. In retaining the raw quality of the original objects, the final pieces essentially become collaborations with all the people who played a part in the life of those objects before they found their way into my pieces. That makes them great visual metaphors for the harmonious human connections that I am trying to foster in my own strange way.'

05 *Projections & Delusions*, 2006. 06 *Open Hearts Urgery*, in collaboration with Lauren Feece, The Group Group Show, Version Kunsthalle, Chicago, USA, 2006. 07 (*above*) *Se Cambian Que?*, reclaimed wood, enamel paint and plastic, 2005.

Lucas Simões

Lucas Simões is an independent Brazilian artist working in São Paulo, with a background in architecture and design. His experiences of training as an architect redefined his perception of art and opened new paths of discovery. In architecture, he says, 'a drawing is more than a drawing: it is the intent that something concrete will materialize through the construction process'. This outlook has influenced his drawing process and his constructive approach to his work with collage and sculpture.

With great inventiveness Simões uses source materials such as maps, books and photographs, which he then folds, cuts and deconstructs into new forms. 'In my work', he explains, 'the materiality of the supporting medium is important. The process of making the support a part of the work is achieved through the experiences it is subjected to, such as burning, cutting, distorting or diluting, which, at its most extreme, can destroy the subject.'

In a series of works called *Unportraits* (2010), he invited friends to tell him a secret and captured the expressions on their faces as they revealed it. Each photo session generated between 200 and 300 shots, of which he chose ten different portraits to cut and overlap. The subjects were asked to choose a colour associated with the secret, which Simões then used in the work. Depending on his interpretation of the moment, he created different types and shapes of cut for each subject. Developing each design on paper, he uses design software for architects (AutoCAD) to achieve greater precision and plan the layering of a piece. The result is like a topographic map, with the layers of each cut photograph resembling curved contours. Using the precise computer drawings, he then cuts the photographs by hand with an X-Acto knife.

With this and other similar portrait series, the finished piece deconstructs the person's face into shredded segments as if viewed in a hall of mirrors. The once flat images become objects with labyrinthine depth through the process of layering. As well as exploring man's multiple layers, the *Unportraits* series comments on the legal requirement in Brazil to carry photo ID. As Simões points out, the standard 3×4 cm ($1 \frac{1}{8} \times 1 \frac{5}{8}$ in.) photograph 'tells the least about us as individuals'. The *Unportraits*, at 30×40 cm ($11 \frac{3}{4} \times 15 \frac{3}{4}$ in.), were enlarged in proportion with the

01 *Estudo para 'tua paisagem' (Study for 'Landscape of You')*, laser print, 2010. 02 *Self-portrait*, digital collage, 2010. 03 *Estudo para 'tua paisagem' (Study for 'Landscape of You')*, laser print, 2010. 04, 05 *Requiem*, 10 cut-out C-prints, *Unportraits* series, 2010.

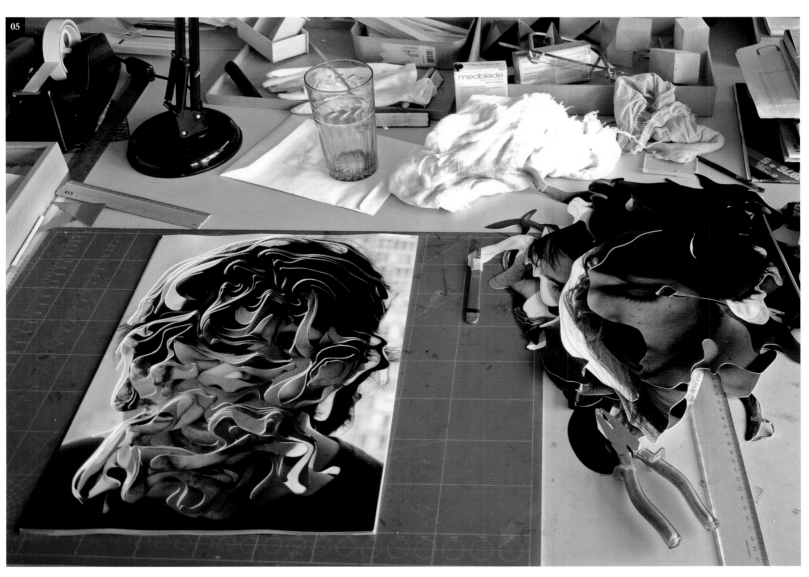

06 Study for *Unmemory*, 10 cut-out C-prints, 2010. 07 Study for *Unmemory*, 10 cut-out laser prints, 2010. 08 Study for *Unmemory*, 10 cut-out C-prints and laser print, 2010. 09 Study for *Unmemory*, 10 cut-out C-prints, 2010. 10 (*above*) *Adios*, ashes of burned photographs over portrait inside a box, 2010.

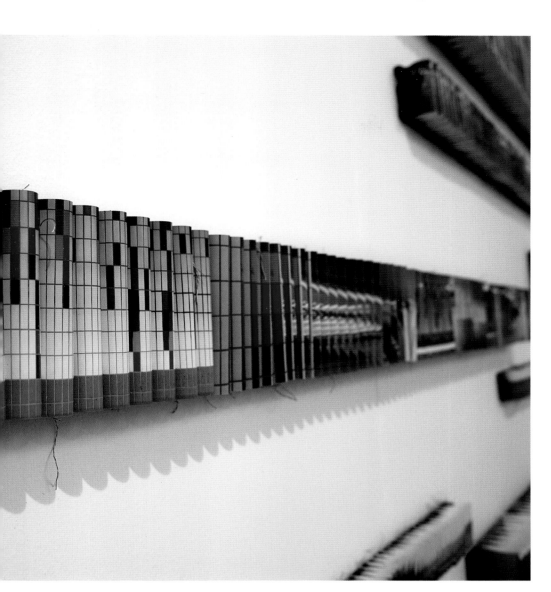

11 *Estudo para 'tua paisagem' (Study for 'Landscape of You')*, laser print, 2010. 12 *Quasi-cinema (Paradestrasse)*, sewn photographs on fabric and wood, 2010. 13 *Quasi-cinema (Zoologischer Garten)*, sewn photographs on fabric and wood, 2010. 14 Installation view of three works in the *Quasi-cinema* series, sewn photographs on fabric and wood, 2010.

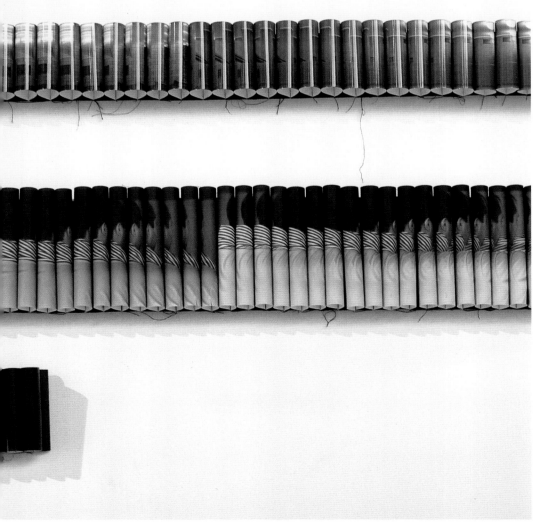

standard format, but through the layers the artist points to the fact that, as individuals with diverse experiences, each of us is a unique story composed of innumerable different facets.

In another series of works called *Quasi-cinema* (2010), Simões explores the idea of film frames. Choosing an ordinary photograph as his subject, he produces multiple copies of the image but alters each slightly: by moving the image a few millimetres within each frame, he creates an illusion of time and motion when the pieces are arranged in sequence. The photographs are rolled and woven together along the horizontal edges so that just a portion of each image is visible. They are then fixed to a support of wood to form a wave of frames and create the sensation of movement. In this way the pieces interpret cinema in a physical way, perhaps in an attempt to give some materiality to it.

In all Simões's many constructive experiments and heavily layered, distorted works, his intention is to intervene in the original meaning of an object or image and create a new representation that oscillates between beauty and strangeness, movement and depth. 'There is a kind of perversion in it, to take the meaning out of place,' he says. 'Strangeness is something that fascinates me, and to make it beautiful is even better.'

Yuken Teruya

Yuken Teruya was born in a rural village on Okinawa, one of a group of Japanese islands in the Pacific Ocean. Once an independent kingdom, Okinawa had its own language and religion but was annexed and subsumed by Japan in the 17th century. After the Second World War, the island came under the trusteeship of the United States for nearly three decades and still hosts a number of American military bases. Although part of Japan, it has preserved many of its traditions and crafts owing to its distance from the mainland. Traditional techniques such as Okinawan *bingata* textile stencilling, used to decorate kimonos, influence Teruya's work. Teruya's Okinawan upbringing has given him the opportunity to experience and observe Japanese culture from a distance while still being part of it.

Teruya studied at Tama Art University, Tokyo, and the School of Visual Arts, New York. During his time in the USA he became strongly influenced by American cultural forms, graffiti and advertising, which he began to contrast with traditional Japanese crafts such as origami. This is shown to great effect in one of his best-known series, *Notice – Forest* (1999–), in which the artist cut out a branch- or foliage-like silhouette on one side of a salvaged paper bag, allowing light to filter through into the interior like sunlight, and then used some of the cut-out parts to create a model of a tree inside the bag, as if it were growing there.

He began to take notice of the interiors of paper bags at art school and decided they were the perfect environment in which to resurrect a tree. Symbolically, the image reminds the viewer of the material origins of the bag. At first Teruya experimented with brown paper bags but gradually he realized that commercial bags from companies such as McDonald's, Starbucks and Christie's auction house also held potential. The colours on fast food and other printed bags reflect the passing seasons in the forest, as well as the conflict between nature and commerce. On first view it appears that the bag is holding up the tree, but it is in fact the strength of the tree that supports the bag.

Teruya has a knack for seeing the potential in the most humble materials. Evoking Aristotle's philosophical musings about an acorn realizing its potential to be an oak tree, whenever Teruya sees a paper product he considers how he can bring the tree back through his work. In his *Rain Forest* project (2006–), he hangs toilet rolls with sprouting paper branches from the ceiling to

01 *Rain Forest* (detail), thirteen toilet rolls, magnets and chains, 2006. **02** *Corner Forest*, toilet rolls, 2008. **03** *Corner Forest* (detail).

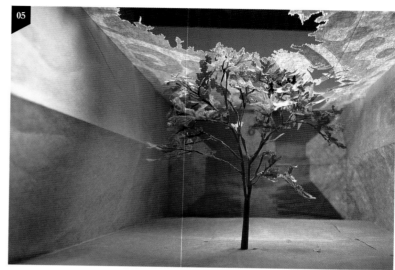

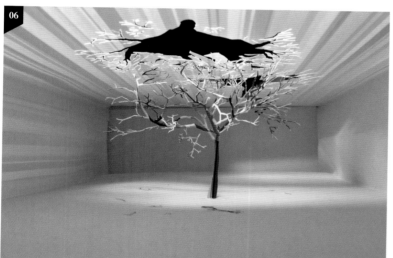

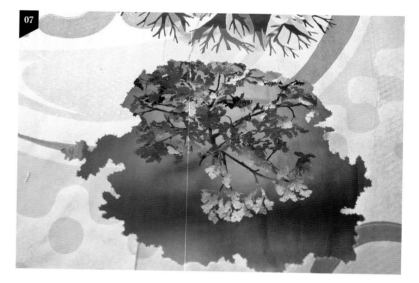

create a mini forest. The round form of the toilet roll resembles a tree trunk, which he then moulds to his will. Through the process of cutting out foliage and folding it from the toilet roll, it becomes a tree. In related series *Corner Forest* (2005–), he cut delicate budding branches from toilet rolls and arranged the rolls on the wall with nails and magnets, which cast shadows across the space.

While his work clearly contains political themes such as consumerism and globalization, these are not the artist's only

or indeed main concerns. Alongside ethical considerations, his intention is to create magical and transforming moments in the course of ordinary life. Using everyday and contemporary materials with which viewers are familiar is integral to this purpose: altering these items interrupts this sense of familiarity and transforms an ordinary object into something extraordinary. Teruya elegantly marries craft and mass production in his work, while subtly reminding us of the skills and traditions of the past.

04 *Notice – Forest*, McDonald's paper bag, 2010. **05** *Notice – Forest*, Burger King paper bag, 2008. **06** *Notice – Forest*, Paul Smith paper bag, 2007. **07** *Notice – Forest*, Burger King paper bag (from above), 2008. **08, 09** *Green Economy*, international paper currency, commissioned by the *New York Times Magazine*, 2010.

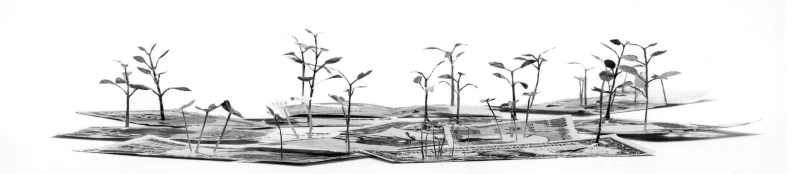

Luis Valdés

Chilean artist Luis Valdés, aka Don Lucho, explores our perceptions of normality through his work and, in particular, how we distinguish the usual from the unusual. By creating familiar yet extraordinary situations, he questions what we accept as customary. His work usually takes the form of installations, performances or sculptural interventions, often conducted with an element of subterfuge.

In the interactive work *Don Lucho's Stand* (2010), deception played a key role: he set up a stall selling cardboard fruit at a fair alongside other stalls offering real produce. The project, he says, was 'born from the idea of camouflage – in other words, to blend in at the fruit and vegetable market as one of the sellers, but to sell these fake fruits as cheap works of art. The idea was to confuse the viewer for a second, to make them think that they were in front of a stand of real fruit.'

The decision to sell contemporary pieces in this context was curious. Fine art tends to be sold in galleries for a specialized audience, and a market seems an unlikely place to find collectors. Although he thought that he might sell just one or two pieces, he achieved more than 100 sales. Rather than making the fruits look pretty in an idealized or artisanal way, he wanted them to pass inspection as realistic, ordinary, everyday items.

Cardboard appeals to Valdés as a material and he has become particularly adept at using it. Not only is it cheap, utilitarian and an effective canvas, but it also has great versatility and flexibility. It can be worked in various ways, allowing him to take advantage of the textures and the folds of its surface. He likes the way that the end result confuses the eye, presenting a mirage of reality, and almost always looks precarious.

In another work that uses cardboard, but on a much larger scale, Valdés created an entire house from scrap pieces that he had found on the street. With *Economy of Resources* (2009) the artist parodies the social reality of the South American dwelling, reflecting a style of makeshift building and the small, fragile spaces that become people's homes. The 'cardboard house' presents a quirky view of poverty that is surprising and charming, and for a moment the viewer is absorbed in a facsimile world and forgets the real social problems of living space. However, once engaged with the work, its underlying message soon becomes apparent.

As Valdés explains, 'In Chile there has always been a problem with living accommodation because many poor

01, 02, 03, 04 *Economy of Resources,* cardboard, paint and adhesive, 2009.

03

04

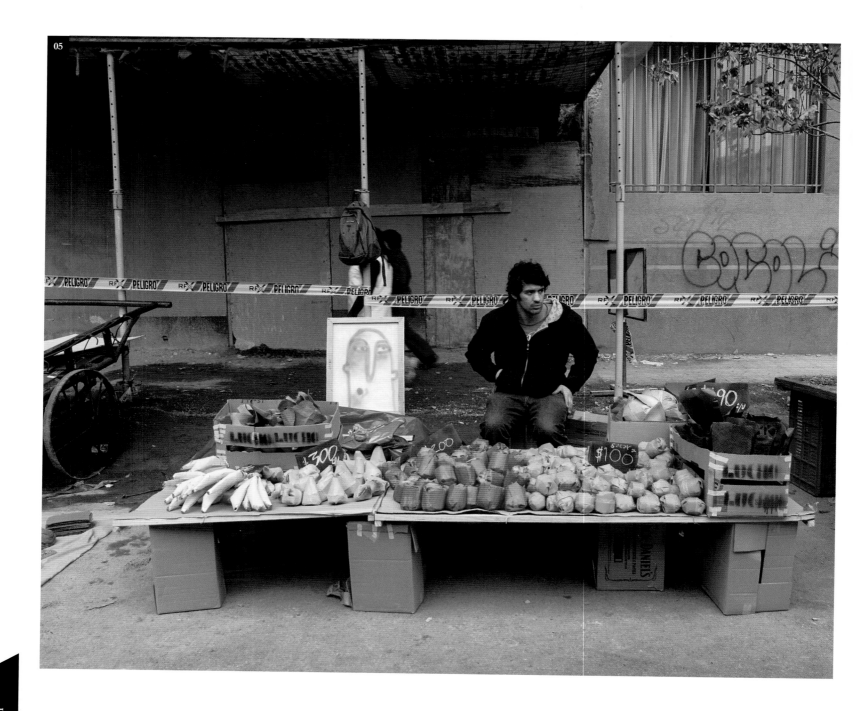

people don't have a home or money to rent a home. These people build small houses from lightweight materials such as cardboard, nylon, thin wood and cans to create settlements known as camps or *poblaciones callampas*. Sometimes, after years of protesting, the government agrees to build them a subsidized house and puts them in provisional housing in the meantime, which is made of wood and has the same dimensions as my cardboard house. Often the wait for the subsidized house becomes interminable due to the bureaucracy of the system. Entire families must live in these tiny houses for several years. Over time, however,

they start to give them character and turn them into warm spaces with true identities. This reality is seen in Chile and most South American countries and beyond.'

To give the rooms of his house a similar sense of character, Valdés created cardboard copies of personal items such as clothes and his skateboard. The work presents a monochromatic view as Valdés considers the house as a sketch in three dimensions – a fragile drawing that cannot be inhabited. Through this simple aesthetic he effectively represents the fragility of the *poblaciones callampas* and those who occupy them.

05, 06 *Don Lucho's Stand*, cardboard, paint and adhesive, 2010.

Felipe Yung

Brazilian artist Felipe Yung, aka Flip, produces calligraphic works, mixed-media paintings and site-specific installations. Starting out as a graffiti writer in São Paulo in the early 1990s, he was one of the first of his generation to begin working with characters and abstract forms rather than focusing exclusively on traditional graffiti lettering. He developed a unique style of characters, called *Flipitos* ('little ones'), quickly executed against a 'paint-dripped' background. These fun and friendly motifs began to appear across the city and have become something of a mascot in his local district of Vila Mariana.

Oriental culture and philosophy have influenced the artist a great deal and are recurring themes in his work. The cosmopolitan city of São Paulo is home to the largest Japanese population outside Japan, with a long history of Brazilian-Japanese artists. In style and technique, Yung draws from his knowledge of Japanese art to explore traditional forms such as textiles, calligraphy and shunga erotic art, as well as contemporary styles such as manga and the Superflat movement founded by artist Takashi Murakami.

In 2003 Yung co-founded Most, the first gallery in São Paulo to promote urban art. He began to apply his talents to commercial projects in fields such as fashion as well as exploring his ideas in a gallery context through canvases, objects and installations. He also started to use found wood such as old boxes and pallets as a material for construction and a foundation for his work. The use of wood has since become a strong theme in his work both texturally and conceptually, as he explains: 'Wood is a fantastic raw support, whose natural textures and patterns complete my work.'

The natural world is a wellspring of inspiration for Yung. He is particularly drawn to trees endemic to Brazil that bring beauty to city spaces, whether they are covered in blossom or have great buttress roots that burst through the tarmac. Observing native trees such as the jaboticaba and the jacaranda, Yung distils their characteristics into abstract patterns, often creating camouflage designs with fluid brushstrokes. Trees, branches and roots are also graphic motifs that he uses symbolically in his paintings. Photography is another medium through which he studies tree forms, which he then uses as a reference in his paintings. The artist also credits an encounter with

01, 02 Native Brazilian trees, photographic reference material. 03 *Pau Malandro* (detail), paint on wooden shack, Barra da Lagoa, Florianópolis, Brazil, 2009. 04 *Entranhas* (detail), paint on found wood, 2010.

ayahuasca – a hallucinogenic drink prepared from the bark of the tropical vine of the same name – as an important moment artistically as the experience opened his mind to perceive natural forms differently.

Yung makes rich connections between the worlds of flora and fauna. His ongoing fascination with the natural sphere extends to its relationships and parallels with man. For example, he draws comparisons between the sap that transports water and nutrients through a plant and the blood that runs through our veins. His characters blend qualities of both worlds to great effect. Yung's work is both figurative and abstract and, with his background in urban and character art, is alive with spontaneous energy. Making work intuitively, Yung bridges the gaps between contemporary pop culture, traditional art and nature.

05 *Gotas de Buda*, acrylic paint on found wood, 2010. **06** *Poda Forçada*, acrylic paint on found wood, 2010. **07** *Graviola in Praia Seca*, acrylic paint on wooden shack, Praia Seca, Rio de Janeiro, Brazil, 2008.

Carlos Zúñiga

A blank canvas can strike fear into an artist, its emptiness and sterility producing creative block, whereas a pre-existing surface or readymade already has a character or history, which can itself present new possibilities. Chilean artist Carlos Zúñiga is a perfect example of someone who takes an existing object as a starting point to create something new and extraordinary. His materials are the pages of selected books and directories, which through a meticulous process of deletion are transformed into the remarkable portraits and landscapes that have become his signature style.

Zúñiga is a trained architect and photographer and also worked in editorial and graphic design before finally settling on art. These multiple disciplines have naturally informed his aesthetic approach and, in the case of his editorial experience, given him an insight into the practice of editing – the selection process that determines what is made public and what is omitted or suppressed. His early works have a political edge, reflecting the recent history of Chile, which after many years of dictatorship under Augusto Pinochet's regime has been coming to terms with those lost decades of repression and censorship. This is particularly apparent in his video artwork *The Origin of Species* (2006), which depicts a hand crossing out line by line, page by page, almost ritualistically, the text of Charles Darwin's iconic and once highly controversial book. The piece, which anticipates Zúñiga's later work, is a clear reference to both political and intellectual freedom and its denial.

The artist subsequently adapted the method of deleting texts to create pictorial images. The inspiration for his debut portrait series, *Next* (2007) – for which he created 135 portraits of young people from his hometown of Santiago de Chile – stemmed from the sight of Chileans taking to the streets following Pinochet's death: specifically, the families of those who had disappeared under the regime marching beneath a curtain of pictures of their loved ones. On a grid of pages taken from local telephone books, each portrait is revealed by systematically ruling out words, which creates a lifelike but broken effect. 'Using a pencil to cross out or correct our mistakes is a mechanism we all use,' the artist explains. 'It is a form of self-censorship that leaves a subconscious trail that is a gateway to our painful feelings.' The act of deleting

01 *Pablo Serra* (eye detail), acrylic paint on phonebook, *Beginning of the Aura* series, 2010. 02 *San Carlos* (birds detail), ink on Argentinian phonebook, *Imperial Poem* series, 2010. 03 The artist at work.

04

names provides a stark visual reminder of censorship and missing victims of the regime.

Zúñiga continued to develop this method with a new series produced at a larger scale, featuring unnamed floating figures submerged under water. Its title, *Detained in Apnea* (2007), is a reference not only to the human condition leading to the temporary cessation of breathing, but also to the dictatorship's practice of disposing of bodies in the ocean. This project was followed by a series of large-scale portraits in colour on a grid of telephone directory pages (*Beginning of the Aura*, 2010), in which red, green and blue were used to cross out text instead of black.

Recently Zúñiga has also been drawn towards landscapes. For *Imperial Poem* (2010), he photographed the rugged scenery of the Falkland Islands as well as local people, using his technique of deleting lines on a grid of Buenos Aires phonebook pages to reinterpret the results: the landscapes take on a new textural quality, the lines emulating scratches and cross-hatchings on the rocks, sea and other surfaces. While there is no direct reference to the Falklands war, something in the starkness of the images, and the process of erasing names of people to create them, evokes memories of those lost on both sides of the conflict.

04 *Dia 5*, ink on phonebook, *Detained in Apnea* series, 2007.
05 *Dia 4*, ink on phonebook, *Detained in Apnea* series, 2007.

06 *Stone Runs Cat*, ink on Argentinian phonebook, *Imperial Poem* series, 2010. **07** *Portrait 5*, ink on Argentinian phonebook, *Imperial Poem* series, 2010. **08** *Portrait 12*, ink on Argentinian phonebook, *Imperial Poem* series, 2010. **09** *Portrait 7*, ink on Argentinian phonebook, *Imperial Poem* series, 2010. **10** *Portrait 6*, ink on Argentinian phonebook, *Imperial Poem* series, 2010.

07

08

09

10

11 *Milena Gröpper*, acrylic paint on phonebook, *Beginning of the Aura* series, 2010. 12 *Kristian Jones*, acrylic paint on phonebook, *Beginning of the Aura* series, 2010. 13 *Daniela Kovacic*, acrylic paint on phonebook, *Beginning of the Aura* series, 2010.

List of Illustrations

ride, generator, compressor, bucket, acrylic paint on vinyl, and video camera, 18.25 × 18.25 m (60 × 60 ft), *Scrambler Drawings* series, Grand Arts, Kansas City, USA, 2004. Photograph by E.G. Courtesy Priska C. Juschka Fine Art, New York. **10** *Good-Time Mix Machine,* acrylic paint on vinyl, and video projections, 18.25 × 18.25 m (60 × 60 ft), *Scrambler Drawings* series, Queens Museum of Art, New York, USA, 2004. Photograph by Stefan Hagen. Courtesy Priska C. Juschka Fine Art, New York. **11** *Good-Time Mix Machine,* Grand Arts, Kansas City, USA, 2004. Photograph by E.G. Courtesy Priska C. Juschka Fine Art, New York. **12** *Good-Time Mix Machine,* Queens Museum of Art, New York, USA, 2004. Photograph by Stefan Hagen. Courtesy Priska C. Juschka Fine Art, New York.

AJ Fosik

01 Hundreds of individually shaped pieces of wood are used in the construction of each work. **02, 03** Paint and stencils in the artist's studio. **04** *Ursine Brawl,* wood, paint and nails. **05** *Two-headed Tiger,* wood, paint and nails, 2010. **06** The artist models one of his works, 2010. **07** *One Hundred Percent Savage,* wood, paint and nails, 2009. **08** *The Third Way Out,* wood, paint and nails, 213 × 91 × 91 cm (84 × 36 × 36 in.), 2009.

Fumakaka

01, 02 *Monster,* Lima, Peru, 2011. **03** *Demolition Portal,* paint, 2008. **04** *Devil,* reclaimed materials, 2009. **05** *Presence in the House,* reclaimed materials, 2010. **06, 07** *Death Trash* installation in progress (*top*) and finished (*bottom*), reclaimed materials, 2008. **08, 09** *Bastard Salvation* installation in progress (*top*) and finished (*bottom*), reclaimed materials, 2008.

Sayaka Kajita Ganz

01 *Japonica,* reclaimed objects (mostly white plastic), 91 × 69 × 79 cm (36 × 27 × 31 in.) without pedestal, 2007. **02** The artist at work. **03** *Emergence (Wind),* reclaimed objects (mostly white and clear plastic), 160 × 198 × 66 cm (63 × 78 × 26 in.), 2008. **04** *Emergence,* 2008. Two-piece installation: *Night,* reclaimed objects (mostly black and clear plastic), 183 × 127 × 43 cm (72 × 50 × 17 in.); *Wind,* reclaimed objects (mostly white and clear plastic), 160 × 198 × 66 cm (63 × 78 × 26 in.).

José Enrique Porras Gómez

01, 02 The artist at work. **03** *Productos de exportación (Export Products),* engraved wooden crates, 2008. **04** *Productos de exportación (Export Products),* engraved wooden crates and woodcut print, 2008. **05, 06** *Ola Ganando Espacio (Wave Moving Through Space)* under construction, 2010. **07** *Ola Ganando Espacio (Wave Moving Through Space),* wood, nails and ink, 2010. **08** *Ola Ganando Espacio (Wave Moving Through Space),* frottage on paper, 2010.

Hiroyuki Hamada

01 *#63,* hessian canvas, enamel, oil, plaster, resin, tar, wax and wood, 114 × 102 × 61 cm (45 × 40 × 24 in.), 2006–10. **02** *#45,* hessian canvas, enamel, oil, plaster, resin, solvents, tar and wax, 51 × 64 × 64 cm (20 × 25 × 25 in.), 2002–5. **03** *#45* (detail). **04** *#47,* hessian canvas, enamel, oil, plaster, resin, solvents, tar and wax, 94 cm in diameter × 15 cm (37 × 6 in.), 2002–5. **05** *#35,* hessian canvas, enamel, oil, plaster, tar and wax, 97 × 91 × 4 cm (38 × 36 × 1 ¾ in.), 1998–2001. **06** Work in progress, foam, wood and hessian canvas. **07** Work in progress: a plaster shell is applied to the structure. **08** Studio materials. **09** Work in progress, foam and wood. **10, 11** Electric drills (*left*) are used to create texture (*right*). **12** *#53,* enamel, oil, plaster, tar and wax, 97 cm in diameter × 37 cm (38 × 14 ½ in.), 2005–8. **13** *#59* (detail), enamel, oil, plaster, tar and wax, 51 cm in diameter × 91 cm (20 × 36 in.), 2005–8. **14** (*left*) *#52,* enamel, oil, plaster, tar and wax, 64 cm in diameter × 48 cm (25 × 19 in.), 2005–8; (*right*) *#59.* **15** *#56,* enamel, oil, plaster, tar and wax, 105 × 105 × 19 cm (41.5 × 41.5 × 7.5 in.), 2005–10.

Haroshi

01 Used skateboards, 2009. **02** The artist's studio, 2009. **03** *Apple* sculptures in progress, 2009. **04** *Big Apple,* used skateboards, 24 × 21 × 21 cm (9 ½ × 8 ¼ × 8 ¼ in.), 2011. **05** *Fire Hydrant,* used skateboards, 84 × 36 × 38 cm (33 ⅛ × 14 ⅛ × 15 in.), 2011. **06** *Screaming my Foot,* used skateboards, 2010. **07** *Screaming my Hand,* used skateboards, 2010.

Valerie Hegarty

01 *Autumn on the Hudson Valley with Branches,* fibreglass, aluminium rod, epoxy, treated plywood, vinyl, acrylic paint and artificial leaves, 183 × 427 × 61 cm (72 × 168 × 24 in.), 2009. **02** *Cracked Canyon,* foam core, paper, paint, wood,

glue and gel medium, 200 × 192 × 5 cm (78 ¾ × 75 ⅝ × 2 in.), 2007. **03** *Rothko Sunset,* foam core, canvas, paper, paint, glue, wire, tape, sand and gel medium, 107 × 81 × 20 cm (42 × 32 × 8 in.), 2007. **04** *Pollock's Flying Carpet,* paper, glue, tape and paint, 168 × 173 × 46 cm (66 × 68 × 18 in.), 2010. **05** *Unearthed,* wood and mixed media, 91 × 56 × 25 cm (36 × 22 × 10 in.), 2008. **06** *Cathedral,* wood, armature wire, wire mesh, Magic Sculp, papier-mâché, plastic, canvas, wood glue, gel media, thread and sand, 206 × 112 × 61 cm (81 × 44 × 24 in.), 2010. **07** *Bierstadt with Holes,* foam core, paper, paint, wood, glue, gel medium and plexiglas, 103 × 85 × 7 cm (40 ½ × 33 ½ × 2 ¾ in.), 2007. **08** (*left*) *Bierstadt with Holes;* (*right*) *Chest of Drawers (Early American) with Woodpecker,* foam core, paper, paint, wood, glue, gel medium and sawdust, 236 × 132 × 67 cm (93 × 52 × 26 ½ in.), 2007.

Luiz Hermano

01 The artist at work. **02** *Tikal,* capacitors and wire, 140 × 210 × 20 cm (55 ⅛ × 82 ⅝ × 7 ⅞ in.), 2007. **03** *Sadu,* electrical components and wire, 220 × 75 × 15 cm (86 ⅝ × 29 ½ × 5 ⅞ in.), 2006. **04** *África,* resin and wire, 150 × 105 cm (59 × 41 ⅜ in.), 2010. **05** *Aterro Orgânico 3,* resin and wire, 100 × 90 cm (39 ⅜ × 35 ⅜ in.), 2010. **06** *Angkor-Wat,* plastic and wire, 180 × 180 cm (70 ⅞ × 70 ⅞ in.), 2007. **07** *Clínica,* plastic and wire, 80 × 86 cm (31 ½ × 33 ⅞ in.), 2009. **08** *Pracinha,* plastic and wire, 105 × 120 × 15 cm (41 ⅜ × 47 ¼ × 5 ⅞ in.), 2007.

Florentijn Hofman

01 *Max,* potato crates, pallets, wood, straw, rope, metal wire and shrink foil, 12 × 8 × 25 m (39 ft 4 in. × 26 ft 3 in. × 82 ft), Leens, Netherlands, 2003. **02** *Pig Juggling with Strawberries,* wood, concrete, corrugated iron and paint, 10 × 10 m (32 ft 10 in. × 32 ft 10 in.), Veghels Buiten, Netherlands, 2010. **03** *Lookout Rabbit* (detail), concrete, sand, grass, metal, wood, paint and cement coating, 6 × 7 × 12 m (19 ft 8 in. × 23 ft × 39 ft 4 in.), Nijmegen, Netherlands, 2011. **04** *Lookout Rabbit.* **05, 06, 07, 08** *Signpost 5,* three grand pianos, each 8 × 6 × 5 m (26 ft 3 in. × 19 ft 8 in. × 16 ft 5 in.), wood and nails, Schiermonnikoog island, Netherlands, 2008. **09, 10, 11** *Fat Monkey,* inflatable and flip-flops, 5 × 4 × 15 m (16 ft 5 in. × 13 ft 2 in. × 49 ft 2 in.), São Paulo, Brazil, 2010.

Michael Johansson

01 *Cake Lift,* objects from the storeroom of the Aarhus Art Building, 140 × 500 × 80 cm (55 ⅛ × 196 ⅞ × 31 ½ in.), Aarhus Art Building, Aarhus, Denmark, 2009. **02, 03** *Rubiks Kurve (Rubik's Curve),* various objects, metal boxes and wooden wall, 15 × 3.5 m (49 ft 2 in. × 11 ft 6 in.), Svartlamon, Trondheim, Norway, 2010. **04** *Vi hade i alla fall tur med vädret (At least the weather was nice),* various materials including a caravan, portable coolers, ice packs, deckchairs, camping equipment and thermos flasks, 300 × 200 × 200 cm (118 ⅛ × 78 ¾ × 78 ¾ in.), Bottna Kulturfestival, Gerlesborg, Sweden, 2006. **05** *Ghost II,* various white objects, 290 × 290 cm (114 ⅛ × 114 ⅛ in.), Arnstedt Östra Karup Gallery, Båstad, Sweden, 2009. **06** *27m3,* objects from the storeroom of Bergen Art Museum, 300 × 300 × 300 cm (118 ⅛ × 118 ⅛ × 118 ⅛ in.), Bergen Art Museum, Bergen, Norway, 2010. **07** *Green Piece,* green outdoor equipment, 60 × 60 × 60 cm (23 ⅝ × 23 ⅝ × 23 ⅝ in.), 2009. **08** *Frusna Tillhörigheter (Frozen Belongings),* various objects including an armchair, a typewriter, books, boxes and a clock, 55 × 80 × 55 cm (21 ⅝ × 31 ½ × 21 ⅝ in.), 2010. **09** *Domestic Kitchen Planning,* kitchen stool and equipment, 40 × 60 × 45 cm (15 ¾ × 23 ⅝ × 17 ¾ in.), 2010. **10** *Strövtåg i tid och rum (Strolls through Time and Space),* various objects including an armchair, books, bags, boxes, a radio and a clock, 55 × 85 × 60 cm (21 ⅝ × 33 ½ × 23 ⅝ in.), 2009.

Anouk Kruithof

01 'Fragmented Entity' show, Art Rotterdam, Rotterdam, Netherlands, 2011. **02** *Clear Heads,* C-print on aluminium, 100 × 70 cm (39 ⅜ × 27 ⅝ in.). **03** *Photos from Photos,* light-jet prints and light-jet prints on aluminium, variable dimensions. **04** *Everything's Metaphor (Criss Cross),* light-jet print on aluminium, 100 × 70 cm (39 ⅜ × 27 ⅝ in.). **05, 06** *Enclosed Content Chatting Away in the Colour Invisibility,* found coloured books, Künstlerhaus Bethanien, Berlin, Germany, 2009.

Jae-Hyo Lee

01 *0121-1110=1091212,* stainless steel bolts, nails and wood, 65 × 65 × 266 cm (25 ⅝ × 25 ⅝ × 104 ¾ in.), 2009. **02** The artist at work. **03** *0121-1110=110101,* bronze, 240 × 70 × 240 cm (94 ½ × 27 ⅝ × 94 ½ in.), 2010. **04** *0121-1110=106111,* wood, 320 × 100 × 320 cm (126 × 39 ⅜ × 126 in.). **05** *0121-1110=1100810,* wood, 88 × 140 × 80 cm (34 ⅝ × 55 ⅛ × 31 ½ in.), 2010. **06** *0121-1110=111038,* wood, 120 × 120 × 180 cm (47 ¼ × 47 ¼ × 70 ⅞ in.), 2011.

07 *0121-1110=110011,* wood (Douglas fir), 168 × 56 × 220 cm (66 ⅛ × 22 × 86 ⅝ in.), 2010. **08** *0121-1110=1080815,* stone, 95 × 95 × 600 cm (37 ⅜ × 37 ⅜ × 236 ¼ in.), 2008. **09** *0121-1110=105102,* stainless steel bolts, nails and wood, variable dimensions.

Luzinterruptus

01, 02, 03 *An Almost Ephemeral Autumn,* fallen leaves, wire and LEDs, 2009. **04** *The Wind Brought Us the Crisis,* LEDs and eighty financial papers, Madrid Stock Exchange, Madrid, Spain, 28 April 2009. Photograph by Gustavo Sanabria. **05** *Literature versus Traffic,* LEDs and 800 found books, New York, USA, 2010. Photograph by Gustavo Sanabria. **06, 07, 08, 09** *Floating Presences,* LEDs, balloons and fabric, Rizoma Festival, Molinicos, Spain, 2010. Photograph by Gustavo Sanabria. **10, 11, 12, 13** *Caged Memories,* 400 golden cages, personal mementos and LEDs, Plaza de los Ministriles, Madrid, Spain, 2010. Photograph by Gustavo Sanabria.

Maria Nepomuceno

01 *Untitled,* ropes and beads, installed: 4.4 × 1.7 × 12.3 m (14 ft 5 in. × 5 ft 7 in. × 40 ft 4 in.), 2010. Copyright Maria Nepomuceno. Courtesy Victoria Miro Gallery, London. **02** *Untitled* (detail), sewn ropes and beads, 120 × 250 × 200 cm (47 ¼ × 98 ⅜ × 78 ¾ in.), 2010. Copyright Maria Nepomuceno. Courtesy Victoria Miro Gallery, London. **03** *Untitled* (detail), ropes, beads and fabric, 440 × 360 cm (173 ¼ × 141 ¾ in.), 2010. Copyright Maria Nepomuceno. Courtesy Victoria Miro Gallery, London. **04** Performance, 2008. **05** *Untitled,* ropes, beads and fabric, 440 × 360 cm (173 ¼ × 141 ¾ in.), 2010. Copyright Maria Nepomuceno. Courtesy Victoria Miro Gallery, London. **06** *Untitled,* braided straw, ropes and beads, 440 × 400 × 350 cm (173 ¼ × 157 ½ × 137 ¾ in.), 2010. Copyright Maria Nepomuceno. Courtesy Victoria Miro Gallery, London. **07** *Untitled,* sewn ropes and ceramics, 140 × 100 × 70 cm (55 ⅛ × 39 ⅜ × 27 ⅝ in.), 2008. Copyright Maria Nepomuceno. Courtesy Victoria Miro Gallery, London. **08** *Untitled,* sewn ropes and beads, 120 × 250 × 200 cm (47 ¼ × 98 ⅜ × 78 ¾ in.), 2008. Copyright Maria Nepomuceno. Courtesy Victoria Miro Gallery, London.

Henrique Oliveira

01 The artist working on the sculpture *Coisa,* wood, PVC, gauze, cement, beeswax and polyurethane, 2008. **02, 03, 04** *The Origin of the Third World* (work in progress), wood, PVC and metal, São Paulo Biennial, São Paulo, Brazil, 2010. **05** *Tapumes – Casa dos Leões,* wood and PVC, 7th Mercosul Biennial, Porto Alegre, Brazil, 2009. Photograph by Eduardo Ortega. **06** *Untitled,* wood and PVC, 3.5 × 12 × 1.5 m (11 ft 6 in. × 39 ft 4 in. × 4 ft 11 in.), Centro Cultural São Paulo, São Paulo, Brazil, 2006. **07** *Paralela,* wood and PVC, 3.7 × 14 × 1.8 m (12 ft 2 in. × 45 ft 11 in. × 5 ft 11 in.), São Paulo, Brazil, 2006. Photograph by Mauro Restiffe. **08** *Tapumes,* wood, 4 × 18.4 × 1.2 m (13 ft 2 in. × 60 ft 4 in. × 3 ft 11 in.), Fiat Mostra Brasil, São Paulo, Brazil, 2006. Photograph by Mauro Restiffe. **09** *Tapumes* (detail). Photograph by Mauro Restiffe. **10** *Tríptico,* wood and PVC, 270 × 550 × 75 cm (106 ¼ × 216 ½ × 29 ½ in.), 2008. **11** *Untitled,* wood, 200 × 300 × 65 cm (78 ¾ × 118 ⅛ × 25 ⅝ in.), 2009. **12** *Túnel (Tunnel)* (entrance), wood, PVC and beeswax, 2 × 30 × 3 m (6 ft 7 in. × 98 ft 5 in. × 9 ft 10 in.), Instituto Itaú Cultural, São Paulo, Brazil, 2007. **13, 14** *Túnel (Tunnel)* (internal view). **15** *Túnel (Tunnel)* (exit).

Erik Otto

01 *Collective Force* (blue), house paint, spray paint, screen print and pencil on panel with lightbulb, 2010. **02** *Dreamcatcher Phase I,* house paint, spray paint, reclaimed wood, glass window and arrows, 2010. **03** The artist with materials. **04** *Road of Prosperity (The Start of a New Beginning),* recycled wood, house paint, spray paint and fishing line, 2010. **05** The artist's studio, recycled wood and house paint, 2010. **06** *Slow Journey (Phase I),* house paint, spray paint, reclaimed wood, caster wheels, rope and found tricycle, 2010. **07** *Immunity,* house paint, spray paint, screen print and pencil on nine panels, 2010. **08** *Moment of Victory,* house paint, spray paint and pencil on scrap wood, 2009. **09** *Silence Speaks Volumes* (detail), house paint, spray paint, reclaimed wood and twine, 150 × 300 cm (59 × 118 ⅛ in.), 2010. **10** *Centripetal Force,* house paint, spray paint and pencil on four panels, 2010. **11** *Collective Force* (red), house paint, spray paint, screen print and pencil on panel with lightbulb, 91 × 91 cm (36 × 36 in.), 2010.

Mia Pearlman

01 The artist at work at the Islip Art Museum, Long Island, USA. Photograph by Gene Bahng. **02** The artist at work in her studio. Photograph by Catrina Genovese. **03, 04, 05** *Penumbra,* paper, Indian ink, paper clips and tacks,

variable dimensions, Plaats Maken, Arnhem, Netherlands, 2010. Photographs by Mia Pearlman. **06, 07** *Maelstrom*, steel, aluminium, paper, Indian ink, monofilament and wire, 370 cm in diameter × 340 cm (145 5/8 × 133 7/8 in.), Smack Mellon, Brooklyn, USA, 2008. Photographs by Jason Mandella. **08** Islip Art Museum, Long Island, USA. Photograph by Gene Bahng. **09** *Gyre*, paper, Indian ink, tacks and paper clips, 210 × 340 × 400 cm (82 5/8 × 133 7/8 × 157 1/2 in.), Islip Art Museum, Long Island, USA, 2008. Photograph by Gene Bahng. **10** *Influx* (detail), paper, Indian ink, tacks and paper clips, variable dimensions, Roebling Hall Gallery, New York, USA, 2008. Photograph by Jason Mandella.

Lionel Sabatté

01 *Février* and *Septembre*, wolves made from dust collected in the Paris Métro, 136 × 50 × 70 cm (53 1/2 × 19 5/8 × 27 5/8 in.), 2006. Courtesy Galerie Patricia Dorfmann, Paris. **02** *Février, Août* and *Septembre*, wolves made from dust collected in the Paris Métro, 136 × 50 × 70 cm (53 1/2 × 19 5/8 × 27 5/8 in.), 2006. Courtesy Galerie Patricia Dorfmann, Paris. **03** *Août*. **04** *Étude à la poussière II (Study in Dust II)*, graphite and dust on paper, 21 × 29.7 cm (8 1/4 × 11 3/4 in.), 2010. Courtesy Galerie Patricia Dorfmann, Paris. **05** *Étude à la poussière IV (Study in Dust IV)*, graphite and dust on paper, 21 × 29.7 cm (8 1/4 × 11 3/4 in.), 2010. Courtesy Galerie Patricia Dorfmann, Paris. **06** *Hells Angels no. 1*, in collaboration with Baptiste Debombourg, natural pigeon and artificial feathers, 50 × 60 cm (19 5/8 × 23 5/8 in.), 2009. Courtesy Galerie Patricia Dorfmann, Paris. **07** *Hells Angels no. 1* (detail). Courtesy Galerie Patricia Dorfmann, Paris.

Chris Silva

01 *No Snowflake In An Avalanche Ever Feels Responsible*, Walker's Point Center for the Arts, Milwaukee, USA, 2006. **02** Studio materials. **03** Work in progress. **04** *Projections & Delusions* (work in progress), 2006. **05** *Projections & Delusions*, 2006. **06** *Open Hearts Urgery*, in collaboration with Lauren Feece, The Group Group Show, Version Kunsthalle, Chicago, USA, 2006. **07** *Se Cambian Que?*, reclaimed wood, enamel paint and plastic, 2005. **08** *This One Will Hold You In Her Arms, These In Their Mouths*, in collaboration with Lauren Feece, found materials, Aguadilla, Puerto Rico, June 2009. **09** *Rubber Swords, Lovers & Fighters*, assemblage and painting, exhibition with Lauren Feece, Philadelphia, USA, 2010. **10** *This One Will Hold You In Her Arms, These In Their Mouths*. **11** *Rubber Swords, Lovers & Fighters*.

Lucas Simões

01 *Estudo para 'tua paisagem' (Study for 'Landscape of You')*, laser print, 7 × 40 cm (2 3/4 × 15 3/4 in.), 2010. **02** *Self-portrait*, digital collage, 20 × 15 cm (7 7/8 × 5 7/8 in.), 2010. **03** *Estudo para 'tua paisagem' (Study for 'Landscape of You')*, laser print, 7 × 40 cm (2 3/4 × 15 3/4 in.), 2010. **04, 05** *Requiem*, 10 cut-out C-prints, *Unportraits* series, 30 × 40 cm (11 3/4 × 15 3/4 in.), 2010. **06** Study for *Unmemory*, 10 cut-out C-prints, 30 × 40 cm (11 3/4 × 15 3/4 in.), 2010. **07** Study for *Unmemory*, 10 cut-out laser prints, 30 × 40 cm (11 3/4 × 15 3/4 in.), 2010. **08** Study for *Unmemory*, 10 cut-out C-prints and laser print, 30 × 40 cm (11 3/4 × 15 3/4 in.), 2010. **09** Study for *Unmemory*, 10 cut-out C-prints, 30 × 40 cm (11 3/4 × 15 3/4 in.), 2010. **10** *Adios*, ashes of burned photographs over portrait inside a box, 15 × 6 cm (5 7/8 × 2 3/8 in.), 2010. **11** *Estudo para 'tua paisagem' (Study for 'Landscape of You')*, laser print, 7 × 40 cm (2 3/4 × 15 3/4 in.), 2010. **12** *Quasi-cinema (Paradestrasse)*, sewn photographs on fabric and wood, 10 × 148 cm (3 7/8 × 58 1/4 in.), 2010. **13** *Quasi-cinema (Zoologischer Garten)*, sewn photographs on fabric and wood, 20 × 308 cm (7 7/8 × 121 1/4 in.), 2010. **14** Installation view of three works in the *Quasi-cinema* series, sewn photographs on fabric and wood, variable dimensions, 2010.

Yuken Teruya

01 *Rain Forest* (detail), thirteen toilet rolls, magnets and chains, variable dimensions, 2006. **02** *Corner Forest*, toilet rolls, 2008. **03** *Corner Forest* (detail). **04** *Notice – Forest*, McDonald's paper bag, 2010. **05** *Notice – Forest*, Burger King paper bag, 2008. **06** *Notice – Forest*, Paul Smith paper bag, 2007. **07** *Notice – Forest*, Burger King paper bag (from above), 2008. **08, 09** *Green Economy*, international paper currency, commissioned by the *New York Times Magazine*, 2010. Photographs by Yoshikazu Nema.

Luis Valdés

01, 02, 03, 04 *Economy of Resources*, cardboard, paint and adhesive, 300 × 230 × 600 cm (118 1/8 × 90 1/2 × 236 1/4 in.), 2009. **05, 06** *Don Lucho's Stand*, cardboard, paint and adhesive, 250 × 150 × 60 cm (98 3/8 × 59 × 23 5/8 in.), 2010. Photographs by Martin La Roche.

Felipe Yung

01, 02 Native Brazilian trees, photographic reference material. Photographs by Felipe Yung. **03** *Pau Malandro* (detail), paint on wooden shack, Barra da Lagoa, Florianópolis, Brazil, 2009. **04** *Entranhas* (detail), paint on found wood, 2010. **05** *Gotas de Buda*, acrylic paint on found wood, 99 × 36 cm (39 × 14 in.), 2010. **06** *Poda Forçada*, acrylic paint on found wood, 99 × 36 cm (39 × 14 in.), 2010. **07** *Graviola in Praia Seca*, acrylic paint on wooden shack, Praia Seca, Rio de Janeiro, Brazil, 2008.

Carlos Zúñiga

01 *Pablo Serra* (eye detail), acrylic paint on phonebook, 103 × 135 cm (40 1/2 × 53 1/8 in.), *Beginning of the Aura* series, 2010. **02** *San Carlos* (birds detail), ink on Argentinian phonebook, 138 × 181 cm (54 3/8 × 71 1/4 in.), *Imperial Poem* series, 2010. **03** The artist at work. **04** *Dia 5*, ink on phonebook, 224 × 134 cm (88 1/8 × 52 3/4 in.), *Detained in Apnea* series, 2007. **05** *Dia 4*, ink on phonebook, 142 × 217 cm (55 7/8 × 85 3/8 in.), *Detained in Apnea* series, 2007. **06** *Stone Runs Cat*, ink on Argentinian phonebook, 138 × 181 cm (54 3/8 × 71 1/4 in.), *Imperial Poem* series, 2010. **07** *Portrait 5*, ink on Argentinian phonebook, 110 × 82 cm (43 1/4 × 32 1/4 in.), *Imperial Poem* series, 2010. **08** *Portrait 12*, ink on Argentinian phonebook, 110 × 82 cm (43 1/4 × 32 1/4 in.), *Imperial Poem* series, 2010. **09** *Portrait 7*, ink on Argentinian phonebook, 110 × 82 cm (43 1/4 × 32 1/4 in.), *Imperial Poem* series, 2010. **10** *Portrait 6*, ink on Argentinian phonebook, 110 × 82 cm (43 1/4 × 32 1/4 in.), *Imperial Poem* series, 2010. **11** *Milena Gröpper*, acrylic paint on phonebook, 103 × 135 cm (40 1/2 × 53 1/8 in.), *Beginning of the Aura* series, 2010. **12** *Kristian Jones*, acrylic paint on phonebook, 103 × 135 cm (40 1/2 × 53 1/8 in.), *Beginning of the Aura* series, 2010. **13** *Daniela Kovacic*, acrylic paint on phonebook, 103 × 135 cm (40 1/2 × 53 1/8 in.), *Beginning of the Aura* series, 2010.

All images were kindly supplied by the artists or their galleries.

Sources of Quotations

p. 78
The quote beginning 'In a bar you can hear gossip' was taken from an interview with the artist by Michal Novotny, an art activist and journalist based in Prague. The interview was recorded in Paris in the frame of an upcoming exhibition project in collaboration with the Institut Français de Prague in 2011.

p. 148
'People seem to really respond to the aggression…': taken from 'Nature's Methodic and Unpredictable Fury', published in *Flaunt* magazine. Matthew Bedard conducted the interview with the artist.

p. 172
'Rarely is a photo the final result…': taken from Artslant.com.

Websites

Felipe Barbosa: felipebarbosa.com
Andrés Basurto: antenaestudio.com
Zadok Ben-David: zadokbendavid.com
Robert Bradford: robertbradford.co.uk
Peter Callesen: petercallesen.com
Monica Canilao: monicacanilao.com
Klaus Dauven: klaus-dauven.de
Gabriel Dawe: gabrieldawe.com
Baptiste Debombourg: baptistedebombourg.com
Brian Dettmer: briandettmer.com
Elfo: elfostreetart.blogspot.com
Ron van der Ende: ronvanderende.nl
Faile: faile.net
Rosemarie Fiore: rosemariefiore.com
AJ Fosik: ajfosik.com
Fumakaka: fumakaka.com
Sayaka Kajita Ganz: sayakaganz.com
José Enrique Porras Gómez: olaganandoespacio.wordpress.com
Hiroyuki Hamada: hiroyukihamada.com
Haroshi: haroshi.com
Valerie Hegarty: valeriehegarty.com
Luiz Hermano: luizhermano.com
Florentijn Hofman: florentijnhofman.nl
Michael Johansson: michaeljohansson.com
Anouk Kruithof: anoukkruithof.nl
Jae-Hyo Lee: leeart.name
Luzinterruptus: luzinterruptus.com
Maria Nepomuceno: victoria-miro.com
Henrique Oliveira: henriqueoliveira.com
Erik Otto: erikotto.com
Mia Pearlman: miapearlman.com
Lionel Sabatté: lionelsabatte.com
Chris Silva: chrissilva.com
Lucas Simões: lucassimoes.com.br
Yuken Teruya: yukenteruyastudio.com
Luis Valdés: flickr.com/photos/33879103@N04
Felipe Yung: flipink.blogspot.com
Carlos Zúñiga: carloszuniga.org

Acknowledgments

Many thanks to Olivia Manco for her inspiration, Carla Haag for translations and Jean Manco for additional support. Thanks to all the contributing artists for their generous insights into their work.

I would also like to thank the photographers Gene Bahng, Nash Baker, Rana Begum, Anders Sune Berg, Heath Cooper, Murray Fredericks, E.G., Catrina Genovese, Stefan Hagen, Avi Hai, Barnaby Hindle, Martin La Roche, Jason Mandella, Yoshikazu Nema, Gene Ogami, Eduardo Ortega, Adam Reich, Mauro Restiffe, Gustavo Sanabria, Tod Seelie and Russel Wong for their kind support.

Thank you also to the following galleries for their excellent assistance: Galerie Patricia Dorfmann, Hada Contemporary, Nicelle Beauchene, Priska C. Juschka Fine Art, Sara Meltzer Gallery and Victoria Miro Gallery.

Special thanks to William Baglione, Nicelle Beauchene, Patricia Dorfmann, Ai Hayatsu, Mathilda Holmqvist, Pippy Houldsworth, Emily Johnsen, Priska C. Juschka, Akinori Kojima, Sara Meltzer, Victoria Miro, Anna Mustonen, Aaron Simonton, Kathy Stephenson and Tom Woo for their invaluable help.

The installation *Ola ganando espacio (Wave Moving Through Space)* by José Enrique Porras Gómez was made possible by the kind support of Fundación Colección Jumex.